Auschwitz and After

Auschwitz and After

Race, Culture, and "the
Jewish Question" in France

Edited by Lawrence D. Kritzman

Routledge · New York London

Published in 1995 by

Routledge
29 West 35th Street
New York, NY 10001

Published in Great Britain by

Routledge
11 New Fetter Lane
London EC4P 4EE

Library of Congress Cataloging-in-Publication Data

Auschwitz and after : race, culture, and "the Jewish question" in
 France / edited by Lawrence D. Kritzman.
 p. cm.
 Includes bibliographical references and index.
 ISBN 0-415-90440-4 (cloth). —ISBN 0-415-90441-2 (paper).
 1. Holocaust, Jewish (1939–1945)—France—Influence. 2. Jews—
France—Intellectual life. 3. Holocaust, Jewish (1939–1945), in
literature. 4. Holocaust, Jewish (1939–1945), in motion pictures.
5. France—Intellectual life—20th century. 6. France—Ethnic
relations. I. Kritzman, Lawrence D.
DS135.F83A87 1994
305.892'4044'09045—dc20 94-27397
 CIP

British Library Cataloguing-in-Publication Data also available.

In Memory of Jean Carduner and Edouard Morot-Sir

CONTENTS

CONTENTS

CONTENTS

ACKNOWLEDGMENTS

The editor gratefully acknowledges the permission of the following publishers to reprint for this volume these essays in their revised form: Basil Blackwell Ltd., for "Difficult Freedom" (chapters 16 and portions of chapter 17) from *The Levinas Reader* (1989); © Editions du Seuil for "Du romanesque à la mémoire" from Alain Finkielkraut's *Le Juif imaginaire* (1983); Éditions La Découverte for "Le défi de la Shoah à l'histoire" from Pierre Vidal-Naquet's *Les Juifs, la mémoire et le présent, Vol. II* (Paris, 1991), previously published by Albin Michel, as "L'épreuve de l'historien: réflexions d'un généraliste" in F. Bédarida, *La politique nazie d'extermination* (Paris, 1989); the Center for Twentieth Century Studies Working Papers (Fall 1986) for Jean-François Lyotard's essay "Discussions, or Phrasing 'after Auschwitz'", translated by Georges Van Den Abbeele; Harvard University Press for "War Memories: On Autobiographical Reading" from Susan Rubin Suleiman's *Risking Who One Is: Encounters with Contemporary Art and Literature* (Cambridge, 1994).

I am pleased to thank those who have assisted me on this project in various ways. First and foremost, I owe a special debt of gratitude to William P. Germano, editor *extraordinaire,* who encouraged me to pursue this project by providing unwavering support, understanding, and friendship. I would also like to thank Eric Zinner of Routledge for his keen editorial and critical skills. For help, advice, inspiration, and encouragement, I would like to thank the following colleagues who enabled me to bring this manuscript into being: Wanda Bachmann, Faith E. Beasley, Dr. D. Dilldock, Alexander Edlich, Alice Yaeger Kaplan, David La Guardia, the late Edouard Morot-Sir, Pierre Nora, Roxana Verona and Pierre Vidal-Naquet.

Lawrence D. Kritzman
Hanover, New Hampshire

In the Shadows of Auschwitz
CULTURE, MEMORIES, AND SELF-REFLECTION

The memory of Auschwitz and the question of Jewish identity have been key critical *topoi* in French political, cultural, and intellectual life since the end of World War II. Since Auschwitz, every word evoking its dark past either dissimulates guilt or simply denies the reality of the extermination. Beginning with the release of Marcel Ophuls's landmark documentary, *The Sorrow and the Pity* (1970), there appeared a whole spate of books, films, and public debates that have not only attempted to demystify the notion of a totally courageous France resistant to Nazi aggression during World War II, but have also pointed out that the politics of collaboration practiced by the Vichy Regime were in some cases the extension of a long-standing French anti-Semitic tradition. Pétain's national revolution was indigenous to certain aspects of French political culture, and not merely a German import.

The paradigmatic theory of racism in modern France can be traced back to the thought of Arthur de Gobineau, who claimed, in his *Essay on the Inequality of the Races* (1853), that the decline of civilization may be historically linked to the contamination of a racially pure culture by foreign elements. From the 1880s to the pre-World War II period, French anti-Semites such as Edouard Drumont, Charles Maurras, and Robert Brasillach, to name but a few, articulated an unresolved tension between French national traditions and what they nefariously characterized as a dangerously unassimilable Jewish identity. The anti-republicanism that began to take shape in the early years of the Third Republic (1870–1940) saw the progressive spirit initiated by the French Revolution, and exemplified by the citizenship of Jews and their access to power in the public sphere, as symptomatic of an attempt to destroy the traditional foundations of French society. The new leaders of the Third Republic succeeded in fostering a cultural universalism based on the "Rights of Man" and a rationalist vision of the world which replaced the closed society of *la vieille France* by one in which the separation of

church and state and the secularization of society would challenge the tyranny of solidarity.[1]

Within this historical context, Jews came under attack for all that was wrong with France. The figure of the Jew represented the *anti-producteur,* the urban monied individual, the antithesis of the noble French peasant whose rural existence was idealized for its settled life, rooted in the values of the earth. Regarded as an agent of evil and a "barbarian," the Jew was also depicted as a nomad who threatened organized society and the identity of "true France."[2] Michael Winock notes: "the Jew intrudes upon this bucolic vision as the antithesis of the Peasant; his fortune is founded upon an uprooting of people and upon the frenzy that comes from progress."[3] Surprisingly, it was the left-wing, socialist anti-Semitism conceptualized in the thought of Toussenel, Proudhon, and Fourier in the 1840s that set the stage for this anti-Jewish discourse. It proclaimed that Semitic high finance, incarnated by the wealthy Jewish bankers, took on the symbolic role of the medieval usurer and accordingly catalyzed the spiritual degeneration of France. If Jews came under attack for their supposed role as economic oppressors and capitalist instigators of social anarchy, they would also be depicted in another context as social revolutionaries, conspiring to seize power and destroy the very fabric of the nation. Paradoxically, Rothschild and Marx existed side by side. In due course, the extreme factions of both left and right would coalesce in a battle waged against the so-called Jewish menace.

Starting with the Boulanger and Dreyfus Affairs, and continuing through the 1930s, Jews became convenient scapegoats for the perceived decadence of French society and the degeneration of its cultural traditions. The masses were indoctrinated with contempt for republican practices, for they were led to believe that France could undergo a national revival with the purgation of foreign elements, namely the Jews. For some, Vichy offered such salvation, a historic opportunity for a demoralized and defeated nation to cleanse itself and change. The economic depression of the 1930s, the decline in the birthrate, and the arrival of many foreign immigrants, mostly Jews, created an atmosphere of fear and hate in which France would undergo an identity crisis capable of threatening the very foundations of its democratic traditions.

For many years the policy of the collaborationist Vichy government toward the Jews was unclear, and this was due in large part to the unavailability to researchers of documents in French archives. However, as soon as the French government began to make these materials more readily available, official records, memoirs, and notebooks revealed that France had had one of the most sinister records on the so-called "Jewish Question" during the Second World War.[4] It took two Anglo-Saxon historians, Michael Marrus

and Robert Paxton, in their groundbreaking study, *Vichy France and the Jews,* to uncover the terrifying facts.[5] According to Marrus and Paxton, Vichy France was thoroughly responsible for the French contribution to the "Final Solution." In essence, the French carried out collaborationist tactics through a powerful bureaucratic machine that functioned in a rather legalistic way. Preceding any German requests for intervention, Vichy instigated anti-Jewish legislation, such as the *Statut des Juifs* of October, 1940, which assigned inferior status to Jews in French civil law and society. Essentially, French Jews were debarred from elective office, teaching, and journalism; in general, quotas were imposed on all other professions. Subsequently, Jewish property was confiscated, prefects were authorized to intern foreign Jews in labor camps, and a *numerus clausus* was imposed on higher education. Finally, in 1941 a Commissariat-General for Jewish Affairs was established, and had as its first minister Xavier Vallat, who gleefully proclaimed "France was stricken with a Jewish brain fever of which she almost died."[6]

Even if the French, unlike the Germans, had not specifically sought a "Final Solution" to the Jewish question, they would become anti-Semites, as Charles Maurras diabolically suggested, out of opportunism and not out of patriotism. Starting in the spring of 1942, the French police, following the initiative of the Vichy government and acting out of pure self-interest, made the calculated political decision to facilitate the Nazi persecution of the Jews. Accordingly, on July 16, 1942, the French police engaged in the massive roundup of approximately thirteen thousand Parisian foreign-born Jews at the *Vel d'Hiver* (a cycling stadium), followed by their deportation to death camps in Germany. Before the war would end, 76,000 French and foreign Jews would be deported, most of them to Auschwitz, of which a mere 2,600 would return. As the French attorney Serge Klarsfeld discovered in the fall of 1991, the Vichy government had established, in spite of its repeated denials, a *fichier,* an official census document recording the Jewish presence in France, and destined to be used to facilitate the "Final Solution."

Most certainly, a large number of Frenchmen neither collaborated with nor condoned the politics of Vichy France. Beyond the official collaboration of Vichy and the racial laws that were enacted, there were many citizens of France who saved at least a quarter of a million French Jews through their courageous activities. Historian Stanley Hoffmann best described this situation nearly a quarter of a century ago:

> In my memory, the schoolteacher—now seventy-five, and still vibrant—who taught me French history, gave me hope in the worst days, dried my tears when my best friend was deported along with his mother, and gave false papers to my mother so that we could flee a Gestapo-infested city in which the complicity of friends and neighbors was no longer a guarantee

of safety—this man wipes out all the bad moments, and the humiliations, and the terrors. He and his gentle wife were not Resistance heroes, but if there is an average Frenchman, it was this man who was representative of his nation.[7]

Nevertheless, the first European nation to have granted citizenship to its Jewish population until recently remained surprisingly silent in assessing its role in the Holocaust and the collaboration. In spite of the establishment of special purge courts after the war, the imprisonment of approximately forty thousand, and the death sentences of an additional two thousand, approximately thirty thousand prisoners never came to trial, and fewer than eight hundred executions were carried out. Support for a massive inquiry into the many crimes of collaboration became an impossibility, because too many Frenchmen felt guilty because of their complicity during the war. A significant number of collaborators went back "into the closet," and the sins of the past were magically eradicated. Denial was carried out to such an extent that in the postwar period the French indiscriminately converged the fate of so-called political criminals such as Resistance fighters and communists who had been sent to labor camps such as Buchenwald with that of the Jews who had been sent to Auschwitz for extermination. The genocide of the Jews disappeared behind the mask of respectability, thus constituting a cover-up of sorts; the historical specificity to which the Holocaust testifies was totalized and discretely assimilated into a discourse of the same. Finally, in 1992, when a group of leading French intellectuals asked President François Mitterrand to have an annual ceremony to commemorate the "*rafle du Vel d'Hiv*" (July 16, 1942) they received a negative response. Claiming that the responsibility for the roundup and deportation of Jews rests with the Vichy state and not with the democratic institutions of the Fifth French Republic, Mitterrand's initial rejection represented a refusal to sully France's national self-image, or if you will, it served as an alibi for forgetting. In 1993, however, Mitterrand reversed his initial decision, and set aside July 16 of each year as a day of national remembrance to take place at the site of the former cycling stadium.

The situation of the Jews has been further exacerbated by a number of cultural and political issues in France that have developed since the late 1970s that might be termed "Holocaust related." First, in October, 1978, the French weekly *L'Express* published an interview with Louis Darquier de Pellepoix, former director of Vichy's Office of Jewish Affairs, in which he declared "only the lice were gassed at Auschwitz." Then, two months later, the prestigious newspaper *Le Monde* published an article, "The Poison of the Gas Chambers, or the Rumor of Auschwitz," by the revisionist "historian" Robert Faurisson (a former literature professor at the University of Lyon).

This essay heralded the emergence of a group of fanatics who are determined to disprove the existence of the gas chambers. Through the disguise of scholarly objectivity and the seductive force of problematically constructed "research," revisionist literature suggested that the frightful acts of genocide practiced by Nazi Germany against the Jews were the invention of Allied propaganda.[8]

Next, an important 1985 television documentary, *Terrorists in Retreat,* made by the French filmmaker Mosco Boucoult, and financed in part by the Mitterrand government, told the story of the Manouchian Resistance fighters, a group consisting largely of newly arrived immigrants in France, many of them Jewish refugees from Eastern Europe. The most controversial aspect of this film is that several of the interviewed witnesses suggest that the French Communist Party refused to permit the group to escape from Paris, even though they were aware that the group was being pursued by the Gestapo. The result was that they were ambushed and killed, thus projecting the image of an anti-Semitism with a different face. It is indeed possible that the nationalist impetus of the French Communist Party in 1943 had implicitly condoned this act of ethnic cleansing by remaining silent and accepting the sacrifice of "foreigners" for native Frenchmen. The mystery surrounding the airing of this documentary on French television produced a somewhat hysterical response across the entire political spectrum (communists, socialists, and even Gaullists) with charges and countercharges of collaboration and participation in the "Final Solution." This "acting out" was both an echo and a return of significance, in that it brought to the surface the fragments of a past that can never achieve closure because of the guilt surrounding it.

Then there was Claude Lanzmann's film, *Shoah* (1985), an epic, nine-and-a-half-hour documentary about the deportation of Jews to death camps. Although this film was not specifically about France, it activated an important critical debate in the public arena, and reaffirmed yet again that the *Shoah* is a historical trauma that will not disappear. As Lanzmann himself points out, the most remarkable and intentionally sympathetic book to be published on anti-Semitism in France immediately after the war, Sartre's *Anti-Semite and Jew,* reveals a remarkable silence concerning the memory of the Holocaust. "The book was published in 1946. . . . And yet there is not a word in it about the Holocaust; because the Holocaust is an event [which] no one at the time could grasp in its full scope."[9] In spite of acknowledging the existence of anti-Semitism in France, could it be that Sartre's (let us call it "unconscious") forgetting was but a symptom of a more generalized inability to come to terms with the Holocaust? The interrogation that underlies *Shoah,* as Lanzmann's questions are translated from French into numerous other languages by a group of interpreters who themselves translate back

answers to their interlocutor, allegorically represents Lanzmann's attempt to take the outside inside, and to literally speak the Holocaust in French. His symbolic gesture enables him to transform memory into language, so that the silence of guilt may be broken through with oral testimony that is transcribed and finally recuperated in the discourse of French culture.

The last fifteen years were also marked by some of the last trials of crimes against humanity by Nazi war criminals. There were those that came to pass and others that essentially did not. For example, the trial of Klaus Barbie, the "Butcher of Lyon," received intense media coverage that ultimately defocalized, as Alain Finkielkraut suggests, the issues surrounding his many crimes.[10] In particular, Finkielkraut expressed discontent at the way in which Barbie's lawyer, Jacques Vergès, a man who claimed Asian ancestry, obfuscated the whole question of war crimes, and made them disappear behind the camouflage of Third World non-European rhetoric. If memory was to become obliterated, it was due to Vergès's strategically cunning attempt to link anti-Semitism with racism against the people of the Third World, particularly in the case of the French-Algerian conflict of the postwar period. Were French colonial policies, as Vergès claims, especially the use of torture, merely a reenactment of Gestapo tactics? Perhaps, if one forces this infelicitous analogy. In effect, Vergès's evocation of this "return of the repressed" ends up by becoming a grotesque form of manipulation, another example of the assassination of memory which entails a repetition of the pain of loss. Ironically, as in the past, the forces of the extreme left and right joined together, only this time to decenter attention away from the genocide carried out against the Jews in order to focus more on France's moral hypocrisy concerning colonial issues. If France was depicted here as adhering to a double standard, it is because Vergès wished to use contemporary history as a means to dislocate the memory of the *Shoah* from its past.

In other instances there was a certain degree of government interference, as in the case of René Bousquet, the head of the French police, who facilitated the deportation of 2,000 Jewish children from the Occupied and Unoccupied Zones. Prior to his murder by a gunman in June 1983 there were repeated delays in his trial, and this culminated in the Ministry of Justice's 1990 decision to refer the case to the purge courts, a judicial institution that no longer existed! Perhaps the thoroughly absurd fate that awaited René Bousquet, who was senselessly shot and killed and never came to trial, reaffirms the tenuousness of our ability to logically explain the horrors of the entire situation.

More recently, in April 1994, the seventy-nine-year-old Paul Touvier, who had been arrested in 1989 after almost a half century hiding in monasteries protected by French clergy, became the first Frenchman to be found guilty of crimes against humanity. Touvier was sentenced to life imprisonment for the execution of seven Jews on June 29, 1944, in the small French town

of Rillieux-le-Pape near Lyons. At that time he was the intelligence chief of the pro-Nazi militia, a political police force that carried out the Gestapo's goals against "enemies of the state." To be sure, Touvier's trial played a special role in the politics of memory concerning France's collaboration in World War II. For the first time a French court had specifically dealt with French complicity with the Germans and Vichy's persecution of the Jews. The state prosecutor won the case not only by proving Touvier's longstanding anti-Semitism, but by suggesting that the Vichy government had assimilated the values of Nazism through the malicious activities of the militia to which Touvier had belonged. Furthermore, the defense's strategy became one of what has been described as Touvier's "Schindler's Defense." Touvier charged that the Gestapo had demanded the execution of a hundred Jews for the Resistance's murder of Philippe Henriot, the Vichy Minister of Information, but on the request of his militia chief to reduce that number to thirty, he had sacrificed only seven, in order to save twenty-three. Of course this absurd logic was an outright fabrication. As the trial proved in a key piece of evidence, Louis Goudard, a former member of the Communist Resistance movement (*Francs-Tireurs et Partisans*), was spared by Touvier *precisely* because he was a non-Jew. In the end, this trial enabled France to lift the taboo of Vichy fifty years later and to realize publicly that the Nazis could not have committed their atrocious acts without the participation of bureaucratic thugs such as Touvier.

Finally, on the intellectual scene, the publication of Victor Farias's book on Heidegger in 1987 not only examined the German philosopher's relationship to Nazism, but also generated a major debate amongst French intellectuals concerning whether a correlation can be made between moral value and philosophical doctrine.[11] The various positions staked out concerning that book, and the central problem of Heidegger's commitment to National Socialism, put the relationship between philosophy and politics at the center of Parisian debate. The result was an intense media event. It set off a frenzy in the French intellectual world that questioned the poststructuralist philosophies that emerged in the 1970s, provoking reactions from the orthodox French Heidegger establishment (Fédier, Aubenque), the postmodernist Heideggerians (Derrida and Lacoue-Labarthe), the old-line moral philosophers who prioritize ethics at the expense of ontology (Lévinas), the neo-humanists (Ferry and Renaut, Finkielkraut), and such diverse folks as Baudrillard, Blanchot, Cixous, and Bourdieu. The darling of deconstruction, Derrida's papa Heidegger, had to be retrieved from the old-age home of philosophy and stand trial. Perhaps what Henry Rousso has characterized as the Vichy Syndrome in France—the repressed guilt of collaboration embedded in the national unconscious—could only play itself out in translation by attacking German antihumanist thought spoken in French.[12]

Besides the presence of the revisionist historians, there has been a rise in

French anti-Semitism during the past decade, as demonstrated by the bombing of several synagogues and Jewish-owned businesses, the desecration of Jewish cemeteries, and the far-right-wing candidate Jean-Marie Le Pen's comment in the 1988 presidential campaign that Auschwitz was a "minor point," or a footnote to history. Even some moderate political figures, such as Raymond Barre, portrayed the victims of the 1980 bombing of the liberal synagogue on the *rue Copérnic,* in remarks on the TV station, TF1, as an attack against "one Jew and three innocent Frenchmen."[13] This climate has produced an increased self-consciousness on the part of writers, philosophers, and filmmakers to ruminate on the so-called "Jewish Question," and in some cases to examine the meaning of Jewish identity and its relationship to the concept of the nation.

Whether they deal with the "Jewish Question" and the writing of history, philosophical or literary writing after Auschwitz, or with Jewish identity and cultural practices, the essays in this volume all attempt, in one way or another, to come to terms with the Holocaust and its aftermath in French cultural life today. These essays are thus written in the shadow of remembrance: remembering what was and re-membering who one is. To be sure, in the now-classic book, *Between Past and Future,* Hannah Arendt makes a distinction between Greek historiography which was concerned with greatness, and Jewish memory, which was based: "upon the altogether different teaching of the Hebrews who always held that life is sacred, more sacred than anything else in the world, and that man is the supreme being on earth."[14] Memory, Arendt suggests, can be a powerful mode of cognition. But as the Jewish historian Yosef Yerushalmi tells us, the Hebrew word *zakhor* (to remember) is always problematic, since memory "is among the most fragile and capricious of our faculties."[15] Ironically, what is remembered is not always recorded, and what is recorded is sometimes selectively forgotten. The problem of remembering Auschwitz is how to remember it in order not to forget what happened at Auschwitz, or how to talk about Auschwitz without betraying or trivializing it. Like the figure of Hamlet's ghost, the *Shoah* cannot be forgotten, for it remains an object of mourning and remembrance, a hauntingly present absence that perhaps binds all of the contributors of this volume together.

On a more personal note, the editing of the volume has been both a painful and liberating experience. It has taken me a long while to reconcile my own sense of Jewish identity with my unwavering love, or should I say *passion,* for France. You see, my parents believed they hated the French. My father's family, German Jews who had voted Republican throughout the Great Depression, thought that the French had bad credit: they had not paid their debts from World War I. But perhaps more distressing to my

parents was that they believed that some of the French were self-serving during World War II and that they had never come to terms with their role in the "Final Solution."

And yet my parent's disgust for the French also had its uncanny attractions. As a child I would spend almost every Sunday afternoon with my family in Greenwich Village. I was told that it was like Paris, with its bookstores, cafés, artists, and intellectuals (whom my father, in particular, thought were lazy and sometimes degenerate pleasure seekers). In a very bizarre way, my parents admired and were repulsed by those Village intellectuals who, like the French, my mother proclaimed, never took baths. What drew them to these curious personages was the fact that they were idealistic freethinkers who spoke up for what they believed was just. That, too, was like France. The French, I was told, were also a highly histrionic people whose intellectuals inhabited an unrealistic world of fantasy. It was a life that could be observed with some voyeuristic amusement, but one that should never be emulated.

For years I have struggled with the meaning of my attraction to that supreme object of desire and the object of my parents' ambivalence, *la France*. Was it mere Oedipal revolt? Was it the desire for continuous maternal nurturance? Perhaps in part. But I do remember the symptomatology of my conflict of being unable to reconcile my fear of disappointment (what the French call "deception") with the so-called facts concerning the treatment of some Jews in France. One evening, in a hotel in Avignon, at the time I was in graduate school, I watched a television drama on Zola and the Dreyfus Affair (a historical issue about which I was pretty well informed intellectually, but not so emotionally). I had already viewed the first two episodes in that series, but that evening, when the actors in a crowd scene took to the streets and cried out *"sale juif, sale youpin"* ("dirty jew, dirty yid") I fled that room like a hurt lover, fully conscious of my embarrassment yet committed to repressing my thoughts, and destined never to view the rest of that miniseries. Curiously, despite my knowledge of the role of anti-Semitism in the Dreyfus Affair, the self-imposed blindness of my earlier years enabled me never to accept anything negative about my beloved France.

However, now in the youth of middle age, and not by chance in the shadow of my own parents' passing, I have been able to approach the complex issue of Jewish life in France, to look at it with more openness, and to confront with maturity and moderation the embarrassment of my own hurt. I have never personally experienced anti-Semitism in France. I always believed that, as a New York Jewish intellectual, I had something special to offer the French, and the French have always accepted me on those terms, as "Larry Kritzman de New York." Yet I have experienced anti-Semitism in my own country, as a New York Jew living in exile from the *terre promise* (the promised land) of my beloved Manhattan.

I have now come to realize, in incarnating my parents' "otherness," that it is that same culture that has seduced and at times betrayed me, French culture, whose intellectual traditions have nurtured me since I was eighteen, that I still love (although somewhat less naively), and which sustains me every day of my life. It is indeed because of my more authentic and somewhat less phantasmic relationship to those traditions that I have finally been able to reflect more critically on the "Jewish Question" in France, and publish this volume.

Notes

1. I have developed these ideas at greater length in "Terms of Endearment: The French and the Jews," *Substance,* 49 (1986), pp. 69–78. The best overview on anti-Semitism in France is that of Pierre Birnbaum, *Anti-Semitism in France. A Political History from Léon Blum to the Present,* trans. Miriam Kochan (Oxford: Basil Blackwell, 1992). The recent books and articles that treat the politics of collaboration and the Jewish Question in France include: Jean-Pierre Azéma, *La collaboration* (Paris: PUF, 1975); Yves Chalas, *Vichy et l'imaginaire* (Paris: Actes Sud, 1985); Philippe Erlanger, *La France sans étoile: Souvenirs de l'avant guerre et du temps de l'occupation* (Paris: Plon, 1974); Marc Ferro, *Pétain* (Paris: Fayard, 1987); Bertram M. Gordon, *Collaborationism in France during the Second World War* (Ithaca: Cornell University Press, 1980); André Kaspi, *Les juifs pendant l'occupation* (Paris: Seuil, 1991); Serge Klarsfeld, *Le mémorial de la déportation des juifs de France,* eds. Beate et Serge Klarsfeld (Paris, 1978); Jean Laloum, *La France antisémite de Darquier de Pellepoix* (Paris: Syros, 1979); Paul Lévy, *La grande rafle du Vel d'Hiv* (Paris: Robert Laffont, 1992); Pascal Ory, *Les collaborateurs: 1940–1945* (Paris: Seuil, 1978); Léon Poliakov, *Histoire de l'antisémitisme* (Paris: Calmann-Lévy, 1977), vol. 4; Françoise Renaudot, *Les Français de l'occupation* (Paris: Lafont, 1976); Marcel Tetel, "Whither the Holocaust?" *Contemporary French Civilization,* 6 (1981–1982); Pierre Vidal-Naquet, *Les juifs, la mémoire et le présent* (Paris: PCM/ Petite Collection Maspero, 1981); Annette Wieviorka, *Déportation et génocide. Entre la mémoire et l'oubli* (Paris: Plon, 1992).

2. I borrow the idea of "true France" from Herman Lebovics, *True France. The Wars Over Cultural Identity* (Ithaca: Cornell University Press). Also see Gérard Noiriel, *Tyrannie du national: Le droit d'asile en Europe* (Paris: Calmann-Lévy, 1991).

3. Michel Winock, *Edouard Drumont et cie* (Paris: Seuil, 1982), p. 205.

4. For the most part, the term "Jewish Question" (*question juive*) is used in a pejorative sense from the 1930s on. In the discourse of Vichy culture it is used precisely as an expression which identifies a social problem: the Jewish presence in France. I use this expression in a variety of ways: as Vichy's official recognition of a racial problem, in the more ironic use of this expression to challenge and problematize the whole question of Jewish exclusion, and in the benign and less confrontational way in which it can refer to multiple issues surrounding Jewish identities in French culture.

5. Michael R. Marrus and Robert O. Paxton, *Vichy France and the Jews* (New York: Basic Books, 1981).

6. Xavier Vallat, preface to Gabriel Malglaive, *Juif ou Français: Aperçus sur la question juive* (Paris: 1942), p. 8.

7. Stanley Hoffmann, "In the Looking Glass: Sorrow and Pity" in *Decline or Renewal: France Since the 1930s* (New York: Viking, 1974), p. 60. Susan Zuccotti, in *The Holocaust, The French, and the Jews* (New York: Basic Books, 1993), argues that the French role in the Holocaust is far less reprehensible than some believe it to be.

8. Two of the best counterarguments to revisionist folly are Pierre Vidal-Naquet's *The Assassins of Memory* (New York: Columbia University Press, 1992), and Alain Finkielkraut *L'Avenir d'une négation. Réflexion sur la question du génocide* (Paris: Seuil, 1982).

9. Claude Lanzmann's interview is quoted in Shoshana Felman's and Dori Laub's *Testimony. Crises of Witnessing in Literature, Psychoanalysis, and History* (New York: Routledge, 1992), p. 244.

10. See Alain Finkielkraut, *Remembering In Vain. The Klaus Barbie Trial and Crimes Against Humanity* (New York: Columbia University Press, 1992).

11. Victor Farias, *Heidegger and Nazism,* eds. Joseph Margolis and Tom Rockmore, trans. Paul Burrell and Gabriel R. Ricci (Philadelphia: Temple University Press, 1990).

12. Henry Rousso, *The Vichy Syndrome* (Cambridge: Harvard University Press, 1991).

13. These remarks were quoted in *Le Monde*, October 7, 1980, p. 10.

14. Hannah Arendt, *Between Past and Future* (New York: Viking, 1961).

15. Yosef Hayim Yerushalmi, *Zakhor: Jewish History and Jewish Memory* (New York: Schocken, 1989), p. 5.

I

Histories, Memories, and Politics

1

The Voice of Vichy

Geoffrey H. Hartman

In case you did not know it, we are living in a thoroughly depressing time. Books, reinforced by the media which keep the information hot, tell us of past and present atrocities. There is no escape from the massacres in Bosnia, the violence accompanying a power struggle in Somalia, assassinations and the violation of human rights in Haiti, state-sponsored terror or random killings almost anywhere. I open my newspaper today (November 10, 1993), the morning after the anniversary of Kristallnacht, and learn that the number of refugees in the world has swollen to 44 million. In a single week, or so it seems, books are published that remind us that since the 1960s more than a hundred thousand Guatemalans have been killed, many of them Mayan Indians, and that between 1941 and 1945 Vichy helped to deport 76,000 Jews, of whom only 2,600 survived. Newsworthy novels, films, and stories appear regularly to thrill, entertain, or horrify with accounts of ruthless regimes, or they pick at the memory-scabs growing slowly around the deep wounds of the Holocaust, the Vietnam War, and the Cambodian genocide.

What makes these renewed confrontations, these seemingly honest words and images, even more depressing, is a perception growing in us, and twisting guts as well as eyes, that this hyperknowledge about both perpetrators and victims, this wish to disclose and expose everything, may be no more remedial than the conspiracy of silence that used to exist. After yet another shooting in an Ulster pub, this one killing six Catholics and a Protestant, the *New York Times* reported that "Ordinary people were plunged into a kind of flattened despair," a condition that an administrator of one of the groups working for peace called "compassion fatigue."

I do not know what will happen if our psychic defenses, ordinarily fairly successful in absorbing traumatic stress, should begin to give way entirely, rather than occasionally malfunctioning and producing new versions of the

original torment or aggression. Without turning into a partisan of silence, I feel it is important to raise the question of what we learn from the assault of bad news—from this kakangelic drive made possible in liberal democracies by the real-time reporting of the electronic media.

It may be, of course, that the public memory now being created, which is more sulfurous in its contents than any hell-obsessed preacher of old, will reveal—precisely because it has removed willful blindness and superficial optimism—profounder strata of human persistence and courage.[1] Yet there are signs that all our just and justifiable research may simply reinforce a prior and very strong religious conviction about persistent human evil. This conviction always incites, when mixed with political and self-interested motives, a Manichaean terror of the other, of the potential enemy in the other—and so exacerbates the xenophobia we are so studiously seeking to prevent. That the ravages of the Holocaust, moreover, were planned in Germany, and abetted by so many in France—that the most civilized countries of that time tolerated criminal regimes—not only increases our own suspicion of Western cultural pretensions, but subjects us to mockery, even by those who are blatantly xenophobic because of their non-democratic or fundamentalist doctrines.

In France, a self-protective silence, though punctuated by scandals and revelations, prevailed for close to fifty years after the Occupation, as if public memory could not tolerate the truth of French complicity in the persecution of the Jews. Not until the early eighties—just at the time that the so-called revisionists were gathering momentum—did *Vichy France and the Jews,* the book by Paxton and Marrus, neither of them French historians, make it impossible to escape a further investigation of the facts. But it still took another decade, until 1992, the fiftieth anniversary of the *"grande rafle"* in Paris, for conferences, journal publications, and ceremonies to catch up with the facts. I do not have to rehearse the entire story of the anti-Semitic policy of Vichy, of what was done to the stateless Jews (*"apatrides"*) who had taken refuge in France and, eventually, to many French nationals (*"les bons vieux juifs de France"*). After the war, most of the top officials responsible for this policy escaped prosecution, and sometimes pursued successful careers in government and business.[2]

The bad news is far from over. Richard Weisberg, founder of the Law and Humanities Institute, and who teaches at Cardozo Law School, is studying the behavior of his own profession during those years in France: how lawyers dealt with the *Statut des Juifs* of October 3 and 4, 1940 and 2 June, 1941, ordinances harsher in their legal definition of Jewishness than Nazi racial laws. Not only those with three Jewish grandparents but persons with two Jewish grandparents when married to a Jew fell under the Vichy definition, which aimed to drive as many Jews as possible from the government, the

professions, and indeed, out of public life altogether. Weisberg shows how rarely the doctrine of the *droits de l'homme,* proud heritage of the French Revolution and pervading legal opinion since then, was used to contest, at any level, these illegal and persecutory statutes.[3]

It was to be expected that Xavier Vallat, the first *"Commissaire Général aux Questions Juives,"* should speak as follows in the preface to a typical broadside of a book written under the banner of what was sometimes called *rational anti-Semitism:*[4]

> The French Revolution, the first, [Vichy is the second, a counterrevolution] was mad enough to consider Jews citizens like any other, and gradually in the next century-and-a-half, all governments successively committed the same error for fear of appearing to be "reactionary." . . . the Jew will want to be a naturalized citizen without this representing a desire to fix his roots in a particular place. Simply to enjoy the fullness of his rights as a citizen, there where he happens to be. . . . And the most curious character of this wandering race is that it wishes to take over, everywhere it travels. Its dream of universal domination attaches itself to each of its offspring, all of whom are conscious of belonging to the superior race. . . . [Jews] have invaded the public and intellectual professions [*les professions libérales et intellectuelles*], the press, the radio, the movies, the higher administrative offices and politics, that is, everything that serves to govern a democracy. France was stricken with a Jewish brain fever [literally, flux to the brain, *transport juif au cerveau*] of which it almost died.[5]

Yet this type of rhetoric is topped in its pseudo-objectivity by a Sorbonne thesis for which André Broc received his *Docteur en Droit* in the same year. Entitled *La qualité du juif: Une notion juridique nouvelle*[6] it claims, just like Vallat, that the Jews would never be assimilated to the nations among which they lived, despite the earlier efforts of Rome under Caracalla and the French at the time of their revolution. To apply to Jews the doctrine of the *droits de l'homme* was an error. "From the fact that the Jews were men, it did not logically follow that they should have been citizens of the country in which they found themselves, but the equivocation that called 'emancipation' their naturalization spread and perpetuated itself." Moreover, notably in France, Broc continues, "the influx of foreign Jews as well as their propensity to play a role in our internal and international politics inspired by their own interests, has restored to the Jewish problem globally a relevance it had lost." He concludes by assuring us that none but technical legal considerations are his subject: he intends to analyze efforts to provide a definition for Jewish specificity from a perspective characterized as *"de pure technique juridique."*

Such instrumental reasoning, or "bureaucratic culture," has long been

identified (first by the Frankfurt School) as an essential factor in the creation of writing-desk murderers and the industrialized efficiency behind the massacres of the Holocaust. It is important to stress that people like André Broc are bystanders in civil society, who collaborate without the threat of martial law. The pressures in Vichy France on lawyers, academics, and intellectuals generally came from their wish to continue in their career, to protect their opportunities (increased by the removal of talented Jews), and to make "discourse as usual," that is, to talk in term of "problems," and "solutions," and "technique." Zygmunt Bauman, in his book on *Modernity and the Holocaust,* and Claude Lanzmann, in *Shoah,* make a strong case that the ethos of bureaucracy and its technical jargon contributed to enervating the human and moral sensibility of the writing-desk murderer.

However, it is difficult to attribute the collaboration, active or passive, of so many bystanders and civil servants simply to opportunism, even when strengthened by fear, professional deformation, and a deceiving distinction between what Maurras characterized as *"antisémitisme d'état"* in contrast to a vulgar *"antisemitisme de peau."* For there is often a note of idealism, or utopian politics, mixed in with what we would prefer to depict as a cynical, xenophobic, or profitable anti-Semitism. Already in the 1930s a disgust with party politics, and sometimes with parliamentary democracy as a whole, led to an ideal of "sinister unifying" (Kenneth Burke, in a 1930s essay on *Mein Kampf),* which sought to suppress divergent and dissident voices. Add a disenchantment with a corruptible human nature that was felt to require the strongest discipline and leadership in order to function collectively, add the rejection of cosmopolitanism as an unrealistic and antinational doctrine, add an aversion to both communism and finance capitalism, and fascist philosophies gain in credibility. They become, in Eric Voegelin's words, "political religions"; they promise, like religions themselves when church and state have not separated, a justified and orderly community, a *Volksgemeinschaft* with a common purpose—an ideal that proves to be even more seductive when national pride is humiliated, as was the case with Germany, or national power is felt to be waning, as in the case of France.

When I asked previously what we could learn from the imagery of violence and the evidence of injustice and persecution that follow us into the most pastoral places, I meant to imply that knowledge of the worst, while it produces flashes of righteous anger, can also incite deep feelings of powerlessness. Imagine now that you are exposed to daily spectacles of *force majeure* and anti-Jewish propaganda. In such an atmosphere, if there is no countervailing thrust, it is all too easy to side with power, to blame the victim who is made to look degraded, and to accept a relentlessly Manichaean picture of politics and the world. What we glimpse here is an unpredictable factor in our new-won realism, our global knowledge of "political wretchedness"

(Terrence des Pres) as disclosed by the media. The good side of this *informatique* is that we cannot not know; the problematic side is that the power of the media is such that the world of appearances and the world of propaganda can be made to merge—a total encompassment that became obvious for the first time in the Nazi era.

My purpose is not to explain in order to forgive, or to mitigate in any way the shameful aspect of collaboration or its cover-up. But often, when I remember what happened, a sense of incredulity rises in me. There is a moral danger in allowing that feeling to persist, without analyzing it as well as the facts that cause the feeling. It may lead us into easy denunciations, into judgments which cost nothing in terms of self-reflection, and which distance us from that era. Yet that era has not entirely passed away, when we look at our position as bystanders; are we not still in the constant presence of images and reports of terror and injustice, and obliged to endure them impotently or to give them a certain talky spin? Who has not experienced a contemporary form of the incredulity with which we regard the Vichy or Nazi past? For we suffer at the present time not only from compassion fatigue, but also from a sense of unreality that is specifically our own. It is as if the news we turn to with a certain eagerness were a kind of show, an electronic spectacle whose images hover in museal or virtual space. It is hard to define that sensation precisely, but it too, this sense of the unreality of our own world, will have to be faced rather than evaded.

By this detour I come finally to the negationists. The principal movers among them are, without a doubt, blatant anti-Semites; but that does not explain how they get away with their tactics, how they think they can deny the documented and overdocumented facts: the archives, the historians, the witness of the survivors, the witness of the perpetrators, the witness of the bystanders. It is true that the negationists nuance their denial in various ways, by saying that, yes, Jews were killed, yet not in the numbers claimed, nor by the use of gas. But this pretense of weighing the facts like regular historians always results in the same negative conclusion: there is no evidence of a Holocaust, that is, of a systematic "Final Solution" that intended to exterminate all Jews. Many Jews were victims, but because of the war, and not a war against the Jews—though, it is alleged, the understandable animosity of true citizens toward these rootless and warmongering nomads made them a special target. Thus the victims are blamed, and doubly so: for it is also charged that they have inflated their casualty figures into a Holocaust in order to demand compensation and embezzle the moral conscience of the world. Moreover, they have been successful in this not because the evidence supports them, but because they still control the media.

You have doubtless noticed that this argument can only be persuasive if

it taps into a double distrust: of the Jews and of the media. That convergence is essential; but even it would not work unless the negationists or those targeted by them did not suffer from a deep and basic anxiety: that seeing is no longer believing; that the world of appearances and the world of the media can be made to merge; that an old-time solidity has disappeared, and now unreality, manipulation, forgery are taking over. It is surely no accident that Faurisson first tried to make his reputation by proving that we were victims of a literary mystification or forgery; and that Maurice Bardèche, together with Robert Brasillach (rabid anti-Semite and brilliant writer, the only intellectual executed after the war for a journalism deemed to be treasonable), authored a first and still very important *Histoire du cinéma.*

Bardèche and Brasillach, certainly, had a love affair with the movies, and a complex understanding of that new and magical medium which, they said, gave *"l'éternité à l'éphémère."* This paradoxical formula betrays a consciousness as impressionistic, aesthetic, and hedonistic as Walter Pater's. The medium which reduces us to watching glittering shadows also serves the authors' eudaemonic desire for recording and preserving the passing moment. Their *"Verweile doch"* combines reality-hunger, the wish of the diarist to inscribe time, with a nostalgia about a time that is always already past. The link between the fixating power of the medium (even though these are "movies") and the mutability of the historical moment, which Susan Sontag described in her book *On Photography* as "the innocence, the vulnerability of lives headed toward their own destruction," is clearly anticipated. In Brasillach, and especially his novels, this vulnerability becomes almost voluptuous; while in Bardèche, as in Drumont, there is a fierce conviction that the old order, *"la France d'alors,"* always seen as a pastoral, organic community, is not just passing away but being actively destroyed.

What is certain is that here, too, the Jews seem to have spoiled everything. It is they who are said to have commercialized the cinema and created an industry in which "pleasing the public" would override all other considerations.

> Les marchands de tapis juifs, roumains ou hongrois, des aventuriers de tout ordre, qui s'étaient rendus maîtres d'une partie du cinéma, aggravèrent la situation par les procédés qui auraient menacé l'avenir de n'importe quelle autre industrie, et qui naturellement poussèrent vers la médiocrité définitive presque toute la production et en particulier la production française.[7]

It is disheartening to multiply instances of the sad and vicious utterances of Bardèche or other negationists, or of self-styled "rational anti-Semites" like Brasillach and Charles Maurras, or of the nasty, instinctive sort like

Léon Daudet and Céline. It is enough to show that they sought to project an image of the Jew as, in Richard Wagner's words, a "plastic demon of decadence," that is, as the very principle of the non-solid, of what is essentially groundless, rootless, shape-shifting, cerebral, cunning, abstract, and — like money in distinction to landed property — an agent of perpetual displacement and dissolution. That stereotype existed before a second, specifically modern sense of spookiness, associated with the cinema as a dangerous if seductive simulation of reality, reinforced it. The assimilated Jew is, for the anti-Semite, but another uncanny and tricky simulation.

The older stereotype is often exemplified by Maurras, and nowhere more crassly than when he celebrates the new racial laws in *La Seule France* (1941). He asserts that it is the right of the French to keep the Jews out of the professions because "we are the masters of the house our fathers have built and for which they have given their sweat and blood. We have the absolute right to impose our conditions on nomads whom we receive under our roof." Gloating over the *chateaux,* lands, apartments, art objects, and collections left behind by the Rothschilds and other fugitives, he suggests that they should be sold off to alleviate the heavy peasant debt. That seems to him an ingenious way of doing justice, of compensating for what the Jews did against the peasant, or against the French earth itself:

> Those who do not have French soil on the soles of their boots, in the final analysis lived off this good earth that our race alone made fertile. The loudmouths [*batteurs d'estrade*] who unleashed against this earth the ravages of war and did not want to face the consequences, had begun by stripping and fleecing it by means of the usury and speculation which permitted them to amass an anonymous and vagabond fortune. . . . May the eternal laborer of this mother earth be better compensated in this way for his hard work. [*Que l'éternel travailleur de cette terre mère soit ainsi mieux payé de son dur travail.*][8]

There is something too eloquent, too indulgently classical here. A high style feeds on the easy and vulgar stereotype it ornately varies. We can separate *fond* and *forme* as in a well-conducted *"explication de texte;"* but since this is not a school exercise but the very voice of Vichy on which lives depend, we glimpse the tragic fact that not the Jews but calumniators like Maurras are out of touch with reality. Yet every reality-loss is blamed on the Jews. Baudrillard, who extends Benjamin's insight on how technology invades sensibility, suggests that the later negationist obsession with challenging the historical reality of the Holocaust is only another expression of our growing sense of the unreality of the past. This unreality fuses our horror of the Holocaust with an incredulity that comes from the awareness that

we now live more and more among simulacra. We have reached, Baudrillard writes in *The Transparence of Evil*, "the impasse of a hallucinatory *fin de siècle*, fascinated by the horror of its origins, for which oblivion is impossible. The only way out is by denial or negation."

Allow me to add a short epilogue. What I have said is relatively devoid of the pathos that comes when we think of Auschwitz as unrepresentable, or, in Jabès's words, as "the indestructible memory of the void." The work of mourning, which cannot yet be limited in the case of the *Shoah,* will necessarily join itself to prior—adequate or not—symbols of grief and desolation. We test those symbols. A "cry without a voice" rises up in Henri Raczymow, a second-generation writer. Or a survivor who visits the Warsaw ghetto shortly after its liquidation hears a "woman's voice calling from the rubble," an unidentified, ghostly sound which makes me think of Rachel lamenting her children, or of the *Shechinah* who accompanies Israel into exile. There are, also, those orphaned tongues Jabès calls from the void— all those questioning and quarreling rabbis, including the marvelous names they bear. They constitute a post-*churban* tradition from which a sort of *midrash rabbah* might be drawn.

But instead of showing how writing and mourning are related, or how the Holocaust renews that dark connection, I have turned to those who live in denial, and suggested that they too are haunted by a loss for which they seek an explanation, a specific cause; and the Jew often becomes that cause. They also are mourning, but with a vengeance. Bardèche, in the remarkable and unrepentant pages of *Nuremberg ou la terre promise,* though he acknowledges the existence of concentration camps and of German crimes against the Jews, denies all French responsibility for their deportation and death in words whose sense of loss and laying of blame beggar even those of Maurras:

> We have ceased to be a great nation today, we have even perhaps ceased to be an independent nation, because [Jewish] wealth and influence have made their point of view prevail over that of the French who are attached to the conservation of their land and who wanted to preserve the peace. ... And still later, we found them heading the persecution and calumny directed toward those of our comrades who had sought to protect from the severity of the Occupation this country, where we have been settled far longer than they have, where our parents were settled, and which the men of our race turned into a great land. And they say that today they are the true husbandmen of this earth which their parents did not know, and that they understand better than we do the wisdom and mission of this land of which certain among them scarcely know the language: they have divided us, they have exacted the blood of the best and purest among us, and they have rejoiced and still rejoice in our dead. The war they desired,

it has given us the right to say that it was their war and not ours. They have paid for it, as one pays for every war. We have the right not to number their dead with ours.[9]

Many will see in this nothing but a meretricious apology for Vichy's policy of collaboration, and a repetition of the most common anti-Semitic clichés. Yet as an exercise in rhetoric, as an exemplary piece of classical prose, this is "French" to the core.[10] What is mourned here, in the very style, is the passing away of a language and culture identified with the nation and its classical past. In short, a *civilized* fear of alienation, which we all share to a degree and which has intensified in the age of electronic simulacra, is contaminated by a *savage* anti-Semitism that preceded the Holocaust and continues today, and not only in the negationists.

Notes

1. I read each week two or three truly moving analyses and admonitions by honorable and conspicuous people like Václav Havel that spell out political and moral truths of the first importance. Are such fine statements more than a balm that covers as if with grass another mass grave recently exhumed? Through them, at best, we clutch at hope, at a renewal of our resilience, while secretly fearful of every green spot remaining on earth or in our minds.

2. See Michael Marrus and Robert O. Paxton, *Vichy France and the Jews* (New York: Basic Books, 1981). By now the role of Vichy in the "Final Solution" has been well documented in important works by Serge Klarsfeld, André Kaspi, and (especially on the "silence" after the war) Henri Rousso.

3. See Weisberg, "Legal Rhetoric under Stress: The Example of Vichy," in *Poethics* (New York: Columbia University Press, 1992).

4. See, e.g., Robert Brasillach in the *Je suis partout* of April 15, 1939, as quoted in *Morceaux choisis*, ed. Marie-Madelaine Martin (Genève-Paris: Editions du cheval ailé, 1948), p. 114: ". . . nous pensons aussi que la meilleure manière d'empêcher les réactions toujours imprévisibles de l'antisémitisme d'instinct, est d'organiser un antisémitisme de raison."

5. Gabriel Malglaive, *Juif ou français: aperçus sur la question juive* (Paris: Editions C.P.R.N., 1942), pp. 6–8. How ominous is, in retrospect, the metaphor of "transport" used here by Vallat! For Vallat, see especially Marrus and Paxton, *op. cit.*, chap. 3.

6. (Paris: Presses Universitaires de France, 1943). The "dépôt legal" is given as December 31, 1942.

7. *Morceaux choisis*, pp. 30–31. In Iris Barry's translation of the book, explicit references to the Jews fall away, and Poland is mysteriously substituted for Hungary: "Itinerant carpet vendors, strange men from Poland and Rumania, adventurers of every sort who had already gained partial control of the cinema. . . ." *The History of Motion Pictures* (New York: W. W. Norton, 1938), p. 374. The impressive side of Bardèche and Brasillach is that they are candid about the mediocrity of most film

production and insist that it is an independent art that must develop its own aesthetic. They regret the passing of the silent movies and a highly stylized visual poetry.

8. Maurras, *La seule France* (Lyons: H. Darchanet, 1941), pp. 197 and 198.

9. *Nuremberg ou la terre promise* (Paris: Les Sept Couleurs, 1948), pp. 188–190. One can set beside this Paul Claudel's article in *Le Figaro* of May 3, 1952 to the Grand Rabbin of Paris, with the headline, *"Les morts de la déportation."* Referring to the State of Israel, asking it "to associate itself officially with the mourning of offended humanity," Claudel writes: *"Ses morts sont les nôtres et les nôtres sont les siens."*

10. Jeffrey Mehlman, in *Legacies of Anti-Semitism in France,* shows the latency of this murderous nostalgia in Giraudoux and other French classics of the modern period.

2

The Holocaust's Challenge to History

Pierre Vidal-Naquet

It is not easy for a historian to grasp the Holocaust. It is even more difficult, when one does not specialize in these questions, to judge the work of others who, on all levels, have attempted to inform us about the monumental event which rends the heart of our century: the genocide of the Jews and Gypsies.

I will do this, however, remaining all the while very conscious of my own limitations; but perhaps these same limits will, in these circumstances, be an advantage.

As I have had occasion to do before, I will begin with a passage from Thucydides, taken from Book III of *The Peloponnesian War*.[1] In this passage the Athenia historian relates what was, in 427 BCE, the civil war between the oligarchs and democrats of Corcyra, an episode which is certainly minor compared to the European civil war (1914–1945), which the poet Paul Claudel and the historian Arno J. Mayer have rightly called the Thirty Years' War. But this episode did leave a permanent impression on this beaten general and politician. Led by lucid reflection to write the history of his time, Thucydides remarked: "Death thus raged in every shape; and as usually happens at such times, there was no length to which violence did not go; sons were killed by their fathers, and suppliants dragged from the altar or slain upon it, while some were even walled up in the temple of Dionysus and died there."[2]

All this happened at Corcyra, but Thucydides adds that this agitation, this rupture of consensus, this *stasis,* won over the entire Hellenic world to an international and civil war. And he adds:

Words had to change their ordinary meanings and to take those which were now given them. Reckless audacity came to be considered the courage of a loyal ally; prudent hesitation, specious cowardice; moderation was

held to be a cloak for unmanliness; ability to see all sides of a question, inaptness to act on any. Frantic violence became the attribute of manliness; cautious plotting, a justifiable means of self-defence.[3]

The above concerns only what Thucydides terms "justifications" (*dikai-ôseis*), perhaps what we would today call ideological pretexts. But it goes without saying that this same remark is equally valid when applied to actions. When Thucydides tells how the Spartans, *circa* 424 BCE, eliminated two thousand Helots who made the mistake of having served them well and who were, consequently, brave enough to one day rebel, he tells us, echoing a coded message he picked up at Lacedaemon: "The Spartans, however, soon afterwards did away with them, and no one ever knew how each of them perished."[4]

Today we are far removed from Thucydides and the two thousand Helots, the obscure victims of war. Voltarian history referred to the Peloponnesian War as a conflict among a few "districts" of a country whose weight is meager on the scales of empires. These Helots amount to very little when compared to the millions of Jews, Gypsies, and Soviets who perished in Hitler's workshops of death. As a historian of ancient Greece, I do not believe, as did Thucydides, that the paroxysmal evils which he describes, and which he compares to a volcanic eruption or an earthquake, "such as have occurred," will continue to occur "as long as the nature of mankind remains the same. . . ." In other words, I believe more in the variations than in the permanence of human nature; but Thucydides himself nuances his assertion by at once adding that such misfortunes will continue ". . . though in a severer or milder form, and varying in their symptoms, according to the variety of the particular cases."[5]

But it is not (or not only) such a lesson, in all its generality, that I would like to draw from Thucydides at the present. It seems to me that his teaching is, in this case, threefold. He reminds us first that a history of the present is indeed possible. However, and this is my second point, any history, including that of the present, presupposes a distancing of the historian from the events. Finally and perhaps essentially, any history is comparative, even when it believes it is not. To constitute as a historical totality the two thousand Helots, each of whom lived his own life and died his own death, it would obviously be necessary to construct the category "Helots."[6] This seems to be, as they say, "self-evident," but in reality it is not easy to accomplish. Such a construction is neither easier nor more difficult than that of the totalizing categories "Jews" or "National Socialist Germany."

One need only know how to read to determine that the historiographic stakes have become crucial. An example of such a historiographic debate is the quarrel which opposes the "functionalists" to the "intentionalists." The

former run the risk of breaking up the organicity of facts (or rather the *whole*) in the dust of details. The latter, who rightly emphasize a deadly ideology, run the risk of creating a closed discourse, as is the case with mythology. Such a discourse cannot account for the time factor. It is surely useless to oppose "facts" to "interpretations," for the chronicle most devoid of commentary is itself an interpretation. The great dispute among our German colleagues, the now famous *Historikerstreit*, shows that, as far as the German public is concerned, the point of disagreement is essentially historiographic. If one takes stock of the situation today by referring to the acts of the colloquium organized in 1982 by the Ecole des Hautes Etudes en Sciences Sociales,[7] one notices that the essential difference between yesterday (however near it may be) and today is this opposition of facts to interpretations. In 1982 there were but three of us: Saul Friedländer, Amos Funkenstein, and myself, who were directly or indirectly preoccupied by these questions. The debate suddenly shifted from direct history to its successive interpretations.[8] If this took place, it is naturally because the historiographic accounting is impressive.

While this accounting is certainly impressive on a global scale, I would at once add that, while giving justice to the pioneering role of Léon Poliakov, and to the activities of both the Center for Contemporary Jewish Documentation and the Institute for Present-Day History (which is at the origin of this present work), the role of France and of the French historical school in this historiography has been unimpressive. Although a state dissertation was published in the past concerning *Le système concentrationnaire nazi*[9] (which did not in any case treat extermination itself), and even though other research is now being conducted, it is not inaccurate to say that the extermination of Jews, Gypsies, and the mentally ill by the Third Reich is a subject which has been neglected by French university historiography. This negligence gave rise to the role which a legal expert such as Léon Poliakov, a biochemist like Georges Wellers or, at a very late date, a specialist in ancient Greek history such as myself were destined to play in this historiography. The same situation has no doubt existed abroad: the author of the major work, finally translated into French, *The Destruction of the European Jews*,[10] is not a historian by trade but a political scientist, a fact which should comfort those who feel that the history of World War II is too serious an affair to be reserved for historians alone.

On the other hand one may feel, without excessive professional chauvinism, that it is better to *also* know something about Byzantium or Louis XIV, and not travel solely on the *Roads to Extinction*, to borrow the title of the posthumous work by Philip Friedman.[11] Arno J. Mayer has recently demonstrated this need for contextualization in brilliant fashion: in order to understand Operation Barbarossa, the offensive launched against the U.S.S.R.

which, like a new crusade, was destined to furnish a time and a place for Hitler's genocide, it is more than slightly important to know about the Crusades and what became of the myth of the Emperor Frederick Barbarossa.[12] Too often in France, instead of an analytical or synthetic history, we have seen what our American colleague Cynthia Haft denounced as the *"sensational* debasement of the tragic."[13] Paradoxically, and at the risk of giving myself a warning and seeming self-contradictory, I would say that the only great French historical work on the massacre, a work destined to endure, is not a book but a film, *Shoah* by Claude Lanzmann—I will return to this shortly. Why, then, this protracted silence on the part of French historiographers, a silence which has only begun to be remedied? I perceive three major reasons for this, each one very different from the others.

The first reason is political. It hides behind the cloak of what Henry Rousso has called *The Vichy Syndrome.*[14] Any work on the extermination of Jews poses the question of France's collaboration with this policy; that is to say it examines the continuity of French history *throughout* the Vichy period. Vichy was not only a government that was declared illegitimate in 1944, but it was also an administration, a police force, a judicial system. In this respect, the questions raised are not fundamentally different from those asked in Germany during the historians' quarrel, with the exception that the German crisis of 1945 was perhaps more violent than the French crisis of 1944. In any event, one should not be surprised that, in France, foreign historians such as Marrus and Paxton, or nonspecialists like the legal expert Serge Klarsfeld,[15] have played a major role in the treatment of these questions.

The second reason for this failure is also political in nature, but concerns university politics in particular. The French university has long held a timorous attitude toward the most contemporary historical subjects. Resistance to change has just begun to crumble: many theses have been or will be defended concerning the Algerian War. I would simply offer the reminder that, in 1935, the historian Jules Isaac was unable to obtain from the Sorbonne the right to file a state dissertation subject dealing with the Poincaré Administration (January 1912–January 1913). Permission was refused because the subject inevitably raised the question of the personal responsibility of Raymond Poincaré in the origins of the war.[16] When I was a student, a third of a century ago, an adage was attributed, accurately or otherwise, to one of our geography professors at the Sorbonne: "Up to 1918, it is history; from 1918 to 1939, it is geography; afterwards, it is politics."[17]

Finally, the third reason for the French historians' silence is one of epistemology. The so-called "Annals" school, which broke in part with the guiding inspiration of the review founded in 1929, during the crisis and partly because of it, chose as a group "the duration" over the isolated event. Single

events were often considered to be mere wrinkles in time; indeed, they were seen as only the "residue of things."[18] Hitler's crime falls within the realm of the short term, even if the long term can put it in perspective.

Must one exclude from these debates the question of "revisionism"?[19] Such a pushing aside would seem to me both legitimate and regrettable. It is legitimate in the sense that "revisionism" embodies neither a historical school nor a type of historical discourse, but instead the pure and simple suppression of what constitutes an object of history. Some have even spoken of "revisionist" writings as "intellectual excrement."[20] I accept this expression, but laboratories do exist in which analysis of excrement is performed. Since when are lies, falsehoods, myths, and the imaginary no longer objects of historical study? Contemporary historiography has developed to the point that a well-known collection, the *Library of Histories* (*Bibliothèque des histoires*), directed by Pierre Nora, has repeated *ad nauseam* the formula: "We are living the explosion of history." Thus we would be incapable of integrating contemporary "revisionism" into a historical analysis!

How can such a study be fruitful, even enriching? Let us pass over the small number of rectifications of detail which may be needed. It was not the revisionists who taught historians that there were no gas chambers at Buchenwald, and to the debates in progress about the number of victims of the "Final Solution," their contribution is strictly nonexistent. "Revisionist" discourse gains in interest only when placed in a series and in perspective. It is a sectarian discourse, and we have long known that sectarian discourse has a totalitarian vocation insofar as it seeks to be a "true" discourse which opposes the dominant "fictions." This is true of the Soviet Bolshevik party prior to 1917, just as it is true of Maurrassianism and of the discourse of *Action française*. It is true of precisely those works with historical pretentions, dating from the beginning of this century, notably the *Précis de l'Affaire Dreyfus* by "Dutrait-Crozon,"[21] the pseudonym of two *Action française* officers. Such works seem to me to embody the best articulated model for contemporary revisionism. An ideological expression of French nationalism, this *"précis"* takes the precaution of imitating a German *Lehrbuch,* right down to its physical appearance.[22] It is a scholarly piece of research, filled with mostly exact references, with rectifications of detail which can at times be useful, but it lacks a certain "detail" which has major importance: the complete innocence of Dreyfus in the accusation of treason leveled against him. In other words, it ignores that "truth" which Zola proclaimed to be "marching on" in the article he wrote for *L'Aurore* of January 13, 1898. It becomes necessary to fight for this truth from time to time.

Certainly no historian, having reflected on the theory and practice of his craft, can share "the prejudice which holds that the historian's language could be rendered absolutely transparent, to the point of letting the facts

speak for themselves: as if it were enough to eliminate the *ornaments of prose* to have done with the *figures of poetry.*"[23] But if it is true that historical research demands "rectification without end," fiction, especially when it is deliberate, and true history nonetheless form two extremes which never meet. Revisionist discourse is part of a theoretical reflection on fallacy which has been going on since Plato; it is not part of an analysis of historical language.

Historical sociology, of course, also has its say in the matter. I have written that this discourse of revisionism was that of a sect, but it sometimes happens that sects become state sects thanks to, for example, great social upheaval. This occurred, for instance, in Russia in October, 1917, and, through paths which were perhaps resistible, resulted in the historical discourse of the Stalinist type. This discourse is exemplified by the *History of the Communist Party of the U.S.S.R.*, whose successive editions constitute the definitive model.

The miniscule revisionist sects active today in France, Germany, Italy and the United States may seem far from seizing power. Yet these sects are simply continuing and recuperating for their own use, in a derisive manner, the dissimulation techniques of the Nazis. The National Socialists' authentic attempt to hide the traces of genocide continued throughout the implementation of the Final Solution. The crime was dissimulated even while it was being perpetrated. This was done by utilizing the coded language of "special treatment," and more specifically, beginning in 1943 when, under the pressure of defeat first in the East, then in the West, the Nazis burned the cadavers and systematically destroyed, first in the slaughterhouses of Poland and then at Auschwitz, the weapons of the crime. Crime and state lies were as one at the center of the SS apparatus, which was responsible at the same time for the murder and for the forgetting of the murder.

The National Socialist state is dead, and subsists only through interposed ghosts, but the example of contemporary Turkish historiography in treating the great Armenian massacre of 1915 shows quite clearly that denial can come to power and in this way believe it is maintaining the fiction of a unified and pure national history.

But let us return to our revisionist sect and to the link we have proposed between crime and denial. The "revisionists" have sought to deny the Nazi genocide in its totality, but they have placed very special emphasis—be they Arthur Butz, Wilhelm Stäglich, Robert Faurisson, or Henri Roques—on the negation of the gas chambers as an instrument of extermination. Many of them have not understood the importance of the question. In what ways do the gas chambers constitute something specific, not only in relation to the Gulag, obviously, or to other forms of state terror, but also in relation to the whole of the Nazi concentrationary system, or even to the collective

murders carried out by the *Einsatzgruppen* in the U.S.S.R.? Between death by gas and death by bullets, or even death by exhaustion or by the action of exanthematic typhus, is there a difference of degree or a difference of nature?[24] In effect, what do the gas chambers *represent* within the SS state? They represent not only, or not essentially, the industrialization of death, by this I mean the application of industrial techniques to killing. These techniques were not applied to producing, even though such production did occur outside the slaughterhouses. If the "crematoria" of Auschwitz are perfected instruments, the gas chambers are merely a very poor technique. This is not what is essential. The essential is the negation of the crime within the crime itself. The problem was laid out quite well by a German attorney, Hans Laternser, in the course of the Auschwitz trial (1963—1965).[25] This argument begins with the fact that camp guards were under orders to kill deportees. But those guards who *selected* between the prisoners to be spared and those to be executed did so not, as it is often stated and as I myself have sometimes said, to separate those prisoners fit to work from those unfit, but rather to choose between those who would replace the depleted work force and those to be killed immediately. According to this argument, then, those who did the sorting were really saviors of the Jews and not their killers. This attorney expressed, in his own way, a reality: the diffusion of responsibility, the quasi-disappearance of responsibility. Who, then, is the killer at Auschwitz? Is it he who puts the crystals of Zyklon B through the opening to the gas chambers? For the most part, the directing of the victims leaving the trains, their undressing, the cleaning of their bodies, and their placement in the crematoria were all performed under the supervision of the SS, of course, but this was done by the intermediary of the members of the *Sonderkommandos* who alone, strictly speaking, were in direct contact with death. The crime can only be denied today on the basis that it was anonymous.

It is time to conclude. I said earlier that the only great French historical work on the theme of Hitler's genocide is the film by Claude Lanzmann, *Shoah.* How does this film question the historian? Lanzmann himself calls attention to the fact that his exposé breaks with historiographic tradition. He begins at Chelmno in December, 1941, with the use of the gas vans. If the extermination by gas truly has the symbolic importance that I assign to it, then Lanzmann is correct in beginning there.[26] But the historian finds himself called into question because historical discourse, of whatever kind, has difficulty escaping from what Spinoza called *concatenatio,* the chain of causes and effects. In effect, how can one avoid moving backward from the gas chambers to the *Einsatzgruppen* and, step by step, to the laws of exclusion, to German anti-Semitism, to that which distinguishes and opposes Hitler's anti-Semitism and that of Wilhelm II, and so on *ad infinitum?* Raul Hilberg,

for instance, proceeded in such a way in his admirable volume. But historical discourse is capable of all sorts of tricks, including the major one which consists of dissimulating that something new took place at Chelmno. The Nuremberg laws were still laws, as were the Vichy statutes, and the *Einsatzgruppen* saw those they killed in the terrible confrontation between executioner and victim. But the majority of the German inhabitants of Auschwitz did not see the Jews and Gypsies die in the gas chambers.

The second question Lanzmann's film asks the historian is perhaps even more fundamental. His attempt contains an element of folly: to have made a work of history at a juncture where memory alone, a present-day memory, is called upon to bear witness. As Michel Deguy has said: "The actors are like their own sons, each one engendered by who he was in his young agony."[27]

I happened to write, prior to the premiere of the film *Shoah,* that one of the questions asked of historians today was how to bring to history the teaching of Marcel Proust: the search for lost time as both time lost and time recovered.[28] This is what Lanzmann accomplishes in this film, where a single document is presented to us, but where everything depends upon the questions it asks of its witnesses today, and upon the answers they give. And I am well aware that behind each of these questions there is the entire historiography of the Holocaust, which Lanzmann knows as well as a professional historian.

Between time lost and time recovered there is the work of art, and the test to which *Shoah* subjects the historian is that of his obligation to be both a scholar and an artist. Failing this, he irremediably loses a fraction of that truth which he pursues.

Translated by Roger Butler-Borruat

Notes

Vidal-Naquet's essay first appeared in *Les temps modernes,* No. 507, October 1988, and was reprinted in F. Bédarida, ed., *La politique nazie d'extermination* (Paris: Albin Michel, 1989), under the title "L'épreuve de l'historian: réflexions d'un généraliste." This essay also appeared in Bernard Cuau et al., eds., *Au sujet de* Shoah: *Le film de Claude Lanzmann* (Paris: Belin, 1990). Vidal-Naquet has included "Le défi de la Shoah à l'histoire" in his recent work, *Les juifs la mémoire et le présent-deux* (Paris: La Découverte, 1991).

1. Cf. my *Les assassins de la mémoire: un Eichmann de papier et autres essais sur le révisionnisme* (Paris: Editions la Découverte, 1987).

2. Thucydides, *The Peloponnesian War,* III, p. 81. Vidal-Naquet cites the French translation by R. Weil. For this English translation, we have consulted the Crawley translation, revised by T. E. Wick, of *The Peloponnesian War* (New York: The Modern Library, 1982). (*Translator's note.*)

3. Thucydides, III, p. 82.

4. Thucydides, IV, p. 80.

5. Thucydides, III, p. 82. Book III ends with the eruption of Mount Etna; the link between the Peloponnesian War and great natural catastrophes is made explicitly in I, p. 23.

6. Of great help in this reconstruction is the book by Jean Ducat, *Les Hilotes de Sparte*, supplement to B. C. H. XVIII, Ecole Française d'Athènes, 1990.

7. *L'Allemagne nazie et le génocide juif* (Paris: Le Seuil-Gallimard, 1985).

8. The ultimate attempt at direct and synthetic history is the book by Arno J. Mayer, *Why Did the Heavens not Darken?: The "Final Solution" in History* (New York: Pantheon Books, 1989). This work is, as it should be, both a narrative and an interpretative summary.

9. Olga Wormser-Migot, *Le système concentrationnaire nazi* (Paris: Presses Universitaires de France, 1968).

10. Raul Hilberg, *The Destruction of the European Jews,* 3rd edition (New York: Holmes & Meier, 1985).

11. Conference on Jewish Social Studies (New York and Philadelphia, 1980).

12. Arno J. Mayer, *op. cit.*, Chap. VII, "Conceiving Operation Barbarossa: Conquest and Crusade."

13. Cf. her article in *Le Monde,* February 25, 1972, and the conclusion of her book, *The Theme of Nazi Concentration Camps in French Literature* (Paris and The Hague: Mouton, 1973).

14. Henry Rousso, *Le Syndrome de Vichy* (Paris: Le Seuil, 1987). This work has been reprinted in an expanded version in the collection *Points* (Paris: Le Seuil, 1990). I do not always agree with the author concerning both details (I reject, for example, his judgment of *Shoah*, p. 253) and form (his chronological ordering) but I do not see a way to refute the question asked in this book.

15. M. R. Marrus and R. O. Paxton, *Vichy et les Juifs* (Paris: Calmann-Lévy, collection *Diaspora*, Calmann-Lévy, 1981); S. Klarsfeld, *Vichy-Auschwitz*, vols. I and II (Paris: Fayard, 1983, 1985).

16. See *Le mouvement social,* January–March 1982, pp. 101–102.

17. In order to savor this adage, it is useful to bear in mind that the last two volumes of *Géographie universelle,* the great undertaking between the two world wars, were published in 1948 and took France as their subject. The author, Albert Demangeon, famous geographer and father-in-law of Aimé Perpillou, evaluated the state of the country in 1939, a fact which provoked numerous protests.

18. In the French, *"l'écume des choses"* (*translator's note*). See the objection of Arno J. Mayer in the "personal preface" to his most recent work.

19. As opposed to the colloquium of 1982, when I was asked to present "theses on revisionism" which may be found, with a few minor modifications, in *Les assassins de la mémoire*.

20. Pierre Pachet, *La Quinzaine littéraire,* November 1–15, 1987.

21. H. Dutrait-Crozon, *Précis de l'Affaire Dreyfus, avec un répertoire analytique* (Paris: Nouvelle Librairie Nationale, 1909). This work follows a "revision" by Joseph Reinach of the *Histoire de l'Affaire Dreyfus*.

22. A point raised by François Hartog during his seminar at the Ecole des Hautes Etudes en Sciences Sociales.

23. Cf. Paul Ricoeur, *Temps et récit, vol. III, Le temps raconté* (Paris: Le Seuil, 1985) p. 225.

24. Arno J. Mayer, *op. cit.*, states that this is a difference of degree, and on this point I disagree.

25. H. Laternser, *Die andere Seite im Auschwitz-Prozess 1963–1965. Reden eines Vertei-digers* (Stuttgart: Seewald, 1966) pp. 185–186.

26. Based on a very different analysis, Arno J. Mayer also identifies the end of 1941, the failure to take Moscow, as a decisive turning point in the war, which allowed the "Judeocide" to occur.

27. Michel Deguy, "Au sujet de *Shoah*," an article now reprinted in the collection of the same title, *Au sujet de* Shoah (Paris: Belin, 1990). The entire article should be consulted.

28. The same problem is presented, but from an opposite point of view, by P. Ricoeur, *op. cit.*, pp. 184–202.

3

Cendres juives

Jews Writing in French "after Auschwitz"

Elaine Marks

> Because he was a Jew my father died at Auschwitz: how can one
> not say it? And how can it be said?
> Sarah Kofman, *Paroles suffoquées,* 1987.[1]

> Do you see that chimney over there? Do you see it? Do you see
> the flames? (Yes, we saw the flames). Over there, that's where
> they're going to take you. That's your grave, over there. Haven't
> you understood yet? Sons of bitches, don't you understand any-
> thing? You're going to be burned. Burned to a cinder. Turned into
> ashes.
> Elie Wiesel, *La nuit,* 1958.

My title is a deliberate attempt to work against the question of who is or
is not Jewish, who is or is not French, by focusing not on the official religious
or national identity of the writer, but on his or her confession of Jewishness
and relation to the French language. My title is also a deliberate attempt to
work against the notion of a universal and always the same Jew, by focusing
on a variety of writers and writings, by insisting on a plural "Jew."[2]

Jews writing in French "after Auschwitz" may be divided roughly into
two groups: those who write about "Auschwitz," and those who write about
how to write about "Auschwitz." "Roughly," because there are, in the first
group, writers who, without abandoning the "Real" (I am thinking particu-
larly of the historian Pierre Vidal-Naquet in his book *Les assassins de la
mémoire* (*Assassins of Memory*) (1987)), never lose sight of the inevitable
mediation of writing, that is to say of rhetoric and discourse. The first
group—those who write about "Auschwitz"—includes, among others—Na-
dine Fresco, Marek Halter, Serge Klarsfeld, Annie Kriegel, André Schwarz-

Bart, Pierre Vidal-Naquet, Georges Wellers, Elie Wiesel. Whether they produce fictional representations of "Auschwitz" based on personal or documentary material, essays documenting what happened at "Auschwitz," or essays contradicting and contesting the revisionist historians, these writers write within a tradition that does not necessarily put into question the relation between words and things, between the text and the *hors texte*. I would consider as belonging primarily, if not exclusively, to this first group the two generations of Jewish intellectuals engaged in preserving the remains of Eastern European Jewish culture through the revival of Judaic studies, particularly Emmanuel Lévinas, about whom Judith Friedlander writes in *Vilna on the Seine* (1990).

The second group, those who write about how to write about "Auschwitz," includes, again among others, Hélène Cixous, Jacques Derrida, Serge Doubrovsky, Jean-Pierre Faye, Edmond Jabès, Alain Finkielkraut, Sarah Kofman, Claude Lanzmann, Patrick Modiano, Georges Perec. Some members of this second group maintain significant connections with the existential-phenomenological, philosophical style and themes of Martin Heidegger, Maurice Blanchot, and/or with deconstruction, poststructuralism, and psychoanalysis. All of the members of this second group have manifested their dissatisfaction with the mimetic principles that sustain the fictional and historical narratives produced by members of the first group.

As examples, and for my analysis of these two groups, I have selected three texts by writers of the first group, and four texts by writers of the second group. In several of these seven texts, the word *cendre* (ash or cinder) singular, or *cendres* (ashes or cinders) plural, as metaphor and/or symbol, is accompanied by the theme of mourning. These are texts in which the writers work through their own mourning—for an individual Jew or for Jews in general—a mourning that in some cases continues the mourning begun at the end of the nineteenth century for the "death of God." In their texts, the French word *cendre(s)* may function as a figure for both or either death and rebirth, mourning and celebration, for Jews who were exterminated in gas chambers and in ovens, and for the philosophical problem of the trace. *Cendre(s)* points not only to the product of incineration and its dispersion, but to anonymity, and also to the figure of the phoenix, reborn from its own ashes. I shall argue that the figure or figures of the phoenix may take unexpected forms, transforming the Heideggerian analysis of the Being-towards-death into a Being-towards-the-other, transforming the historical-social-ethical question of the extermination of the Jews into a philosophical-poetical-linguistic question of presence and absence. These texts are, more or less in the order in which I shall discuss them: from the first group, *La nuit* (*Night*) by Elie Wiesel (1958); *Le dernier des justes* (*The Last of the Just*) by André Schwartz-Bart (1959); and *Difficile liberté: Essais sur le judaïsme*

(*Difficult Freedom: Essays on Judaism*) by Emmanuel Lévinas (1963); from the second group, the scenario from the film *Shoah* by Claude Lanzmann (1985); *Paroles suffoquées* (*Suffocated Words*) by Sarah Kofman (1987); *W ou le souvenir d'enfance* (*W or the Memory of Childhood*) by Georges Perec (1975); *feu la cendre* (*Cinders* or *The Recently Dead Cinders*) by Jacques Derrida (1987).

Towards the end of Claude Lanzmann's film *Shoah,* there is a sequence in which the political scientist, Raul Hilberg, highlights one aspect of the language problem that haunts those who attempt to write about the *Shoah* and who are conscious of the danger of reproducing stereotypical figures and cliches:

> This is the *Fahrplanordnung* 587, which is typical for special trains. The number of the order goes to show you how many of them there were. Underneath: "Only for internal use." But this turns out to be a very low classification for secrecy. And the fact that in this entire document, which after all deals with death trains, one cannot see—not only on this one, one cannot see it on the others—the word *geheim*, "secret," is astonishing to me. That they would not have done that is very astonishing. On second thought, I believe that had they labeled it secret, they would have invited a great many inquiries from people who got hold of it. They would then have raised more questions; they would have focused attention on the thing. And the key to the entire operation from the psychological stand-point was never to utter the words that would be appropriate to the action being taken. Say nothing; do these things; do not describe them. (pp. 138–139)

Claude Lanzmann's mission as researcher, cinematographer, editor, lucid yet empathetic inquisitor in the film *Shoah,* is to uncover the covered traces, to decode the coded expressions, to replace euphemisms with dysphemisms, with words that describe as accurately as possible the "things" that were done. The film *Shoah* exterminates the Jews for a second time in the presence of spectators for whom the veil of secrecy has been lifted. Claude Lanzmann's relentless questioning and pursuit of recurring detail is a systematic attempt to work against the camouflage of events and places through language, to work against litotes, allusion, obliqueness. And yet the camouflage of language, the use of litotes, allusion, and obliqueness are precisely the strate-gies of poststructuralism and deconstruction, in their deliberate refusal of the conventions of realistic description and narrative representation. Were the Nazis poststructuralists and deconstructors *avant la lettre* in their desire "never to utter the words that would be appropriate to the action being taken"? Or, more worrisome still, were and are Heideggerians and poststruc-turalists, as has been asserted in France and the United States during the recent debates concerning the politics and the philosophical and/or literary

theories of Martin Heidegger and Paul de Man, engaged in an intellectual enterprise that involves inherently dangerous modes of thought? Does an obsession with the primacy of language and etymology lead inevitably to extermination? Does questioning direct access to the Real imply a trivialization of reality and suffering? Does an investigation of historical narrative imply a turning away from historicity? What happens to the Jewish question in French writing when it is viewed in the light or the glare of the humanism/ antihumanism exchange? How does the putting into question of the status of subjects and agents affect the Jewish question? These are some of the questions that inform this essay, questions to which I will propose neither answers nor solutions, but to which I will add other equally crucial questions.

In *Night,* by Elie Wiesel, and the last chapter of *The Last of the Just,* by André Schwarz-Bart, writers and narrators attempt to memorialize and to mourn through familiar narrative strategies. In spite of the differences in length, style, and intention, both of these novels contain a certain number of identical elements in the representation of "Auschwitz" and *cendres juives*: the description of a small *shtetl* of Eastern Europe and/or a Jewish ghetto in a large, Western European city; the presence of the Gestapo, the local police, and the Jewish officials in charge of deportations; the young, innocent hero-narrator; the voyage by train from the shtetl or, in France, from Drancy near Paris, to Auschwitz, a voyage made in anxiety, anguish, humiliation, and physical suffering both individual and collective; the arrival at Auschwitz at night, with the howling dogs, the barked orders in German, the two lines, the smoke and the odors; the "experience" of those who are immediately gassed and/or those who are forced to work in the camps; and finally the *cendres juives* that the protagonists become or that the protagonists witness, and whose provenance—the ovens in which members of their families, from whom they were separated shortly before, were burned— they suddenly understand. In *The Last of the Just,* as in the final scenes of other novels in which the protagonists walk into one of the gas chambers at Auschwitz, someone sings, in Hebrew, the prayer or profession of faith that Orthodox Jews recite three or four times a day, and that dying Jews, whether or not they are Orthodox, frequently recite on their deathbed: *"Schema Israel"* ("Hear, o Israel, the Eternal (is) our God, the Eternal is One"). It is finally this affirmation of faith in God, this affirmation of monotheism in Hebrew, that defines the Jewish presence. Thus the representation in fiction of Auschwitz has become fixed and codified, inevitable and unchanging. And yet it might be said that the tragic mode is averted by the words of the *"Schema,"* for if God is listening, or if the Jews who intone the *"Schema"* think that God is listening, the Jews are not alone, their agony is not without a witness. These conventional narratives are thus informed by an equally conventional and reassuring metaphysical apparatus from which God is never entirely absent.[3]

God is always present in the writings of the philosopher Emmanuel Lévi-nas, and in his unabashedly Jewish apologetics. In Judith Friedlander's recent book, *Vilna on the Siene* (1990), an account of the revival of Judaic studies in France after 1968, Emmanuel Lévinas is given a leading role, as a member of the older generation educated in both European and Jewish cultures. My comments will bear on only one of his books, *Difficult Freedom: Essays on Judaism,* a collection of essays written between 1945 and 1960, and also on an essay entitled "La renaissance culturelle juive en Europe continentale" ("The Jewish Cultural Renaissance in Continental Europe"), published in 1968. I do not consider Emmanuel Lévinas to be representative of all French Jewish religious thinkers, nor do I place myself, in relation to his writing, in a position other than that of a compassionate lay reader.

We find at the core of Lévinas's essays an investigation of violence, of all those acts that threaten the rights of the Other. The Other is a face to whom words are addressed. Lévinas denounces the naked violence haunting the Occident; he rejects the claims of the Logos to unify and totalize, to produce a homogeneous image of man and of the world. Lévinas writes against his early teachers, Husserl and Heidegger. In the words of Seán Hand, Lévinas's "post-rational ethics stands as the ultimate and exemplary challenge to the Solitude of Being, a rigorous and moving testimony of one's infinite obligation to the other person" (p. v). For Lévinas, Judaism, or rather, biblical and Talmudic studies, represents the source of an ethics of exigency:

> In the aftermath of Hitler's exterminations, which were able to take place in a Europe that had been evangelized for fifteen centuries, Judaism turned inwards towards its origins. Up to that point, Christianity had accustomed Western Judaism to thinking of these origins as having dried up or as having been submerged under more lively tides. (p. xiii)

My appropriation of Emmanuel Lévinas draws from what I will call tenta-tively his critique of Christianocentrism, a critique that provides a way of speaking critically about Christian culture.

In several of his essays in *Difficult Freedom,* Lévinas reminds his readers of the "fraternal contact" that many Jews had with Christians during the Nazi period, ". . . Christians who opened their hearts to them—which is to say, risked everything for their sake" (p. xiii). In spite of this frequent re-minder, Lévinas nevertheless raises serious questions about the inevitable presence of Christian culture and the impossibility of escaping from it, even in contemporary secular states. The separation of church and state in France, according to Lévinas, has not dissipated this religious "Christian atmo-sphere" which we take in, like the air we breathe, and without realizing it. He notes that French legal time and calendar are punctuated by Catholic holidays, that towns are built around cathedrals or churches, and that French

art, literature, and ethics have been and continue to be nourished by Christian themes. The only way of freeing oneself from Christianity, he suggests, is through immersion in the Hebrew language. It is the forgetting of Hebrew, according to Lévinas, that is in part responsible for our neglect of ethical questions. Lévinas consistently represents Christianity as the conqueror of the Occident, and Judaism, to his continuing astonishment, as that which has always refused to recognize the conquest. The Wandering Jew becomes the emblematic figure of that refusal.

It is possible to see in Lévinas's critique of Christianocentrism a parallel with the critique of phallocentrism. It may well be that women and Jews, as psychoanalytic theory and analyses of ideology suggest, occupy a similar position within both the unconscious and the nonconscious of texts and images. Within French culture, from the end of the nineteenth century until 1944, the figures of "*Le Juif*" and "*La France*" provide an intriguing clue to the relationship between woman and Jew. Because "*Le Juif*" was frequently portrayed as fat, with a bulbous nose and blubber lips, sexually perverse, effeminate, and cowardly, there are resemblances between "*Le Juif*" and the feminine. And because "*La France*" was frequently portrayed as tall, erect, brandishing a flag, leading the troops with her often-exposed phallic breasts, there are resemblances between "*La France*" and the virile.

A radical solution to this perpetuation of stereotypes and clichés, and another way of reading *cendres juives,* is proposed by Emmanuel Lévinas in at least two of his essays. In "How is Judaism Possible?" Lévinas writes: "It is the spread of Christian culture everywhere that gives Christianity its impact, not the pious sermons and the parish bulletin. We are the only ones in the world to want a religion without culture" (p. 247). And in "The Jewish Cultural Renaissance in Continental Europe," Lévinas strongly affirms the importance of Hebrew studies:

> What we expect from a return to Hebrew learning is that we will receive the light of the world through Hebrew, through the arabesques that are often drawn by the square letters of the prophetic, talmudic, rabbinical, and poetic texts, in the same way as we receive the light through the stained glass windows of the cathedrals or through the poetic lines of Corneille, Racine, or Victor Hugo. (p. 25)

What Emmanuel Lévinas seems to be proposing is that, at the very least, Judaism in France separated itself from the term "Judeo-Christian tradition" and claimed its uniqueness: the indispensable association of study, *conscience* (consciousness and conscience), and justice. Judaism, for Emmanuel Lévinas, refuses the seduction of myths, mysteries, and the supposed magical power of the sacraments. For him, Judaism counteracts the violence that is

at the heart of Christianity. In *Difficult Freedom,* he is less concerned with writing about "Auschwitz" than with coming to terms with what made "Auschwitz" possible. He does this by raising "The Christian Question," and displacing the meaning of *cendres* from death, through violence towards Others, to rebirth, through Talmudic texts that emphasize the ethical relationship to the Other.

In certain respects, Sarah Kofman's *Suffocated Words* is a paradigmatic text for Jews writing in French "after Auschwitz." Like many texts written or edited by Jews and focusing on the *Shoah*—for example, Edmond Fleg's *Anthologie juive (Jewish Anthology)*, Elie Wiesel's *Night,* André Schwarz-Bart's *The Last of the Just,* Serge Klarsfeld's *Mémorial aux juifs déportés (Memorial to the Deported Jews)*, Pierre Vidal-Naquet's *Assassins of Memory*—*Suffocated Words* is dedicated to a family member who died at Auschwitz. In *Mourning and Melancholia* (1917), Sigmund Freud writes: ". . . Mourning impels the ego to give up the object by declaring the object to be dead and offering the ego the inducement of continuing to live. . . ." (p. 257) It is interesting to note that, in *Suffocated Words* as in the other texts, the ending marks a reversal, a movement from absorption in and identification with the dead body to detachment and new signs of life. Sarah Kofman suggests gingerly, on the last page of her text, ". . . the possibility of a new ethic."

Sarah Kofman also incorporates, through direct quotations and multiple references, fragments from texts by Theodor Adorno and Jean-François Lyotard. But most of her quotations are from Maurice Blanchot's *L'ecriture du désastre (Writing the Disaster)* (1980), and from Roger Antelme's *L'espèce humaine (The Human Species)* (1947), on his experience as a non-Jew in German concentration camps. What is essential for Sarah Kofman, as it is for Maurice Blanchot, Roger Antelme, and Claude Lanzmann, is to write endlessly about writing about "Auschwitz," in order not to forget what happened at "Auschwitz," while respecting the proscription against representation which follows Talmudic law, as well as poststructuralist directions within contemporary literary theorizing. The problem remains for Sarah Kofman: how to write about "Auschwitz" without betraying "Auschwitz"? Without telling a story, ". . . a story before Auschwitz . . . even if it were the story of a Passion, the passion of Christ" (p. 46)? Sarah Kofman does not tell a story, but she mingles philosophical inquiry, citations, and anecdotal fragments. Readers piece together the following events: her father was a rabbi, arrested in Paris on July 16, 1942, deported from Drancy to Auschwitz, and buried alive, so witnesses relate, because he insisted on observing the Sabbath and on saying prayers for both the victims and their tormentors. He insisted on maintaining a relationship in language with god. He and his words were literally suffocated, and Sarah Kofman's writing mimes this suffocation by attempting to translate intensity and silence with the aid of

41

quotations: "To be obliged to speak without being able to speak nor be heard, such is the ethical exigency which Roger Antelme obeys in *The Human Species*" (p. 46). *Suffocated Words* is a text on "Auschwitz" and writing, separately and together, in which the anecdotal referent survives.

The anecdotal referent also survives in Georges Perec's *W or the Childhood Memory*. This is a narrative in two parts, marked by three different kinds of type: italic characters for the narration of the voyage to W—a fictional island situated by the narrator in the archipelago of Tierra del Fuego—and the description of life on W—an allegory of the concentration camp universe in the imaginary of a boy; roman characters for the autobiographical account of the narrator's childhood, between 1936 and 1949; bold characters for the two brief central texts that recount the death of his father in the French army, the day after the anniversary of the Armistice in 1940, and the death of his mother, at Auschwitz, following her deportation on February 11, 1943, from the camp at Drancy in the convoy number 47.[4] Here, the work of mourning consists in projecting the narrator's affect onto the constructed décor of a terrifying narrative, at once familiar and strange. The three-and-a-half pages that tell the story of the narrator's Polish-born mother's life and death (what he knows of them) are remarkable for their sparseness and their precision. These are the last four sentences: "She was caught in a police raid with her sister, my aunt. She was interned at Drancy on January 23, 1943, and deported on the 11th of February in the direction of Auschwitz. She saw her native land before she died. She died without understanding" (pp. 48–49). Although Auschwitz is referred to only once in *W or the Memory of Childhood,* as the presumed end of his mother's voyage, it permeates, indirectly and unremittingly, the entire text.

There are no anecdotes, no narrative, no history in Jacques Derrida's *feu la cendre* (*Cinders*) other than, in the Prologue, two indications concerning the genesis of this text. The first, and perhaps, for my purpose, the most significant, relates the mysterious coming of a sentence into the writer's consciousness, a sentence that had haunted him for over fifteen years (earlier than 1972), a sentence rich in semantic and thematic ambiguities: "There is ash there" (p. 7). The semantic ambiguity resides in the difference between hearing and reading the sentence, between the adverb "*là*" ("there"), with its *accent grave* (its grave accent, already funereal), and the feminine definite article "*la*" ("the"). There is also a phonetic similarity prolonged throughout the text by the words *cendre* (*"ash"*) and *centre* ("center"). Thematic ambiguities and questions abound, nourished by familiar Derridian themes: the trace and dissemination; the disjunction between the words of a text and the things to which they refer; the indecision and the indetermination of meaning. And there is the heavy debt to Martin Heidegger evident in the sentence that haunts the narrator(s) of *cinders* with its references to *es gibt*

("there is") and *da* ("there"), the *da* of *dasein,* the very core of Heidegger's thinking on Being. The reader of Derrida's text is alerted, then, from the beginning, to the presence of such Heideggerian themes as astonishment and the need to be attentive to the call of Being, the opening of the question—here of *cendre*—by the interrogation of a word, and the emphasis on language as, in Heidegger's words, "the house of the truth of Being" (p. 43). A debt to Heidegger in 1987, the year during which the Heidegger debate raged in France, focusing on the relationship between Heidegger's thought, his adherence to the Nazi party from 1933 to 1945, and his persistent silence concerning the *Shoah,* is a particularly heavy debt to bear for a "Jewish" writer who will at the same time acknowledge the debt and include, in his meditation on *cendre,* references to the *Shoah.* Derrida's own contribution to the Heidegger debates includes a lecture published as an extended essay in 1987, *De l'esprit. Heidegger et la question* (*Of Spirit: Heidegger and the Question.*) The essay begins with the following opening sentence: "I will speak of the ghostly, of flame and of ashes" (p. 11). Both Heidegger and the *Shoah* are at the center of Derrida's texts written during the late 1980s.

The second anecdote relates that *Cinders* was written in response to a request, made in 1980, by Derrida's friends at the journal *Anima* for a text on the theme of *la cendre.* Both of these anecdotes suggest the importance of an outside: the first, an outside of consciousness, and the second, the world outside the writer; as if Jacques Derrida were solicited by his unconscious and by his friends to produce a text in which *cendre,* as signifier and signified, would be both in the background and highlighted.

The Prologue, unlike most other texts by Jacques Derrida, gives us serious clues about its own genesis. It also describes the text in some detail, and insists on the relationship between the text to be read and the text to be listened to as a cassette, recorded with the voices of the author and of actress Carole Bousquet, and made available, like the printed text, by the Édition des Femmes. It is worth asking why Derrida surrounds this particular text with so much context, why he is so specific about the occasions that prompted its writing?

Cinders, like Jacques Derrida's text *Glas,* is a double text. On the right-hand side of the page, an indeterminate number of voices engage in a polylogue, a conversation in which gender and identity are deliberately confused. Sometimes the voices suggest a love duo, at other times a series of hopeless soliloquies. All imaginable themes associated with *cendre* appear and disappear: from the more abstract and philosophical considerations of trace and remains, of being and nothingness, to the more concrete associations with the "Holocaust," with Germans, and with Jews.

On the left-hand side of the page, there are quotations from other texts by Derrida in which *cendre* is a central signifier: *La dissémination,* 1972; *Glas,*

1974; *La carte postale,* 1980. An attentive reader will also hear echoes of *cendre* in *Schibboleth: Pour Paul Celan,* 1986; *Of Spirit: Heidegger and the Question,* 1987; and "La guerre de Paul de Man," ("Paul de Man's War," 1988). Deconstruction is haunted by death, temporality, and mourning, as is the thought of Jacques Derrida's principal philosophical mentor, Martin Heidegger. The ashes of the Holocaust mingle with the ashes of other dead in other places, for example with those of Paul de Man (pp. 216, 230), mingle with the theme of death and mourning, and with the ontological question of being as it had been thought before the *Shoah* changed the terms of the meditation on death for many Jews and non-Jews writing in French "after Auschwitz." Jacques Derrida is in a unique category. He is a Jew, writing in French "after Auschwitz," for whom the *Shoah* is always present but rarely appears as such, never appears as anecdote or as representation, but always already transformed into trace, dissemination, it remains, always haunting, in the prismatic fragmentation of his texts.

I offer a possible reading of *Cinders.* I remain respectful of Jacques Derrida's insistence, here and elsewhere, on polysemy and heterogeneity in texts. Nonetheless, I propose to read the *cendre* of *Cinders* as "*cendres juives*" (Jewish ashes). Furthermore, I would suggest that this text has its place in the curious polylogue in France, Western Europe, and the United States that has engaged revisionist historians—those who claim that the Jews were not deliberately gassed in the extermination camps of Poland by the Nazis, but rather died in the concentration camps of diverse illnesses—and such eminent philosophers and linguists as Jean-François Lyotard in France and Noam Chomsky in the United States. For Lyotard in *Le différend* (*The Differend*) (1983), the revisionist thesis became the occasion of philosophical debate: How can one determine what did take place, how can one weigh the rhetorical evidence when there is no one to bear witness? For Chomsky, who wrote the preface to Robert Faurisson's *Mémoire en défense: Contre ceux qui m'accusent de falsifier l'histoire* (*Defense Brief: Against Those who Accuse me of Falsifying History*) (1980), the revisionist thesis became the occasion of political debate: the necessity of upholding free speech, of upholding the right to publish the most outrageous positions.

Jacques Derrida's text enters poetically rather than polemically into the debate, suggesting that the protagonist—the voice and the voices—like Hamlet in *Hamlet,* has a debt, an obligation towards the spectre which is the *cendre.* The *cendre,* again like the ghost in *Hamlet,* contains a secret. But, unlike the ghost, it cannot speak, it can only be spoken about. The secret is never divulged anecdotally, but it is alluded to, even played with:

> You said a moment ago that there was no expression in today's language
> for that word ash. There is only one that is perhaps worthy of being

made public. It would convey that which burns everything, in other words holocaust and the gas oven, in German in all the Jewish languages of the world. (p. 41)

Above the sacred place, there is still incense, but no monument, no Phoenix; there is nothing erect that stands—or falls—there is ash without ascension, the ashes love me, they change their sex, they become cinders and masculine, they androgynocide. (p. 45)

The word games and the puns do not trivialize the *Shoah,* do not negate or minimize the event. Rather, the plays on words, the words within words, emphasize the notion that, in 1987, what remains are words, like traces, with their secrets, their etymologies, their histories. These words that haunt us, like the word *cendre,* must be attended to, interrogated. This kind of interrogation, when it is philosophical, linguistic, poetic, like *Cinders,* has among its many effects the deepening and broadening of our meditation on the *Shoah* and its textuality.

There is a curious irony in this examination of Jews writing in French after "Auschwitz." Although Martin Heidegger was silent about the *Shoah,* many of his French disciples and students, whether non-Jewish, like Maurice Blanchot, Jean-François Lyotard, and Philippe Lacoue-Labarthe, or Jewish, like Jacques Derrida, Sarah Kofman, Emmanuel Lévinas and Alain Finkielkraut, have incorporated the extermination of the Jews into their meditation on Being-toward-death, or rather, their meditation on our primordial anxiety has been inflected by the *Shoah.* Heidegger's silence, even more than his National Socialist affiliation, has been and is being referred to by writers on both sides of the Atlantic, Jewish and non-Jewish, to condemn his pernicious influence on contemporary modes of thought. And yet it is precisely those texts, like *Cinders,* where Heidegger's thought and poetic style are most recognizable, which, through metaphoric indirection, produce an effect of horror and of silence acceptable to my expectations, at least, of writing "after Auschwitz." If there is a lesson about "culture" to be learned from these examples, it is that some Jews writing in French "after Auschwitz" are strongly rooted in German thought.

Notes

1. The quotations from texts by Lanzmann, Lévinas and Wiesel are from the English translation. All other translations are my own.

2. It is not irrelevant to note here, at the beginning of this essay, that the writer writing describes herself, for this occasion, as an atheist and a Jew.

3. Serge Doubrovsky's "autofiction" *Le livre brisé* (*The Shattered Book*) (1989) maintains a delicate balance between the genre with which it is traditionally associated and the questions it raises that threaten the integrity of the genre. Here, *cendres juives*

are introduced as one element among others in an extended work of mourning. Mourning for the narrator's youth, for his idol, Jean-Paul Sartre, for his mother, for his divorced wife, Claudia and his ex-mistress, Rachel, for his dead Austrian wife, Ilse, for her stillborn baby, for his own past, for what he can and cannot remember. His non-Jewish wife, Ilse, is incinerated and buried in a Jewish cemetery, in passages dominated by the metaphor of Auschwitz.

4. For both Sarah Kofman's father and George Perec's mother, Serge Klarsfeld's *Mémorial aux juifs déportés* provides confirmation of their deportation: their names, place of birth, and the number of their convoy. At the Centre de Documentation Juive Contemporaine, 17 rue Geoffroy L'Asnier, in the 4th arrondissement in Paris, where I have worked, on and off, during the summers of 1988, 1989, 1990, men and women continue to come and to ask for the *Mémorial,* which they peruse for the names of family members and friends. They are equally distraught when they find the names for which they are looking and when they do not.

Works Cited

Derrida, Jacques. *feu la cendre* (Paris: des femmes, 1987), trans. Ned Lukacher.

———. *Cinders* (Lincoln: University of Nebraska Press, 1991).

———. *De l'esprit: Heidegger et la question* (Paris: Galilée, 1987).

Freud, Sigmund. "Mourning and Melancholia," in vol. 14 of *The Standard Edition of the Complete Works of Sigmund Freud,* trans. and ed. James Strachey (London: Hogarth Press, 1953–1974).

Kofman, Sarah. *Paroles suffoquées* (Paris: Galilée, 1987).

Lanzmann, Claude. *Shoah* (Paris: Fayard, 1985). Trans. A. Whitelaw and W. Byron (New York: Pantheon, 1985).

Lévinas, Emmanuel. *Difficile liberté: Essais sur le judaïsme* (Paris: Albin Michel, 1963, 1976).

———. *Difficult Freedom: Essays on Judaism* Trans. Seán Hand. (Baltimore, The Johns Hopkins University Press, 1990).

———. "La renaissance culturelle juive en Europe continentale," in M. Davis *et al., Le renouveau de la culture juive* (Brussels: Editions de l'Institut de Sociologie de l'Université Libre de Bruxelles, 1968).

The Levinas Reader, edited by Seán Hand (Oxford: Basel Blackwell, 1989).

Perec, Georges. *W ou le souvenir d'enfance* (Paris: Denoël, 1975).

Schwarz-Bart, André. *Le dernier des justes* (Paris: Editions du Seuil, 1959).

Wiesel, Elie. *La nuit* (Paris: Editions de Minuit, 1958). *Night,* trans. Stella Rodway. (New York: Bantam Books, 1986).

4

War Memories
On Autobiographical Reading
Susan Rubin Suleiman

I have no childhood memories.
> Georges Perec, *W ou le souvenir d'enfance*

Write then, I must.
> Saul Friedländer, *When Memory Comes*

A few years ago, I realized with a jolt that I belong to a diminishing segment of the world's population: men and women who have personal memories of World War Two in Europe. I don't have many, since I was only five years old when the war ended. But I have some, particularly from the last year of the war; whereas for friends who are only a few years younger than I, the war is at best a transmitted memory, for me it is a lived one. Does this fact make a difference in the way I read other people's accounts of wartime experiences? Do I read them differently from, say, someone similar to me in temperament but born in the United States around 1950, or even 1945? I don't know. What I do know is this: I read certain kinds of war memories with a breathless attention few other kinds of writing elicit in me, and that has no real correlation with the "literary quality" of the writing; the war memories that most affect me are those in which I recognize aspects of my own; and finally, reading other people's war memories has become indissociable, for me, from the desire (and recently, the act) of writing my own.

"Everyone has at least one book in them—their autobiography." Among people I know—writers, academics—this is a truism: call it the autobiographical imperative, whether acted on or not. The idea I want to pursue here is that the autobiographical imperative applies not only to writing about one's

life but to reading about it; reading *for* it; reading, perhaps, *in order to* write about it. That is what I call autobiographical reading, or more emphatically, "strong" autobiographical reading.

Strong, because in one sense, the notion of autobiographical reading is banal and familiar. We all project ourselves into what we read, especially into narrative. Just as it has been claimed that all writing—even the driest of critical studies—is in some way autobiographical, so it can be claimed that all reading is. That too is a truism—but insofar as it is only that, a very wide generality, the observation loses its interest. What makes it interesting is its enactment in, and implications for, specific cases. One might say, then, that "strong" applies not only to a particular kind of autobiographical reading, but to a particular kind of account of such reading. To explore this double possibility, I want to discuss the autobiographical reading of war memories, using first the specific case of an other, then my own.

I.

"I never spoke about it; I never made notes; I only read. I read every single book that appeared on the Holocaust. I still do. I'm a voracious reader of Holocaust Literature and World War II Literature. I still want to understand what happened." The person speaking here is Elie Wiesel, around 1974.[1] By then he was internationally known and celebrated, the author of more than a dozen books translated into many languages. The time he is speaking about, however, is the ten-year period, from 1945 to 1955, that elapsed between his liberation from the Buchenwald concentration camp and the writing of his autobiographical account of the last year of the war. *Night* (*La nuit*), first written in Yiddish in 1955, and published in Argentina in 1956, appeared in French in 1958. Over the next decade, Wiesel published eleven books—more than one per year. He has stated that only *Night* is autobiographical; yet, "All the stories are one story . . . [built] in concentric circles. The center is the same and is in *Night*. What happened during that Night I'm afraid will not be revealed."[2]

So much writing, at whose heart is an absence: will "what happened during that Night" not be revealed because the author willfully withholds it from his reader? Or because he himself is in the position of a reader confronted with a text he does not understand—a text that, for precisely that reason, he must continue to read and to write over and over, replacing revelation with repetition? Probably, it is a little of both. One cannot discount the cynicism, or more exactly the hopelessness of being understood, that might prevent a witness from revealing all he knows. In his third book, *Day* (*Le jour*, 1961), which, despite its hopeful title, strikes me as extremely dark and despairing, Wiesel invents a scene in which the narrator, a survivor

of Auschwitz, decides very consciously *not* to tell what he knows. He realizes that his listener, although insistent in asking him the right question ("Answer me! Why don't you want to live? Why?"), would not be able to bear hearing the answer: "I felt like telling him: go. Paul Russell, you are a straightforward and courageous man. Your duty is to leave me. Don't ask me to talk. Don't try to know. . . . The heroes of my legends are cruel and without pity. They are capable of strangling you."[3] In the end, when his listener—the doctor who operated on him after an accident and saved his life—persists with his questioning, Eliezer lies to him: "I began to persuade him he was wrong so he would go away, so he would leave me alone. Of course I wanted to live. Obviously I wanted to live, create, do lasting things. . . ." The doctor leaves, satisfied: "I admit my mistake. I'm glad. Really." Eliezer mockingly echoes him: "I too. I was glad to have convinced him. Really" (pp. 273–274).

This example of narrative withholding is complicated, of course, by the fact that the reader is given more information than the well-meaning doctor, who remains in ignorance. But even while sharing the narrator's inner thoughts, the reader receives no revelation—unless it be that for Eliezer there can be neither a forgetting of the past nor a final, redemptive telling of it. There can only be retellings, each one a failure in its own way. "In all of my books, I think, I indicate the impossibility of communicating a story," Wiesel states, in one of his conversations with Harry James Cargas (p. 85). *Day* can be read as an extended parable, or set of parables, of just that impossibility. Besides the scene with the doctor, there are at least three other scenes of failed communication about "what happened during that Night," including one in which the narrator himself becomes the unwilling listener of another victim's story. When confronted with the horror of what a young woman who has invited him to her room endured as a 12-year-old child prostitute in Auschwitz (" 'Did you ever sleep with a twelve-year-old woman?' she asked me"—p. 290), Eliezer runs away. Her story, like his, has the power to strangle its listeners: "I listened . . . my clenched fingers were like a vise around my throat" (p. 289). After he runs away from her, incapable of listening to one more word, he realizes that his hands are still clutching his throat.

The most significant thing about this failed encounter is that, even though he, too, was at Auschwitz, and even though the young woman's name, Sarah, is that of his dead mother, who perished there, Eliezer is unable to respond adequately to her story. "You are a saint. A saint: that's what you are," he tells her, provoking her sarcastic laughter (p. 293). Just how inadequate this response is, is clear to the reader who remembers an earlier scene (told earlier, though occurring later in the fictional time), where a young American woman with no experience of the camps calls Eliezer a saint,

provoking *his* sarcastic laughter. Unlike him as listener, she stays after hearing his story, and even falls in love with him. But their communication fails too, in the end, because she demands that he "forget the past," and think only of their love. The day after he promises her to do just that, Eliezer purposely steps in front of an on-rushing taxi. He survives, but does not forget the past. Quite the contrary: "I think if I were able to forget I would hate myself. Our stay there planted time bombs within us. From time to time one of them explodes. . . . It's inevitable. Anyone who has been there has brought back some of humanity's madness" (p. 303).

By its repeated stagings of "the impossibility of communicating [the] story," *Day* paradoxically demonstrates, at the same time, the absolute necessity, for the survivors, to tell their story. Wiesel speaks of the "obsession to tell the tale,"[4] which, according to him, is the obsession of all those who remained alive—even though, as he demonstrates in *Day*, this obsession may be accompanied by the equally strong feeling that any attempt to communicate their experience will ultimately fail. The earliest of the narrative stagings in *Day* is instructive in that regard. Recounted in a flashback that interrupts the scene where Eliezer tells his story to the American woman, Kathleen, this is literally the "primal scene" of narration: standing with a stranger on the deck of a ship in the middle of the ocean, Eliezer, who has been thinking of throwing himself into the water, listens as the stranger tells him about a similar incident in his own life. Then, suddenly, he too begins to tell his story: "I told him what I had never told anyone. My childhood, my mystic dreams, my religious passions, my memories of German concentration camps, my belief that I was now just a messenger of the dead among the living. . . ." (p. 243). The stranger listens to Eliezer's narrative in complete silence, asking for neither explanations nor clarifications; then, just before dawn, he speaks: " 'You must know this,' he finally said. 'I think I'm going to hate you' " (p. 244).

I call this the primal scene of narration not only because it is the first such scene in the novel, and not only because we are told that it is the first time Eliezer tells the story to anyone, but because it clearly refers back to Wiesel's own first work, the autobiographical narrative of *Night*. We don't actually hear what Eliezer tells the stranger, but its summary ("my childhood, my mystic dreams," and so on) corresponds almost exactly to the story told in *Night*. The fact that the listener never interrupts but listens in silence suggests that he could also figure as a reader. The paradox is this: insofar as the communication of the story is successful, it compels the listener/reader to hear it to the end, but also makes him hate the one who tells it— and thereby makes any further communication impossible. Indeed, after listening to Eliezer's story, the stranger flees; and although Eliezer returns to the deck several more times in an effort to find him, he never sees him again.

Far from fulfilling its apparent promise of an edifying tale (although it has been read as such by some[5]), *Day* exemplifies rather what Alvin H. Rosenfeld has called the "revisionary and antithetical nature of so much of Holocaust writing, which not only mimics and parodies but finally refutes and rejects its direct literary antecedents."[6] Whereas the sequence of titles, *Night, Dawn* (*L'aube,* 1960), *Day* (in some countries, they have been published in a single volume) seems to promise an edifying upward arc, the actual movement in this trilogy is from night to a day whose most salient characteristic is that it is bearable only to the extent it refuses to put the night behind it.

"I never spoke about it; I never made notes; I only read. I read every single book that appeared on the Holocaust." Before writing about his own experience, Wiesel waited ten years, during which he read. It would seem that the obsession to tell the tale is doubled by the obsession to read the tale. His, then, is an exemplary case of "strong" autobiographical reading.

II.

My own case is more modest, but may also offer some insights; for I too am an avid reader of a certain kind of Holocaust literature.

Whose writings, whose memories elicit my most breathless attention? Those of concentration camp survivors, whether Jewish or not—ranging in literary artistry from Primo Levi or Charlotte Delbo (or Elie Wiesel, in *Night*), to Lise Lesèvre, whose only published work, as far as I am aware, is the memoir she published at the age of eighty-six;[7] and those of European Jews who were children during the war. Necessarily, very few of the latter are concentration camp survivors, and none who were very young at the time, because all young children—say, under ten years old—who were deported were immediately sent to their deaths, whether alone or with their mothers.[8]

As far as autobiographical reading is concerned, there is a discrepancy here—for if I was a very young child during the war, neither I nor my immediate family (father, mother, aunts, uncles, grandparents) experienced the camps. The memories of camp survivors are as incommensurable with my memories or experience as with those of any other reader, contemporary or not, who did not experience the camps. This is not, therefore, autobiographical reading in the most literal (or "strongest") sense of the term. But I think it would be a mistake to insist on a narrowly construed, strictly experience-based self-definition as the basis of autobiographical reading. To recognize aspects of one's own life story in another's is no doubt easier for one who has undergone some of the same experiences, in the same time and place; but it would be far too restrictive, and wrongheaded, to suggest that *only* one who has undergone a certain experience can respond to another's story, and to its telling, "properly"—or, in my terms, autobiographically.

For one thing, no individual's experience of an event, even of the exact same event, is fully identical to another's; even in such a case, it requires an imaginative leap to read the other's story "as if it were one's own." The willingness or ability to make that imaginative leap may be stronger in one who has firsthand experience of the time and place; but paradoxically, the closeness to the experience may also provoke a reverse reaction, a refusal to read autobiographically, or to read at all (think of Eliezer's reaction to the story of the girl who had been at Auschwitz). Such refusal, not unusual among Holocaust survivors, would be the subject of another essay.[9] For now, I will content myself with the somewhat lame remark that "it all depends"; the ways of the imagination and its relation to the experience of self are too complicated for categorical pronouncements.

My reading of the memories of camp survivors, independently of any appreciation for the author's style or depth of vision, is shamelessly, unsophisticatedly referential: What happened? When? Where? How did it feel? The more straightforward the telling, the more hooked I am. I am unable to read *novels* about the camps—what I want, and need, are events that are remembered, even if distorted or blurred. In this domain, I am a firm believer in Philippe Lejeune's "autobiographical pact"—which does not mean that I believe everything remembered is "objectively true."[10] I assess the quality of my response not only by its breathlessness, but also by what makes me cry. In Lise Lesèvre's book, which I find astonishingly "upbeat" for such a work, I cried in two places: first when she describes meeting her fifteen-year-old son in the courtyard of the Montluc prison, both of them about to board the train that will take him to his death:

> Suddenly, my Jean-Pierre appears in a group. He looks very tall to me, very pale, very thin seen thus in broad daylight. I rush toward him: the soldiers bar the way with guns. I break through the barricade and I'm in the arms of that big boy. The soldiers try to separate us, but without brutality. The trucks arrive, it's all push and shove. I lose Jean-Pierre. (p. 75)[11]

The second place was at the very end, when she arrives at the Hotel Lutetia in May, 1945, with other deportees and is met by her sole surviving family member, Georges:

> Soon, a group of *maquisards* [Resistance fighters] makes its joyful entry. They race toward me: Georges arrives the first. What joy! I must have lost consciousness for some time. The first, Georges! And the last as well. I found that out a few weeks later. (p. 153)

The fact that I myself am the mother of two sons, one of whom just turned fifteen and is a "big boy," does not escape me as I think about this.

Charlotte Delbo, a survivor of Auschwitz who wrote several books about her experience (like Lise Lesèvre, she was not Jewish.), she was deported as a member of the Resistance), has suggested an important distinction between remembering and recounting past events from "deep memory, the memory of the senses" or from "external memory, the memory of thought."[12] Readers of Proust may be reminded of his distinction between voluntary memory, which recalls the past only partially, distanced by rational ordering, and involuntary memory, which comes unbidden and renders the past in all its richness of sensory detail, all its pleasure and pain. Possibly the "upbeat" quality of Lise Lesèvre's book may be due to its having been written chiefly from "external memory" (I would say that about another recent war memoir, Lucie Aubrac's triumphal account of "outwitting the Gestapo," *Ils partiront dans l'ivresse*[13]). Yet, Lesèvre's book made me cry. Did I cry when reading Charlotte Delbo's first book about Auschwitz, *Aucun de nous ne reviendra?*[14] I don't think so, even though Delbo is a true writer who succeeds in recreating Auschwitz in its full horror, from "deep memory." My crying has nothing to do with the quality of the writing, or with my ultimate literary experience of the work, which can be very powerful without crying—rather, with its autobiographical resonance. In Lesèvre's book, the resonance was with/to my life as a mother; in *Night*, I cried when reading Wiesel's description of his father's death in Buchenwald, during the last days before liberation. There the resonance was with/to my life as a daughter whose father died young—my father, having survived the war, died fourteen years later of a heart attack at the age of forty-nine. Note that gender is not the most relevant category here; the loss of a father affects sons and daughters if not identically, no doubt equally deeply.

But I want to come, finally, to the kind of autobiographical reading that is most intimately linked, as prelude or as accompaniment, to autobiographical writing. In my case, it is reading the war memories of Jews who were young children in Europe during the war. As before, the question of literary quality (or perhaps I should say literary self-consciousness, crafting, complexity) plays only a secondary role in my response to these works, which range from Georges Perec's highly crafted *W ou le souvenir d'enfance* (1975), recognized by critics as one of that great writer's most important books, through Saul Friedländer's only "literary" work (besides his numerous publications as a historian), *When Memory Comes* (*Quand vient le souvenir*, 1978), to the short reminiscences written by the psychoanalyst Claudine Vegh in the voices of the fifteen men and women to whose recollections she listened, *I Didn't Say Goodbye* (*Je ne lui ai pas dit au revoir*, 1979). All of these narratives, written many years after the events they tell, are narratives of loss—and, as the other side of loss if you survive it, of autonomy and self-reliance. Perec, born in 1936, lost his father to the French army in 1940 and his mother to

the Nazis in 1942; Friedländer, born in 1932, said a wrenching good-bye to his parents, Czech refugees living in France, when he was ten years old, and never saw them again. The men and women Claudine Vegh listened to (for a *"mémoire de psychiatrie"* at the end of her medical training) were all, like herself—she includes her own reminiscence in the book—children who lost at least one parent to deportation; two of them, a man and a woman, are the sole surviving members of their families. I read these books for the first time years ago, usually at one sitting (the "breathlessness test"). I reread them all just now, in preparing to write this essay: their effect has not worn off. I still cry in places, which turn out, upon reflection, to be exactly the places I would expect, given who I am.

What exactly am I looking for, and finding, in these works? I did not lose a parent during the war—yet I recognize the stories all too well. They could have been my own.

Luck

> The arrival at A. There were many buses . . . the children declared as French must hold a green slip of paper (I still don't understand why I was declared as French, and my brothers and sisters who were much younger, were not). We are separated. . . .[15]

This is Robert, in *I Didn't Say Goodbye*—the only surviving member of his family. They were rounded up by French gendarmes in 1942 in the Dordogne, southwestern France, where they were in hiding. His father, mother, sister, and two brothers were deported and did not return; he was left behind. Spared.

Here is Saul (at that time, still Paul) Friedländer, sent by his parents to a summer camp for Jewish children in the Massif Central in July 1942:

> A terrible din woke us up about two or three o'clock the next morning. . . . Downstairs in the entrance hall gendarmes in helmets were bustling about. . . . Someone read out a list: those whose names were called had to get dressed immediately. . . . All the children over ten were being taken away.[16]

Paul was just ten. Lucky. And here is Georges Perec, newly baptized in 1942, in his boarding school run by nuns in a small town near Grenoble:

> Once, the Germans came to the school. It was one morning. From very far away, we saw two of them—officers—crossing the courtyard accompanied by the principals. We went to class as usual, but we didn't see them again.[17]

The other day, I came across an astounding statistic; literally, it dumb-founded me. Deborah Dwork, in her study of Jewish children in Europe during the war, writes:

> Only 11 percent of Jewish children alive at the beginning of the war survived to its conclusion. . . . The very fact that they survived at all makes them exceptions to the general rule of death. There is absolutely no evidence to indicate that survival was due to anything more—or anything less—than luck and fortuitous circumstances.[18]

I am part of the lucky ninth. I am especially lucky, since my parents too survived.

Separation/Self-Reliance

> My mother accompanied me to the Gare de Lyon. I was six years old. She entrusted me to a Red Cross convoy that was leaving for Grenoble, in the Free Zone. She bought me a picture magazine, a Charlie Chaplin, whose cover showed Charlie with his cane, his hat, his shoes, his small mustache, jumping with a parachute. . . . (p. 76)

For years, Perec remembered himself in this scene—the last time he saw his mother—with his arm in a sling; yet his aunts, who survived and remember, assure him that both his arms were just fine—no sling. They disagreed, for a while, on the question of whether he wore a hernia brace, but after some checking he determined that he did wear such a brace. He concludes this section as follows:

> A triple trait runs through this memory: parachute, arm in a sling, hernia brace: it involves suspension, support, prosthesis almost. In order to be, you had to be propped. Sixteen years later, in 1958, when the haphazard fate of military service made me into a short-lived parachutist, I was able to read, at the very instant of jumping, the decoded text of that memory: I was thrown into the void; all the threads were broken; I was falling, alone and without support.

Free fall. Then the parachute opened: "The corolla unfolded, a fragile but sure prop before the mastered fall" (p. 77).

Separation, a feeling of absolute abandonment, followed by mastery: two sides of a single, terrifying experience. In order to be, you had to be propped. When the external prop disappears, one either sinks . . . or not. All of these children managed not to sink—at a price, however.

> I was ten when they were deported; I think it's my mother's absence that has marked me most, even more than the deportation. . . . I feel that I have struggled so much during my life, and now I don't even understand the meaning of that struggle. It's as though there is an immense vacuum around me, a vacuum which, in spite of all my efforts, I cannot fill. (Vegh, pp. 146–7)

This is Colette, who lost her whole family. When she spoke these words, she was married, a mother of four children; a successful professional, like all the other people who told Claudine Vegh their story. Like Saul Friedländer: "since I could not forget the facts, I made up my mind to view everything with indifference; every sort of resonance within me was stifled" (p. 102).

Self-reliance is bought at the price of numbness, then or later. Sometimes, the lucky ones found their mother in dreams, or heard her from beyond the grave. Ten-year-old Saul Friedländer, ill from his loss and ready to let himself die, dreamed of an incident that happened four years earlier: on the train that carried his family from Prague to Paris, he had wandered away from their compartment and could not find his way back. Then, just when he was totally panicked, he saw his mother: she had gone searching for him. He threw himself into her arms, sobbing (pp. 97–98). After this dream, he recovered from his illness. Robert tells a similar story:

> From the train that took them to Auschwitz, my mother dropped a card; it reached me, when I was ill, at the priests' home. There were just a few words: "*Boubele*" (a Yiddish endearment), "look after yourself. We are on our way to Auschwitz. I love you, Mummy." . . . It was fortunate that I received that message, otherwise I wouldn't have fought to survive. (Vegh, p. 158)

Until very recently, I was unaware that my most characteristic response to a threatened loss—of a friend, a lover, anything or anyone that meant something to me—was to cut loose. *Do it now, before the pain begins. If you do it now, there will be no pain. You don't need this person, this thing. You are self-reliant.*

Split Selves

> I had passed over to Catholicism, body and soul. . . . Thus, in my own way, I had become a renegade: though conscious of my origins, I neverthe-less felt at ease within a community of those who had nothing but scorn for Jews. . . . Paul Friedländer had disappeared; Paul-Henri Ferland was someone else. (pp. 121–122)

Different name, different religion, different self. Simulation, dissimulation: how does one know who one is? Perec, after he was baptized, became very devout, finding special comfort in a picture of the Virgin and Child he hung above his bed. Friedländer changed his name again after the war, this time voluntarily: he became Saul. Now he wonders:

> Perhaps I am the one who has become totally different, perhaps I am the one who now preserves, in the very depths of myself, certain disparate, incompatible fragments of existence, cut off from all reality, with no continuity whatsoever, like those shards of steel that survivors of great battles sometimes carry about inside their bodies. (p. 110)

These are more than the ordinary "split subjects" known to psychoanalysts. These are the walking wounded, the survivors of great battles.

Memory/Delay

"It took me a long, long time to find the way back to my own past," Friedländer writes (p. 102). The first autobiographical section of Perec's *W ou le souvenir d'enfance* begins with the contradictory sentence: "*Je n'ai pas de souvenirs d'enfance*," ("I have no childhood memories") (p. 13); and all of Claudine Vegh's subjects insist that they are speaking about their war memories for the first time since the war. It is as if the rule of forgetting, and its corollary, the rule of silence, necessary at first in order to make life bearable, had eventually to be broken—but not for many years. Claudine Vegh recounts how, in the summer after the war, she was sent to a vacation camp with other Jewish children, many of them orphans, all of whom had suffered the trauma of loss. The rule of the camp, she recalls, was "oblivion at all costs or, at least, never to talk 'about it'" (p. 27). Bruno Bettelheim, in his postface to Vegh's book, focuses on how one remembers after years of willed forgetfulness: "It seems that it requires a distance of twenty years or more, to understand how much a particular tragedy suffered in childhood can transform your whole sense of life."[19] Analysts who are doing current work on trauma have suggested that a "latency" period is part of the very structure of trauma: "events, in so far as they are traumatic, assume their force precisely in their temporal delay."[20] It follows from this that war memories, even more than ordinary memories, are necessarily layered: they "bring back" the past, but a past perhaps truly experienced for the first time through the prism of the delayed present.

Writing

The road to one's past does not necessarily pass through writing—or, for that matter, reading. But for some people, it does. And for them, it is an

absence at the heart of the past that makes writing necessary. It is because his parents have no burial place that Saul Friedländer feels he must write: "Writing . . . does at least preserve a presence" (p. 135). Perec is less optimistic about the link between writing and presence:

> I know that what I say is blank, is neutral, is the sign once and for all of an annihilation once and for all. . . . I will never rediscover, even in my constant retelling, anything but the last reflection of a word absent to writing, the scandal of their silence and of my silence.

Yet, the very annihilation that he feels compelled to signal over and over ("what I say is blank") produces something tangible, an affirmation:

> I write because we lived together, because I was one among them, a shadow amidst their shadows, a body near their body; I write because they left in me their indelible mark and the trace of it is writing: their memory is dead to writing; writing is the memory of their death and the affirmation of my life. (p. 59)

This kind of writing can only exist layered: The *W* sections of *W ou le souvenir d'enfance*, constituting a kind of science fiction fantasy, make up for the absent memories (the memories annihilated by the disappearance of the mother) with fiction. The autobiographical sections, alternating with the *W* sections, string together the memories that remain; but these memories exist and can be told only in a dissociated, fragmentary form, of which the alternation of chapters (always involving interruption, a cutting off) is but one indication:

> From then on [after the mother's disappearance], memories exist, . . . but nothing links them together. They are like that noncursive writing, composed of isolated letters incapable of joining with others to form a word, which was my characteristic mode until I was seventeen or eighteen years old. (p. 93)

No smooth linkages, no grand syntheses are possible in this writing; it is fragmentary and incomplete *in its essence*. Claudine Vegh writes her subjects' stories, like her own, with abrupt beginnings and endings, short paragraphs, clipped sentences. Saul Friedländer, although allowing himself a more lyrical, reflective style, nevertheless insists on a certain lack of pattern and completion: "For it is not a matter here of simplifying the image and presenting, in an exemplary mode, the story of a descent and a rising again. Those who have descended never completely rise again."[21]

III.

Those who have descended never completely rise again. Why, then, write? Why tell the tale? With these questions, we come full circle: back to the dilemma, and the paradox, explored by Wiesel in *Day*. But although the double bind of "having to tell, having to fail" belongs most excruciatingly to those whose tales are the most painful, the most unrepresentable, perhaps it is inherent in all autobiographical writing. No one will ever experience my life as I have, no one will ever fully understand my story. Will I ever fully understand my story?

A few months ago, I told a friend that I was working on this essay, and was particularly interested in the memories of Jews who had been children during the war. "Would you like to meet some?" he asked me. "I can put you in touch." He then told me that he belonged to a group which met monthly at the homes of different members. Some of the people in the group had been in the camps, others not; some were young children when the war broke out, others already teenagers; some had lost parents, others not. They had come to the United States from Germany, Austria, Poland, Hungary, Belgium, Holland, France—some directly, others via Israel. The group had existed for around nine years. I expressed surprise that such a group existed around Boston without my having heard about it, even though I have lived here for over ten years. My friend told me to come to the next meeting.

As I walked up the path of the neat suburban home on a May afternoon, carrying my bowl of pasta salad (for the potluck meal following the formal part of the meeting), I asked myself what I had in common with the person I saw ahead of me: an elderly man, short and balding, wearing a short-sleeved, open-necked shirt, and walking with a slight stoop, who reminded me of the vague friends my mother would introduce me to when I visited her in Miami Beach. Inside, the first person I saw was a woman I had met at graduate student parties in Cambridge many years ago, and had bumped into once or twice in Harvard Square more recently. When she saw me, her jaw dropped. "What are you doing here?" she asked. "I am like you," I answered. Her surprise was no greater than mine.

As the meeting got under way and I looked around the room, I had to admit to myself that I felt little in common with most of the people there. They appeared to be quite a bit older than I, and many spoke with heavy accents. They were all "professionals" (as the friend who had invited me had proudly told me), but they still seemed to me to belong to another world. (It now occurs to me that two of the women were professors of French—where exactly was my "difference"?). One of the Hungarian women, evidently a long-standing member of the group, for she spoke easily

and a lot, reminded me of a favorite aunt from my childhood, my father's sister: besides the unmistakable accent, which signals a Hungarian to me anywhere, in elevators, restaurants, or the most crowded noisy room, this woman had the sparkling humor and the bossy but pleasant manner I had always associated with my aunt, from the time when I first knew her as a little girl in Budapest. After the meeting ended, and we broke up into informal groups around the table laden with food, I spoke to the woman, and discovered she was only a few years older than I. She told me she had spent the last year of the war in one of the special houses set aside for Jews in Budapest, as I knew my grandmother had done. We spoke in Hungarian, a language I rarely speak, now that most of the people with whom I was used to speaking it—my mother, her sister, her brother, that whole generation of her family—are dead. Later, as I left the house carrying my empty bowl, I wondered whether I would go to the group's next meeting. I am still not sure, but I think perhaps I will.

Those who feel compelled, at some time in their life, to embark on autobiographical writing do so because they have no choice: they must do it, whatever the consequences. Some, especially blessed, find readers others than themselves, some of whom may in turn one day become writers of their own lives, their own losses. For, as may have been clear from the start, the only kind of autobiography I find truly essential, to read *or* write—and this, I admit, may be a prejudice on my part—is the kind that tries to recover, through writing, an irrecoverable absence.[22]

Notes

This essay is reprinted from Susan Rubin Suleiman, *Risking Who One Is: Encounters with Contemporary Art and Literature* (Cambridge, Mass., 1994). By permission of Harvard University Press.

1. Harry James Cargas, *In Conversation with Elie Wiesel* (New York: Paulist Press, 1976), p. 89.

2. *Ibid.*, p. 86.

3. Elie Wiesel, *Night Dawn Day* (New York: B'nai B'rith, 1985), p. 271; subsequent page references will be given in parentheses following the quotation. *Day* was first published in English as *The Accident* (New York: Hill and Wang, 1972). The translation is by Anne Borchardt.

4. Cargas/Wiesel, p. 87.

5. Harry James Cargas, for example, sees this as a novel of emotional and spiritual recovery, fueled by love and friendship—a possible reading, but one that has to ignore a great deal. See Cargas/Wiesel, p. 120.

6. Alvin H. Rosenfeld, "The Problematics of Holocaust Literature," in *Confronting the Holocaust: The Impact of Elie Wiesel,* ed. Alvin H. Rosenfeld and Irving Greenberg (Bloomington: Indiana University Press, 1978), p. 22.

7. Citations for Lesèvre's and Delbo's works are given in Notes 10, 11, and 13. Other first-person accounts of concentration camp experiences in French include David Rousset's *L'univers concentrationnaire* (Paris: Editions du Pavois, 1946); Robert Antelme's *L'espèce humaine* (Paris: Gallimard, 1957); and Germaine Tillion's *Ravensbrück* (Paris: Editions du Seuil, 1973 and 1988).

8. For a full-scale study on the fate of Jewish children during World War Two, see Deborah Dwork, *Children with a Star: Jewish Youth in Nazi Europe* (New Haven: Yale University Press, 1991). Besides official documents and historical works, Dwork based her study on oral testimonies, rather than on written accounts by survivors.

9. Shoshana Felman quotes the videotaped testimony of a child survivor: "I was unable to read any books . . . I didn't read a word about the Holocaust . . ." like a negative echo of Wiesel's compulsion to read. After years of refusal, this witness, Menachem S., nevertheless agreed to tell his story for the Fortunoff Video Archive at Yale University. See S. Felman and Dori Laub, *Testimony: Crises of Witnessing in Literature, Psychoanalysis, and History* (New York and London: Routledge, 1992), p. 46.

10. According to Lejeune (*Le pacte autobiographique* [Paris: Editions du Seuil, 1975]), the sign of true autobiography—as opposed to, say, autobiographical fiction—is the single, identical name of author, narrator, and character; this identity signals that what the author recounts is to be understood as having "really happened" to him or her—whence the notion of an "autobiographical pact" between author and reader. Lejeune's criterion of identity has been criticized by some theorists, and is challenged by postmodern writing which blurs the line between fiction and autobiography—for example, by giving the main character of an autobiographical novel the same name as the author's.

11. Lise Lesèvre, *Face à Barbie: Souvenirs-cauchemars de Montluc à Ravensbrück* (Paris: Les Editions du Pavillon, 1987), p. 75; my translation. Subsequent page references will be given in parentheses in the text.

12. Delbo, *La mémoire et les jours* (Paris: Berg International, 1985), p. 14. Lawrence Langer discusses Delbo's concepts and makes extensive use of them in his study of oral testimonies from the Fortunoff Video Archives at Yale, *Holocaust Testimonies: The Ruins of Memory* (New Haven and London: Yale University Press, 1991).

13. Lucie Aubrac, *Ils partiront dans l'ivresse. Lyon, mai 43—Londres, février 44* (Paris: Editions du Seuil, 1984). The English translation by Konrad Bieber, with the assistance of Betsy Wing, is titled *Outwitting the Gestapo* (Lincoln: University of Nebraska Press, 1992).

14. Delbo, *Aucun de nous ne reviendra* (Paris: Editions Gonthier, 1965). Delbo's other books include (besides *La mémoire et les jours,* already cited) *Une connaissance inutile* (Paris: Editions de Minuit, 1970), *Mesure de nos jours* (Paris: Minuit, 1971), and *Le convoi du 24 janvier [1943]* (Paris: Minuit, 1965), which gives short biographies (including their camp numbers) of each of the 230 French women who were in the convoy that took Delbo to Auschwitz. Of the 230, forty-nine survived. Delbo's powerful writings about the experience of Auschwitz are not sufficiently well known outside France (or inside).

15. Claudine Vegh, *I Didn't Say Goodbye,* trans. Ros Schwartz (New York: E. P. Dutton, 1984), p. 150). Further page references will be given in parentheses in the text.

16. Saul Friedländer, *When Memory Comes,* trans. Helen R. Lane (New York: Farrar Straus Giroux, 1979), pp. 73–74. Subsequent page references will be given in parentheses in the text.

17. Georges Perec, *W ou le souvenir d'enfance* (Paris: Denoël, 1975), p. 135; my translation, here and in subsequent quotations from this work.

18. Deborah Dwork, *Children with a Star: Jewish Youth in Nazi Europe* (New Haven: Yale University Press, 1991), p. xxxiii.

19. Bruno Bettelheim, "Postface" to Vegh, *I Didn't Say Goodbye,* p. 164. I have modified the translation.

20. Cathy Caruth, "Introduction" to *Psychoanalysis, Culture and Trauma,* special issue of *American Imago,* 48:1 (Spring 1991), p. 8. The unusually intense recent interest, by analysts, historians and literary critics, in the question of trauma and memory, specifically as it relates to representations of the Holocaust, may itself be a phenomenon of "delayed reaction" analogous to that of trauma. Besides works already cited, see for example, *Probing the Limits of Representation: Nazism and the "Final Solution,"* ed. Saul Friedländer (Cambridge, MA: Harvard University Press, 1992).

21. Friedländer, *When Memory Comes,* p. 159; I have modified Helen R. Lane's translation slightly in this instance.

22. I had intended to end this essay with a fragment of my own autobiographical writing about the war, as a "proof" of my argument about autobiographical reading. Upon reflection, I realized—or at least, hoped—that the essay could stand without such proof. For previously published work, see two short memoirs: "My War in Four Episodes" (*Agni,* 33, Spring 1991), in which can be found all of the elements—luck, separation/self-reliance, split selves, memory/delay, writing—that I discuss in my reading of others' war memories; and "Reading in Tongues" (*Boston Review,* May–August, 1992), which adds a few more pieces. I wish to thank Jack Beatty, Lawrence Kritzman, and Doris Sommer for their close reading of an earlier version of this essay, and their excellent suggestions for revision.

5

Anti-Semitism in France, 1978–1992

QUESTIONS AND DEBATES

Judith Friedlander

Introduction

Works on anti-Semitism in contemporary France almost always begin with World War Two, and the role Vichy played in assisting the Nazis rid Europe of Jews.[1] Over 75,000 Jews were deported from France in the early 1940s, most of them immigrants of Eastern European origin. Packed into cattle cars and sent to Poland, the vast majority of these people never returned, but ended their lives in death camps created by the architects of genocide who served Hitler's campaign.[2]

When Vichy agreed to collaborate with the Germans, their decision to do so shocked many Jews living in France, particularly those who had recently arrived.[3] Despite the Dreyfus Affair at the turn of the century, Jews, for the most part, had faith in the French, the first nation in Europe to emancipate their people and make them citizens of a democratic nation-state. Jews from the East had emigrated to France in the interwar years by the tens of thousands, fully believing they had come to a country committed to the principles of the French Revolution, for Jews and Gentiles alike.[4] What they failed to understand were the terms of that commitment, terms which made it possible for democrats to protect the rights of those who shared the same cultural heritage and discriminate against those who did not.

It would be irresponsible, not to say outrageous, to link the persecution of Jews under Vichy to the French democratic tradition. Without conflating the two, we might still suggest that collaborationists in France found ways to distort the democrats' aversion to difference. From the very beginning of the French Republic, those favoring the emancipation of Jews envisioned creating an ethnically homogeneous nation. When they made Jews citizens

in 1791, progressives in France showed remarkable tolerance, but they did not hide their distaste for diversity. To enjoy the privileges of the French Revolution, Jews had to agree to assimilate and embrace the ideal of cultural uniformity. In the language of the time, they had to endorse the notion of "one nation within one state." Before legislating that all men were created equal, lawmakers insisted that everyone be the same: speak the same language and identify with the same national culture. As Count Stanislas de Clermont-Tonnerre put, it in his famous declaration to emancipate the Jews:

> We must refuse the Jews everything as a nation and give them everything as individuals; they must constitute neither a political group nor an order within the state; they must become citizens as individuals.[5]

During the eighteenth and early nineteenth centuries, enlightened Jews understood the limits of this emancipation, but they accepted the terms. They agreed to compromise, to give up their collective cultural autonomy in order to gain individual political freedom. Becoming "Frenchmen of the faith of Moses," Jews living in France agreed, in most cases, to do away with many of their own traditions, so that they might conform to the national mold and join a system that celebrated sameness, not difference, before the law. Their efforts, however, were challenged periodically by waves of new immigrants, Jews from the East who sought refuge in France and who did not blend in.

Philosophers sympathetic to democratic theory believed anti-Semitism would eventually disappear if political systems minimized differences and broke down the barriers that kept people apart. Jean-Paul Sartre proclaimed, after World War Two, that the democrat was the Jew's best friend, because he based his law on the idea of the abstract individual. Still, Sartre admitted, the democrat, as such, was a "feeble protector":

> No doubt he proclaims that all men have equal rights; no doubt he has founded the League for the Rights of Man; but his own declarations show the weakness of his position. . . . He recognizes neither Jew, nor Arab, nor Negro, nor bourgeois, nor worker, but only man — man always the same in all times and all places.[6]

Others wondered whether the democrat could protect even the man. Modern anti-Semitism, Hannah Arendt pointed out, emerged only after the Jews had assimilated in the West and stopped being different.[7] Despite her concern, Hannah Arendt remained faithful to the Western democratic tradition. She warned against systems like National Socialism which elabo-

rated upon differences, inventing them where they did not exist to justify a theory of race supremacy.

In recent years, French intellectuals and activists have challenged the stipulation that there be only one nation within the state. Since 1968, veterans of the student left have promoted the idea that democracy and cultural pluralism are compatible. In the name of freedom, the state, they claim, should support and encourage the attempts of diverse groups to cultivate their languages and traditions. Coming up with the slogan *"le droit à la différence,"* they have called on the French to find ways to sponsor ethnic groups in their attempts to maintain and develop the cultures of their people. This interest in difference has influenced, in particular, the analyses of individuals struggling to combat racism and anti-Semitism in the country today.

As we turn now to address the problem of anti-Semitism in France since 1978, I would like us to keep in mind the challenge facing a democracy like France as it tries to embrace cultural diversity. In Part I of this paper, I give a brief sketch of the major incidents and controversies surrounding anti-Semitism, revealing, in the process, the disturbing alliance that has recently developed between individuals on the extreme left and extreme right, people on both sides of the political spectrum who use a strategy similar to the one used by Vichy to manipulate and distort the democrat's aversion to difference. In the process, they reinterpret history as they make their case for maintaining ethnically homogeneous nations in Europe and the Middle East. We will also see how outbreaks of anti-Semitism in contemporary France have led assimilated Jews to reconsider their commitment to the universal values of French/European culture. In Part II, I review the tragic story of Pierre Goldman, the Polish-Jewish-French radical who came to symbolize the contradictions Jews felt after 1968, as they tried to negotiate an identity for themselves as secular left-wing Jews in contemporary France. Finally, in Part III, I conclude with a discussion of a recent scandal in French schools, involving Islamic children, not Jews, but one which led Jewish activists to use the case as a way to debate their own relationship to Judaism, Jewish nationalism, and the legacy of the French Enlightenment. Expanding on the work of Alain Finkielkraut and Pierre-André Taguieff, I raise questions in this context about cultural relativism, racism/antiracism and anti-Semitism/anti-anti-Semitism.

I.

Political Scandals, Controversies, and Terrorist Attacks, 1978–1992

Monsieur, thirty-six years ago you turned over 75,000 men, women and children to the Germans. You are the French Eichmann.

What are all these numbers?

Everybody knows them; they are reported in this document [Serge Klarsfeld, *Le mémorial de la déportation de France*].

I was sure of it: a Jewish document. Here we go again with Jewish propaganda. Of course you have nothing to show me but Jewish documents; no others exist.

Interview with Louis Darquier de Pellepoix[8]

In October 1978, Philippe Ganier Raymond, journalist and author of a book on French anti-Semitism,[9] published an interview with Louis Darquier de Pellepoix, *Commissaire Général* of Jewish Affairs in Vichy France. An infamous figure in the Occupation period, the *commissaire* vanished at the end of the war. The French tried him *in absentia* in 1947, and condemned him to death, but Darquier de Pellepoix eluded his sentence. Thirty-one years later he turned up in Madrid, having preserved both his life and convictions: "Six million Jews disappeared? Pure invention. A Jewish invention. . . . In Auschwitz they only gassed lice."[10]

For the French, the war years have not faded into the pages of history. Vichy's collaboration with the Germans continues to haunt and humiliate them. Only weeks after publishing the interview with Darquier de Pellepoix, newspapers carried stories about Robert Faurisson, the literature professor at the University of Lyon who claimed that gas chambers never existed. Although nearly everyone objected to his so-called research, a handful of people gave Faurisson their enthusiastic support, among them Pierre Guillaume, the leader of a band of extreme leftists.[11]

Guillaume called his group *La Vieille Taupe* ("the old mole"),[12] assuming the name of a radical bookstore he and his followers had taken over in 1967. Five years later the comrades closed shop, but the old mole lived on, digging in for a while before reemerging in 1978 as a publishing house specializing in "revisionist" accounts of the Nazi period.[13]

La Vieille Taupe issued Faurisson's book (*Mémoire en défense*), in 1980, together with an opening statement by Noam Chomsky, the celebrated American linguist, political activist (and Jew).[14] Chomsky made his case for Faurisson in the abstract terms of liberal theory. He was writing in the name of freedom of speech, not in defense of the ideas put forth in the literature professor's book. Many interpreted his actions differently, and Chomsky's remarks provoked international scandal. Still, the linguist held his ground: he had written an "opinion" as a civil libertarian, not the "preface" to a work whose arguments he endorsed. In fact, he admitted, he had never read the book.[15]

Next, Guillaume published a detailed analysis of the reactions people had to *Mémoire en défense*. It was edited by Serge Thion, an anthropologist

previously known for his writings on the Cambodian crisis.[16] In this massive volume, Thion argued that the French had rejected Faurisson's book on ideological grounds, not on the quality of the man's research.[17]

Everyone was talking about the "Faurisson affair." In the press, journalists and scholars mounted vigorous campaigns against revisionist accounts of the Nazi period. They alerted their readers to the dangerous alliance recently established between political extremists on the right and the left. But the outcry did not silence Faurisson, who went on to pursue his investigations and inspire others to do the same.[18]

Many assumed that Faurisson and his followers enjoyed the respect only of marginal members of the French academic community. In 1988 they learned differently. Faurisson also had the support of Jean Beaufret, a distinguished philosopher and celebrated hero of the Resistance. According to an article in *Libération,* before Beaufret died, he sent a note to Faurisson, congratulating him on his courage and confessing that he too had doubts that the gas chambers had ever existed.[19]

Jean Beaufret introduced Martin Heidegger to France after World War Two, hardly an incidental detail in 1988. By the time people read of his correspondence with Robert Faurisson, many of them were deeply involved in heated debates about the importance of Nazism to the German philosopher's work. Heidegger himself had never hidden his party affiliations, but over the years scholars have tried to distinguish between his intellectual contributions and political choices. While praising the first, some went to great lengths to condemn the second, among them Emmanuel Lévinas and Jacques Derrida.[20] Then Victor Farias published *Heidegger et le nazisme* in 1987, and challenged those who separated Heidegger's intellectual work from his political convictions.[21] Basing his argument on archival materials, Farias claimed that Nazism was intrinsic to Heidegger's thought. Some hailed the new book, but others demurred, refusing to join the campaign to eliminate Heidegger from the roster of eminent European thinkers.

In two highly regarded essays on the subject, the philosopher Elisabeth de Fontenay confronted Heidegger's Nazism directly, while continuing to support the merits of his work.[22] Her first article appeared in April 1987, six months before the publication of Farias's book, and nine months before *Libération* reported that Beaufret had written to Robert Faurisson. Without knowing anything, at the time, of his recent correspondence, Fontenay criticized Beaufret for not challenging Heidegger's ties to the Nazi Party. She then went on to condemn the German philosopher for his political choices, and identified, before Farias, the influence of National Socialism in some of Heidegger's writings. In her second article, published after the scandal had broken, Fontenay now cautioned those eager to reject the work of the German phenomenologist. We can use Heidegger against Heidegger,

she explained: challenge the inexcusable mistakes he made in his life, and in some of his work, with arguments drawn from his major contributions to twentieth-century thought.[23]

The crimes of the past continue to burden the courts as well, with the trials of people given up for dead many years before. In the spring of 1987, the French found guilty Klaus Barbie, the German officer also known as "the Butcher of Lyon," who had previously evaded justice for nearly forty years, possibly with the help of the CIA. Like Faurisson before him, Barbie gained the support of a handful of people identified with the left. His own lawyer, for example, had previously defended revolutionaries engaged in the struggle for the liberation of Algeria. Now Jacques Vergès made a case for Barbie by putting France on trial, comparing the activities of this Nazi soldier to those of the French Army during the Algerian War.[24] Many feared Vergès might embarrass the country further by digging up forgotten incidents of collaboration with the Germans.[25]

More recently, in the Spring of 1994 the courts tried Paul Touvier, a pro-Nazi intelligence officer who was based in Lyon during the occupation. Known as the "French Barbie," he was finally arrested in 1989 on charges of having been "directly responsible" for deporting Jews from France, as well as for having organized the capture and murder of several individuals. Touvier remained free for so many years thanks to the help he received first from members of the Church hierarchy in Lyon, then from a group of ultraconservative Catholics. After many months of deliberation, the courts set Touvier free in April of 1992, claiming that they did not have enough evidence to convict the seventy-seven-year-old suspect. According to a public opinion poll, seventy-three percent of those interviewed in France were shocked by the decision and in April 1994 Touvier was judged guilty of crimes against humanity.[26]

The political arena has had its embarrassments as well. Several incidents have involved Jean-Marie Le Pen. When he campaigned for president in 1987 Le Pen observed in a speech that Auschwitz was a "minor point," a footnote to history.[27] Running on the ticket of *Le Front National,* the xenophobic Le Pen spent most of his time criticizing France's liberal immigration policy which, according to him, gave jobs away to foreigners. As he toured the country, arousing the passions of the extreme right, he made racist remarks against Arabs, mostly, not Jews, but he still reverted at times to older forms of bigotry, embracing the rhetoric of French anti-Semites. In the spring of 1988, Le Pen won more than fourteen percent of the vote in the first round, dividing the right, and gaining the support of a number of people who had previously identified with the Communist Party.[28] Although he took a beating in the next round, Le Pen still enjoys a strong following in France, and continues to make shocking statements to the press.

In addition to enduring verbal abuse, Jews have been targets of terrorist attacks: in synagogues, Jewish centers, restaurants, and cemeteries.[29] According to responsible sources in France, within months of the interview with Darquier de Pellepoix, these acts of aggression increased considerably.[30] And the violence continued at regular intervals through 1982, becoming sporadic after that, but never disappearing during the entire period under review in this paper.

After studying the problem for several years, in 1983 researchers for the *Centre d'Études et de Recherches sur l'Antisémitisme Contemporain* confirmed what journalists and scholars had been suggesting for some time, namely that anti-Semitism in France involved the alliance and cooperation of two distinct groups, one on the extreme right, the other on the extreme left: (1) those "who long for the rehabilitation of Hitler"; and (2) those who support the Palestinian struggle in the Middle East:

> Together they back Faurisson and produce the political equation, Israel = the New Nazi State. Denying that the Genocide ever took place, they dismiss the evidence as a huge hoax fabricated in order to justify the creation of the state of Israel (and, incidentally, to deceive the Germans). In this way, they have come up with yet another way to blame the Israelis.[31]

Why have members of the extreme left joined efforts with the likes of Faurisson? Alain Finkielkraut has yet another explanation:

> Those [on the left] who deny the existence of gas chambers do not hold it against Jews for being Jews (that is for being different, monotheistic, obscurantist, or greedy), but for mixing up the historical process, for *conspiring against the dialectic* by claiming to be victims of a wrong that is greater than the one endured daily by the working class.[32]

For these "metaphysicians of history," Finkielkraut continues, Auschwitz is unthinkable. Therefore, it never happened. Faurisson appealed to members of the pro-Palestinian left, for he undermined, they believed, the moral reasons for supporting Israel.[33] If the literature professor could demonstrate that gas chambers never existed, the saviors of Marx would no longer have to respond to the national demands of those claiming to be survivors of the Final Solution. Eliminate the "myth" of Nazi atrocities, and the world will no longer feel conflicted about supporting the Palestinians, the real victims in the Middle East, and the rightful inhabitants of the territory given to Israel in 1948.

Many Jews of the generation of 1968 broke with the extreme left and the Communist Party over the question of Israel. But some of them also took

stands against individual actions of the Jewish State, and their numbers increased with the invasion of Lebanon in 1982 and the massacres there at two refugee camps, Sabra and Shatila.[34] Committed to Israel as a way to express their own national/cultural heritage, and identified with the left, these French Jewish intellectuals joined groups which were looking for ways to recognize the rights of Israelis and Palestinians.[35]

Pierre Goldman is a well-known example of an extreme leftist of Jewish origin who broke with the Trotskyists because he differed with them about Israel, among other issues. For many, the young radical has come to symbolize the struggle of Jews on the left to remain true to the ideals of socialism while they also defend the rights of their people. Describing himself as "a Polish Jew born in France," he devoted the last years of his life to trying to bring his politics and personal history together. Let us turn briefly to the life and death of this political radical, before looking at debates about anti-Semitism and racism in France during the 1980s and early nineties. Those involved in these debates are, for the most part, Jewish intellectuals of the generation of 1968.

II.

Pierre Goldman

Two gunmen shot Pierre Goldman down on September 20, 1979, at the place des Peupliers, in the thirteenth arrondissement. He was thirty-five years old. A neo-Nazi group called *Honneur de la Police* assumed responsibility for the murder, explaining to the press that they had taken the law into their own hands because the French authorities had been too conciliatory.[36] In the days following Goldman's death, *Le Monde* described the radical as a "Jew, political activist, gangster, writer."[37]

Pierre Goldman was born in Lyon in 1944 to Jewish parents, originally from Poland, who had joined the Communist resistance in France.[38] When the war ended, his parents separated, in part, Goldman suspected, because his mother had remained faithful to Soviet Communism and his father had not, but he never heard the full story. He only knew that his mother stayed on in Paris for nearly three more years, and worked for the Polish embassy or consulate. In 1948 she received instructions to return to Poland, and she fully expected to take Pierre with her. But Goldman's father intervened at the last minute, and kidnapped the child with the help of some friends. Even though the man had previously shown little interest in his son, he could not bear the thought, he later explained, that his boy would grow up in a country where millions of Jews had recently been exterminated and where anti-Semites and Stalinists now ran the government. And so Pierre

Goldman remained in France, living first with an aunt, then, beginning in 1950, with his father and his father's new wife.

Raised in the family's radical political tradition, Goldman went on to participate in the communist youth group affiliated with his *lycée,* a boarding school he attended in Evreux (Eure). In 1963, he joined the Union of Communist Students at the Sorbonne. Politics rapidly became his major concern, and within a year he had dropped out of school and was training full time to fight with the guerrillas in Latin America.

In 1966, Goldman took a job on a Belgian freighter to pay his way to the Americas. When the boat docked in New Orleans, he jumped ship, went to Texas, and stole across the Mexican border. He did not get very far, however, before the U.S. immigration authorities caught up with him, sent him back to New Orleans, and threw him into jail. A few days later, the Belgian captain agreed to take responsibility for Goldman, and the young radical returned on the same ship that had brought him to the States.

In 1967, soon after the Six Day War, Goldman took off once again, but this time he had the funds he needed to fly directly to Cuba. There, he met with revolutionaries who had operations in Venezuela, and they invited the French, Jewish, Polish radical to join them. But first they told him to go back to Paris and wait for instructions, and this took nearly a year. Goldman, therefore, was still in France during the student uprising of May 1968. His struggle, however, was elsewhere. He showed little interest in what was happening in Paris.

Goldman did not write much about the fourteen months he spent in Venezuela, but he did say that he lived a clandestine existence with a group of rebels whose mission had failed. In September 1969, he went back to Paris, and settled down on the edges of society, earning his reputation as a gangster. The following December, the police placed him under arrest, and charged him with armed robbery and murder. Sentenced to life imprisonment, Goldman used his first years in jail to complete two degrees with honors: a *licence* in philosophy, and a *maîtrise* in Spanish. He also wrote his now-famous memoir, *Souvenirs obscurs d'un juif polonais en France,* in which he told his life story, describing himself as an outsider, the typical Jew in exile:

> To be or not to be French, that was never the question. I didn't think to ask it. I believe I always knew that I was simply a Polish Jew born in France.[39]

> I was only a Jew in exile with no promised land. Exiled indefinitely, forever, for good. I did not belong to the proletariat, but I, like a member of the working class, was a man without a country, with no homeland other than this absolute exile, this Jewish exile in the diaspora.[40]

In his memoir, Goldman also pleaded his case. He had not killed the pharmacist or his assistant on the rue Richard-Lenoir. If given another chance, he could prove it. Pressured by the public's response to the book, the authorities relented and gave him a second trial. This time, with the help of civil-rights lawyer Georges Kiéjman, the political radical cleared his name of the murder charges. But he had still committed armed robbery, and returned to jail in May, 1976 to finish six more years of what had now been reduced to a twelve-year term. Five months after returning to jail the courts released him on parole.[41]

During the remaining three years of his life, Goldman wrote articles for *Libération* and other journals, and served on the editorial board of *Les temps modernes*. He also published a novel,[42] and was working on a philosophical manuscript. Politically, he continued to identify with the extreme left, but he no longer belonged to a party.

While Goldman maintained close ties with the Trotskyist *Ligue Communiste Révolutionnaire*, he could not entirely endorse the position of this group either. As he explained in an interview published in their paper, he disagreed with them on a variety of issues, including the question of Israel.[43] A diaspora Jew to the end, Goldman felt exiled in Israel as well,[44] but this in no way weakened his belief that the Jewish state had a right to exist.

Had Goldman lived to witness the subsequent troubles in Lebanon and the West Bank, he might well have joined other Jews of the generation of 1968 in voicing his objections to Israeli policies in the Middle East. Like them, he, too, would probably have done so without any thought of challenging the state's legitimacy in the area. He might also have worked with a group of Jews and Gentiles who founded *SOS Racisme* in 1984, a movement dedicated to combating racism in France, the main victims of which are not Jews, but Moslem immigrants from North Africa. What we know for sure is that, when he died, he was still struggling with the meaning of his Jewish identity, sounding tortured and confused, but reflecting the feelings of many of his peers.

In an interview he gave a few weeks before he was shot, Goldman spoke at some length about being Jewish:

> To be Jewish means, perhaps, nothing more than to come from a family influenced by customs, by Jewish culture. My life is not filled at the conscious level with Jewish culture. There is no Jewish music, or Jewish books or Jewish religion. Within me, there are many things that have nothing to do with being Jewish. Still, they are a part of my Jewishness. To be Jewish is not what I have, but my condition. Not even that. It's a space that I fill existentially with this and that. My books are not Jewish, but in each and every one of them, there is the past of a Jew. To be Jewish is to

convey the past. And why is this so important? Because of anti-Semitism.
Because of the hatred. The only answer to the question of what it means
to be a Jew, is Auschwitz. The Holocaust has renewed Jewish identity for
centuries.[45]

The journalist Luc Rosenzweig wrote a "Kaddish" for Goldman in *Libéra-
tion*, the newspaper where they had worked together for a few years. A
veteran of the students' movement and a secular Jew, Rosenzweig composed
a mourner's prayer instead of an obituary for his friend, honoring Goldman's
decision to express himself publicly as a Jew. Promising to carry on the
struggle, Rosenzweig added, "At times we found your hatred of anti-Semites
excessive and anachronistic, [but] we now embrace it entirely and com-
pletely and will act on it."[46] Rosenzweig kept his word, and in 1986 wrote
a book (with Bernard Cohen) on the Nazi past of Kurt Waldheim, the former
Secretary General of the United Nations, and the newly elected President
of Austria.[47]

Like Pierre Goldman, many Jewish intellectuals of the generation of 1968
were born into a world dominated by the horrors of National Socialism.
Even for those who came after the war, the spectre of Auschwitz formed
them, pushing many into radical politics and leading them out again as
extremists made alliances with their enemies.

III.

Racism/Antiracism, Anti-Semitism/Anti-Anti-Semitism

After 1968, Jewish radicals like Pierre Goldman began to rethink their
relationship to their Jewish identity as they questioned their loyalty to the
left. National movements around the world were calling for the rights of
colonized peoples, challenging the wisdom of universal solutions to prob-
lems involving specific ethnic groups with their own histories. As Third
World countries liberated themselves from the economic and political yoke
of imperialism, they also asserted their cultural independence, influencing,
in the process, minorities in the West. Since the 1970s, groups of Bretons,
Corsicans, Occitans, and Jews have been calling for the right to develop
their cultural traditions, persuading Mitterand in 1981 to turn their slogan
"*le droit à la différence*" into a campaign promise. As Jewish activists have
continued to define themselves in ethnic and national terms, some of them
have embraced curious causes, making alliances with groups who defy equal
rights in the name of cultural/religious autonomy.

In the days following 1968, Jewish nationalism in France divided, essen-
tially, into two groups: Zionists and minority nationalists. The former

73

worked actively for Israel, while the latter tried to create in France a secular national tradition for Jews living in the Diaspora. For the most part, minority nationalists modelled themselves on the Jewish Socialist Bund, a party which flourished in Poland in the interwar years. In doing so, they remained faithful to the ideals of the French Enlightenment, for members of the Bund had tried to establish a Jewish national culture that would meet the standards set by theorists in eighteenth-century France.[48] Despite their separatist rhetoric, Zionists and minority nationalists share similar values with Jewish assimilationists, in that they all endorse the political and civil rights of citizens spelled out in the French Constitution. They differ only on the question of whether these rights can only be protected in a culturally and linguistically homogeneous context.

In recent years, when people speak of multiculturalism they often mean multireligious, and question the necessity of living in a purely secular state. Jews who have recently converted to Orthodox Judaism no longer accept the eighteenth-century formula of being a Frenchman of the faith of Moses. They want the right to express themselves publicly as well as privately as Jews. Challenging what he calls the "illusory Jew," sociologist Shmuel Trigano has vigorously challenged the assimilationist Jewish position, angering many along the way, and allying himself with those struggling to create a freer environment of religious expression than presently exists for all the inhabitants of France.

Perhaps the most interesting recent conflict between church and state is the case of the "Islamic scarf" ("*le foulard islamique*"). In 1989 the principal of a *lycée* in a working-class suburb of Paris (Creil), expelled three girls for coming to school wearing a head covering required of observant Moslem women. Although he acted within the law, his decision to do so caused a national scandal. In the end Lionel Jospin, the minister of education, obliged the *lycée* to admit the girls, dressed in their scarves, if the families refused to cooperate and send them to school free of religious symbols or attire.

Within the Jewish community, a wide range of people took sides in the matter, from the Chief Rabbi of France, to Alain Finkielkraut, to minority nationalists. Those concerned with "*le droit à la différence*" and the problem of protecting immigrant workers in France joined forces on this issue with those calling for greater freedom of religious expression. The left divided on the question, as did the feminists, some of whom, in the name of respecting cultural diversity, ended up supporting the right of Moslem parents to maintain restrictions on women, represented through a dress code, not tolerated in the wider democratic society.[49]

It is here we return to the basic contradiction facing those who seek to combat sexism, racism, and anti-Semitism in France, while rejecting as well the compromises reached by eighteenth-century theorists of democracy.

Fighting the tide, Alain Finkielkraut defends the French Enlightenment and the call for universalism in his controversial book, *La défaite de la pensée*. In building his case, he warns against the dangers of eighteenth-century German Romanticism and nationalism which, he suggests, led to National Socialism, and which has more recently appeared in the rhetoric of cultural relativism and in the writings of Third World theorists. Challenging the interpretations of Claude Lévi-Strauss and Franz Fanon, Finkielkraut defends the principles of the Enlightenment against those who blame them for bringing about the end of cultural diversity in Western Europe. In a nation like France, nothing prevents the government from respecting the traditions of its minority peoples, at least up to a point. Citizens of a democratic nation-state do not have to assimilate into one hegemonic culture, but they do have to accept a common set of laws; Finkielkraut admits, laws that favor the rights of individuals over cultural groups. No matter who they are, all ethnic groups must agree to obey the rules imposed equally on every participating member of the contract-nation, even if some of the obligations defy the beliefs practiced by their people.

With no apologies, Finkielkraut asserts the superiority of a culture and political system like the democratic nation-state, which protects the right of the individual. What is more, he implies that ethnic minorities only come into conflict with the policies of this kind of state when they do not respect the freedom of individual members of their group. Democracy, he agrees, will threaten the ways of people whose customs resist treating everybody equally before the law.[50]

Traditional cultures, it is true, frequently protect the interests of the group at the expense of the individual, abusing, in the process, rights the Europeans consider inalienable. But Finkielkraut leaves himself open to criticism when he frames the problem in these terms and then does not challenge the contradictions that exist in almost every democratic nation-state. Praising the virtues of the kind of society envisioned by Diderot, Voltaire, and Condorcet, he does not examine the problems encountered daily by many citizens living in less idealized versions of the eighteenth-century dream: in contemporary France, for example, or the United States, where many do not yet enjoy the privileges promised to abstract individuals. Although the situation has improved in recent years, Finkielkraut's description of the enlightened West does not account for the abuses experienced by members of the working class, women, blacks, North Africans, and other minority groups, including the Jews.

Finkielkraut has studied the problem of anti-Semitism in France in several essays, including one on Faurisson and another on Barbie. In both cases, he analyzes the dangerous alliance that exists between the extreme right and the extreme left, as both groups build cases against Jews and against

the universal ideals of the Enlightenment.[51] André-Pierre Taguieff develops the same theme in a series of essays, focusing in particular on the way the left and the right have transformed pseudoscientific theories of race into one of cultural identities.[52] He then goes on to show how *"un antiracisme différentialiste"* repeats the errors of the universalism it claims to correct, eventually ending up in an ideological knot and defending a "persecuted" Le Pen.[53] But Taguieff does not embrace the Enlightenment either.

In his major work on the subject, *La force du préjugé: Essai sur le racisme et ses doubles,* Taguieff concludes on a pessimistic note, accepting the probable existence of a double barbarism: *"barbarie universaliste"* and *"barbarie différentialiste."* As for myself, I lean towards sharing Finkielkraut's faith in the French Enlightenment, but I, too, remain a little pessimistic; pessimistic, however, in the spirit of the last paragraph of Taguieff's book:

> Pessimism is not necessarily conservative, for it requires us to act, to keep on living even if what we know works against life. It calls on us to have hope beyond hope. It makes us think about both sides of the question at the same time, about the contradictions. Pessimism thus turns us into philosophers, children or novelists. It reveals one of those half-truths F. Scott Fitzgerald spoke about, the simple fact of which we aspired to demonstrate in these pages: "One should, for example, be able to see things are hopeless and yet be determined to make them otherwise."[54]

Notes

1. Much of the material presented in this essay comes from Chapter 2 of my book *Vilna on the Seine: Jewish Intellectuals in France Since 1968* (New Haven: 1990), where I use it to serve a different, but compatible, analytical purpose.

2. Serge Klarsfeld, *Le mémorial de la déportation des juifs de France* (Paris: Centre de Documentation Juive Contemporraine de Paris, 1979); *Memorial to the Jews Deported from France, 1942–1944* (New York: Beate Klarsfeld Foundation, 1983).

3. David Weinberg, *A Community on Trial: The Jews of Paris in the 1930s* (Chicago: University of Chicago Press, 1977).

4. See, for example, Gérard Israël, *Heureux comme Dieu en France* (Paris: Robert Laffont, 1975); and dedication in Robert Badinter, *Libres et égaux* (Paris: Fayard, 1989).

5. Count Stanislas de Clermont-Tonnerre, cited in Léon Poliakov, *Histoire de l'antisémitisme* (Paris: Calmann-Lévy, 1968), vol. 3, *De Voltaire à Wagner,* p. 342, note 2.

6. Jean-Paul Sartre, *Réflexions sur la question juive,* (Paris: Gallimard, 1946); *Anti-Semite and Jew,* trans. George J. Becker (New York: Schocken Books, 1976), p. 55.

7. Hannah Arendt, *The Origins of Totalitarianism* (New York: Harcourt, Brace and Company, 1951).

8. Philippe Ganier Raymond's interview with Louis Darquier de Pellepoix, "L'Express Document," *L'Express,* October 28 to November 4, 1978, p. 167 (hereafter cited as *Express* interview).

9. Philippe Ganier Raymond, *Une certaine France* (Paris: Balland, 1975).

10. *Express* interview, pp. 167 and 173.

11. Robert Faurisson, " 'Le problème des chambres à gaz' ou 'la rumeur d'Auschwitz'," *Le Monde*, December 29, 1978, p. 8.

12. The old mole is an allusion to an allusion to an allusion. Shakespeare used the image first, in the ghost scene in *Hamlet*. Then Hegel borrowed it, and Marx took it from Hegel, creating the now-famous phrase: "Our old friend, the old mole, who works so well beneath the earth, then surfaces unexpectedly as the Revolution."

13. Nadine Fresco, "Parcours du ressentiment," *Lignes*, No. 2, February, 1988, pp. 38–40 (hereafter cited as "Parcours du ressentiment"). See also Fresco's earlier article on the revisionists in France: "Les redresseurs de morts," *Les temps modernes*, No. 407, June, 1980, pp. 2150–2211. The earlier article appeared in *Dissent* in an abridged version: "The Denial of the Dead: On the Faurisson Affair", Fall, 1981, pp. 467–483.

14. Robert Faurisson, *Mémoire en défense* (Paris: La Vieille Taupe, 1980). *Faurisson on the Holocaust* (Costa Mesa, CA: Institute for Historical Review, forthcoming). The Institute's journal, *The Journal of Historical Review* has published translated selections from this book and other works by Faurisson over the years. See index of first 13 volumes — the journal began in 1980 — in issue published in fall, 1993.

15. Nicole Bernheim, " 'Le débat intellectuel français est marqué par le goût de l'irrationnel et le mépris pour les faits,' nous déclare M. Noam Chomsky," *Le Monde*, December 24, 1980, p. 10.

16. Serge Thion, *Des courtisans aux partisans, essai sur la crise cambodgienne* (Paris: Gallimard, 1971).

17. Serge Thion, *Vérité historique ou vérité politique* (Paris: La Vieille Taupe, 1980).

18. See, for example, the case of Henri Roques, as described in Nadine Fresco, "Parcours de ressentiment," p. 63 ff.

19. *Libération*, January 7, 1988.

20. For Emmanuel Lévinas, see, for example: *En décovrant l'existence, avec Husserl et Heidegger* (Paris: Vrin, 1949); *Existence and Existents*, trans. A. Lingis (The Hague: M. Nijhoff, 1978); *Totalité et Infini, Essai sur l'extériorité* (la Haye, M. Nijhoff, 1961); *Totality and Infinity: An Essay on Exteriority*, trans. A. Lingis (Paris: Arthème Fayard et Radio France, 1982); *Ethics and Infinity: Conversations with Philippe Nemo*, trans. Richard A. Cohen (Pittsburgh: Dusquesne University Press, 1985); *Emmanuel Lévinas, qui êtes-vous?* with François Poirié (Paris: La Manufacture, 1987).

For Jaques Derrida, see, for example: "Violence et métaphysique, essai sur la pensée d'Emmanuel Lévinas," *Revue de métaphysique et de morale*, No. 3 and 4, 1964; reprinted in *L'ecriture et la différence* (Paris: Editions du Seuil, 1967), pp. 117–228; *Writing and Difference*, trans. A. Bass (Chicago: University of Chicago Press, 1978); and *De l'esprit Heidegger et la question* (Paris: Galilée, 1987).

21. Victor Farias, *Heidegger et le nazisme*, trans. from the Spanish and German by M. Benarroch and J.-B. Grasset (Lagrasse: Verdier, 1987). The English language version, *Heidegger and Nazism*, is edited with a foreward by Joseph Margolis and Tom Rockmore and translated by Paul Burell and Gabriel Recir (Philadelphia: Temple Univ. Press, 1989). "Fribourg-Prague-Paris, comme l'être, la détreesse se dit de multiples manières," *Le Messager Européen*, No. 1, 1987, pp. 75–122; and " 'Quant à son essence la même chose,' écrit Heidegger," *Le Messager Européen*, No. 2, 1988, pp. 159–178.

23. We should keep in mind that during the same period, the Paul de Man scandal broke in the United States. Professor of Comparative Literature at Yale University, and one of the major proponents of deconstructionism in the country, de Man came to this country from Belgium after the Second World War, leaving behind him several years of journalism in a collaborationist newspaper, for which he wrote at least one blatantly anti-Semitic article. Details of de Man's involvement in writing National Socialist propaganda emerged soon after his death. See, for example: James Atlas, "The Case of Paul de Man," *The New York Times Magazine,* August 28, 1988, pp. 36ff; the article by de Man's friend and colleague, Jacques Derrida, "Like the Sound of the Sea Deep within a Shell: Paul de Man's War," trans. Peggy Kamuf, *Critical Inquiry,* vol. 14, No. 3, Spring, 1988, pp. 590–652; W. Hamacher, *et al.*, eds., *Wartime Journalism 1939–1943 by Paul de Man,* (Lincoln: University of Nebraska Press, 1989); W. Hamacher, *et al.*, eds., *Responses: On Paul de Man's Wartime Journalism* (Lincoln: University of Nebraska Press, 1989).

24. Jacques Givet, "Jacques Vergès, avocat de Klaus Barbie," in *Archives d'un procès, Klaus Barbie,* ed. Bernard-Henri Lévy (Paris: Le Livre de Poche, 1986), pp. 183–188 (Hereafter cited as *Archives d'un procès*).

25. In addition to the newspaper coverage in France and the U.S., see Bernard-Henri Lévy, editor, *Archives d'un procès,* Marcel Ophuls' film *Hôtel Terminus,* and Alain Finkielkraut's *La mémoire vaine* (Paris: Gallimard, 1989).

26. *Le Monde,* April 17, 1992, p. 9. For good coverage of the trial, see *Le Monde* and *Libération* during the month of April of 1992. The verdict was announced on April 13. For a brief report on his arrest, see *The New York Times,* May 25, 1989, pp. A1, A3.

27. Bruno Frappat, "M. Le Pen et l'effet détail'," *Le Monde,* September 16, 1987, pp. 1 & 8.

28. James Markham, "Mitterand Far Ahead in Round 1; Chirac is Second as Le Pen Gains," *New York Times,* April 25, 1988, pp. A1 and A9.

29. To mention only the most famous incidents: the bombing of the kosher student restaurant in the Latin Quarter, rue de Médicis (March, 1979), of the synagogue in the 16th arrondissement, rue Copernic (October, 1980); of the Jo Goldenberg restaurant in the Jewish Quarter (Marais) (August, 1982); and the desecration of the Carpentras cemetery (April, 1990).

30. "La recrudéscence des actions antisémites en France depuis 1975," *Le Monde,* October 7, 1980, p. 11.

31. Nelly Gutman and Jacques Tarnero, "Trois ans après Copernic—un an après la rue des Rosiers—l'antisémitisme en France—le point automne 1983," pamphlet distributed by CERAC (Centre d'études et de recherches sur l'antisémitisme contemporain), p. 3.

32. *L'avenir d'une négation: Réflexion sur la question du génocide* (Paris: Editions du Seuil, 1982), p. 55.

33. *Ibid.,* p. 135. In addition to Finkielkraut, see the excellent analyses of Faurisson by Nadine Fresco, *op. cit.* (note 12) and Pierre Vidal Naquet, *Les assassins de la mémoire,* (Paris: Editions de la Découverte, 1986).

34. See, for example, the heated controversy in *Les temps modernes,* October and November, 1982.

35. Among the organizations that have played, and in some cases continue to play, an important role, I note the following: l'Association des Intellectuels et Chercheurs pour la Paix au Moyen Orient; socialist Zionist groups such as Le Cercle Bernard Lazare, and L'Union Juive Internationale pour la Paix. In May, 1989, for example, when many in the Jewish community vehemently opposed François Mitterand's decision to invite Yasir Arafat to France, groups such as these supported the initiative (*Libération,* May 2, 1989, p. 6 and *New York Times,* April 30, 1989, p. 13).

36. J. Louis Pénou, "L'assissinat de Pierre Goldman," *Libération,* September 21, 1979, p. 3.

37. Laurent Greilsamer and Bertrand Le Gendre, "Juif, militant, gangster, écrivain," *Le Monde,* September 22, 1979, p. 12 (hereafter cited as "juif, militant").

38. Unless otherwise noted, the following summary of Pierre Goldman's life comes from his memoirs, *Souvenirs obscurs d'un juif polonais né en France* (Paris: Editions du Seuil, 1975); *Dim Memories of a Polish Jew Born in France,* trans. J. Pinkham (New York: Viking, 1977), hereafter cited as *Souvenirs obscurs*).

39. *Ibid.,* p. 33. English, p. 7. The translation is mine. Whenever I quote from a text written in French which has been translated into English, I give both references, but provide my own translations.

40. *Ibid.,* p. 56. English, p. 28.

41. "Juif, militant."

42. *L'Ordinaire mésaventure d'Archibald Rappaport* (Paris: Julliard, 1977).

43. "Entretien avec Pierre Goldman (Octobre, 1977)", reprinted in *Rouge,* September 28 to October 4, 1979, p. 62.

44. *Souvenirs obscurs,* p. 62.

45. Catherine Chaine, "Une interview inédite: Goldman l'étranger," *Le Monde,* September 30, 1979.

46. Luc Rosenzweig, "Kaddish pour Pierre," *Libération,* September 21, 1979, p. 4.

47. Luc Rosenzweig et Bernard Cohen, *Le mystère Waldheim* (Paris: Editions Gallimard, 1986); *Waldheim,* trans. Josephine Bacon (New York: Adama Books, 1987).

48. See my book, *Vilna on the Seine: Jewish Intellectuals in France Since 1968* (New Haven: Yale University Press, 1990), chap. 3, for a lengthy discussion of this movement, the main leader of which is Shakespearean scholar Richard Marienstras, who moved to France as a young child from Warsaw just before World War Two.

49. To get a sense of the debate among Jewish intellectuals, see Alain Finkielkraut, "Voiles, la sainte alliance des clergés," *Le Monde,* October 25, 1989, p. 2; Elisabeth Badinter, Régis Debray, Alain Finkielkraut, Elisabeth de Fontenay and Catherine Kintzler, "Prots, ne capitulons pas!" *Le Nouvel Observateur,* November 2–8, 1989, pp. 58–59; Shmuel Trigano, "Carrefour du judaïsme: Les juifs illusoires," *L'Arche,* December, 1989, p. 38; and Pierre Birnbaum, "L'etat et les églises," *L'Arche,* December, 1989, p. 63. For an excellent discussion, see Pierre-André Taguieff, "Mobilisation national-populiste en France: Vote xénophobe et nouvel antisémitisme politique," *Lignes,* no. 9, March, 1990, p. 96 (hereafter cited as "Mobilisation national-populiste.")

50. Alain Finkielkraut, *La défaite de la pensée* (Paris: Gallimard, 1987), p. 131; *The Defeat of the Mind* (New York: Columbia University Press, 1995).

51. Alain Finkielkraut, *L'avenir d'une négation, op. cit.,* note 31; and *La mémoire vaine: du crime contre l'humanité* (Paris, Gallimard, 1989); *Remembering in Vain* (New York: Columbia University Press, 1992).

52. Pierre-André Taguieff, "Réflexions sur la question antiraciste," *Mots,* No. 18, March, 1989, p. 76 (cited hereafter as "Réflexions").

53. This is a reference to an article unidentified by Taguieff in which the author claimed Le Pen was unfairly blamed for the defamation of the graves at the Carpentras cemetery.

54. Pierre-André Taguieff, *La force du préjugé: Essai sur le racisme et ses doubles* (Paris: Gallimard, 1987), p. 493, trans. J. Friedlander. The quote from F. Scott Fitzgerald came from *The Crack-Up* (1936). See: Edmund Wilson, editor, *The Crack-Up, With Other Uncollected Pieces, Note-Books and Unpublished Letters* (New York: New Directions, 1945), p. 69.

II

Identities and Cultural Practices

6

From the Novelistic to Memory

Alain Finkielkraut

> I must acquire everything, not just the present and the future, but even the past, that thing gratuitously bequeathed to every man; that also I must acquire, that is perhaps the hardest task; if the earth turns to the right—I don't know if it does—I must turn to the left to catch up with the past.
>
> Kafka

To claim as my own: such was, for many long years, my unique and glorious mandate. I was not one of the "chickens" who, in order to avoid trouble, gallicized their names and fled their cumbersome identity through silence or unbelief. "So what are you anyway?": I would never have taken advantage of the misunderstanding which reduced Judaism to a confessional bias by answering such a question with: "Me? Nothing, I'm an atheist, I don't believe in God..." My atheism was not a cover; I didn't seize the pretext of irreligion to abandon my community and gain admittance to the peaceful and comfortable circle of freethinkers. I was a Jew without God, but a Jew above all. No behavior seemed to me more odious, more degrading than that of the *renegade.* To this cowardice I opposed my own candor: to lay claim to my condition was, for me, to remain one step ahead of the eventual aggressor; it meant asserting I was Jewish before the label could be applied by the malevolence of another. I was therefore proud of my origins, and my Judaism had no content other than this arrogance and vigilance.

I did not forget the genocide: on the contrary, I never wanted to stop thinking about it. But this obsession was curiously accompanied by a very deep ignorance. What need did I have to know the history of the extermination in its practical details? It sufficed for me to have heard a few family stories, to have seen a few unforgettable images from *Night and Fog (Nuit et brouillard)*, and to constantly repeat a number: six million Jews exterminated

during the last war. The rest mattered little to me. Knowledge belonged to the scholars; the certitude of instinct belonged to me. Judaism ran in my veins; it was my interior truth and the color of my blood. I carried in the depths of my being the experience of the ghettos and the scars of deportation. Twenty centuries of suffering had shaped my character; I was one of the *loci* of this world where the *Jewish soul* expressed itself. I would never have thought of using the execrated term "race" and yet, saturated with the sensitivity of my people, a pure instant in a process, a link in the unbroken chain of existence, I implicitly pledged allegiance to the determinism of racial thought. Without knowing it, I was a "Barresian." I could therefore do without memory: Judaism thought and spoke in me.

What I didn't see then is that, by taking the genocide upon myself, I was occulting it, softening its horror. It took only five years to swallow up an entire civilization. I was not conscious of this disappearance as long as I continued, intrepid and vigilant, to occupy the space of the victim. In my haste to bear the weight of Jewish destiny, in my desire to merge with my people, I forgot one thing: there is no longer a people. A catastrophe had separated me from Jewish culture and, absorbed in my rebellion, I restored a factitious and reassuring continuity between past and present. I filled in the gap which separated me from earlier generations. I felt I was doomed to exile as a Jew, while in reality I had been exiled from that very collectivity by the event of the genocide. Pretending to participate in the sufferings of my kind, I denied this separation; an orphan of Judaism, I gave myself an ancestry, and the trick worked: I had domesticated Auschwitz, I had constructed a purely quantitative massacre, and by that very fact had made it reparable. It would only take energy, fertility, and time. In short, in the very center of my piety, I treated the disaster casually, as if it were a painful parenthesis in a history that still hadn't lost its unifying thread.

Today I would no longer trust my Jewish spontaneity: instinctively, I am nothing; I cannot cling to any cultural singularity. My gestures, my language, my appearance, my habits, and my way of life have been stripped of all particularism. In the eyes of others, as in private, I am the same as non-Jews, an impeccable likeness. And I have had the opportunity neither to desire this normality nor to refuse it. Nor is it the result of the erosion of a culture in decline, of the homogenizing power of capitalism or of the inexorable consequences of progress. Would the West, that vast and elusive entity with a capital "W," be responsible for this leveling phenomenon? Will we condemn once again, and *in absentia,* the society of sameness? No: what transformed Jewish life into folklore in a single stroke was a precise, punctual, and very recent event: genocide. One must not underestimate Hitler, on the pretext that his task was interrupted and that he lost the war. The extermination was a success which cannot be measured by the number

of dead alone, but which must be gauged as well by the current poverty of Judaism. Chaïm Kaplan committed the sin of optimism when he wrote in his chronicle of the Warsaw ghetto: "Our existence as a people will not be destroyed. Individuals will be destroyed, but the Jewish community will survive."

Certain communities, it is true, have subsisted virtually intact, but they are those which the murderous violence of the Nazis could not reach. As for the others, the opposite of what Kaplan predicted actually occurred: in spite of the monstrous number of their victims, the Germans failed numerically: the debacle of their retreat didn't give them enough time to carry out the Final Solution, but they were qualitatively successful: they wiped a unique culture from the face of the earth—*Yiddishkeit*. And that is why, as an Ashkenazic Jew, I am a Jew without substance, a *Luftmensch*, but not in the traditional sense of a vagabond or a beggar. . . . The *Luftmensch* of today is the Jew in a state of weightlessness, lacking the ballast of what could have been his symbolic universe, his particular place, or at least one of his homes: Jewish life. As a consolation, I still have one bone to gnaw on—my depth. Psychological complexity is the vengeance I take on the diaphanous thinning of my true Judaism. Lacking membership in a living community, I can at any time devote myself to the pleasures of solitary questioning: to he who is deprived of Jewish ethnicity, the Jewish Question provides its interminable subjects of meditation.

Circumstances have made me an introspective Jew, and have left me but a single faculty with which to escape from the monotony of the interior gaze: memory. Involuntary, laborious, incomplete, untiring memory; this alone has such a power, and not the presence in me of two thousand years of history. Judaism does not come naturally to me: between the Jewish past and me there is an unbridgeable distance; I have no heritage in common with the human collectivity swept away in the catastrophe. The imperative of memory is born of the painful consciousness of this separation. An inexhaustible nostalgia for the Jewish life of Central Europe: that is all my inheritance. Judaity is what I lack, and not what defines me; it is the infinitesimal burning of an absence, and not the triumphant plenitude of instinct. All things considered, I call Jewish that part of myself which does not resign itself to live with the times, that part which cultivates the formidable supremacy of what has been over what is today.

> It sometimes happens that peoples lose their sons: this is a great loss, to be sure, and it is hardly easy to console oneself about it; but along comes Doctor Soïfer with a loss of his own. . . . For he is one of those who are in the process of losing their entire people. . . .
> What? What is it he's losing? . . . But we've never heard of such a loss![1]

A young bourgeois spared by history feels a growing fascination for the time when his people lived. Should we see in this curiosity the expression of a return to origins? The image is seductive, but inexact: it evokes the countless former disciples of progressivism who patrol henceforth in bygone ages, waiting for the past to divulge the foundation and the truth of their being. Ah! If only tomorrow could be like yesterday, that distant and delicious time when a shave cost nothing. Each of them turns to his genealogy to discover the meaning so cruelly lacking in his present existence: a great disenchantment has come over the former devotees of the meaning of history; now we have a taste for origins, just as we used to have a taste for the revolution. The need for roots is the evil of the last quarter century. But how the devil could I go about putting down roots in Galicia or in prewar Warsaw, I whose knowledge of Polish and Yiddish is limited to a few insults, a few endearments, and a few proverbs? This assassinated world concerns me directly, it haunts me, but precisely insofar as I am completely excluded from it. It is not myself I look for there, it is what I am not, what I can no longer be. And memory will not resorb my exile; memory will rather deepen it by giving it a concrete form. No feeling of recognition links me to the defunct Jewry of Poland. To know it, to associate with it in books (the only place where it still manifests itself), is to take measure of my strangeness. These people, these prewar Polish Jews, who are brought to life again in certain scholarly and literary works, these are my people, and try as I may to dig, rummage, scrutinize the very depths of myself, nothing remains there of them, unless perhaps my love of poppyseed cake, boiling hot tea, and chewing the sugar instead of dissolving it in the cup. Roots which are, one would agree, tenuous and quite fragile.

What I am calling memory here is, then, the futile passion which a vanished civilization inspires in me; futile and, one would say, morbid. What's dead is dead. What's the use of wasting energy stirring up ashes, when that energy might better be used to encourage the rebirth of Judaism or the establishment of a more just society? For that reason at least—the Jewish life whose absence I feel—everything today contributes to making us believe it never existed. Everything; in other words, not only the indifference of those who don't feel themselves concerned, the demands of current events, and the worries of the present, but also the manner (so ceremonious, however) in which our epoch commemorates the genocide. On this matter, no expense is spared, and the commentary is assuredly irreprochable: superlatives jostle one another, voices choke up, and sobs come in torrents. And yet, between two exclamations we are erasing from history the very people whose lives were not so long ago torn from them. Consider our most recent imagery: from *Holocaust* to the *Guichets du Louvre,* from the miniseries judged to be idiotic, to the film praised for its intelligence and lucidity, the

impression is unanimous: when the war began there were only two sorts of Jews in Europe: the Westerners, proper, white, normal, who had the pure, cleanshaven faces of You-and-Me [*Vouzémoi*], and the old-fashioned Jews, medieval residues, quaint vestiges recognizable by their sidelocks and black caftans. The normal Jews spoke, with exemplary correctness, the language of everyone; the costumed silhouettes spoke in Yiddish, and could find nothing better to do, in the hour of peril, than to put on their prayer shawls and sway back and forth. Children who watch television will know what a Jew of the past was like: someone who rocked back and forth permanently. There is of course no disdain in this representation: our epoch pours forth its compassion toward the swaying Jews, and cannot find words harsh enough to describe the barbarians who liquidated them. In its zeal and guilty pity, our epoch even tends to describe the pale erudites of the synagogues as inhabitants of the Garden of Eden, and their perpetual swaying as an ideal state that we will never again attain. Our epoch would like us not only to lament these long-bearded psalmodists, but to envy their dead wisdom, or at least for us to pay them the homage of our pity. What fault may one find in such a debauchery of feeling? Simply that the opposition on which it is based is false. The Jews who peopled Europe between the two world wars did not constitute a homogeneous community, far from it, but neither were they divided into doctors, lawyers, bankers on one side and savages on the other. Yiddish was not the exotic jargon of a few backward fossils living in a world in mutation. There were three million Jews in Poland, and their culture was that diversified space in which there coexisted, and sometimes conflicted, groups of believers and laymen, Zionists and Bundists, Orthodox and Reformed Jews, cosmopolitan townspeople and inhabitants of the shtetls. It was possible to respect the *shabbat* without wearing the prophets' beard, to enjoy both the Yiddish theater and Bizet's *Carmen*, to study the Torah and play Ping-Pong or volleyball, to be fully Jewish and reject the commandments of the Talmud. Modernity and Judaism were not the two incompatible options which are retrospectively set in opposition to each other.

Even in France, our fair country, the immigrants from Eastern Europe were so ostensibly Jewish that they embarrassed their coreligionists. The assimilated Jews, on the whole, turned away from these foreigners who "vulgarly" betrayed their origins, while the former exhausted themselves to make their Jewishness invisible. Everything about these new arrivals proclaimed Israel: accent, gestures, physiognomy—everything except religious behavior. For the small craftsmen of the Belleville, République and Marais neighborhoods of Paris took great liberties with the synagogue: neither assimilated nor traditionalist, they are therefore absent from our reconstructions. In the *Guichets du Louvre*, a film devoted to them, they are dressed

in levites they did not wear, and while waiting for the police raid, they are given the characteristic swaying of the stereotypical Jew (*Juif d'Epinal*). By trying so hard to see clearly, we see nothing at all and we commemorate like amnesiacs, the annihilation of a nation. Thus the Jewish people has died twice: once by assassination, and once by forgetting. There is no room in our collective memory, except for people who resemble us and for museum pieces or circus freaks.

We like them much more than the Mona Lisa, these Jews of another age: the pathetic is obligatory when the deeds of the *Chassidim* are recalled. Nevertheless, to reduce Jewish life to an archaism is to implicitly define the genocide as an acceleration of history. . . . Such a cruel and inhumane waste it is, but weren't they condemned by progress, these anemic scholars who learned, explicated, and mumbled nothing but the holy word? It certainly would have been preferable to let Jewish culture die a natural death. Hitler didn't see things that way: those of an elegaic temperament can always visit Me'a-She'arim in Jerusalem, or a neighborhood of Brooklyn or Anvers; there they will see in the flesh the bizarre beings who are, for our time, the last representatives of Eastern European Judaism.

So, such is the official cult of the dead: a falsification. In a deluge of tears the assassination of a senile people is depicted, when in reality it was a living, multiform, creative culture that the Nazis killed. Indifference, pure and simple, would no doubt be less pernicious than that form of commiseration. Because finally, with a mental image of aged people without strength, mumbling their secular sorrow in the swaying of their worn out bodies, what can the public conclude? That they were herded to the slaughterhouse like docile and resigned sheep, and that they responded to their own annihilation with the calm and immense passivity of those who do not doubt the future coming of the Messiah. Religious hope does not encourage military vocations, and real *résistants* cannot be made of people who sway day and night, bent over a prayer book. It is true that no one is now unaware of the Warsaw Ghetto uprising. It is even celebrated with insistence, as if to better underline its exceptional character. It's a good thing they were there, those few rebels, to save *in extremis* the honor of an anesthetized people! This unique prowess, incidentally, has been spontaneously ascribed to the least Hebraic of the Jews, to the mutants, the already-Israelis, to those like us, our equals, our brothers, to those who had the requisite courage to throw off the ancestral yoke of their superstitions.

This legend of Jewish passivity is a tenacious one; it is an abject myth worse than oblivion: in effect, it treats the victims of the genocide as *collaborators* in their own destruction. The SS were certainly infamous executioners, but mustn't one add that the frightened, taciturn, fearful Jews did their part? A suicidal tendency? Masochism? An immemorial sacrificial-lamb complex?

Did they place their trust in God in a burst of religious fervor? Did they accept their fate by submitting to the decrees of the Lord, or did they refuse to see their fate by the pure and simple denial of reality? Religion and psychology fight indefinitely over the answer to the enigma, and that is how Auschwitz is little by little becoming a testimonial to the dizzying passivity of men. It is no longer the mystery of the Nazi horror which excites people's curiosity, but the intriguing mystery of the Jewish wait-and-see policy.

> He just kept on talking about that sort of thing. Why don't the Jews rebel? Why don't they fight? Why can the Germans say: *Die Juden sind die billingsten und willingsten Arbeiter?* The kind of questions you're asked by those who have a heart of stone and eyes of ice.[2]

The arrogance which assigns the inhabitants of the ghettos and the prisoners of the camps to an abstract tribunal is indefensible and scandalous. In spite of one's disgust, this indictment must be answered. The Jews who suffered forty years ago at the hands of Hitler are in need of advocates. Today we have reached the stage, and shall remain there for a long time to come, of justifying the victims of the massacre carried out against them. A task of rehabilitation falls upon us which allows no possible evasion: Jewish memory is none other than the ceaseless combat we must lead against majority memory, so that the genocide's dead may be saved from the conformity which tends to take possession of them and disguise them, for posterity, as consenting and dazed victims.

Oh, if only the Children of Israel could have formed a gigantic and diasporic underground army, instead of letting themselves "fry" in the crematoria, or digging their own graves! If only one, two, three Jean Moulins had succeeded in awakening these pale and pious intellectuals in round hats from their rabbinic torpor! Similar expressions of astonishment are uttered at every retrospective. The logic is idiotic but impeccable: when one is condemned to die, one may as well die with honors, as a brave man and, if possible, as a hero. When one has nothing more to lose, and yet one wants to remain a man, one doesn't give up without fighting, without selling one's life dearly. But did the Jews of occupied Europe even know that they were all bound to die? Were they saturated with information, like these indecent inquisitors who today issue them certificates of poor military conduct, and who don't hesitate to grade them below average in pugnacity? Had the Jews seen films about Auschwitz, complete with a visit to the gas chambers, an estimate of their efficiency, and a description of the effects of cyanide? Even the high-level Nazi dignitaries didn't receive the order to apply the "Final Solution" until January, 1942, at the well-known Wannsee

conference; a few among them, the most hardened, were stupefied by the incomprehensible news. Even from a *technical* point of view, it was not within the means of just any bureaucracy to eliminate eleven million people! Machine guns were obsolete, exhaust fumes were not sufficient for the task, carbon monoxide required much too complicated arrangements, and it was necessary to tone down the rabid anti-Semitic propaganda of the early years of Hitlerism. The architects of the killing would not be able to take up the challenge by putting more rounds in their rifles or more violence in their manner of speaking. A qualitative breakthrough was needed: mass murder required both Zyklon B gas and the mystification of its victims. And that is how, with the progressive evolution of the concentration camps of Poland into extermination camps, euphemism came to replace bombast, and suavity took the place of hateful eloquence. This rhetoric remained, of course, credible, for the Germans weren't promising the Riviera to the deportees; they were simply in charge of their "regrouping" or their transfer to the East. Very strict rules of language banished death from the Nazi vocabulary. Are the Jews guilty of being taken in by this disinfected lexicon? Let us abandon for a moment the eminent position of the judge, and imagine the internees of Pithiviers or of Beaune La Rolande who, in May, 1942, must leave their camp for an unnamed destination in Central Europe. What they are promised is forced labor. Isn't this perspective absolutely terrifying in itself? What more can the Germans do to them? "Make them another asshole"?[3]

In the attitude of those who believed they were being transferred to the East, when in fact they were being taken to Auschwitz, one should discern neither blind confidence nor naïveté. From the outset of the hostilities, the Jews expected the worst from Hitler. The worst was, for example, forced labor, in other words slavery, the sequestering of a people and its transforma-tion into an unpaid, totally exploitable workforce. But Hitler did not give them what they expected: he gave them *worse than the worst*. And what he gave them — planned annihilation — Jewish historical memory prevented them from foreseeing. It is true that they were deceived, but deceived in the first place by their own pessimism. Frank, due to excessive experience, even less prepared, because they were certain they were ready for anything, the Jews felt they couldn't be stumped on the subject of persecution. In two millenia they had seen calamity from all angles; they had become ultracompetent. The Nuremberg Laws? An attempt to overturn the Emanci-pation, to return to the *ancien régime*. The creation of the ghettos and the compulsory wearing of the yellow star? A pure and simple return to the Middle Ages. Each measure set off an echo. These experts in tragedy seemed as though they would never be caught off guard. From their miserable past they drew the assurance that they had a name for everything. They had

none for the third stage of the Germans' policy: their learning furnished them with no equivalent for genocide.

Foreigners without power, they were accustomed to fits of sometimes bloody hatred on the part of indigenous populations. These outbursts served as a decoy and a distraction from all social conflicts. The Jews' presence allowed frustrations to be vented without putting order in peril. Fodder thrown to the discontented, the Jews were a godsend to nations: the world needed expiatory victims. Certain Jewish communities, resigned to this sacrificial role, maintained a policy of remaining silent and letting the storm pass: such were French Jews during the Dreyfus Affair. With their backs to a wall of several centuries of persecution, so as not to have to look at it, the Jews thought Hitler would obey the same logic of sacrifice, when in fact he had invented another, that of extermination. These external *scapegoats* were rudely shoved into a world without landmarks, a world which declared total war on them and treated them as *absolute enemies*. How many Jews, mystified by their clairvoyance, tried to escape the massacre by considering the Germans as the most dreadful of ordinary anti-Semites! To appease their tormentors, they thought cleverness would suffice, and in two thousand years they had had the time to perfect their techniques of adaptation: they knew how to corrupt authority and how to make themselves indispensable. During the war, this ingeniousness only served to *normalize* their interlocutor, by crediting him with a language he didn't speak: the language of utility. We know today that the Germans went against their own interests by eliminating an often irreplaceable labor force which fed their wartime economy. If they first liquidated the unproductive population it was not—as the Germans let them hope—to spare the productive workers, but simply to avoid clogging the system: they couldn't kill everyone all at once; the massacre had to be methodized, priorities established. So there were innumerable "biological enemies" of the Reich who did not understand, from the outset, the politics of the Final Solution, because they deciphered its coded text by using codes suitable for other messages. No doubt burned by the sacrificial and economic violence they had suffered, the Jews were in no condition to anticipate the gratuitous violence which was about to come crashing down on them.

Let us understand their *stupor,* and let us cease, as armchair *résistants,* to degrade it to passivity! Between the Nazis and their privileged victims lay the filter of a history of hatred, verbal aggression, various kinds of lynchings, and subservience. The Jews knew distress only too well, and could only find in Hitler's menace a kind of *déjà vu.* Historical experience deceived them by making them think that they were no strangers to the unimaginable. They had been through so many trials that they believed they could get used to Nazism, and absorb it in one of the categories of their memory. That is how, in a kind of tragic misreading, so many of the doomed tried

useless remedies against extermination, remedies they had learned through persecution.

But in its ultimate ends, as well as in its manner, Nazi violence was unprecedented. Hitler was not an overwrought gang leader; and the SS, tightly buttoned in their handsome uniforms, had nothing in common with the instigators of pogroms. Too proper, too meticulous, too polished, they did not resemble the Polish or Ukrainian plunderers the Jews were accustomed to. There were no doubt plenty of sadists among the German troops, and they could, as never before, allow their bloodthirsty tendencies to blossom. But the true executants of genocide, those who made it possible despite its heinousness, were model bureaucrats, lacking the slightest perversion. Consider Eichmann, or Rudolf Hoess, the commandant of Auschwitz: these civil servants exercised on their victims a neutral, administrative, dispassionate, and routine ferocity, while the Jews still identified violence with fury, and knew barbarism only by its animal face. Evil, their still-recent experience told them, is a spectacular and sporadic derangement: what was inconceivable to them was the crime made commonplace, the dull, methodical, and sustained terror the Nazis would make them suffer. The Final Solution indeed broke with anti-Semitic tradition, and replaced the savagery of ancient Saturnalia with those two great virtues of work—discipline and economy of operation. And the Jews were to have anticipated and opposed this in an effective manner! This is the lecture they're given! With an affection tinged by a touch of annoyance, we chide them! "Hey, were you napping? Couldn't you have resisted those vile brutes even a little? . . ." But here is the most incredible thing: the very people who put the supposed passivity of the victims on trial reiterate their lack of comprehension thirty-five years later, [ed. in 1980] and in spite of the accumulated evidence. These prosecutors understand nothing about the genocide. It is as blind people that they complain about the Jews' blindness. Today we still deny them what we blame the prey for not knowing how to perceive: the mediocrity of the hunters, their drab and laborious impassibility. They are depicted with the quasi-legendary features of the "indefatigable little workers" (Musil) of extermination. Their behavior is eroticized, bestialized, adorned with the crimson colors of decadence or the vivid hues of primitivism. They are no longer technicians, they are monsters, heroes of de Sade loosed in the wild, Teutonic ogres presiding over their horrors to the music of Richard Wagner. Original violence or crepuscular evil, our epoch obstinately clings to an imagery that the Nazis made completely obsolete. Romantic or perverse torturers wouldn't have been able to carry out a genocide. A task of that magnitude required qualities without prestige: National Socialism transferred into the realm of crime a rationality hitherto reserved for the industrial sphere. One must concede no depth—be it sexual, unconscious, or animal—to these

"managers." They were the heroes of maximum efficiency and of absolute indifference. Industrious administrators, they recognized no values except those of productivity or obedience. Barbarians they were, certainly, but by an excess of normality; they manufactured Jewish death with diligence and know-how, as their contemporaries were experts at manufacturing medicines. It would certainly have been reassuring to be able to attribute this crime without precedent to human beasts, to the violently insane or to fanatics, but in reality the most merciless inhumanity emanated from the most ordinary humanity. Such is the *disturbing familiarity* of genocide, that it is tailor-made for modern man. The modern man is, indeed, too refined to participate in a pogrom, such a boorish amusement. The sight of blood nauseates him, cruelty repulses him, from the moment it is concrete and carnal. His scrupulousness can much better put up with the abstraction inherent to bureaucratic violence than the rage or excesses of spontaneous violence.

With Hitler, the evil inflicted on the Jews changed in degree, but, above all, in nature. The most powerful state in the world planned the disappearance of a people lacking an army, land, and allies. Never was a more mismatched war fought than this one, between an overequipped country and a defenseless nation. In spite of astonishment, in spite of impotence, Jewish partisans did exist in all the occupied countries. There was the Warsaw Uprising, there were the thousands of Jews of Lublin, Lodz, and Bialystok, killed on the spot because they refused to obey an order, because they insulted an SS officer, struck him, or spat in his face. There were also, of course, the members of the Jewish police who thought they could save their lives and their families by delivering their daily quota of deportees to the Occupation authorities. In the ashes of the ghetto, informers were even seen leading German soldiers to the bunkers where the last survivors were holed up. . . . Nonetheless, at a time when all of Europe lay helpless under Hitler's domination, it is not the resignation of the Jewish majority which is inexplicable, but rather the revolt of the few. We are today only too inclined, in our air-conditioned Europe where any gesture is gratuitous, to invert and make a norm of this unheard-of behavior: the tearing free from servitude of the man who says "no."

But resistance and resignation are crude approximations: these two terms enclose reality in a rigid Manichaeism which disfigures it and dehumanizes it. The masses who did not take up arms are not, because of that fact, guilty of indolence or inertia. The Germans wanted the Jews to die; the Jews were therefore forced to give proof of ceaseless and feverish *activity* in order to remain alive. Rather than engaging in a surely suicidal rebellion, they opposed their exterminators by ruse; not by carelessness, but infinite skill in all of the illegalisms that made up existence in the ghettos. There were

numerous escapes to the Aryan side, swarming with Polish blackmailers much more gifted than the SS in picking out a Jewish face in a crowd. There was contraband smuggled to feed people when the Nazis sought to starve them to death. A very dense network of clandestine institutions existed to maintain community solidarity at any price. Flour mills were hidden in cellars or attics, tiny orchards on roofs or balconies. Even a very low suicide rate bears witness, in the middle of hell, to an unbelievable will to live. . . .[4] These efforts and minor stratagems to pull through have nothing of the spectacular. They are not, by any means, the stunning deeds of a martial epic. Often, against the German steamroller, they were of no use at all. But only the unawareness born of comfort and the fanaticism for virile qualities lead us nowadays to belittle such practices, and to see in them only variations of a unified and degrading passivity.

As for those who chose the path of rebellion, they were not resistance fighters in the classic sense of the term. They were not in combat like the partisans who, through sabotage, espionage, or guerrilla attacks, weakened the occupying power and facilitated the task of the Allies. They were not, like the *maquisards,* the auxiliaries of conventional forces engaged on the battlefield. The Jewish *résistants* conducted a solitary and futile combat. The ghettos and the camps were the only places where they were forced in such tragic fashion to choose resistance *against* hope of survival. Victory for these insurgents was like a promised land which, by rising up, they were certain never to reach. To revolt was to choose certain death over the (even tiny) chance of holding on until Hitler's defeat. To make this choice meant that the will to escape, or to vanquish, had to be weaker than the will to bear witness and to shame the world for its *apathy* toward the disaster. Indeed, where did the real scandal, the real passivity lie? In the procession of deportees who accepted an atrocious death without resisting? In the uncanny calm of the Sons of Abraham? Or wasn't it rather in the indifference shown by the vast majority of their contemporaries toward the annihilation? By asking oneself how the Jews allowed themselves to be dominated, one avoids the fundamental question: how did the rest of the world allow it happen? By so passionately questioning the mutism of the doomed Jews, one evades the *other silence:* that of the populations who witnessed the genocide, of the silence of the church, of the Allied governments and their media, of the *Résistance* itself, little disposed to come to the aid of people who could in no way be useful to them. Do we know, for example, that the most debated subject in Poland just before the outbreak of war was the emigration of the Jews? It was a crucial question, one which took precedence, in the view of a majority of Poles, over the German menace. In his own brutal way, Hitler, through the organizing genius of his administrators, fulfilled the wish explicitly formulated all through the 1930s by a unanimous society: make them

go away! Make them vanish! Do we also know that immediately following the war, when barely fifty thousand out of three million Polish Jews had survived, there were pogroms in Kraków, Kielce, Chelmno and other cities?[5] Do we know that the Jews of the ghettos, because they had no government in exile to represent them in London, and because their strategic value was nil, had the utmost difficulty in raising armies and so on.[6]

We have seen, since World War Two, other genocides. It is vain to claim for the Jews moral privilege or a monopoly on extermination, for the Germans were, in this domain, precursors and not exceptions. Something, however, remains unique about those four years of dereliction and it is not, as the comfortable cliché would have it, the resignation of the victims. "What was unique between 1940 and 1945 was the abandonment" (Emmanuel Lévinas). There were no petitions then, no press campaigns, no media to "cover" the Holocaust, no marches, no grassroots movements. No sign came from the outside. Between the dying and the other side was an insurmountable wall made of hostility, detachment, skepticism, or ignorance. Try as one may to hide this silence with unrepentant babbling about Jewish passivity, it remains as vertiginous and incomprehensible today as it was during the war.

What is natural today is to look ahead. "Forward march!" is an almost universal watchword. The eccentrics who look back over their shoulder must give their reasons for doing so: their nostalgia must give a meaning to their present existence; it must be useful here and now. Their addiction to the past fits into the triumphant vision of time which makes of the past an imperial value to which everyone is supposed to pay tribute. Consider the arguments that those who refuse to forget the genocide, and who want to maintain a link to their vanished culture, must use: "Memory," they say in essence, "is nothing but a category of vigilance. We do dredge up the past, that is true, dear friends; in our obsession itself we remain modern, for in this way we can keep the past from coming back to haunt us." Certain zealots of modernity do not accept this excuse: they say that the Jews, in their willingness to reopen old wounds, are creating a diversion. They say that, by always bringing up the past, these one-track minds are diverting us from the glaring injustices and urgent genocides of the present. With a little encouragement, they would compare the Jews of today with the anti-Semites of yesteryear: the Jews of today are attracting attention to a bygone disaster, when that attention could better be polarized on present-day history. This is exactly what anti-Semites of the past did by transforming into racial hatred a social bitterness that might have shaken the very foundations of capitalism. If one believes these censors of memory, we now honor Auschwitz in the same way the hook-nosed parasite was once detested: to exorcise collective

violence, to replace real conflicts with a fictitious unanimity against a defenseless enemy. The Elders of Zion were a smoke screen for the true authors of misery; in the same way, any commemoration of the genocide blots out the torture chambers of Uruguay, Chile or Argentina, the boat people of Southeast Asia, the Soviet Gulag, unemployment in France. That is why, when *Holocaust* was broadcast, there were few critics who discussed the actual weak points of the film (notably the complete absence of Jewish life). On the other hand, there were countless debates criticizing this dangerous entertainment. The time is past to lament the Jews, they said. Make way for the young! Make room for the latest accursed!

The partisans of Jewish memory say that the dead inform the living, warn them and open their eyes. The enemies of Jewish memory say that those dead serve no purpose, they get in the way, they weaken our vision, they hide what is important today. . . . Both sides can only conceive of *useful* dead.

I myself spent all of my long adolescence using the dead, annexing them to myself without shame, voraciously appropriating their destiny, taking pride in their agony. I know now that memory consists neither of subordinating the past to the demands of the present, nor of painting modernity in colors which dramatize it. If the future must be the measure and reference of all things, then memory cannot be justified, for he who attempts to gather together the materials of memory works on behalf of the dead, and not vice versa. He knows that they have no one but him in the world, and that if he turns away from them, from the way they lived and the way they died, then these dead Jews who were at his mercy will die completely, and modernity, in love with itself, besieged by the intrigues which surround it every day, will not even notice this disappearance.

Translated by Roger Butler-Borraut

Notes

This text forms chapter 3 of Alain Finkielkraut's *Le Juif imaginaire* [*The Imaginary Jew*] (Paris: Seuil, collection "Fiction & Cie," 1980).

1. David Bergelson. I found this quote in the wonderful book by Richard Marienstras, *Etre un peuple en diaspora* (Paris: Maspero, 1974).

2. Adolf Rudnicki, *Le marchand de Lodz* (Paris: Gallimard, 1969).

3. Jean-Claude Grumberg, *L'atelier* (Paris: Stock, collection "Théâtre ouvert," 1979): "People told me, 'Be careful, Monsieur Léon,' but I thought, 'What if I do get caught? What can they do to me? Make me another asshole?' "

4. "Life in the ghetto is, as it were, stagnant and frozen. There are walls around us; we have no space, no freedom of movement. All that we do, we do illegally. Legally, we do not even have permission to live." Chaïm Kaplan, *Scroll of Agony: The*

Warsaw Ghetto Diary of Chaïm Kaplan (New York: Macmillan, 1965). The admirable account by Emmanuel Ringelblum, *Notes from the Warsaw Ghetto,* trans. Jacob Sloan (New York, McGraw Hill, 1958), should also be consulted.

5. Yes: pogroms *after* the camps. On the situation of Polish Jews in the years prior to the war, one may consult the book by Celia S. Heller, *On the Edge of Destruction* (New York: Columbia University Press, 1977).

6. On the causes and the reality of the isolation of the Jews during the war, see Lucy S. Dawidowicz, *The War Against the Jews* (New York: Holt, Rinehart, and Winston, 1975).

7

Critical Reflections

SELF-PORTRAITURE AND THE REPRESENTATION OF JEWISH IDENTITY IN FRENCH

Lawrence D. Kritzman

In the period following Auschwitz, the questions of Jewish identity and the concept of "race" have become key issues in critical thought. Most particularly in France, starting with Sartre in the immediate postwar period, and continuing into the 1990s with the postmodernist thought of Derrida, Lyotard, and Nancy, a number of intellectuals have addressed the questions of Jewish identity and how the subject position of the Jew may be constructed. In this essay I shall focus on a number of exemplary self-portraits written by Jews (Memmi, Finkielkraut, and Derrida) and a portrait of the Jew in one of the most provocative and influential philosophical inquiries on the so-called Jewish Question, written by a non-Jew (Sartre). At stake in each of these critical exercises is the representation of the image of a Jew who is identifiable as *different,* and whose self-image is inscribed in a rhetoric that is tied to history, memory, or myth. If cultural or ethnic differences are foregrounded in these portraits, it is because they are represented in a language that discloses the otherness of Jewish identity as a phenomenon to be either transcended or simply reinforced.

To reflect on Jewish identity requires a philosophical investigation of the intersubjective relationships between self and other, as well as the more ironic exploration of the otherness within the self. Accordingly, each of the writers studied here frames his respective narrative around an abstract category of Otherness which is sustained by fictions depicting a fundamental and constitutive difference. Beyond the rhetoric of European anti-Semitism which is based on "racial" and "scientific" theories of otherness, these self-defined images of Jewish identity more or less emanate from an existential uncertainty that legitimizes their being in the authority established by the

demarcation of difference. In the face of what may appear to be a form of cultural marginalization, the figure of the Jew represented in these portraits emerges from the tropes defining the multiple voices of Jewish subjectivity.

Perhaps more than anyone else in France since the end of World War II, Jean-Paul Sartre set the tone for the philosophical debate on the question of Jewish identity. In his landmark study, *Anti-Semite and Jew* (1948), Sartre tried to define who Jews are, and how Jewish identity takes shape.[1] In spite of Sartre's goal to defend Jewish "plight," his focusing on Jewish characteristics, and on Jewishness as a socially constructed way of being, led him to formulate a negatively conceived essentialism on what he termed the "Jewish question." The phenomenological descriptions that structure Sartre's text represent a Jewish subject who comes into being through a quasi-stereotypical series of clichés, ranging from physiological characteristics to language traits.

At the core of the Sartrean model is the dialectical relationship he establishes between a so-called Jewish self and the anti-Semitic Other. From Sartre's perspective, Jewish individuation is the result of the anti-Semite's gaze; the anti-Semite constructs the "Jew" through a specular process that operates as a mechanism for securing the "identity" of the Jewish subject. "The Jew is one whom other men consider a Jew: that is the simple truth from which we must start. In this sense the democrat is right as against the anti-Semite, for it is the anti-Semite who *makes* the Jew" (p. 69). To be sure, if the "Jew" is the anti-Semite's Other, it is because the "Jew" functions as an object of scorn, translating both a passion and a conception of the world that defies humanity in its odiousness. "The anti-Semite has chosen hate," claims Sartre, "because hate is a faith. . . ." (p. 19).

In order to be relieved of the fear created by a mythic Jewish omnipresence, the anti-Semite engages in a form of scapegoating that is based on thoroughly irrational impulses. In essence, the anti-Semite freely chooses a comprehensive view of a world in which Jews dominate and non-Jews succumb. Accordingly, the perceived phantasmatic power emanating from this menacing Other requires the anti-Semite to totalize the entire realm of experience; the "Jew" is reduced to the incarnation of evil, a phenomenon whose force Sartre derives from its rhetorically conceived negative character.

> The Jew . . . is completely bad, completely a Jew. His virtues, if he has any, turn to vices by reason of the fact that they are his; work coming from his hands necessarily bears his stigma. If he builds a bridge, that bridge, being Jewish, is bad from the first to the last span. . . . Strictly speaking, the Jew contaminates even the air he [the anti-Semite] breathes. (pp. 33–34)

Relying on the blinding spirit of a self-imposed synthesis, the anti-Semite comprehends the world as a whole that determines the meaning of all its individual parts. Anti-Semitism is therefore predicated on the need to vilify an abstract yet quintessentially Jewish will to evil; it seeks legitimation in its quest for the salvation of the universe through a kind of catechistic fervor. Blinded by the power of fantasy, the anti-Semite flees responsibility in this mythological crusade against evil. "The anti-Semite has chosen to be a criminal, and a criminal *pure of heart.* . . . He knows that he is wicked, but since he does Evil *for the sake of Good,* since a whole people waits for deliverance at his hands, he looks upon himself as a sanctified evildoer" (p. 50). Sartre's text opens up the representation of Jews to the possibilities of referential aberrations realized through a series of tropes that transform Jewishness into a form of alterity that can never be assimilated to the purity of the same.

If the anti-Semite participates in an agonistic struggle with the Jewish menace, it is because he adheres to the narcissistic belief that this alien other threatens his sense of tranquility. Frightened by the weight of his consciousness, the anti-Semite opts for "the permanence and impenetrability of stone (p. 53)," a reified self-image that threatens the narrative of his personhood but paradoxically allows him to deny the very idea of Jewish humanity. "The anti-Semite is a man who wishes to be pitiless stone," claims Sartre, "a furious torrent, a devastating thunderbolt—anything except a man" (p. 54).

For Sartre, then, the "Jew" is both the sight (the vision) and the site (the *locus*) of the anti-Semite's existence. Within this framework, the "Jew" becomes the repository of absolute hatred. In the model presented by Sartre, the identity of the viewed Jewish object posits the desire of the viewer in a position that overdetermines Jewish subjectivity and makes it the effect of the anti-Semite's visual prowess. Victim of the fatal power of an anti-Semitic gaze, the "Jew" becomes the person whom Others consider to be Jewish; the "Jew" therefore loses the sense of agency from which "real" subjectivity may potentially emerge.

> The Jew . . . finds himself in a paradoxical situation: it is perfectly all right for him to gain a reputation for honesty, just as others do and in the same ways, but this reputation is added to a primary reputation—that of being a Jew—which has been imposed on him at one stroke and from which he cannot free himself no matter what he may do. The Jewish workman in the mine, in the foundry, at the wheel of a truck, can forget that he is a Jew; the Jewish businessman cannot forget it. Let him multiply acts of disinterestedness and honesty, and perhaps he will be called a *good* Jew. But Jew he is and must remain. (p. 74)

Inscribed in these statements is a disturbing politics of discrimination that portrays the doubleness to which the "Jew's" self-image is subjected. If the

workman can deflect the lure of the anti-Semitic look, the businessman, on the contrary, having internalized the anti-Semite's psychic image of the "Jew's" apparent greed and deception, assumes an image that affirms a pregiven identity.

In essence, the "Jew" consumes the gaze of the Other, not in terms of anything that is inherent to its being, but rather, as the result of a look that regulates Jewish difference as something that is stereotypically projected. For it is the anti-Semite's eye that provides the "Jew" with a mirror image that re-presents the desiring subject's "I" as a problematic referent for the language of the Self. "The root of Jewish disquietude is the necessity imposed on the Jew ... of assuming a phantom personality, at once strange and familiar, that haunts him and which is nothing but himself—himself as others see him" (p. 78). The Jewish subject comes into being through the identificatory process of specularity through which its fictive origins are introjected. So this self-image, which appears to function at the level of the cliché, produces an identity that is realized through the paradox of the "Jew's" self-effacement in a cultural representation grounded in the eye or "I" of the anti-Semite.

Sartre's rhetorical formulations situate the anti-Semite and Jew in a relation laden with the intense narcissism of the former. For it is the anti-Semite's desire that brings about the construction of a Jewish identity conceived as the re-presentation of a masterly "I." Instead of the "Jew" being constituted by what he does, what he does is justified by his needs. "Indeed, it is vis-à-vis the Jew and the Jew alone that the anti-Semite realizes that he has rights ... the anti-Semite is in the unhappy position of having a vital need for the very enemy he wishes to destroy" (p. 28). Indeed, the construction of the "Jew" is the effect of the Other's fear. Condemned, in a way, to a life devoid of freedom, his always-already state of contingency emprisons him in a situation where the right to choose has been appropriated by the gaze of the Other.

But what, finally, makes a Jew become a "Jew," according to Sartre's theory? How does the Jew become the object of an onomastic practice—to name a Jew a "Jew"—that synthesizes alterity and keeps a sense of order within the marginality of the Jewish community? The answer to this question may be found in the Sartrean concept of *situation,* a notion that, in this context, demonstrates that it is the atmosphere created by anti-Semitism that determines the lives of its victims. Here the idea of *situation* produces a sense of difference derived from the petrifying order of the same:

> It is neither their past, their religion, nor their soil that unites the sons of Israel. If they have a common bond, if all of them deserve the name of Jew, it is because they have in common the situation of a Jew, that is, they live in a community which takes them for Jews. (p. 67)

101

Defined by neither blood ties nor common history, the Jewish condition is the result of a subliminally shared perception that conceives of race as a phenomenologically constructed entity. Clearly, the situation that is assigned here to Jews reveals Sartre's desire for monolithic thinking, as well as his preference for homogeneity.

Ironically, instead of displacing the problem of race, Sartre's analysis of the Jewish Question curiously *reifies* it. This practice becomes most blatant when Sartre discusses the distinctions between Jews and "ordinary" Frenchmen, and authentic and inauthentic Jewish behavior. By differentiating between Jews and Frenchmen, Sartre commits himself to the primacy of race as cultural value. "To be a Frenchman is not merely to have been born in France, to vote and pay taxes; it is above all to have the use and sense of their values" (p. 80). For Sartre, when Jews try to do what "ordinary" Frenchman do, they are perceived, in the eyes of the anti-Semite, as intruders, since it is believed that the true sense of things French—what might be termed "the *genuine* France"—must inevitably escape them.[2] To be Jewish is to be marked negatively. Yet to be like others and to assimilate forces Jews into a state of inauthenticity and ultimately into a condition of bad faith; assimilation signifies stepping beyond prescribed boundaries and wearing a mask. Quite clearly, the reasoning that led Sartre astray locates the axis of French culture in a society that is tradition-laden and organic. The attempt to assimilate is deemed to be a form of transgressive behavior, both in terms of French nationalism and in Sartre's ethical imperative, which requires Jews to remain authentic and still be true to themselves.

> Authenticity for him is to live to the full his condition as Jew; inauthenticity is to deny it or to attempt to escape from it. Inauthenticity is no doubt more tempting for him than for other men, because the situation which he has to lay claim to and to live in is quite simply that of a martyr . . . the authentic Jew is the one who asserts his claim in the face of the disdain shown toward him. (p. 91)

The Sartrean concept of *authenticity* appears to be fixed as an invariant for epistemological and moral reasons. Thus Sartre would have "real" Jews adjust to the existence of anti-Semites by keeping Jews different and separate from anti-Semites. This strategy, so it would seem, would enable Jews to live out their situation in an exemplary manner by showing society what it does, and thereby demonstrating how injustice may be inflicted on Jews. When all is said and done, however, Sartre's "humanistic" gesture demands an essentialist assertion of identity that engages Jews in a form of theatricality. The Jews are required to project the image of a *persona* whose exemplarity represents the mirror of social incarceration.

In short, Sartre's idealized portrait abandons Jews in a "no-exit" situation whose logic is one of unacceptable stagnation. If Jews opt for authenticity, they become the mere reflection of the anti-Semite's gaze; if they opt to do things differently, by assimilating and adopting the discourse of the dominant Christian culture, they end up as victim of their own bad faith. In a way, Sartre defines the Jewish "I" by situating it in relation to the eternal and fatalistic gaze of the anti-Semite and the "we" of French culture. Accordingly, Jews cannot individuate freely in this structure. Their existence is bound to a theory of alterity that reduces Jewish identity to a simulacrum of being, a caricature of sorts that is the result of the anti-Semite's so-called perception. In attempting to delineate the radical difference of Jewish otherness, Sartre ultimately produces an almost equally objectifying idea. Although the choice of authenticity for Sartre might be justified on the ethical level, it offers little or no hope in political terms.

In Albert Memmi's *Portrait of a Jew* (1962), self-portraiture and philosophical meditation converge.[3] Born in the Jewish ghetto in Tunis, and subsequently having survived the Nazi work camps of World War Two, Memmi describes himself as the victim of a triple-cultural estrangement. As a Tunisian, he had experienced alienation in his native land by being educated in the foreign culture of the European colonizer (French); as a Jew, he was isolated from the indigenous Arab Muslim culture that surrounded him; and perhaps most striking, he was alienated as a Jew living in a dangerously anti-Semitic universe.[4] The culturally hybrid world that Memmi inhabits—Arab, French, and Jewish—contains within it a drawing of boundaries which produces a subject position destined to remain on the margins. "I am both of this world and not of it" (p. 59). Memmi's vision of Jewish existence thus reflects a situation that forecloses on the Jew's ability to adopt a hegemonic position of any kind. Set apart from others as well as from itself, the Jewish subject emerges as an "I" disembodied from the many cultural spheres in which it circulates but to which it can never totally belong.

In a way, Memmi's reflection on the Jewish condition transforms the Sartrean intertext from which it is derived (and to which it is dedicated) into a confession that analyzes the "curse" of being Jewish. In spite of Memmi's praise for *Anti-Semite and Jew,* he proclaims that "the enterprise [of reflecting on the Jewish question] must be conducted by a Jew, from the inside" (p. 16). Accordingly, Memmi constructs a discourse in which the "reality" of the Jewish subject position is authorized by a mental inclination that is determined by a perception of negativity and absence:

> Sometimes the Jew appears as a national minority; he is then primarily a foreigner, who speaks the language of the country poorly and is fairly ignorant of its customs. Sometimes, as a recent emigrant, he is even ethni-

cally different, in biological contrast to the people that accept him. But, in every case, at the base of Jewish misfortune, one finds the same absence; it is another name for his misfortune. Through the diversity of individual Jewish lives scattered over the globe, and his social activities, it constitutes one of the fundamental threads of Jewish existence. . . . Through the body and diversity of negative traits, that absence of Jews in the world in which they live, gives them a negative destiny, a true face in the shadows. (p. 256)

The place of difference and otherness, as it is described here by Memmi, occupies the position of "the face in the shadow." It signifies a veiled presence, one whose visibility is clouded over by the darkness emanating from the void constituting the image of Jewish non-being. Released from the standards of absolute cognitive accountability, the Jewish presence in the world is represented as something that dis-places recognition, and therefore renders its existence problematic. Ironically, the void constituting Jewish identity depends on the non-Jew's totalizing references to race, and a cultural tradition that disposes of the signs of ethnic subjectivity—that "vague spiritual malaise" (p. 15)—in the abyss of difference.

For Memmi, consciousness of misfortune is the key prerequisite for understanding the Jewish condition. "What is called Jewish history is but one long contemplation of Jewish misfortune," Memmi laments (p. 21). Conceived as an endless succession of disasters, Jewish history is nourished on a heavy dose of martyrdom; it is transcribed by an oxymoronic trope representing a semi-sweet optimism born from a state of utter despair. Memmi's Jewish subject is trapped within a historical narrative that alternates between ghastly catastrophe and the joys of deliverance. In this context, Jewish rites of freedom are recalled in a space where the pedagogical and the performative coincide; they simultaneously evoke the tragedy of enslavement and the euphoria marking the salvation of a new beginning in a variety of celebratory feasts: Hannukah, the festival of lights, the symbolic reminder of the freedom which the Maccabees paid for with their lives; Purim, the liquidation of the tyrant Haman through the charms of Queen Esther; and Passover, the deliverance of the Jews from the bondage of the Egyptians. These ritualistic festivals, marking the eternal return of the oppressor and the oppressed, make the Jewish people subjected to a historical process that inscribes them in a syntax of repetition, the ultimate sign of their ethnic destiny. The insecurity handed down from generation to generation puts Jews in a situation of inner restlessness that is incapable of ever being quelled.

From Memmi's perspective, Jews are victims of a tragic fate. Bearing the intolerable burden of the Jewish condition, Memmi's Jewish subject is constructed through a strategy that ascribes to that figure a pre-given origin—

"everything that happened to us was deemed inevitable" (p. 24)—which becomes the *locus* of Jewish discontent. Memmi's narrative aligns his self-perception with what he views as the universal condition of Jews:

> The Jewish fate . . . is first of all one of misfortune. . . . Are there no happy Jews? I am tempted to answer: no, not as *Jews*. No, in truth, I know scarcely any Jew who rejoices in being one. There are Jews who, perhaps, are happy in spite of their Judaism. But because of it, in relation to it—no! Adjusting to it, eluding it, forgetting it, if one can. The moment you face it, the moment it arises, it inevitably becomes a strain, another shock, an honorary obligation if you insist, but in every way a burden. (p. 21)

To be Jewish is, first and foremost, to be a victim of an all-encompassing sorrow and the target of constant accusation. The apparent emptiness at the base of the Jewish condition stems from a feeling of paralysis that functions as the sign of spiritual malaise. But if, as Memmi claims, this figure of unhappiness appeals to Jews, it is because Jews long to identify with it, and ultimately find in it what they believe is most becoming to their self-image.

In essence, Jews discover a sense of mortality in the "individual condemnation" constituting the Jewish condition, and not in some abstract or collective way. From the moment that being a Jew is perceived as an inescapable fatality, one can no longer ignore it, for, according to Memmi, Jewishness is always already a condition of uneasiness which demands recognition. Yet the "Jewish nature" referred to here by Memmi is not totally essentialist in character; rather, it is the result of a fostered anxiety created by the misfortune of living in a world of threats:

> Sooner or later, be the discovery slow or sudden, hesitant or an overwhelming, decisive intuition, a man becomes aware that he is a Jew. Sooner or later each Jew discovers his little Jew, the little Jews he sees around him and the *little Jew* who, according to other men, is within him. . . . I am a Jew. I am a Jew to myself. I am a Jew to other men. It is a fact, definite, compact, important for me and for others. (p. 26)

Not only does Memmi assume the Sartrean hypothesis that anti-Semitism emanates from the gaze of the other, but he also dramatically demonstrates that the production of an image of identity within the self functions like an eye/I from which it can never escape. To be sure, an existential agony emerges from this Jewish subject, whose being is trapped within the claustrophobia of self-reflection. "You cannot be a Jew," Memmi claims, "and not think about it" (p. 27). Jewishness can never be anything beyond the mere reification of torment, the reflection of a problem that the Jewish subject interiorizes. "I am a problem . . . in our societies the Jew is of necessity

considered a problematic being; he is driven to become a problematic being. A problem to other men, why would I not be a problem to myself" (p. 54).

Memmi's definition of Jewish subjectivity is therefore based on a theory of ethnicity that denies a certain amount of freedom to Jews. At times, Memmi perceives Jewishness as a phenomenon derived from "social facts" which, to a certain extent, are beyond the realm of the individual and external to the embodied subject of desire:

> I can recognize myself as a Jew or pretend to forget it, I can seek to develop myself as a Jew, or attenuate or hide my Jewish characteristics. But in a certain way, I am already outside of myself; in a certain way the Jew is above all still a Jew. Jewishness is first of all a collection of facts, conduct, customs which I find in myself, but especially outside of myself, through my entire life. (p. 288)

The question of identity functions like a reflex reaction, a self-awareness that affirms Jews' distinction from others as the result of the spatiotemporal parameters of socially and historically given situations. The illusion of individuation as it is described here is rooted in the cultural alignment of a group whose transcendental grounding is embodied in an invariant structure whereby one just is a Jew, or simply not.

In spite of the many enviable qualities Memmi associates with Jewish difference, such as strong family ties, monotheism, and the quest for survival, he sees these very qualities as a means of reinforcing the exclusionary tactics practiced by the non-Jew. "Difference," he claims "emphasizes and seems to make separation legitimate. Separated, the Jew cannot help feeling that he is different, and finally, other men end up considering him as different" (p. 64). Distinguishing Jews from non-Jews is thus understood in terms of difference. Yet it is, according to Memmi, non-Jews who reinforce the experience of Jewish self-consciousness by sanctioning the reality of difference as the founding principle of an exclusionary procedure that forecloses on the possibility of identification with the established order. Without any doubt, difference for Jews simply must be regarded as an accusation that is accepted as an uncontestable problem. "Difference being bad, it is inevitable that the oppressed is automatically charged with it: he is the one who is different, he is the evil one, the ridiculous, the guilty man" (p. 73). This notion is deployed on behalf of a collective subjectivity which idealizes itself in the name of the dominant ideology.

Memmi situates Jews in an intersubjective relationship based on the power of illusion. Looked upon as different, Jews accept themselves as different, and thereby adhere to the collective bewitchment that authorizes their guilt and empowers others to treat them negatively. "The Jew is one of the most

perfect examples of a defendant in our day" (p. 79). The permanent accusation brought against Jews becomes one of the cornerstones of this unhappy condition. Determined by neither real biological nor economic factors, the figure of the Jew represented by Memmi is one that is based more on the idea people have of Jews than on the reality *per se*. The function of this psychological impressionism is to project a mythical portrait of the Jew, an *a priori* presence, in order to justify oppression. "It [the mythical portrait] is the symbol of his oppression; its preliminaries and its crowning point: the myth justifies the oppression in advance and makes the consequences lawful" (p. 179).

What clearly emerges from Memmi's self-portraiture is a description of the Jewish condition perceived as a form of personal oppression that takes on universal proportions. Yet it is in the second part of a subsequent study, *The Liberation of the Jew* (1966), that Memmi offers a corrective to the so-called Jewish problem, in the form of nationhood for the Jews.[5] Born from the liminality of the Jewish condition, the Israeli nation-state is offered as a curative to the Jew's "narcissistic wound," for it is capable of transforming the marginality of Jewish difference into what Homi Bhabha terms "the otherness of the people as one."[6] Turned outside in, Jewish difference becomes the source of "ethnic pride" that is realized within the parameters of nationalistic fervor.

> The specific liberation of the Jews is a national liberation . . . and this national liberation of the Jew has been the state of Israel. . . . Only a national solution can exorcize our shadowy figure. Only Israel can infuse us with life and restore our full dimensions. Only the liberation of a people can provide a real opportunity to their culture. (pp. 285, 296)

The abundance found in the promised land is invoked by the figure of hyperbole which summons Jews to acquire full ontological status in the liberating culture of the nation-state.

Conceived as absolute foreigners, Jews can only transcend alterity and the menace of discriminatory practices by constructing a Jewish nation where the plenitudinous space of homogeneity shall reign. "For Israel alone can put an end to the negativity of the Jew and liberate his positivity" (p. 294). Nationalism imposes itself by exorcizing the shadowy figure of the Jew, and by desanctifying a cultural tradition that is a symptom of oppression. Jewish liberation paradoxically depends on the disappearance of Jewishness as it had been previously known. Understood in these terms, the deliverance of Jewish identity from a state of nothingness represents its own coming into being, its historical emergence from the constraints of the stereotypical Jewish condition. For Memmi, then, the nation represents a

filling presence in which Jews can assume an implicitly normative and positive identity. Ironically, if assimilation finally becomes acceptable, it is because the existence of a Jewish homeland will absolve Jews from the accusation of camouflaging their identity through the practice of assimilation. By gaining the freedom to cease being a "Jew," Memmi's Jewish subject averts the process of enframing practiced by non-Jews, and escapes the classificatory procedure that passes itself off as objective truth. From that process, Memmi's liberated Jews achieve authority and the affirmation of identity through a difference that is almost no longer one. In the end, the exclusion necessary for the nation-state to exist is analogous to the exclusion necessary for narcissistic identity to take shape.

Alain Finkielkraut's *The Imaginary Jew* (1980) also uses Sartre's meditation on the Jewish question as the point of departure for his *autocritique*.[7] Born after World War II, the child of middle-class Holocaust survivors, Finkielkraut questions the Jewish identity he assumed by donning the tragic mask representing the pain of the previous generation of Jews. By initially adhering to the Sartrean model, Finkielkraut believed that he authentically lived the Jewish condition by affirming a pregiven identity through gestures, language, and affect:

> Sartre said to me with unquestioning rigor that I was an *authentic* Jew, that I *assumed* my condition and that it took courage if not heroism to claim loud and clear that I belonged to a people held in such contempt. The terms chosen by Sartre literally made me drunk: in them I read my life, written in sublime style. Through them, my proclamations of loyalty seemed like true acts of bravery. (p. 16)

The text of Sartre's *Anti-Semite and Jew* provided Finkielkraut with a message not only of difference, but also one of value. For him, it was the production of this image of identity, that is the being for an Other, which certified his existence in the world. However, in due course Finkielkraut came to realize that this claim to self-recognition found its criteria in impulses and gestures functioning as mere bravado:

> On one side me; facing me, the others. That is the novel in which I spent the greater part of my life. Raised by an imprescriptible decree above the crowd and a common destiny, separated from my contemporaries without their even noticing it, I was the one who was different, the one who had been skinned alive, the survivor, and I never got over savoring that image. (p. 15)

In *The Imaginary Jew*, Finkielkraut rejects his adolescent appropriation of Sartrean theory which paradoxically nurtured his bad faith. By uncritically

adopting the Sartrean image of the so-called "authentic" Jew, Finkielkraut created instead a simulacrum of the Jew, a *persona* whose malaise was totally foreign to him. This psychic ontology of Jewishness was rooted in a theatricality projected by a Jewish subject whose existential condition was pure myth. "My megalomania proved to be legitimate, for my gestures were acts and my theatre was commitment" (p. 17). Clearly, the refusal to assimilate, as it was realized in the Jewish subject's "acting out" of a predetermined role, ironically enabled him to engage in an imaginary form of heroism. The staging of this cultural self-fashioning is a fallback to a fantasy life of sorts, and its ontogenesis within the context of Finkielkraut's family romance reveals that his identity was more the result of a past he had not lived rather than of the reality of his present condition. Finkielkraut's "I" was not a reimaging of the "we" of a family to which he belonged, but one whose unthinkable history could only become his own through the creation of a fictional scenario.

The ideology of difference realized through the histrionics of this so-called politically committed youth was grounded in what appeared to be a particular historical moment (World War II) and a specific political situation (the Holocaust). Yet one could view Finkielkraut's socially constructed difference as the demand for a narcissistic investment in the bliss of a novelistic existence. In essence, he became a Jew not as a result of the Other's gaze, but in order to render himself more desirable for the Other. "To say 'I,' is to already strike a pose, and mourning for the Self must always be begun anew—the vain, seductive and voracious self which draws to itself the history of an entire people and annexes that history to its need to be loved" (p. 208). Recognition, the knowledge of the aim of desire, supplies the energy and motivates this Jewish actor's will towards the power of self-representation.

Finkielkraut's appropriation of the adjective "Jewish" enabled him to engage in a self-fashioning that controlled the power of the gaze, and made him appear the way he wished to be perceived. "For a long time, I retained from Judaism only the adjective it awarded me a right to use and the narcissistic use that I could make of it. Jew: as in Just, Proscribed, Victim, Rebellious People, the vale of Tears" (p. 207). In projecting the spectacle of his otherness, Finkielkraut represents the differentiating order of the Jewish subject as that which is unique. By committing himself to a so-called Jewish ontology, Finkielkraut situates the process of identification in the path of desire. If Jewish identity is so special for Finkielkraut, it is because doing things differently turns out to mean doing them better; it requires a process of self-selection that empowers an oppressed subject through the authority of critical perception. "What I therefore derived from my use of Judaism was neither a religion nor an ethic, but rather the assurance of a superior sensibil-

ity" (p. 16). The exemplarity depicted here almost takes on racial overtones, for it is built upon an epistemology of forcible separation—between Jews and their "others"—functioning in the name of difference for the sake of a utopian identity.

In this context, Finkielkraut's Jewishness is represented as an imagined Jewishness, based more on the power of illusion than on reality *per se*. In effect, the notion of the imaginary Jew is transformed into an anachronistic figure subjected to a nostalgic relationship with the past. Protected from the historic dangers of anti-Semitism, Finkielkraut was able to portray the imaginary capture of the subject in an image that was little more than a Jew *in absentia*:

> The famous right to difference hid under its exterior of freedom an insidi-ous constraint: the obligation to think Judaism in terms of self and identity. "I am Jewish," I said, and this sentence condensed my entire knowledge of Judaism, my deepest truth and my rediscovered dignity. I only spoke one language and it was the one that made demands. Settling down to a life of defiance, I spent many happy days on the edge of the social order, enchanted with the character I was playing. It was this role more than anything else, more than social pressure or the imperatives of assimilation that kept me away from Jewish culture. (p. 215)

Finkielkraut's text draws our attention to the question of identity as a process of self-differentiation as it is projected by the Jewish subject. In this strategic display of difference, Finkielkraut dissimulates the content of "real" Judaism behind a politically correct identity politics in which an assumed sense of oppression positions the ego as the imaginary recipient of what he terms an "ornamental Judaism." Occupying the space of the victim allowed Finkiel-kraut to express a very deep sense of arrogance by permitting himself to become the *locus* of the Jewish soul. The representation of Jewish identity had less to do with the racist's traditionally conceived biological view of reality than it did with the projected affectivity and apparent credence in Jews' superior understanding of the world.

> I would never have thought of using the execrated term "race" and yet, saturated with the sensitivity of my people, . . . I implicitly pledged alle-giance to the determinism of racial thought. Without knowing it, I was a "Barresian." I could therefore do without memory: Judaism thought and spoke in me. (p. 48).

This racially charged iconographic representation of Jewishness presented a model that synthesized the general qualities of a group, and through that process made race become the "soul" of history.

Yet if the politics of race came into play for Finkielkraut and his rebellious friends of 1968, it was only used, as he later came to realize, for the purposes of a metaphoric posing by a generation that had never truly suffered a day of their lives. When the student radicals of May, 1968 claimed that "we are all German Jews," they articulated a discourse in which the field of the "true" emerged as the effect of a political "staging." In their curious self-conception, sixties radicals practiced a politics of betrayal toward those who had experienced the violence of the ghetto and the scars of deportation, by forming an identity based on the re-presentation of a Jewish past that is re-membered in vain. Doomed to an exile of another kind, Finkielkraut domesticated Auschwitz, a phenomenon that put the "I" in an enunciative position that generated a significant discontinuity with the past. "Our existence, neither seen nor known, took off toward a higher social category . . . all German Jews? Come on now, we were all imaginary Jews" (p. 30). Ironically, this posing is predicated on an emptiness resulting from the representation of an image of history no longer present. To recognize the difference of Jewish presence is to realize that the figure of the Jew, as Finkielkraut portrayed it, occupied a space of double inscription. What we see here is the subject's demand for authority through the ruse of appearance.

For Finkielkraut, the Jewish condition was therefore experienced as a void or an absence, an identification with something that will never truly be interiorized.[8] "The Judaism from which I have come has acceded to the status of a historical object: it's this sudden distance that makes it both a painful and desirable object for me. I now feel its absence while up until now I have only had the experience of my own Jewishness" (p. 213). Unable to ascribe this feeling of nothingness to the effect of contemporary anti-Semitic practices, Finkielkraut sees it as a phenomenon emanating from the emptiness of his own history and the illusion that he was committed to a Jewish way of life. "Judaity is what I lack and not what defines me" (p. 51). To conflate the question of Jewish identity with the practice of Judaism was indeed an attempt to fashion a self, a *Luftmensch,* who took the label "Jew" stereotypically and isolated it from more serious religious practices. The construction of such an epistemological object made the signifier of Jewishness become a mere façade camouflaging a spiritual lack.

Stripped of its singularity, the figure of the Jew, as portrayed by Finkielkraut, falls prey to the homogenizing power of the contemporary world and the erosion of ghetto culture. "In my haste to bear the weight of Jewish destiny, in my desire to merge with my people, I forgot one thing: there is no longer a people" (p. 49). On a symbolic level Jewish life has twice disappeared for Finkielkraut: once as the result of the genocide, and yet again through the need to dispose of the so-called "victim" who spoke and thought Jewish identity without ever really "experiencing" it.

But what remains for this Jew who is no longer able to opt for a parenthetical existence in the syntax of culture, the Jew who has been abandoned to the Diaspora of the postmodern world ("a society sprinkled with an infinity of individual islands" [p. 109])? Unlike Memmi, Israel offered Finkielkraut limited hope. On the one hand, he saw the creation of the State of Israel as an antidote to the historical problem of anti-Semitism, by allowing Judaism to be named as an identifiable difference and therefore made free of any immediate danger. But on the other hand, the Zionism that was the impetus for its creation produced a reaction that threatened the idealism of the Jewish experiment. For Finkielkraut, nationhood paradoxically allowed Jews to identify with the idea of race.[9] Placed within a dialectical framework, this response to Israeli nationalism produced a counter-discourse which became the "poison" activating the return of the repressed, a discourse which at times degenerated and approximated a new form of anti-Semitism. So in attempting to liberate himself from a cultural identity once again founded on the ideal of persecution, Finkielkraut instead opted for (but never really adhered to) the more authentic rituals of Judaism by making this marginalized residue of Jewish life the *locus* where the displaced Jewish subject could potentially retrieve a plenitude of sorts. "The rites that we perpetuate with the timidity of beginners and the clumsiness of amateurs are not the center . . . of Judaism: they are its residue. . . . [These rituals] now serve as our only chance to escape the fate of becoming imaginary Jews" (p. 123).

To be sure, the value of Finkielkraut's quest may be found in the desire to relocate the Judaic beyond the anguished presence of the void within the Jewish self. In a way, one might claim that Finkielkraut attempts to transcend a worn-out identity politics that trades upon naïve, referential, or realist assumptions derived from the ethnocentric impulses of an imagined community. "The undefinable quality of Judaism is precious: it shows that the political categories of class and nation have only relative truth. It marks the impotence of thinking the world as a totality. The Jewish people do not know what it is, they only know that they exist . . . " (p. 204). By situating himself before an *infinite* he does not quite understand, Finkielkraut, like Lévinas before him, sees the individual in an ex-ceptional relationship with Judaism, which itself becomes the site of transcendence, the *locus* of a concept without a name.[10] Having lost its unifying thread with the world, the figure of the Jew can only hope to rediscover plenitude in a desire that constitutes the quest for the infinite.

In the somewhat atypical text *Circumfession* (1990), Jacques Derrida explores the question of identity through a self-portrait consisting of fifty-nine fragments.[11] These periodic self-reflections are part of a book by Geoffrey Bennington which includes his *Derridabase*, a study of the major theoretical *topoi* of the Derridian *corpus* which is typographically situated above the

ongoing inscription of the philosopher's writerly self-image. *Circumfession* becomes the *corpus,* the rhetorically embodied life of Derrida scattered in fragments which intermittently enter a dialogic rapport with and critique of Bennington's text.

Derrida's self-portrait plays on the con-fusion created between the confession drawn from Augustinian tradition and the symbol of circumcision, the mark of difference inscribed on the body of the Jewish male, signifying identity, separateness, and loss. Derrida draws upon an intertext found in *Genesis,* where circumcision is enjoined by God upon Abraham and his descendants as the penultimate obligatory act of adherence to Judaism.[12] Functioning as the sign of the convenant sealed in the flesh (*berit milah*), circumcision marked the body of the Jewish male as exemplary and unequal to that of non-Jew. This ritualistic practice gives birth to a Jewish subject through an indelible mark left on the body by an Other, and through the ceremony, in the course of which the *mohel* bestows on the child a name. Identity is constructed in and founded on Jewish law. As a result, Jewishness is the effect of a particularistic and exclusionary procedure that differentiates Jews from all other races.

If in its ceremonial practice circumcision enacts a loss that paradoxically signifies the blood of lineage or the idea of belonging, the "cutting" that metaphorically realizes the circumcision within the Derridian text represents an originary violence that reproduces in its inscription the emission or transmission of a seed that is the result of an exit from the economy of the same. The self-portraiture in *Circumfession* not only enacts the wandering in the desert of deconstruction, but it also traces the figure of a Jew represented under the sign of a cut which makes identity the contour of periphrasis or the result of differences derived from the same:

> Circumcision, that's all I've ever talked about . . . yes but I have been, I am and always will be, me and not another, circumcised . . . CIRCUMCISED, across so many relays, multiplied by my culture . . . CIR-CON-SI, imprints itself in the hypothesis of wax [*cire*], no, that's false and bad, that doesn't work, but saws [*mais scie*], yes and all the dots on the i's, I've greatly insisted on it elsewhere . . . but that's what I was talking about, the point detached and retained at the same time, false, not false but simulated castration which does not lose what it plays to lose and which transforms it into a pronounceable letter, i and not I, then always take the most careful account, in anamnesis of this fact that in my family and among the Algerian Jews, one scarcely ever said "circumcision" but "baptism," not Bar Mitzvah but "communion," with the consequences of softening, dulling, through fearful acculturation. (p. 72)

Unlike the ancient Judaic tradition whereby circumcision is a ceremony in which a name is bestowed on the child as representing the essence of its

bearer, the Derridian circumcision practiced in the text portrays a splintering of the subject that is the result of metonymic contamination. If the proper name is indeed the sign of a concrete individual, the mark inscribed on the Derridian *corpus* is drawn into a system of differences that cuts round or encircles a scriptural self situated on the periphery of a void. "Circumcision remains the threat of what is making me write here, even if what hangs on it only hangs by a thread and threatens to be lost" (p. 202). The birth of the subject that circumcision is supposed to ritualistically enact ironically produces in Derrida's text an identification based on the transcription of the differences within the self. The blood that is the result of the outpouring of circumcision represents an ontological ellipsis; it can only be compared to the liquidity emanating from the flow of Derrida's pen-syringe which produces a simulacrum of being: "it's me but I'm no longer there" (p. 12).

This being without a core that Derrida depicts in the self-portraiture constituting *Circumfession* transcribes, however, "what remains of Judaism" (p. 303). Speaking as a Jew, Derrida paradoxically engages in an Augustinian-like avowal, and directly addresses a non-transcendent "god" to whom he remains both tied and endlessly estranged. The "god" in question is everywhere before him, a hidden "god" who is "not known by this or that name" (p. 263). Like Lévinas, Derrida's quest affirms in its practice a relationship with an elusive otherness which takes the form of an ethical stance that ideally anticipates the fullness of truth and justice, and yet ironically relegates that revelation to an undisclosed future:

> We'll have to get up early, at dawn on this day with no evening, for after all but after all what else am I in truth, who am I if I am not what I inhabit and where I take place. *Ich bleibe also Jude,* i.e. today in what remains of Judaism to this world, Europe and the other, and in this remainder I am only someone to whom there remains so little that at bottom, already dead as son with the widow, I expect resurrection of Elijah, and to sort out the interminably preliminary question of knowing how they, the Jews and the others, can interpret circumfession, i.e. that I here am inhabiting what remains of Judaism, there are so few of us and we are so divided, you see, I'm still waiting before taking another step and adding a word, the name from which I expect resurrection. . . . (pp. 302–303)

Derrida looks to the future and finds hope, and expectation in the figure of Elijah and the metaphor of a Sabbath without end, which he specifically borrows from both Talmudic and Augustinian (*Confessions* XIII) traditions, where the Seventh Day is depicted as a *lacuna* in the continuity of creation. Like Elijah, the guardian of circumcision and the most "eschatological" of the ancient prophets to whom he relates through the semantic contiguity

of his given name Elie, Derrida assumes the image of that celestial messenger wandering incognito over the earth in the garb of a nomad. The invisible presence of Elie-Elijah draws attention to what Derrida terms "the eschatology of circumcision," whereby the image of the scar (from the Latin *escarre*) emblematizes the violence done to writing whose traces anticipate but never fully give rise to a self-present truth. "It is impossible to follow my trace . . . I never write or produce anything other than this destinerrancy of desire, the unassignable trajectories and the unfindable subjects" (p. 199).

If Derrida's self-portrait enacts the figuration of what remains of Judaism, it is in order to put into play a thought that resists mastery through the simulacrum of circumcision. Far beyond the reductiveness of the ontotheological tradition, Derrida's prophetic discourse breaks open the language of the text, and engages in a scriptural practice generated by "the secret I am excluded from" (p. 155). The possibility of questioning produces a writing-of-exile that in many ways is analogous to Jewish exegetical tradition, and which projects the image of a future (*avenir*) that is infinitely differed (*à venir*). The circumcised word in the Derridian text "bleeds" the materiality of language in a confessional mode, and is disseminated in the fragments of a scriptural *corpus* where the Jew is depicted as a trope functioning under the sign of a cut. "The disfiguration reminds you that you do not inhabit your face because you have too many places, you take place in more places than you should, and transgression itself always violates a place" (p. 124). In effect, the alterity that the Jew represents for Derrida engages the figure of the writer in a quest without closure, in an endless pursuit of the "other in me" (p. 216) which itself re-turns the possibility of revelation. Identity is, therefore, the result of the scars of self-portraiture and the eschatological longing that may never be realized. Jewishness becomes a somewhat precarious enterprise as it enters the realm of undecidability. Nevertheless, the repeated gesture of circumfession produces, through analogy, a ritualistic reenactment of the biblical convenant that paradoxically undoes the absolutism of sacred law, and defies the naming of the subject. The drive toward sameness underlying the Jewish practice of circumcision, which has imprisoned Jews in a universalism of sorts, is dramatically undermined by Derrida's textual *praxis*, which reaffirms the right of difference to be different.

What characterizes the writing of self-portraiture in these exemplary case studies is the desire to transcend the limitations of homogenization and the adherence to the image of a universal Jew. The necessity of establishing a politics of difference beyond the essentialist assumptions of anti-Semitic traditions allows each of these writers to establish a Jewish subject position founded on a concept of ethnicity that is rooted in particularist concerns. Nevertheless, there is hardly a unifying voice that emerges in this struggle.

On the one hand, Memmi and Finkielkraut composed their self-reflections in the shadow of Sartrean negativity, in which the figure of the Jew is conceived as an essentially secular being, suffering from an intense spiritual malaise. On the other hand, Derrida's unconventional self-portrait draws on a variety of references, particularly from Judaic scripture which, in spite of projecting a radical scepticism, offers the illusion of hope.

To reflect critically on Jewish identity in the contemporary world signifies, as Lévinas suggests, that it is perceived as something already lost.[13] For the rational universalist Sartre, "real" Jewishness is unchanging; it is subject to a theatricality that paradoxically advertises itself as a form of authenticity. As Sartre's analysis unwittingly suggests, if Jews were not designated "Jews" by others, their sense of self would virtually disappear. Possessing neither historical specificity nor religious content, Sartre's Jew is imprinted on a flat surface camouflaging the vacuous presence of a subject who can only be apprehended by the absence it constitutes.

If Sartre represents a stereotypical idea of Jewishness resulting from a menacing gaze, then Memmi and Finkielkraut's desire to transcend this simulacrum of being can only be realized by overcoming the perception of *absence* attributed to the Jewish condition. In the case of Memmi, the fulfillment of cultural identity is inextricably linked to the invention of an Israeli state, where the absolutism of Jewish difference is subsumed by the Zionist exigencies of the Same. Impelled by the desire to get beyond the reality of persecution, the Jewish subject exchanges the emptiness of the Diaspora for the plenitude of in-difference.

In yet another example, Finkielkraut's sense of emptiness is derived from the self-imposed difference of the imaginary Jew, one who is not simply a Jew, but merely Jewish. By wearing the mask of Jewish suffering, Finkielkraut ironically occupied the space of the Other as a missing person. Whereas Memmi finds solace in the Enlightenment ideal of progress, Finkielkraut's only hope of recapturing the lost identity of the Jew may be realized by going back to the future, where the residue of Judaism offers the potential of restoration through religion (*religere*, to read over again, or to bind). To be sure, Derrida also insists on the absence motivating the writing of his self-portraiture. But if the concept of "identity" is invoked it is never as a reaction to anti-Semitic practices as such; it is only through a rhetorical strategy which, in its formlessness, emblematizes the infinite to which Jews are subordinated. "All that turning around nothing, a Nothing in which God reminds me of him, that's my only memory, the condition of all my fidelities, the name of God in the ash of Elijah, an evening of rest that never arrives" (p. 273). Yet, unlike Finkielkraut's recuperative tactics, Derrida's scriptural positioning, realized through the practice of circumcision, transforms his rhetorical acrobatics into a labor of love. In the end, Derrida's

self-portrait represents survival itself, as it guarantees the play of difference as that which remains of Judaism.

Notes

1. Jean-Paul Sartre, *Anti-Semite and Jew,* trans. George J. Becker (New York: Schocken, 1976). After having completed this essay I read with great profit the excellent study of Daniel and Jonathan Boyarin, "Diaspora: Generation and the Ground of Jewish Identity," *Critical Inquiry,* 19 (Summer 1993), pp. 693–725.

2. For an interesting analysis of some of these issues, see Herman Lebovics, *True France: The War Over Cultural Identity, 1900–1945* (Ithaca: Cornell University Press, 1992).

3. Albert Memmi, *Portrait of a Jew,* trans. Elisabeth Abbott (London: Eyre and Spottiswoode, 1963).

4. On the question of Memmi's novelistic representation of cultural estrangement, see *The Pillar of Salt* (1953), trans. Edouard Roditi (Boston: Beacon Press, 1992).

5. Albert Memmi, *The Liberation of the Jew,* trans. Judy Hyun (New York: The Orion Press, 1966).

6. Homi K. Bhabha, "Dissemination," in *Nation and Narration* (London: Routledge, 1990), p. 301.

7. Alain Finkielkraut, *Le juif imaginaire* [*The Imaginary Jew*] (Paris: Seuil, 1980). Translations are my own.

8. For a discussion of the *topos* of absence in Finkielkraut, see Judith Morganroth Schneider, "Albert Memmi and Alain Finkielkraut: Two Discourses of French Jewish Identity," *Romanic Review,* 81 (1990), pp. 130–136. Also see Judith Friedlander, *Vilna on the Seine. Jewish Intellectuals in France since 1968* (New Haven: Yale University Press, 1990).

9. "Ultimately the nation must identify itself, spiritually as well as physically or carnally, with the race, the 'patrimony' to be protected from all degradation (and as for the race, so for the culture as substitute for, or interiority of, the race)." Etienne Balibar, "Paradoxes of Universality," in *Anatomy of Racism* (Minneapolis: University of Minnesota Press, 1990), p. 284.

10. The key essay here is on "God and Philosophy" in *De Dieu qui vient à l'idée* (Paris: Vrin, 1982), pp. 93–127. Also see Finkielkraut, *La sagesse de l'amour* (Paris: Gallimard, 1984); and Robert Bernasconi, "Lévinas and Derrida: The Question of the Closure of the Metaphysics," in *Face to Face with Lévinas* (New York: State University of New York Press, 1986), pp. 181–202.

11. Geoffrey Bennington and Jacques Derrida, *Jacques Derrida,* trans. Geoffrey Bennington (Chicago: University of Chicago Press, 1993).

12. On the *topos* of circumcision and cultural tradition, see James Boon, *Other Tribes, Other Scribes* (Cambridge: Cambridge University Press, 1982); Daniel Boyarin, " 'This We Know to Be the Carnal Israel': Circumcision for the Erotic Life of God and Israel," *Critical Inquiry,* 18 (Spring 1992), pp. 474–506; Howard Eilberg-Schwartz, *The*

Savage in Judaism. An Anthropology of Israelite Religion and Ancient Judaism (Blooming-ton: Indiana University Press, 1990).

13. See Emmanuel Lévinas, *Difficile liberté* (Paris: Albin Michel, 1963).

8

Jewish Identity in Raymond Aron, Emmanuel Berl, and Claude Lévi-Strauss

Jeanine Parisier Plottel

It used to be said, with a twinge of irony, that every country has the Jews it deserves. What was meant was that the characteristic faults and virtues one finds among the descendants of Jacob should be attributed to the influence of various cultural practices of the lands in which they happen to live, rather than to a Jewish quintessence. In this perspective, when we consider the Frenchmen Raymond Aron, one of the leading political scientists of our time, Emmanuel Berl, an underestimated and neglected essayist and historian, and Claude Lévi-Strauss, preeminent social anthropologist and paragon of structuralism, and if we attempt to characterize how they viewed their Jewish identities, it is likely that what will be established may not be Jewish at all. To paraphrase Jacques Lacan, the "Jew" does not exist, but Jews do. The "Frenchman" is a myth, but Frenchmen are alive and well.

A few biographical facts: Aron, born in 1905, was three years older than Lévi-Strauss, who was born in 1908, and thirteen years younger than Berl, born in 1892, who was himself twenty-two years younger than his friend Marcel Proust. If one designates a generation by assessing the central historical event shaping that generation, from the perspective of the Dreyfus Affair, the parents of the three men belonged to the generation most touched by it, and their beliefs presumably affected their offspring. Berl was a young child at the time of the trial in 1894, and like Aron and Lévi-Strauss, he knew about it only secondhand.

If World War One is used as the determining factor, then one must remember that while Berl participated in what was supposed to be the war to end all wars, the other two were children of the home front. One should take notice of this when venturing to grasp why Berl applauded the Munich

peace efforts. Like many World War One French veterans of varying political colors, he became a pacifist because his experience had taught him that war was something repugnant that made "you live in trenches with rats running on top of you."[1]

None of the three actually fought in World War Two, and in this respect they resemble other Frenchmen of their age. Their Jewishness itself, however, needs to be taken into account here, because like almost all mainland European Jews living before 1945 who remained alive, they are but accidental survivors of the genocide that included at least six million of their brethren. I contend that European Jews who were contemporaneous with this occurrence, no matter the number of decades between their dates of birth, may be said to belong to one extended generation. Probably almost none among them retained an intact view of his or her Jewish identity.

The Jewish bourgeois families into which these three were born are similar in obvious ways. Their ancestors came from Alsace or Lorraine, and while the grandparents kept up Jewish traditions—for instance Lévi-Strauss's maternal grandfather was the Chief Rabbi of Versailles—the parents themselves were very assimilated. In Berl's words: "Families that remained Jewish, but at the same time, were not really so. They found conversion repugnant, but they no longer went to synagogues."[2] They were fervent French patriots. According to Aron, it is unlikely that they ever asked themselves the now fashionable question: Jews first or French first.

Although Jewish traditions were more or less familiar, none of the parents appear to have been truly religious or observant. Aron's father, for example, who had been a Freemason in his youth resembled his university friends with leftist leanings, be they Catholics or freethinkers.[3] Above all, these households stressed the value of education, and tried to encourage their children to compete for admittance into prestigious schools in order to earn the highest degree possible. Berl's mother's aim for her son was that he get into l'École Normale Supérieure. Her greatest happiness would have been for him to have become a professor engaged in a perfectly useless task of great intellectual challenge, for example, rendering into Greek an extremely difficult Sanskrit text.[4]

In the nineteenth and early twentieth century, one's educational achievements proved an efficient way to assimilate into elite French society. This was true not only for Jews, but also for anyone who wanted to climb the ladder of success. It was part of the republican credo and of the ideology of the Third Republic that differences of social condition could be eradicated by attaining intellectual distinction. While it is possible that many individuals are indeed motivated by ambition, and pursue learning not for learning's sake, but for more mundane reasons having to do with fame and wealth, one cannot deny that many others seek to acquire knowledge for no other

reason than they want to know what there is to be known. At the same time, while it may be true that the respect for learning is an enduring tradition in the history of the Jewish people, in the perspective of our secular society, the intellectual who is Jewish—Berl, and Lévi-Strauss—should not be placed in a special class.

In this connection, Didier Eribon, who conducted a series of interviews with Lévi-Strauss, reported to him that his fellow anthropologist Alfred Métraux was purported to have written in his *Journal* about his colleague that he was "the very type of the Jewish intellectual."[5] Lévi-Strauss maintained that such a verdict didn't disturb him at all, and that he was willing to concede that certain attitudes may be more common among Jews than elsewhere. Jews often have a deep sense of belonging to a national community at the same time that they are painfully aware that many members of the community reject them. This may make a Jew particularly sensitive, and in order to disarm any latent criticism, he or she often tries to prove him or herself by working harder and by being more perfect than is necessary.[6]

This can be illustrated by the worry that Jews often have that a Jew in a position of power may not benefit other Jews. She or he, it is surmised, will go out of his or her way to be evenhanded in order to ensure that he or she cannot be reproached with favoring other Jews in any way. The consequence is often that the abuse of impartiality may lead one to discriminate against one's own people. It was a similar delusion that made many French Jews insist that they were required more than any other citizens to prove their allegiance to France. Paradoxically, their Judaism was often the factor responsible for their striving to be more French than the French.

Alain Finkielkraut has used the term "imaginary Jew" to denote Jews who have experienced disability only vicariously by identifying with Jewish suffering second-hand. Conversely, I propose the designation "imaginary Frenchman" for individuals who adopt a stance of ideal patriotism by substitution rather than by actual accomplishments. For example, when Maurice Barrès turned from a decadent dandy into a socially prominent, ardent nationalist, he became an "imaginary Frenchman." Those who follow his pattern belong to this class, which may include someone at one time, but not always, under some circumstances, but not others.

In a comparable vein, the desire of not allowing one's circumstances to determine one's reasoning led intellectuals of Jewish persuasion to set aside their learned tradition in order to adhere to a universal metaphysical ideal that transcended all contingent categories relevant to time, place, genders, race, and nation. The philosophers Victor Basch, the authority on Kant and former president of the Ligue des Droits de l'Homme, who was assassinated by the French *milice* almost at the end of the war, and Léon Brunschvig, a philosophy professor at the Sorbonne, who was affected by Vichy's racial

laws, steadfastly affirmed these positions that would be challenged by their students of the following generation, including Jean-Paul Sartre, Aron, Lévi-Strauss, and others. One recalls that Sigmund Freud tried very hard to seek Christian adepts of psychoanalysis, and that he took great care with Carl Gustav Jung and Ernest Jones, for example. He was intent on ensuring that his discovery gain universal significance, instead of being designated a Jewish science, which was exactly what happened when the Nazis came to power.

Notwithstanding Michel de Montaigne and Marcel Proust, anti-Semites in France, themselves "imaginary Frenchmen," have often claimed in a similar framework and ambience that it was impossible for any sort of Jew to produce authentic works in a given national literature. American academia was appalled to discover recently that, during the last war, the late Paul de Man had written several pages to that effect in a Belgian collaborationist newspaper. In the hubris that followed, there was a failure to recollect that even more respectable writers have upheld this tradition. I am thinking, for example, of André Gide's entries in his *Journal*. But here, I want to illustrate the converse, a Jewish writer hired to compose texts that convey utterly chauvinist Frenchiness. Until recently, a conspiracy of silence surrounded situations of such ilk, but now nuances of inclinations and opinions may be expressed without incurring reprobation.

In 1940, for most Frenchmen and Frenchwomen, Marshal Pétain's speeches, identified with his so-called National Revolution, contained some phrases that would come to symbolize the special French quality of his puppet regime. I am referring to his utterances dismissing politicians of the Third Republic: *"Je hais les mensonges qui vous ont fait tant de mal"* ("I loathe the lies that have been so hurtful to you") and preaching a return to rural virtues: *"La terre, elle, ne ment pas"* ("The earth itself does not lie..").

The Marshal, who was a member of the French Academy, hardly ever wrote a word by himself, and on his staff he kept a stable of ghostwriters, which in the early thirties included Captain Charles de Gaulle. This time, however, someone in his organization, probably his minister Boutheiller, had hired the former editor of the socialist newspaper *Marianne,* a Jew whom *Je suis partout,* the fascist tabloid that would evolve into Occupied France's foremost collaborationist rag, called a *"juif bien né,"* a "well-bred Jew," that is to say Berl, our very subject, to work on his orations. Although his cooperation came to an abrupt end when the Vichy Racial Laws took effect, and he was forced to hide for the entire war, for the rest of his long life he had to bear the cross of having been the actual author of these lines at a time when probably nobody had an inkling of the tragedy that was to unfold.

Although Berl was able to forgive his old and dear friend, the fascist Pierre

Drieu la Rochelle, who for a while believed that the SS were saints, and also Céline, the author of *Bagatelles pour un massacre,* who raved against Jews, among whom he sometimes included Jean Racine, yet the lugubrious Vichy operetta remained for Berl, the way it does for many Jews today, including this writer, the unpardonable sin.

"What stunned and disturbed me," he wrote,

> was the noble conscience of all these persons who were going to betray Churchill on behalf of Hitler, deliver Red Spaniards, Polish and Eastern European Jews, etc. [to the Nazis]. And do all that with an aura of austerity, smug self-denial, work ethic draped in virtuous morality.[7]

Drieu and Céline were absolved because unlike the Vichy clique, "Pétainism's scent of holiness, the former had never believed himself to be an apostle and the latter did not hold himself out as a Saint." According to Berl, the coterie surrounding the Marshal was made up of persons who had been Berl's friends, but who, he claims, "pretended they didn't know me when they strolled by me a meter away. . . . What I still can't stomach is that they felt themselves purified when they refused to shake hands with me, a Jew. . . . They had the impression they were redeeming themselves. . . ."[8]

It is intriguing to observe that heretofore Berl seemed not to have found his previous experiences with anti-Semitism particularly threatening. His viewpoint is characteristic of many Frenchmen, both Jews and Gentiles. Being called names was an archetypal experience of almost every Jewish boy going to school. In recollecting his childhood, Berl relates an incident in which he was stalked from the Lycée Carnot to his house with cries of "Down with the Jews." He countered with punches and blows. When it was over and he had proved his point, he went on his way, arm in arm with his friends.

"This is what fooled everyone in Hitler's anti-Semitism," he wrote in his old age.

> I myself was used to regarding anti-Semitism as a fact, period. That was that. One had no need to be astonished; there was Germanophobia in France, and the North scorned Southerners. I never imagined that it would take on the terrifying forms it took on with Hitler. . . . Although during the Dreyfus Affair the French Press was just about the same as the Goebbels press. . . . Besides, what had been the outcome? Announcing that Jews would no longer be admitted to the Jockey Club? But because except for Charles Haas [one of the models for Charles Swann in Proust's novel] no Jew had ever been admitted, it didn't make all that much difference.[9]

Berl's opinion was that in the nineteenth century and up to World War Two, anti-Semitism represented a modality of the bourgeoisie's perception of itself. It attributed to Jewishness all that it despised about itself. When we recall that, in 1929, Berl wrote a book whose title was *Mort de la pensée bourgeoise* (*Death of Bourgeois Thought*), we are hardly surprised that he once viewed French anti-Semitism in this benign way. If one believed that the feeble bourgeoisie was dying, then one might suppose that anti-Semitism, the self-image of this social class, was just as weak and frail, and would therefore disappear. Today, Burghers and capitalism are very much with us, and alas, anti-Semitism has yet to wither away completely.

There may be another lesson to be found here. The example of Berl's own trajectory is a testimony to the inherent ambiguity of French Jewry's political positions, and it suggests that generalizations are precarious at best. How are we to define this Jew who was a friend of Drieu la Rochelle and André Malraux, a socialist newspaperman who was opposed to French intervention during the Spanish Civil War, and who published his paper by doing his best to reflect the point of view of the Quai d'Orsay and his friend Alexis Saint-Léger (alias Alexis Léger, alias Saint John Perse), a pacifist who was a passionate partisan of Munich, a stylist who was asked to write part of Pétain's first two speeches in order to ensure the quality of its French language? Inexorably, at the end of his life, this totally assimilated French Jew, whose cousin Lisette Franck, an "honorary Aryan" had married Fernand de Brinon, the Vichy ambassador to the Germans in Paris who was executed in 1947 for collaboration,[10] discerned that Judaism remained an intractable category of being and would spend his last years, with the kabbalah at his bedside, studying Jewish mysticism.

Aron, echoing Berl's contention that pedestrian anti-Semitism had not served as a warning of what was to come, looked back on his Jewish itinerary with restrained puzzlement, but contrary to Berl, his path appears to have a certain consistency. An early student of phenomenology, he studied in Germany, and in the thirties, in the wake of rising anti-Semitism, he made it a point to assert his Jewish origin.

When the war broke out, he made his way to London, where he was charged with writing *Chroniques de France.* He took special care to achieve an objective tone, and according to Richard Cobb, the great English historian of the French Revolution, it was the only French publication one could read that was a cultivated review without any excessive propaganda or polemics.[11] Yet, when Jean-Louis Missika, a young TV journalist working on Aron's *Interviews* for the French television station *Antenne 2,* wondered why he had been so discreet about Jewish questions, with hindsight, Aron expressed consternation at his lack of coverage of the Vichy Jewish statutes or the *Vel d'Hiv* round up. At the time, because he was a Jew, he probably believed it

was his duty as a Frenchman to avoid dwelling on a subject that might be construed a parochial one. The nagging question here is whether these scruples—was he being somewhat of an "imaginary Frenchman"?—led him to betray in some way the concept of fraternity that is at the root of what is universal in the ideals the French Revolution has bestowed to the rest of the world. Here is what Aron pleads in his *Memoirs* in the 1980s:

> Today still, I am haunted by a doubt. What did we know about the geno-
> cide? Did English newspapers allude to it? If so, was it a hypothesis or an
> assertion? At the level of plain consciousness, my perception was more or
> less the following: concentration camps were cruel, managed by convict-
> guards recruited not among political prisoners, but among common-law
> criminals; mortality was high, but as for gas chambers, industrial murder
> of human beings, no, I acknowledge that I did not imagine this, and
> because I could not imagine this, I did not know.[12]

Many Germans have offered the same excuse for their lack of awareness. In view of the enormity of the crime, one hesitates to believe them. Yet Aron's objective testimony about his own convictions may provide some evidence that they may be telling the truth. He elaborated further: "I did not attribute, even to Hitlerites, the idea of *Endlösung*: the cold killing of millions of men, women and children, a monstrous operation by a people of high culture, who would have forecast this?"[13] Still, perhaps he should have followed up whatever hints there were. It was rumored in London, for example, that two leaders of the *Bund* had committed suicide in order to attract the world's attention to the genocide taking place in Eastern Europe. Who can blame Aron, however, when the two men besides the Pope, who knew and might have spoken, Churchill and Roosevelt, remained silent!

One should remind the reader that Aron was the man who served as Sartre's model for the depiction of the authentic Jew. He asserted his religion, but for the remainder of the war none of his published political stances could be attributed to his Judaism. In 1945, he did not participate in *"l'épura-tion,"* in reprisals against collaborationism; he was one of the first individuals to encourage reconciliation with Germany. In 1947, he took notice of the birth of Israel without fanfare, and his references were to French interests in the region, and to the ambiguous rules of political morality.[14] His position was that we belong to only one nation, but in a democratic regime national allegiance does not have totalitarian characteristics. Consequently, it is possi-ble to be French and be attracted to Israel. But one need not live in Israel in order to perpetuate the heritage of Judaism. When he was asked the question whether a French general who is Jewish would execute orders if these orders were directed against Israel, Aron's answer was that a French general obeys the orders of his superiors.

It follows that his own commentaries on the Middle East respected these constraints insofar as he supported Israel's right to exist, but recognized the grievances of the Palestinian population and the entire Arab world. In any case, a Jew whose culture is French, who is a citizen of France—and one must not forget that there were Jews in France before there were Normans—need not declare himself a Jew if he chooses not to do so. As to the question of whether there is a Jewish people, all that Aron is willing to assert is that if there is such a people, it is a people unlike every other ethnic or national group, alone, unique, and unto itself.

In view of these positions, Aron himself was astounded at the intensity of his feelings when Israel was attacked by Egypt in 1967. Like many Jews all over the world, he found himself more deeply affected and engaged than he had believed possible. Why and how?

The phrase that was to confirm him in the revelation of his loyalty to his Jewishness were the words uttered by General de Gaulle, when he referred to Jews as an elite people, sure of itself, and domineering: *"un peuple d'élite, sûr de lui et dominateur."* He pointed out that this vision of Jews in the Diaspora, Jews who had been persecuted for centuries, who were isolated in ghettos, excluded from most professions, summoned back beliefs of traditional anti-Semites from Charles Maurras, the founder of Action Française, Edouard Drumont, the author of *La France juive,* and Xavier Vallat, Commissioner of Jewish Affairs under Vichy. Aron, who though he was a Jew, did not identify with Jewishness, who had never been a Zionist, now discovered that the possibility that the State of Israel might be destroyed and its population massacred, wounded his soul to the quick. Many Jewish intellectuals of the left who had supported the PLO and other movements found themselves in the same situation. For the first time, French Jews were united in their resolve that, as Frenchmen living in a democracy, they had the same rights to assert their Jewish diversity as did Basques or Bretons. Although this point of view was widely shared, there were a number of exceptions, for example Lévi-Strauss himself.

Frenchmen and women who were born after 1945 often criticize their elders for their care in avoiding conduct or behavior that might be construed as fueling anti-Semitism, in short, for being "imaginary Frenchmen." They point out that the fault lies with the anti-Semite, not with his scapegoat, who gives offense no matter what he does. So one might as well do what one wants, and if this is offensive, so be it. In contrast to this posture, on April 9, 1968, Lévi-Strauss wrote a letter to Aron in which he deplored the excessive pro-Israeli sentiment of the French press, whose numbers include many Jews. It seemed to him that, by manipulating public opinion, the press was leaving itself open to charges whereby Jews would again be accused of conspiracy. The letter, which Aron reproduces in his *Memoirs,* contains

the following: "As a Jew, I was ashamed of this [he is referring to press coverage] and also of the impudence spread out in full daylight by Jewish notables who dare to speak on everyone's behalf."[15] He supposes that the General's words, intended to reprimand or scold the French Jewish community, were inevitable. It was regretful that they had taken the form they had, but "at the same time he was forced to recognize, alas, that the chosen adjectives fit reality: because certain Jewish elements of France, taking advantage of their power over the written and/or spoken press . . . showed that they were 'sure of themselves and domineering'."

Aron must have responded with something to the effect that objective historical truth is hard to fathom, and that different groups perceive the same situation differently. Lévi-Strauss, in turn, replied that his own perception of Israeli events was subordinated to the destruction of American Indians by other oppressed and persecuted human beings who settled in their country:

> It goes without saying that I cannot feel the destruction of Redskins as a fresh wound in my flank and react in an opposite way when Palestinian Arabs are involved, even if (and this is the case) the brief contacts I have had with the Arab world have inspired in me ineradicable antipathy. . . .

His conclusion was that his disagreement with Aron was a slight one:

> You are moved by and forgive French Jews for having enthusiastically taken this occasion to proclaim themselves both French and Jews. On the contrary, I believe they should not have done this, I believe even less that they should have attempted to foment this enthusiasm in an underhanded way.[16]

One should not reach the conclusion that Aron, any more than Lévi-Strauss, approved of any allegiance of French Jews to the State of Israel. A French Jew is French, and if he believes that Israel is his true country, then he should exchange his French nationality for the Israeli one. But an argument can be made that almost everyone is more attracted by some countries than others. Lévi-Strauss particularly likes Japan; Berl had affinity for England and Russia; and Aron admired the United States. Italian-Americans, Irish-Americans, Polish-Americans may have a soft spot in their hearts for the country of their ancestors, but that fact does not necessarily bring their Americanism into question. Jews have the same right to proclaim their attachment to Israel, even if they look upon Israelis as second-cousins once removed, the way Lévi-Strauss does.

There is still another reason why Jews are justifiably drawn to Israel. Berl, for instance, who had been an anti-Zionist in his youth, became a passionate

advocate of the Jewish State when the Nazi experience revealed to Jews that, because they lacked a state for themselves, their quasi-extermination took place without the world's knowledge. Even a weak and powerless Israel would have been able to speak out and break the silence, thus wrecking the secrecy that was a necessary condition of the "Final Solution." One likes to assume that, if men and women of goodwill and good faith had known about this project, the genocide would have been stopped. In this historical perspective, considering the world today, in which peaceful coexistence of ethnicities has become more and more trying now that central powers have crumbled, "challenging the State of Israel is the same as challenging the Jews' right to life."[17]

In conclusion, it must be articulated that these three men convey no religious meaning to their adherence to Judaism. The phrase "I am Jewish" does not imply any pious or godly observance. One can be an entirely secular Jew, and a Jew nevertheless. This is surely the case for Lévi-Strauss. While he believes that the universe has a sacred dimension, he seeks it beyond organized rites of his own tradition, in the other aspects of the cosmos: in music, nature, art, and poetry. Berl, though he was a student of the *kabbalah,* in his old age probably seems not to have ever observed any rites. Aron was a believer of no church at all; he "left a vacant place for transcendental faith, and his own faith was the faith of the philosopher, doubt rather than negation."[18] The Judaism of these three Frenchmen is inscribed in the anticlerical tradition of the French Republic itself.

Notes

1. All translations are by the author. Emmanuel Berl, *Interrogatoire par Patrick Modiano,* followed by *Il fait beau, allons au cimetière* (Paris: Gallimard, 1976), p. 34.

2. *Interrogatoire,* p. 14.

3. Raymond Aron, *Mémoires. 50 ans de réflexion politique* (Paris: Julliard, 1983), p. 13.

4. *Interrogatoire,* p. 16.

5. Claude Lévi-Strauss & Didier Eribon, *De près et de loin,* followed by an unpublished interview, "Deux ans après." (Paris: Editions Odile Jacob, 1988, 1990), p. 215.

6. *De près et de loin,* pp. 215–216.

7. *Interrogatoire,* p. 94.

8. *Interrogatoire,* p. 95.

9. *Interrogatoire,* pp. 16–17.

10. *Interrogatoire,* p. 20.

11. *Mémoires,* p. 174.

12. *Mémoires,* p. 176.

13. *Mémoires*, p. 176.

14. *Mémoires*, p. 607.

15. *Mémoires*, p. 520.

16. Letter of April 19, 1968, quoted in *Mémoires*, p. 520.

17. Emmanuel Berl, "Faute d'un état," *Essais.* (Paris: Julliard, 1985), p. 615.

18. *Mémoires*, p. 749.

III

Philosophy and Jews

9

Blanchot, Violence, and the Disaster

Allan Stoekl

I.

Much has already been written on Maurice Blanchot's writing of the 1930s: it is today well known that Blanchot, perhaps the single most important (and influential) French literary critic of the postwar period, was before World War Two a very active right-wing propagandist, a leading contributor to reviews such as *Combat* and *L'Insurgé*.[1] My concern here is not with those writings, but instead with Blanchot's work after the war, which cannot at all be said to be "anti-Semitic" in any way that could correspond to prewar right-wing ideologemes (the preservation of French culture, the affirmation of "rootedness" in the face of "cosmopolitanism," and so on). I certainly have no intention of pilloring Blanchot as an anti-Semite for his writings in the postwar period. Instead what interests me is how a critic such as Blanchot, steeped as he is in the German philosophical tradition of Nietzsche, Husserl, and Heidegger, attempts to account for anti-Semitism.[2] It would seem that Blanchot, after the war, goes directly against the approach he took in the prewar period: now he affirms Judaism, and attempts to understand the illogic of anti-Semitism. This is an important problem, because Blanchot's work both anticipated (in the late 1940s and 50s) and is representative of much of the work being done in philosophical criticism in France in the sixties: anti- or posthumanist, it nevertheless attempts to defend the rights of an oppressed minority, not on the basis of what can loosely and often disparagingly be called law, democracy, and humanism, but in the name of an anti- or posthumanism, nomadism, and exile. Blanchot's work thus presages and even sums up a trend of French writing most commonly associated with such names as Deleuze, Foucault, and Derrida. Problems that appear in Blanchot's approach to anti-Semitism and Judaism in general, then, may very well have significance for an understanding not

only of Blanchot's work as a whole, but also for that of an entire stratum of French thought that valorizes the "rhizome," marginality, dissemination, and so on. But beyond this, they indicate the extreme difficulty—and unavoidable perils—that attends writing on the Holocaust,[3] especially if one is attempting to displace a Western tradition of utility, sense, and transcendent truth.

Blanchot starts Part I of Chapter Five of *L'entretien infini* (1969),[4] entitled "Etre juif," with the question: What is it to be a Jew? There are, it seems, very often negative answers given to this question: to be Jewish is pure misfortune (Blanchot cites Clara Malraux and Heinrich Heine): "to be a Jew is to be deprived of the principal possibilities to live, and not in an abstract manner, but in a real one" (EI, p. 181). Here Judaism is negative because the only defense that can be used by Jews is that, except for their religion, they are really the same as everyone else. Judaism is only a "lack" that sets people apart, something for which they suffer. On the other hand, Sartre's conception of Judaism (in *Anti-Semite and Jew*) is more positive: the Jews affirm a "right to difference" in their very act of choosing to be Jews. But Sartre, too, is negative, in that for him, as Blanchot puts it, "the Jew is only the product of the gaze of others." The Jew, in this view, only recognizes the "Jewish difference" as a way of refusing anti-Semitism: Judaism for Sartre thus becomes, according to Blanchot, only a "negative of anti-Semitism" (EI, p. 182). In the Sartrean view, the Jew's only other option, it seems, is one of pure bad faith: denying his or her religion and cultural heritage in the face of oppression.

The solution to this problem, in a characteristic Blanchotian move, is to render a negative as a positive, all the while retaining its negativity: "[Judaism] exists so that the idea of exodus, and the idea of exile as a just movement can exist; it exists, through exile and by means of this initiative that is exodus, so that the experience of strangeness can be affirmed near us in an irreducible relation; it exists so that, by the authority of this experience, we can learn to speak" (EI, p. 183).

Judaism is certainly being positively affirmed here, but as a kind of conduit for three things, two of which might conventionally be seen to be quite negative: exile, exodus, and speech (*la parole*). We should first try to understand what Blanchot means by exile and exodus, how speech is related to these terms, and, finally, why anti-Semitism takes such exception to them, and to the people associated with them.

Blanchot affirms exile in its very negativity. But what has always been held to be a negative characteristic, or a misfortune, is in fact a positive one: if the Jew is condemned to, indeed has the "vocation" of "dispersion," that lack or loss of place "as it summons to a residing without place [*séjour sans lieu*] . . . ruins all fixed relations of power with *an* individual, *a* group,

or *a* State" (EI, p. 184). Before the "demand for Totality," dispersion instead "forbids the temptation of Unity-Identity." On a number of different levels, "exile" comes to disrupt totality: on the personal (the "individual,") the social (the "group"), and the political (the "State"). Moreover, this "ruining" is also philosophical: we are given to understand that "Unity-Identity" is nothing less than the great "temptation" of the entire Western philosophical tradition. The Jews not only destabilize a unity or philosophy of being or "presence," but their destabilization precludes any Heideggerian gesture of resituating a "Being" in a single locus, a single soil. The Jew's "Being," if we can even call it that, refuses the easy "rootedness" of any given culture: in that sense it truly is "nomadic."

Blanchot's target here is as much the French right-wing tradition of Maurras and Barrès (the author of *Les Déracinés*) as it is Heidegger (to whom, in his critique, he clearly owes so much). This becomes evident a few pages further on, when we see that the *enracinement* (literally, "rooting") is one of a relation to culture: ". . . the order of reality where there is rooting [in culture] does not hold the key to all these relations to which we must respond" (EI, p. 186). Blanchot, the former disciple of Maurras and ex-right-wing propagandist, is hailing the Jews because, in some way, through their exile, they undo an easy embrace of "culture," and throw into question a simple affirmation of a single language, literature, or common place (*lieu commun*).

So far Blanchot's affirmation of the Jews is mainly the flip side of the reactionary's condemnation: if a Barrès, or a disciple of Barrès, could decry their rootlessness, a (postwar) Blanchot could affirm it. Now their rootlessness is positive, but the terms remain the same. Blanchot's affirmation becomes more complex, and more interesting, however, when we come to the ultimate instance of exile: the interpersonal one. Here Blanchot (via Lévinas, as we will see) is clearly rewriting the postwar French phenomenological concern with the dialectical relation of self and other. But for Blanchot, this relation is precisely not dialectical; it is one in which the interpersonal relation is also a nonrelation, an impossibility of relation: "But I will bluntly say that we owe to Jewish monotheism not the revelation of the unique God, but the revelation of the word as the place [*le lieu*] where people remain in relation with what excludes all relation: the infinitely Distant, the absolutely Foreign [*l'absolument Étranger*]" (EI, p. 187).

The Jews, in effect, are exemplary in that they "bear witness" (EI, p. 189) to a relation that itself is not specifically Jewish. It is a "relation with difference whose human face, as Lévinas says (that which is irreducible to the visual in the face) brings to us the revelation and entrusts to us the responsibility" (EI, p. 189). It seems that the "strangeness" or "foreignness" of the Jews, along with their "inscribed word" (EI, p. 190) which is inseparable

from their religion, are meant to be emblematic of the relation between all people, all "faces." They "bear witness," and it is their internal exile, so to speak, along with their word, that communicates to us a state of "distance which defies the possibility of simple unification-through-communication. To speak is to seek out the prefix in the words 'exodus, existence, exteriority, strangeness' (*étrangeté*). This prefix itself designates the 'gap and separation' at the origin of all 'positive values' " (EI, p. 187).

To be a Jew is not only to bear witness, but to bear the strangeness of the word, the prefix. At the same time, though, the "word" does not seem to be specifically Jewish, because its "strangeness" is clearly meant to apply to *all* human relations. (Thus Blanchot is using the terms "witness" or "testimony" in a much broader sense than that used to designate the account of the Holocaust survivor; for Blanchot, all Jews "bear witness.") It is the Jewish testimony, and not the word itself, that is different. The anti-Semite's error is to characterize negatively the Jews as the bearers of an entirely negative *exigence d'étrangeté*: "[Anti-Semitism] represents the revulsion inspired by Others [*Autrui*], the sickness [*malaise*] before that which comes from far away and elsewhere, the need to kill the Other, in other words to submit to the all-powerfulness [*la toute-puissance*] of death that which cannot be measured in terms of power" (EI, p. 189). Power attempts to crush the word that eludes it; but that word, and the originary and unbridgeable gap of human relations, is not specifically Jewish. It is everyone's word: it is a gap, a difference, that is to be affirmed.[5] The anti-Semite tries to turn its "infinite distance" into a negative value (thus refusing his own proximity to the word), identifying the Jews with the supposed negativity of the word to which they testify. What are really "positive" values borne by the Jew (exile, exteriority, and so on) are made negative (EI, p. 189); in fact the true negativity is the anti-Semite's, who, "grappling with infinity, wills himself to a limitless movement of refusal" (EI, p. 190). The Jew bears witness; the anti-Semite refuses. The anti-Semite sees the "nomadism" implicit in all relations as exclusively negative, and then projects that negative valorization onto the Jew. It is a classic paranoid mechanism, but Blanchot's analysis, paradoxically, would not work if the Jew really were somehow the exclusive repository of this nomadism. It is the anti-Semite's mistake, and finally crime, to assume that the exteriority of relations resides exclusively in the Jew; the exteriority is also at the basis of the anti-Semite's own experience. The anti-Semite is the one who punishes the bearer of what he sees as bad news.

Blanchot has clearly attempted to interpret positively the Jewish experience but, ironically, Judaism is positive for him only so long as it is negative, in two different ways. First, because it is associated above all—though not exclusively identified—with what is usually considered in Western culture

to be negative: exile, distance, discontinuity, strangeness. (This association of exile with negativity marks anti-Semitism as a profoundly Western thing, and not at all an aberration.) In this sense Blanchot is again merely reversing commonly accepted poles, and in so doing he affirms a quite traditional negative/positive structure of values (recall, however, that exile and exodus, in Blanchot's sense, were meant to destabilize such oppositions — negative/positive, visible/invisible — which characterize the Western philosophical tradition [EI, p. 186].

More important, Blanchot ultimately negates the specificity of Judaism by indicating that it "bears witness" to something that presumably characterizes all relations, and not just Jewish ones, or those between Jews and Gentiles: the "pure separation and pure relation" which is a way of designating that which, in human relations, "exceeds human power" (EI, p. 189). What does "bearing witness" mean? If there is any Jewish specificity at all, it is to be found in this "witness." But here new problems arise. Clearly this "witness" is meant to stand as an alternative to other, more typically Western attributes of cultural identity: consciousness, essence, experience. At no point, however, does Blanchot suggest that Jews are somehow intrinsically "more aware of," or "experience more profoundly," exile, dispersion, nomadism. Thus the example of any specific Jew or group of Jews not personally concerned with these things, or even aware of them, would not serve to invalidate Blanchot's position. Any reference to awareness or consciousness would only return the bearer to a version of Unity, the very thing nomadism is said to put in question. In a very interesting footnote (EI, pp. 190–191), Blanchot attempts to answer the criticism of those who would object to his approach: these critics would say, according to Blanchot, that stressing the "metaphysics of the Jewish question" (as he does) is beside the point. What is more important is a historical analysis of the question, which presumably will lead to historical solutions. Such a solution is the founding of the State of Israel. Blanchot recognizes the fundamental importance of Israel, but it is also clear that, for him, Israel has little to do with the fundamental aspect of Judaism for which he has been arguing. "Zionist ideology" is a "purely occidental solution" to a problem that "goes beyond all determined historical signification": Israel is modelled on a "nineteenth-century conception of the State, demanding for itself the reality of the Law, the affirmation of the Totality [le Tout], transcendence" (EI, p. 191).

Being a Jew at this point becomes even more of a mystery: as we already know, it is not a function of consciousness, knowledge, and so on; nor is it, we learn now, related to Law or Totality. In this all-encompassing negativity, there is little room for a model based on individual or group awareness, responsibility, and democratic (and legal) representation. There is no model of the "human" (a word that Blanchot does, however, use in connection

137

with his version of "face-to-face" interaction) with whom "human rights" could be associated or attributed, nor is there a possibility of a larger polity. Nor, in attempting to explain what it is to be Jewish, does Blanchot ever mention the determinateness of birth, succession, or genealogy—perhaps because he associates these with biologism. Moreover, the tendency of nomadism to elude or undo "power" would seem to preclude any political model at all, whether one based on the interests of the individual, or on those of the specific social group.

I do not necessarily want to argue here for a return to traditional notions of political subjectivity, representation, legality, and action. But if we do away with these terms, what will replace them, in practice if not in theory? Or will practice be unaffected by these theoretical transformations? Will the distinction theory/practice itself be put in question by the nomadism Blanchot associates with or prescribes for the Jews? (Is his determination of their nomadism a constative—is he representing what is already "out there"—or is it a performative—is his declaration a determination that from now on the Jews will always already have been nomadic?) As one can see, this is a series of problems crying out for an answer—particularly the question of practice, because the problem of the practical Jewish response to anti-Semitism is such an important one. But Blanchot's postwar politics, when at all discernible, seem largely to have been negative: the right to refuse, out of anger and disgust, an already-discredited collaboration.[6] So too the Jew is characterized negatively here, with none of the traits that might be associated with bourgeois humanism or democracy. His testimony comes down, finally to the "inscribed word" and the "books from which Jews speak" (EI, p. 190)— but how important are these writings in determining Judaism, specifically in the context of anti-Semitism, if Jews without any specifically Jewish religious or even cultural formation have been persecuted and murdered? And Jewish books are susceptible, like all books, to citation, fragmentation, (mis)translation, interpretation. Much of this activity of re-citation has been done by Gentiles (Christians, Muslims). Or is the textual aspect of these books, their very citability, somehow Jewish? How? Is textuality in general Jewish? How? What then of Gentile textual traditions? And where is the specificity of the word for a people whose experience is not personal, not subjective, not even cultural or social in any accepted sense, and whose social aspect is an interpersonal event (for lack of a better word) that, in its "infinite separation," is precisely not interpersonal, not an experience of mediation and union, not, finally, an experience at all (EI, p. 187)? These are all difficult questions for Blanchot because, even setting aside the question of Jewish-bearing-witness, there still remains—at the center of his analysis—the fact of anti-Semitism. How can we attempt to account for anti-Semitism—and do something about it—if it remains a resistant social and political fact?

Judaism or Jewishness for Blanchot is, however, precisely *not* social or politi-
cal, at least not in any commonly accepted and generally comprehensible
sense. If the Jew and the interpersonal, social experience of the Jew—the
face-to-face, the text—becomes ever more elusive, as they shade into every-
one's social experience, and then are recognized to be not a union or group-
ing at all but instead an "insurmountable abyss," the fact of the existence
of anti-Semites nevertheless remains the same: they are the group that hates,
persecutes, and kills Jews. Blanchot, in an interpretation that leaves the
confines of social and political analysis, is still attempting to account for a
social/antisocial and political activity.

Another way of putting this is that, in Blanchot's essay, one collectivity—
the Jews—tends to disappear in their specificity before our very eyes, while
another, the anti-Semites, is very precisely identified, its threat noted as very
real. Indeed the overwhelming fact of anti-Semitism, and the need to do
something about it, serves as the starting point for, as well as the conclusion
to, Blanchot's reflections. The problem of the loss of specificity marks other
writings by Blanchot. In his later *The Writing of the Disaster* (1980), Blanchot's
recognition of the Holocaust as a definitive event that puts in question the
very possibility of literature and language calls forth *another* writer, and
generates ever more literature and language. The consequent loss (such as
it is) of the specificity of the Holocaust in Blanchot's later work may be tied
to the incessant act of writing on the part of the critic. As in much recent
writing—philosophy, criticism, fiction—the "nomad," persecuted, heroic,
murdered but triumphant, loses historical and cultural specificity to the
point that he can be, indeed must be, doubled by the figure of the philoso-
pher or writer himself. Transfers of guilt and innocence take place to the
extent that the commentator faces the real impossibility of writing the
disaster.

II.

We are left with the question: what is the specificity of the Holocaust?
How can—how *must*—it be considered as something more, or as something
other than just another instance of murderous violence?

One can never hope to *represent* the Holocaust: to attempt to do so would
be to present it as just another historical event, politically and historically ·
derived from certain things, and leading to others. The Holocaust, however,
is different, radically different, and to talk about it, to write about it, is, on
the one hand, to turn it into nothing more than a profitable topic, a topic
for a novel, a collection of essays, a spectacular Hollywood film; on the
other, it is to offer testimony, without being entitled to do so (unless one
has actually *been there*). The writer on the Holocaust is in an impossible

position. And yet the Holocaust is always there, an unavoidable subject especially for those who would rewrite it as a moment having something to do with a definitive end of history, a transgression or elimination of all possible meaning, a not-knowing at the heart of European knowing. Writers cannot leave the Holocaust alone, and their attempts at writing it, even and above all in its unwritability, only affirm a larger question of their own guilt and complicity. But there is a double bind, too—because in the very unwritability I have indicated there is a silence which cannot just remain silent—which will always be rewritten because the Holocaust clearly *is* an event that cannot be ignored, that certainly is a rent in the fabric of a knowable history, a European history of sense and of a sensible recuperation of violence. So the writer cannot not write on the Holocaust, either. He or she cannot escape the unenviable task of writing on the unwritable, necessarily and guiltily.

Blanchot, in *The Writing of the Disaster* (1980),[7] takes great pains from the outset to indicate that the "disaster"—his disaster—is not a dialectical endpoint, does not entail what we might call "empirical" destruction. Indeed the very concept of the empirical—which can easily be set in opposition to the "imaginary"—is out of the question here. Blanchot's characterization of the disaster entails not the privileging of one opposition over the other, but the doubling or cancelling out of terms through the linkage of seeming contraries.

> The disaster ruins everything, all the while leaving everything intact. It does not touch anyone in particular; "I" am not threatened by it but spared, left aside. It is in this way that I am threatened; it is in this way that the disaster threatens in me that which is exterior to me—an other than I who passively become other. There is no reaching the disaster [*Il n'y a pas atteinte du désastre*]. (WD, p. 1)

If the categories of self and other are cancelled, if their mediated opposition is annulled without being suppressed or destroyed (and annulled as well is the Lévinasian "face to face" that we saw in the Blanchot of the 1950s and sixties; it now seems to have been superseded by a direct and impossible relation with a kind of nonapocalypse), so, too, time and its moments— past, future—as well as its completion are "*dissuadé*" (dissuaded): "We are at the edge of the disaster without being able to situate it in the future." Time is not eliminated or completed, nor does it simply "go on"; we confront here, instead, a moment that is not a moment, that is always already "immanent," that both is the disruption of at least the aspirations of a historico-temporal model, while at the same time it leaves that time, that history intact (as it leaves "me" intact, and as it leaves "everything").

The "disaster" does not escape history, or in any way challenge it. To do so would be an eminently historical gesture. Instead Blanchot posits two movements, "two languages, or two requirements: one dialectical, the other not; one where negativity is the task, the other where the neutral remains apart, cut off both from being and from not-being" (WD, p. 20). But this "apartness," so important because it alone is the difference between a simple return to the dialectic and a difference from it, is also inseparable from an imbrication, a complication of dialectic and disaster. This complication comes to haunt or invest the society of which Blanchot writes—namely, the society of writers (everyone?). In this passage Blanchot goes on to state: "In the same way each of us ought both to be a free and speaking subject, and to disappear as passive, patient—the patient whom dying traverses and who does not show himself" (WD, p. 20).

Already we see Blanchot's questioning as a circling around a duality of a subject which is not just a subject, but a "passive and patient" writing function, as removed from the "human subject" as the disaster is removed from the negativity of the dialectic. Removed and yet with it, in it, accompanying it while "apart."

A duality of the writer, perhaps—but it is hard to see how the Blanchotian figure would embrace or affirm both a dialectic—and all that that implies of sense, labor, liberation, and completion—along with, and as a passivity so passive that the disaster passes "leaving everything intact." Perhaps by turning to a few versions of the Holocaust in *The Writing of the Disaster* we can see how the doubleness comes to inhabit Blanchot's writing at a moment in which it would "write on" an event that, by Blanchot's own reckoning, cannot be written, certainly cannot be described, cannot really be testified to. Beyond this, and most important for my purposes here, the Blanchotian writer comes to double, in the ethical conundrum he or she faces, the fundamental duality of the Holocaust.

The Holocaust is presented by Blanchot as being the terminus point, a completion, of a certain human history of sense and labor—as well as an instance of the "disaster," because nothing can be said about it. It goes beyond or under or outside the boundaries of description and signification in general. This doubleness of the Holocaust is familiar, because it is inseparable from the model of the writer advocated by Blanchot which entails a devotion to sense—the "free and speaking subject"—along with the passive patient "traversed by dying." But using the Holocaust as an example of this bind, or even perhaps as a motivation behind it, introduces a complication in ethics that Blanchot does not consider.

First there is the version of the Holocaust as the ultimate, and perhaps inevitable, stage in the dialectic of history and of sense. As Blanchot puts it:

> Concentration camps, *emblems* wherein the invisible has made itself visible forever. *All the distinctive features of a civilization are revealed and laid bare.* ("Work liberates," "Rehabilitation through work"). Work in societies where, indeed, it is highly valued as the materialist process whereby the worker takes power, becomes the ultimate punishment: no longer is it just a matter of exploitation or of surplus-value; labor becomes the point at which all value comes to pieces and the "producer," far from reproducing at least his labor power, is no longer even the reproducer of his life. For work has ceased to be his way of living and has become his way of dying. Work, death: equivalents. (WD, p. 81, my italics)

This, I think, is an important formulation: in it, we see death camps as both emblems and revelations. They are emblems in that they stand for what is hidden in our civilization: the intimate connection between work and death. They represent it, and presumably then it *is* representable. They also "reveal" or "lay bare" the connection; they are not only emblems, but devices which demonstrate the ultimate truth of our civilization: work, pushed as far as it will go. The dialectic of labor and sense, in other words, ends in, becomes identifiable with, death, the extinction of life and meaning.

The use of this word "emblem" is important. The Holocaust is now an example, one version of Western logic pushed as far as it will go. It is *emblematic.* And it is not the only one; a little further on (WD, pp. 82–83) Blanchot establishes an implicit comparison between Auschwitz and the Gulag, stating first "Horror reigns at Auschwitz, senselessness in the Gulag" (WD, p. 82), and, then, a little further on, "Surely, senselessness is at Auschwitz, horror in the Gulag" (WD, p. 83). In other words, the writer uses the Holocaust, as he does Stalin's murders, as an emblem. It is not silence, but usable material within a history of sense, at the end of a history of sense. And it is comparable to other mass murders in a reverse symmetry. The Holocaust reveals that history, it discloses it, it embodies it, it completes it. Nothing could be more public, more visible—the machinery of death, of labor as death can be and was charted, blueprinted, and mechanically reproduced.

So an ultimate emblem of the futility of work and use is itself put to work, and is used. The writer, in a surprising way, therefore, enters into complicity with the very people who set up the system in the first place, because he uses it. The Holocaust is yet another example of the (self-)defeat of a dialectic of labor, sense, and use from *within* that dialectic. That is how it can be used—and by using it in this way we, too, as writers, are fully situated within the logic whose completion the Holocaust signals and embodies.

But the writer who would use the Holocaust nevertheless must also confront the impossibility and the horror of this use. As Blanchot puts it, "The meaning of work is then the destruction of work in and through work"

(WD, p. 81). Pushed as far as they go, work, utility, need, all end in silence and death. In the same way, words that would attempt to make use of the Holocaust (if only by understanding it and using it as an example) can only know it by knowing a death that is the end (in both senses of the word) of knowing. The writer's labor of knowing, after the Holocaust, is the death of knowing in and through knowing. Blanchot seems to judge harshly those (including himself, one would have to conclude) who would attempt to use in any way their knowledge of Auschwitz and what it represents: "Knowledge which goes so far as to accept horror in order to know it reveals the horror of knowledge, its squalor, the discrete complicity which maintains it in a relation with the most insupportable aspects of power" (WD, p. 82). This quote would at first seem to apply primarily to those who, as prisoners in the camp, go along with the system, even try to survive, in order to understand it, or in order to enable others to understand it. It also applies, nevertheless, to everyone, for, as Blanchot asks, "how can one accept not to know?" (And knowledge implies a certain acceptance of horror, if only in the sense that one does not try to shut it out entirely: one studies it, mastering its details. Soon one finds oneself retracing not only the steps of the victims, but those of the killers as well, trying to understand their actions, their motives, their values.) Knowing, and the horror and complicity of knowing, are themselves inseparable from the death of knowing: "The wish of all, in the camps, the last wish: know what has happened, do not forget, *and at the same time never will you know*" (WD, p. 82).

This not-knowing, if we can call it that, attained through the *labor* of knowing, reverses the situation: at this point the writer, who reaches the loss of knowledge through the use of everything that can be known about the camps, now becomes a laborer with more in common with the inmates than with the masters of the camp and the masters of a completed history of labor and sense. "Never will you know": any attempt to know the events will lead to a defeat of knowledge, to a death in and through language.

But how can anyone have the audacity to say that a writer, sitting safely in a room and writing on the Holocaust, faces the same senselessness of knowledge as that faced by an inmate of a camp, who is bearing, or who wishes to bear, witness? The answer is that both try to know, to use their knowledge to comprehend and convey the truth, both face the not-knowing of knowledge—but there the similarity obviously ends. The Blanchotian writer comes to identify this impossibility of knowing with the "disaster" itself, a "disaster" that may include the Holocaust, but that is not necessarily reducible to it. The one who bears witness, on the other hand, grapples with the definitively unspeakable.

In opposition to the one who would know the Holocaust as the ultimate stage in a history of labor and sense, there is, then, another: the person who

recognizes the Holocaust as a radical break *with,* and out of, history. Rather than a completion and self-defeat of history, the Holocaust is a movement outside and against history. The Holocaust is the disaster, the unwriteable, and the writer—and reader—watch over this silence, affirm this necessary and definitive silence after Auschwitz.[8] As Blanchot writes at the beginning of *The Writing of the Disaster,* "The calm, the burn of the holocaust, the annihilation of noon—the calm of the disaster" (WD, p. 6). It is not only that there cannot be a story, a fiction, or an entertainment concerning Auschwitz, or even that there can be no poetry, or literature, after it; beyond this, Auschwitz is a word, a name, that exits from the very possibility of language itself. Blanchot writes, further on: "The Unknown name, alien to meaning: The holocaust, the *absolute* event of history—which is a date in history—that utter-burn where all history took fire, where the Movement of meaning was swallowed up. . . . How can it be preserved, even by thought? How can thought be made the keeper of the holocaust where all was lost, including guardian thought? In the mortal intensity, the fleeing silence of the countless cry." (WD, p. 47). It is like the need of the dying prisoner, who grasps for bread "even if one is perfectly aware that death is a few minutes away" (p. 84). This "need," then, is "exalted," "glorified," "made into something inhuman," to the extent that need is now not connected to nourishment or survival, but to an "empty absolute where henceforth we can all only ever lose ourselves."

Like this "empty absolute need," the word Auschwitz—and all words after Auschwitz—open a void into which we all fall. Blanchot thus warns us of the "danger" of words, which would "claim to evoke the annihilation where all sinks always," without also heeding the necessary command to silence after Auschwitz. But it is still necessary to bear witness, to "watch and to wake," to maintain a "ceaseless vigil," because everything—"(Israel, all of us)"—is "marked by this end from which we cannot come to the end of waking again" (WD, p. 84).

We have come full circle: from a recognition of the radical silence of the word, of its status as an "empty absolute" completely beyond the realm of work, utility, and sense, to an affirmation of the continuation of writing, of using words, if only because history has once again started at its end. A vigil is necessary, if only to watch over what has emerged out of the Holocaust—a recommencement of history ("Israel, all of us").

But then, how absolute is the Holocaust? To what extent can it be resituated in history? To what extent is the Holocaust an "empty absolute" that definitively loses the word, loses everything, and to what extent is it merely another name for the "disaster," a powerful one, to be sure, but only one of a series, an example of a much larger (non)phenomenon? This is perhaps the point at which one most clearly sees the limitation of Blanchot's effort

to write the Holocaust, and to situate a writer in relation to it. If the Holocaust is only an example of the disaster which entails the "swallowing of meaning," then one wonders to what extent the Holocaust is once again being used, this time not as a way of identifying the terminal point of a history of sense, but rather as an instance of an "annihilation where all sinks always."

We should recall once again the formulation with which *The Writing of the Disaster* opens: "The disaster ruins everything, all the while leaving everything intact." In this sense the disaster is out of history, unrecuperable within a dialectical framework. And yet, if the Holocaust is an example of the disaster, an emblem of it — even if it is the major example — how can we say that it leaves or that it left "everything intact"? In order to use the Holocaust as an example of a posthistorical empty absolute ("the disaster"), Blanchot is forced to attribute to it a radical lack of attribute that goes against its status as a historical event, as *the* historical event, which Blanchot himself affirms. In one fragment he writes: "We feel that there cannot be any experience of the disaster, even if we were to understand disaster to be the ultimate experience. This is one of its features: it impoverishes all experience, withdraws from experience all authenticity; it keeps its vigil only when night watches without watching over anything" (WD, p. 51).

By denying its status as experience, and then affirming it as "the ultimate experience," Blanchot in effect nullifies the Holocaust as an event through which, indeed, neither everything nor everybody was "left intact." Here again the demand for an affirmation of an "empty absolute" that is out of history would seem to conflict not only with the historical status of the Holocaust, but with its admittedly unspeakable horror and pain, which, we are told, is at the basis of its unwritability. Certainly one could grant that point, but the status of the linguistic loss nevertheless leads to a double diminution of the Holocaust: first it becomes just another, albeit impossible, instance of a disaster which, because of its very (non)nature, eludes all characterization (as Holocaust or as anything else) and, second, the Holocaust, as an extrahistorical event, finally cannot be seen to have any effect, entail any experience, lead to any happening which could and would have to be situated historically (dialectically or otherwise), in other words, *in* history rather than out of it or transgressing its limit.

The historicizing writer whom we saw before — who would put the Holocaust to work as the example of the ultimate stage of labor and sense (at the point where these terms attain their senselessness), now meets his or her double: the one who would identify the Holocaust as another version of the disaster, and who would put it to good use in that way. The writer who affirms the Holocaust's radical silence is now the one who appropriates it. But, as Blanchot himself recognizes, the Holocaust is or was more than the performance or reperformance of silence. It was mechanized and bureau-

cratized murder, and to ignore that is itself a highly questionable gesture. Blanchot himself agrees on the necessity of the "ceaseless vigil over the immeasurable absence," a vigil beyond a forgetting or a use of the Holocaust (the type of opposition which is escaped and invalidated by the disaster). But the Holocaust as "disaster" also moves beyond any specificity, becoming an emblem of a category that necessarily is outside the bounds of a limited event and its details: "Instead of finality, the burn of life which cannot burn out. From this fever all ending is excluded, all coming to finish in a presence. Infinite, as unforeseen, as foreboding. Forgetfulness, remembrance of the immemorial, without recollection" (WD, p. 105). The Holocaust as example of the disaster must shed its specificity to such an extent that now its "burn . . . cannot burn out." One could perhaps argue in a larger sense that this is true—we live in the shadow of the Holocaust, to be sure, and literature itself is impossible after it—but in another sense it is quite false: the "disaster" might go on, as it always already has, but the Holocaust itself ended in 1945. The problem is to try to understand it, to prevent any possibility of its recurrence. The difficulty with a passage such as the one I have just cited comes from the too-easy conflation of historical event and experience with a posthistorical exigency. What gets lost, inevitably, is the specificity of the event; all that remains is a category (the "disaster") that escapes and defeats all categories.

The Holocaust, as we can see from all this, defies the writer who would write on it, who would represent or reproduce it. This is especially true if it is presented as being emblematic or representative (but how can it not be?). If it is fully situated *in* history as an emblem *of* the self-defeat of Western history and use (of history as use, as work, and of history as sense, consciousness), then the writer is forced into complicity with the Holocaust's perpetrators; he or she would put it to work, if only by using it as an example. The writer, too, in this case, would be a belated chapter (or footnote) in a history whose climax is the Holocaust: the history of work as work, knowledge as knowledge. But this writer also contains the loss of this position, since the work of the Holocaust he or she inevitably mimes is itself senseless, work pushed as far as it will go, into the destruction of work and sense. This in turn leads to a second writer, the double of the first one, who situates the Holocaust not in history—the ultimate moment of work—but alongside it (but not in opposition to it), in a space that is one of annihilation, of the disaster. But, as we have just seen, this writer as well puts the Holocaust to work, making it a kind of subset of "the disaster," and therefore losing the very specificity that mandated a post-Holocaust loss of words, the "fleeing silence of the countless cry."

The one who writes on the Holocaust—and thus on history—seems to be torn between these two options, which nevertheless lead back into each

other. (The definitive silence of the cry and the necessity of the continuation of writing are summed up by Blanchot in the juxtaposition of the words *cri* ["cry"] and *écriture* ["writing"].[9] The only other direction in which to head would be the silence of a simple forgetting, sleep, which, as Blanchot himself would remind us, is also impossible. Instead there is, and must be, wakefulness, vigilance, "*la veille.*" Blanchot, by his very refusal to forget the conflict within the writing of the Holocaust, signals the force of his own vigil.

Notes

1. See Jeffrey Mehlman, "Blanchot at Combat: Of Literature and Terror," in *Legacies of Anti-Semitism in France* (Minneapolis: The University of Minnesota Press, 1983), pp. 6–22. Steven Ungar is currently working on a book-length study of Blanchot's prewar writings.

2. Blanchot was one of the first serious French readers of German phenomenology; he studied at Strasbourg in the late 1920s and was an acquaintance there of Emanuel Lévinas, whose thesis, *La théorie de l'intuition dans la phénoménologie de Husserl* (Paris: Alcan, 1930) introduced Husserl to the French reading public.

3. I realize that this word itself is not without difficulty; "Holocaust" in its original meaning implied a burnt, sacrificial offering. This is quite inappropriate as a designation of the Nazis' murder of the Jews: it seems to imply that the Jews themselves were in complicity with it, in the sense that they were somehow being sacrificed to their own God. Other terms have thus been proposed, such as "Auschwitz" and "*Shoah.*" The latter seems the most appropriate. Yet it is worth noting that, for example, the *American Heritage Dictionary* (Boston: Houghton Mifflin, 1973), p. 629, defines "holocaust" as not only a "burnt offering," but also as "2. Great or total destruction by fire; a conflagration. 3. Any widespread destruction. — See Synonyms at *disaster.*" I will use "Holocaust" throughout this article because this is the term Blanchot uses in his book *The Writing of the Disaster*—where the word is, in fact, a synonym for disaster.

4. Maurice Blanchot, *L'entretien infini* (Paris: Gallimard, 1969), hereafter "EI." All translations are my own.

5. Paraphrasing Lévinas, Judith Friedlander writes: "The other invades my world, puts limits on my freedom, forces me to take him or her into account as I live my own life. Confronted with the naked face of the other, with a vulnerable, unarmed being, I must assume responsibility for this intruder, who is outside myself, who is not me, who will never become just like me, but will remain the other in an asymmetrical relationship to me" (*Vilna on the Seine: Jewish Intellectuals in France Since 1968* [New Haven: Yale University Press, 1990], p. 97).

6. See, for example, Chapter XIII of Blanchot's *L'amitié* (Paris: Gallimard, 1971), pp. 130–131, entitled "Le refus." In the same work Blanchot does write affirmatively of Marxism (pp. 109–117), but it is understood that while Marxism may somehow accompany the relations with which Blanchot is concerned, they nevertheless are separate—"two lives," as Blanchot calls them (p. 113).

7. *The Writing of the Disaster,* translated by Ann Smock (Lincoln: The University of Nebraska Press, 1986), hereafter "WD." This book is a translation of *L'écriture du désastre* (Paris: Gallimard, 1980).

8. The act of reading is inseparable from writing, and both imply social functions or *personae* ("writers," "readers"), as well as sheer performatives. This problem is glossed over, I think, in Kevin Newmark's otherwise excellent article on *The Writing of the Disaster,* "Resisting, Responding," in *Responses: On Paul de Man's Wartime Journalism,* ed. W. Hamacher, N. Hertz, and T. Keenan (Lincoln: University of Nebraska Press, 1989), pp. 343–349. It should be stressed that Blanchot himself fully recognizes the importance of the question of the responsibility of the writer, critic, or intellectual. See his recent article "Les intellectuels en question," in *Le débat* 29, March, 1984.

9. This crucial wordplay—if one can even call it that—has been noted both by Kevin Newmark (see above note) and by Alexandre Leupin, in his article "La fiction et Auschwitz (Hermann Broch et Maurice Blanchot)" in *Esprit créateur,* XXIV, 3 (Fall, 1984), pp. 57–67.

10

Discussions, or Phrasing "after Auschwitz"

Jean-François Lyotard

I.

This lecture has been entitled "Discussions."[1] Such a title announces a genre of discourse, the *dialéktikè*, the theses, arguments, objections, and refutations that Aristotle's *Topics* and *On Sophistical Refutations* analyze and seek to bring within norms. The "greater" dialectics, speculative dialectics, dismisses this genre as frivolous: "Objections—if they really are connected to the thing against which they are directed—are one-sided determinations. ... These one-sided determinations, insofar as they are connected to the thing, are *moments of its concept*; they are thus brought forth in their momentary place during the latter's exposition, and their negation within the dialectic immanent to the concept must be demonstrated. ..." This is so much the case that in regard to a work which seeks to compile objections, such as the one undertaken by Göschel (the author of the *Aphorisms* commented upon here by Hegel), "Science could demand that such work be superfluous, since it would arise only through thought's lack of culture and through the impatience proper to the frivolity of defective thought."[2] Science, in the Hegelian sense, does not simply brush aside the *dialéktikè* as did Aristotelian didactics. It encloses the *dialéktikè* within its own genre, speculative discourse. In this genre, the *two* of *dialéktikè*, which is what provides material for paralogisms and aporias, is put into the service of the didactic end, the *one*. There is no true discussion.

But this phrase[3] (the speculative phrase) is a phrase which is nevertheless up for discussion. The fact that this is so is "our" entire affair, an affair of linking phrases *(une affaire d'enchaînement de phrases)*. Is not oneness the aim of and therefore the law for the linkings of phrases? Does not man, the

"we" in "our" affair, owe his unique (his singular) name solely to the fact that he links together his propositions in the direction of making them one?

On this question, here are two chains of phrases. One bears Derrida's signature. Here are some of its links:

> There will be no unique name, even if it were the name of Being. And we must think this without *nostalgia*.

> Such a *difference* would at once, again, give us to think a writing without presence and without absence, without history, without cause, without *archia*, without *telos*, a writing that absolutely upsets all dialectics, all theology, all teleology, all ontology.

> What might be a "negative" that could not be *relevé*? And which, in sum, as negative but without appearing as such, without *presenting* itself, that is, without working in the service of meaning, would work? but would work, then, as pure loss?

> What is difficult to think today is an end of man which would not be organized by a dialectics of truth and negativity, an end of man which would not be teleology in the first person plural.[4]

These are so many objections, or rather disjections, made to unobjectional thought. The Latin word, *disjectio*, more or less covers the meanings of *dissemination* and *deconstruction*. Neither the former nor the latter are sufficient to obtain "some dislocation without measure."[5] Consider, by way of proof (here is an argument), the definition of the deconstructive strategy: "an *overturning* of the classical opposition [between terms such as speech/writing, presence/absence, and so on] *and* a general *displacement* of the system." This double operation, presented as the "only condition" capable of giving to deconstruction "the means with which to *intervene* in the field of oppositions that it criticizes, which is also a field of nondiscursive forces,"[6] could, if taken literally, just as well be (here is a refutation) a definition of the work of speculative dialectics itself.

The other chain of phrases, which links up with the former, bears the name of Adorno and the colors of negative dialectics. Here are a few of its linkages:

> It lies in the definition of negative dialectics that it will not come to rest in itself, as if it were total. This is its form of hope.

Dialectics is obliged to make a final move: being at once the impression and the critique of the universal delusive context, it must now turn even against itself.

According to its own concept, metaphysics cannot be a deductive context of judgments about things in being, and neither can it be conceived after the model of an absolute otherness terribly defying thought.

[Metaphysics] would be possible only as a legible constellation of things in being *[als lesbare Konstellation von Seiendem].*

[Metaphysics] would bring [things in being] into a configuration in which the elements unite to form a script.

The smallest intramundane traits would be of relevance to the absolute *[Relevanz fürs Absolute].*

Metaphysics immigrates into micrology. Micrology is the place where metaphysics finds a haven from totality.

These phrases are taken from the end of *Negative Dialectics.*[7] It is stated there that "the micrological view cracks the shells of what, measured by the subsuming cover concept [this is directed against Hegel], is hopelessly isolated and explodes its identity, the delusion that it is but a specimen" (ND, p. 408).

The question of the specimen *(l'exemplaire)* is decisive. It is the question of the name. What conceptual name does the so-called proper name bear? By what intelligible, dialectical phrase can the factual name be replaced? What does a proper name *mean to say (veut dire)?* According to Adorno, this is the speculative question. This question presupposes, moreover, a reversal by which the particular becomes an example of the generic. That is why he writes, in the Preface to *Negative Dialectics*: "Part three elaborates models of negative dialectics. They are not examples; they do not simply elucidate general reflections . . . the use of examples which Plato introduced and philosophy repeated ever since: as matters of indifference in themselves" (ND, p. 8).

Now, in this third part, which is entitled *Models (Modelle)*, the section, "Meditations on Metaphysics," begins by, let's say, a micrology whose title is "After Auschwitz." Here, and in adjacent passages, are to be found the following phrases:

After Auschwitz there is no word tinged from on high, not even a theological one, that has any right unless it underwent a transformation.

> If death were that absolute which philosophy tried in vain to conjure positively, everything is nothing; all that we think, too, is thought into the void.

> In the camps death has a novel horror; since Auschwitz, fearing death means fearing worse than death (ND, pp. 367, 371).

If one discusses or disputes what is indisputable (*indiscutable*), speculative thought, is it only out of impatience, frivolity, and lack of culture? Are "Auschwitz" and "after Auschwitz," that is, Western thought and life today, something which disputes speculative discourse? If so, is it frivolous? If not, what happens to and what becomes of the speculative which would not be speculative? What then is the discourse, named "Auschwitz," which disputes the speculative? Or which seeks, without success, to dispute it? This question of the end, death, and aim of speculative dialectics, is also necessarily that of the ends of man, of "our" ends.

(I will not speak about Marxism. It is twice implicated in the question: once, on the side of *speculatio*, and once, on the side of *disputatio*.)

II.

"After" implies a periodization. Adorno counts time (but what time?) from "Auschwitz." Is this name that of a chronological origin? What era ends and what era begins with this event? This question appears ingenuous when it is remembered what kind of disintegration the dialectic inflicts upon the idea of beginning in the first chapter of Hegel's *Science of Logic*, and already in the second Kantian antinomy. Has Adorno forgotten this?

"Auschwitz" is a model, not an example. From Plato to Hegelian dialectics the example, says Adorno, has the function in philosophy of illustrating an idea; it does not enter into a necessary relation with what it illustrates, but remains "indifferent" to it. The model, on the other hand, "brings negative dialectics into the real" (ND, p. xx). As a model, "Auschwitz" does not illustrate negative dialectics. Negative dialectics, because it is negative, blurs the figures of the concept (which proceed from affirmation), scrambles the names borne by the stages of the concept in its movement. This model responds to this reversal in the destiny of the dialectic: it is the name of something (of a paraexperience, of a paraempiricity) wherein dialectics encounters a nonnegatable negative (*un négatif non niable*), and abides in the impossibility of redoubling that negative into a "result." Wherein the mind's wound is not scarred over. Wherein, writes Derrida, "the investment in death cannot be integrally amortized."[8]

The Auschwitz model would designate an experience of language which

brings speculative discourse to a halt. The latter can no longer be pursued "after Auschwitz," that is, "within Auschwitz." Here would be found a name "within" which we cannot think, or not completely. It would not be a name in Hegel's sense, as that figure of memory which assures the permanence of the *rest* when mind has destroyed its signs. It would be a name of the nameless (there are other such names, such as, according to Adorno, the "intelligible character" of the Kantian moral act: "the impulse to do what is just," which justly remains unintelligible [ND, p. 297, translation modified]). It would be a name which designates what has no name in speculation, a name for the anonymous. And what for speculation remains simply the anonymous.

Why say that this anonym designates an "experience of language," a "paraexperience"? Is that not to insult the millions of real dead in the real barracks and gas chambers of real concentration camps? It can be surmised what advantages a well-led indignation can derive from the word of reality. And what is spawned by this indignation is the embryo of the justice-maker. It is this indignation, however, with its claim to realism, which insults the name of Auschwitz, for this indignation is itself the only result it derives from that collective murder. It does not even *doubt* that there is a result (namely itself). Now, if this name is a nameless name, if Auschwitz does not provide an example but a mode, it is perhaps because nothing, or at least not all, of what has been expended in it is conserved; because the requirement of a result is therein disappointed and driven to despair; because speculation does not succeed in deriving a profit from it, were it the minimal one of the beautiful soul. That all this is an affair of language is known only too well by asking the indignant ones: What then does "Auschwitz" mean to say to you *(que veut donc dire "Auschwitz" pour vous)*? For one must, in any case, *speak (dire)*. Some argue over the number of dead in concentration camps: is that what it is, to speak "after Auschwitz"?

"An experience of language, a paraexperience." The word *experience* is *the* word of Hegel's *Phenomenology of Mind*: the "science of the experience of consciousness." And experience is the "dialectical process which consciousness executes on itself."[9] In the sphere which belongs to it, experience supposes the speculative element, the "life of the mind" as a life which "endures death and in death maintains its being" (PM, p. 93). This sojourn liberates the *Zauberkraft* [magical force—tr.] of the mind, the power to convert the negative into Being, the *göttliche Natur des Sprechens*.[10] Can one still speak of experience in the case of the "Auschwitz" model? Would that not be to presuppose the "magical force"? Is the death named (or not named) "Auschwitz," this sojourn wherein the reversal, the old paradox of the affirmation of non-Being, can take place? Adorno writes: "Since Auschwitz fearing death means fearing worse than death." What can make death not yet

the worst is its being not simply the end but only the end of the finite and the revelation of the infinite. Worse than this magical death would be irreversible death, or simply the end—including the end of the infinite.

That could not therefore be said to be an experience, since it would have no result. Its not having a speculative name does not, however, prevent one from talking about it. The question raised by Auschwitz is that of the texture of the text which "links onto" Auschwitz. If this text is not the speculative one, what might it be? How can it authorize itself, if it is not thanks to the *Umkehrung* [reversal—tr.]? It is thanks to the move which passes the thing, the *res (die Sache)*, from the position of referent in the universe of an unmediated phrase to that of addressor and addressee in the universe of a phrase "linking onto" the preceding one that the second phrase is in effect authorized. It is authorized on account of the fact that what is formulated about the referent of the first phrase is formulated by it (the referent), as addressor, and addressed to it, as addressee. Apart from this movement, how can Auschwitz, something which is thought from the outside, a referent placed only "near itself" *(an sich) (auprès-de-soi)* "for us" *(für uns)*, be interiorized, suppressed *(supprimé)*[11] as an unmediated position or presupposition, and show itself to itself, know itself in the identity (be it ephemeral) of a for-itself *(für sich)*? In the absence of this permutation, there is, according to Hegel, only chatter, emptiness, subjectivity, arbitrariness, at best regression towards "ratiocinative" thought, towards the discourse of the understanding, towards the "modesty" of finitude. Now this modesty, he writes, because it is subjective vanity erected into an absolute is "wickedness."[12]

Nevertheless, in contending that one must speak about "Auschwitz" and that one can speak about it truly only if the anonymous object of the phrase becomes its subject and consequently names itself, this summons to express the result of "Auschwitz," to speculate on the anonym, is an intimidation that prejudges the nature of the object. If the name hidden by "Auschwitz" is the death of the magical "beautiful death," how could the latter, which sustains the speculative movement, repossess itself after the former and sublate it? And supposing it was the case, on the other hand, that "after Auschwitz" speculative discourse has died, does it follow that only subjective chatter or the wickedness of modesty remains in its place?

This alternative is formulated only within speculative logic. In accepting the alternative, one perpetuates that logic. But if this logic is to be perpetuated, one might as well attribute the magical force of the negative to "Auschwitz" and already make of it an example of the "beautiful death." For the opposite hypothesis, that of subjective chatter, is in this case excluded by its very construction.

It is possible that some kind of discourse, some kind of logic, sprung from the anonym "Auschwitz" would be maintained "afterwards" which would

not be its speculative result? One would have to imagine the following: that the cleavage introduced into Western thought by "Auschwitz" does not go outside speculative discourse, that is (since the latter has no outside), that it does not determine its effect inside that discourse as an incomplete, invalid, or unexpressed exit, as a kind of neurotic stasis on a figure (that of "Auschwitzian" death) which would only be, all things considered, but a moment. Rather, this cleavage would breach speculative logic itself and not only its effects, would jam the functioning of certain of its operators but not all of them, would condemn that logic to the disarrangement of an infinity which would be neither the good one nor the bad, or which would be both at once. This is how Derrida imagines the "breach" *(fêlure)* of the philosophical tympanum: "By means of this breach, . . . the bloodiness of a disseminated writing comes to separate the lips, to violate the embouchure of philosophy, putting *its* tongue into movement. . . . A necessarily unique event, nonreproducible, hence illegible as such and when it happens. . . ."[13] Would "Auschwitz" be a name for this illegibility? As such, how does it enter into the "legible constellation" fabricated by Adorno's micrologies?

III.

In making of the name "Auschwitz" a model for and within negative dialectics, Adorno suggests that what meets its end there is only affirmative dialectics. But in what way is the dialectic affirmative? In the *Philosophical Propaedeutics* of 1809, Hegel makes a distinction within logic between "the dialectical side or side of negative reason" and "the speculative side or side of positive reason."[14] This distinction is made again in the 1830 *Encyclopaedia*: "In the dialectical stage these finite determinations suppress themselves and pass into their opposites. . . . The speculative stage, or stage of positive reason, apprehends the unity of determinations in their opposition—the *affirmative*, which is involved in their disintegration and in their transition."[15]

This distinction is not respected everywhere in Hegel's opus. In fact, how could it possibly be respected in a discourse whose resources are found precisely in the negative as the magical force that converts non-Being into Being? What ought to be surprising, rather, is that the opposition should have been made at all and that it should be maintained apart from its own dialecticalization, like a concession made on the side to the understanding. This opposition is a trace, the scar of a wound in speculative discourse, a wound for which that discourse is also the mending. The wound is that of nihilism. This wound is not an accidental one; it is absolutely philosophical. Skepticism (of the ancient kind, it should be understood) is not just one

philosophy among others; it is, writes Hegel in 1802, "in an *implicit* form
. . . the free aspect of every philosophy." Hegel continues:

> When in a given proposition expressing reasoned knowledge, one has
> isolated its reflective aspect, that is, the concepts enclosed within it, and
> when one considers the way in which these concepts are connected, then
> it necessarily appears that these concepts are sublated [*relevés, aufgehoben*]
> at the same time, or that they are united in such a way that they contradict
> each other; otherwise, the proposition would not be one of the reason,
> but one of the understanding.[16]

In paragraph 39 of the 1830 *Encyclopaedia*, Hegel refers to the 1802 article
as if he still approved of it.

In paragraph 78, however, a stern corrective is placed upon the philosophi-
cal liberty to dissolve determinations: "Skepticism, made a negative science
and systematically applied to all forms of knowledge, might seem a suitable
introduction, as pointing out the nullity *(Nichtigkeit)* of such assumptions.
But a skeptical introduction would be not only an unpleasant but also a
useless course; and that because Dialectic, as we shall soon make appear, is
itself an essential element of affirmative science" (HL, pp. 111–112; translation
modified, my emphasis). This corrective has already been given in the Intro-
duction to the *Phenomenology of Mind:* "Skepticism always sees in the result
only *pure nothingness*, and abstracts from the fact that this nothing is determi-
nate, is the nothing of *that out of which it comes as a result*" (PG, p. 74, PM,
p. 137).

Animals are given in the *Phenomenology of Mind* as examples of wisdom
in regards to the truth of sense-certainty: they despair of the latter's reality
and they eat it up *(zehren sie auf)* (PG, p. 91, PM, p. 159). Skepticism is
unpleasant because it is the animality of the mind, its stomach, so to speak,
which consumes determinations. Such is the wounding fascination exerted
by nihilism, a consumption or consummation that leaves no remains. The
balm and the exorcism are as follows: to make this distressing negativity
work for the production of an affirmation. To close up the tympanum. Is
the anonym "Auschwitz" a model of negative dialectics? Then, it will have
awakened the despair of nihilism and it will be necessary "after Auschwitz"
for thought to consume its determinations like a cow its fodder or a tiger
its prey, that is, without leaving a result. In the sty or the lair that the West
will have become, only that which follows upon such a consumption will
be found: waste, shit. So must be spoken the end of the infinite, as an
endless repetition of *Nichtige*, as a "bad infinity." You wanted blood, you
get shit.

What would a result of "Auschwitz" consist in? What is a *result*? In the

same paragraph 82 of the *Encyclopaedia*, Hegel goes on to write: "The result of Dialectic is positive, because it has a *determined content*, or because its result is not *empty and abstract nothing*," but the negation of *certain specific determinations* which are contained in the result—for the very reason that it is a resultant and not an *unmediated nothing* (HL, p. 119; translation modified). The *Resultat*—a word whose root is *salt-, saltare, sauter* (to jump) (as in *insult* or *exult*)—is a rebound, a rebounding: something is in motion, it encounters that which stops it; transformed, it re-bounds *(re-saute).*

What is in motion? Let us say, a signifier in search of its signified. For example, what does one say in saying *Being (Être)*?[17] What makes the word falter? Its opposite. In saying *Being*, one says *nothing*, therefore one says nothing. Here, ratiocinative thought is blocked and lacks a result. It holds onto the propositional form, it wants to attribute a determination to the propositional subject, *Being*, and it finds nothing to predicate except nothingness, the contrary of Being. Now, this predication is forbidden to ratiocinative thought by its major rule, the principle of noncontradiction.

But if there is an aporia here, it is by reason of the rules that have been fixed for this language game: a rule for forming terms, a rule for forming phrases, a rule for linking phrases. Let us examine the rules of the game. Here, in short, are those necessary for the speculative one:

(1) A rule for forming terms. Terms enter into a dialectical phrase only on the condition that they have at least two signifieds, and if possible, mutually opposing ones. The model is given by *aufheben*.[18] But this condition is amply satisfied in natural languages, the speculative capacity of each being measured according to the amount of its words in *Doppelsinnigkeit* (double meaning), in *Zweifelhaftigkeit* (uncertainty), and no doubt also in *Verzweiflung* (despair, not only of the kind inflicted on the translator, but also the nihilistic despair before the flight of the signified).

(2) A rule of immanent derivation, which defines negative dialectics, and which could be formulated thus: *if p, then non-p; if non-p, then p, p* being indifferently a term or a phrase (PG, pp. 53–55; PM, pp. 113–115). The figure of Epimenides or Russell's antinomy will be recognized here, the figure that threatens every attributive or propositional logic, the anti-principle of contradiction.[19] (A prescriptive analogue of this figure is given by Aristotle's *Do not obey.*) The elaboration of the double *if, then,* even if performed by an aporetic mind (that of the understanding), already contains the result, but only as it is performed, only as it is given *in* the operation of the elaboration itself. The double implication, that is, the elaboration of the equivocacy of the signifieds and the skeptical course through doubt, *is* the result: the implication is dialectic. But it fails to say so.

(3) A rule of expression. The movement of the double immanent derivation must express itself in a single phrase or term which designates the unity

of the dialectical movement. The movement *through* which, according to the second rule, the determinations are first dissolved, must express itself (this is the *ausdrücken*), give itself a name, address to itself the news of its name. It is then that it becomes a *Resultat*.[20]

This summary, it will have been noticed, transcribes the operators of speculative discourse into the discourse of phrase games; it turns speculative discourse into a phrase game, of which it gives the rules of formation and linkage. The question is to know whether or not this transcription—and what it presupposes in turn—escapes the grasp of speculative discourse. In pursuing this transcription, have we not taken an exterior "point of view" towards that discourse? Are we not dealing with an opinion, with a subjective *Meinen*, which arises from the understanding, or indeed from logical empiricism? The stakes are important: that of the necessity of making linkages from one phrase to the next. Or yet again: that of the homogeneity of phrases in their apparent heterogeneity, of their common, although contradictory, *relevance*[21] to a single genre. Or else, if we proceed in a reverse manner, what is at stake is the possibility, as Derrida writes and italicizes, "of an other [of the philosophical phrase] which is no longer *its other.*"[22] Would the anonym "Auschwitz" have that name: not that of nonlinkage, but of a linkage which is other than "result"?

IV.

It would be a question, in sum, of evading the *Resultat*, of conceiving— and thus, of already making work within this very conception—a dialectics which would not be a moment in speculative discourse. This dialectics would obey, for example, the rules of equivocacy and of immanent derivation; it would ignore the rule of expression. But how could this be possible? Is it not necessary that, in all cases, that which is in question *name* itself, that this name be *its* name? And how could it be named unless it is that Self itself which gives its name to itself? How then can dialectics stay negative? Is it not possible that what is being sought under the name of negative dialectics is just another way of fitting together phrases, and that the name it gives itself then is deceptive? The breach would be covering a fracture.

The question of the necessity of making linkages will be raised in relation to a strong point in the articulation of phrases: that of the *we*. In "our" societies, the pronoun of the first person plural answers in principle to the question of sovereignty. It is the supreme argument of authority, or rather of authorization. It is, in fact, the link which is supposed to bind series of prescriptive phrases (such as articles in codes, court rulings, laws, decrees, ordinances, circulars, and commandments) to their legitimation. A prescrip-

tive phrase is formulated as follows: *It is an obligation for x to accomplish act* ∝. A normative phrase has the following formulation: *It is a norm edicted by y for x to accomplish act* ∝.[23] This norm is considered legitimate, in "our" societies, if it is admitted that *x* and *y*, the addressee of the prescription and the addressor of the norm, must be the same. The legislator submits to the obligation. The obligated one legislates. The former says, *I decree that I must*; says the latter, *I decree that I must*. The four instances (addressor and addressee respectively for the normative and the prescriptive) being perfectly commutative, obligee and legislator are thus united in the same *we*. This is how the figure of autonomy is constructed.

This construction is not self-evident, however. The first person plural has been pulled out of a hat because two first person singulars were put into it. but in the hat, there were also some *hes* and some *yous*. It has been demonstrated by Benveniste to what extent each of these personal pronouns presents in and of itself a phrase universe *(univers de phrase)* different from that of the others.[24] But here, to boot, the pronouns are included in phrases belonging to heterogeneous families. Since the category of the *we* belongs to the problematics of enunciation, let us first examine the question of its formation in that regard.

From the point of view of the legislator, the normative phrase is formulated, *I decree as norm that*, . . . and the prescriptive phrase, *They (the French, the deportees, and so on) must accomplish act* ∝. From the point of view of the obligated, the respective formulations are, for the normative phrase, *They (the legislator, the SS, and so on) decree as norm that*, . . . and for the prescriptive phrase, *I must accomplish act* ∝. Thus is expressed the one-sidedness of the subjective phrase. The description which uncovers this one-sidedness shows that while *I* and *he* are indifferently applied to the same name (what is *I* for oneself is *he* for another), the proper names (the SS, the deportees) remain unchanged and unexchangeable. Subjective singularity does not rebound.

The heterogeneity of the phrases reinforces this immobilization. The normative phrase, *I (or He) decree(s) as norm that*, . . . is declarative and belongs to the genre of descriptive statements. A descriptive invites the addressee to situate himself, at the time of a subsequent occurrence, on the addressor instance. This is the rule of *homologia* or of consensus. A: *The door is shut*. The addressee consents to this by saying, *The door is shut*. Addressor and addressee can easily say a "we" which unites then an *I* and an *I*. Such is not the case in the prescriptive phrase. In response to the command, *Shut the door*, the addressee cannot indicate his consent by saying, *Shut the door*, to the addressor of the command. There is dissymmetry in the case of prescription: the *I* and the *you* are not easily unifiable here.

Before proceeding further, I must clear up a misunderstanding that threat-

ens to arise. In the following, as in the preceding, observations, one might suspect a "wild," unquestioning use of certain notions borrowed from pragmatics, specifically those of addressor and addressee. In reality, no *use* at all is being made of them. What is presupposed in these observations is rather a manner of speaking (which I'm not naming, let's say, a phrase game; that is already the whole question) circumscribed, very poorly but sufficiently, by the following phrases:

If there is one phrase, then there are several phrases. A phrase presents a universe. No matter what its form, a phrase entails a *There is (Il y a)*, whether it is marked or not in the form of the phrase. What is entailed by a phrase is that it presents. A phrase is an event, *ein Fall*, a token. It presents a universe constituted by instances (referent, addressor, addressee, sense) which can be marked or not in the form of the phrase. The phrase is not a message passed from an addressor to an addressee who remain independent of it. The latter are situated in the universe that the phrase presents, together with the referent and the sense. To present phrases as messages is what a phrase does (in the theory of communication); to present a context is also what a phrase does (in sociology or in pragmatics). The phrase universe is not presented to something or someone as if to a subject. The presentation is that there is a universe. There are as many universes as their are phrases, as many situations of instances as there are phrase universes, that is, as many as there are forms of phrases. Space and time are situations of instances in phrase universes. The presentation entailed by a phrase is not itself presented in the universe that the phrase presents; another phrase may present that presentation, but this last phrase also entails a presentation which it does not present. One could call the presentation "Being"; it can be qualified as *absolute*, but it is thereby presented. Therefore, it is situated in the universe of the phrase that presents it, and is relative to that phrase universe. Being is only as if presented *(comme présenté)*, that is, it is presented as an existent *(étant)*, as non-Being. There is no synthesis of the presentations which are entailed; there is only a synthesis of presentations insofar as they are themselves presented in a phrase which synthesizes them. (There is no transcendental time.) "Now" can only be presented (as "the now" of a given phrase). The "now" entailed in a phrase is not presented in the universe that the phrase presents. The linking of one phrase to another requires still another phrase, to present the linkage. This linkage is a necessary one if it follows rules of derivation whose result is termed necessary. These rules are themselves presented. A phrase can copresent several universes along with the one it presents (equivocation).

That should suffice. I will add the following: *phrase* comes from Greek *phrazō*, root *phrad*, which, if I am not mistaken, has no etymological correspondent in Latin. *Phrazō* is to *legō* as *telling* or *declaring* is to *speaking*. An

archaic meaning of the word seems to be *to indicate*. Liddell and Scott cite an interesting occurrence of this meaning in Herodotus: *phōnēsai men ouk eikhe, tē de kheiri ephraze*, "unable to express her meaning through speech, she indicated with her hand." Whence it follows that *to phrase* is not to give voice (*phonein*).

I will also add the following: the preceding phrases imply a displacement of man. In them, man is not understood as the subject matter which needs to be signified, that is, as the referent. For this reason, these phrases do not arise from the human sciences, nor from pragmatics in particular. They reverse the relationship of phrase and context: the latter belongs to the universe presented by the phrase. As the occasion arises, men (proper names) come to occupy given instances in phrase universes. The phrase, *The meeting is called to order*, is not performative *because* its addressor is the person who chairs the meeting; rather, that person is the chair of the meeting *to the extent that* the phrase is performative. Man is not what is; what is, is what is presented, an existent, situated at a given instance. It might be objected that the delimitation of the phrase universe into instances remains nonetheless anthropological, linguistic. Not at all, for it is not man who articulates language, but language which articulates not only the world and sense, but also man. To articulate is not anthropocentric. No more than *to phrase* is. Is this structuralist? No, not that either. Speech *(langage)* is not language *(langue)*. While the latter is understood as a structure made up of codes, the former is composed of moves in games. The rules for phrase games are not structures of language.

V.

Returning now to the problem of the *we*, we find that language very naturally authorizes the synthesis of *I* and *he* in the pronoun of the first person plural, that synthesis providing one of the pronoun's linguistic values (the other is the synthesis of *I* and *you*). But while the philosophy of the subject of enunciation feeds, and feeds upon, this analysis of personal pronouns, it comes up against an old problem, that of the non-I. There is something of the non-I in the *we*. To this philosophical obstacle, pragmatics adds the heterogeneity between two phrase games: the descriptive and the prescriptive.

If "Auschwitz" has no name, is it not because it is the proper name of paraexperience, that of the impossibility of forming the *we*? Is it not the case that in concentration camps there is no plural subject? And is it not further the case that, for want of this plural subject, there can remain "after Auschwitz" no subject which could presume to name *itself* by naming this "experience"?

It will be objected, first of all, that the theoretical and philosophical difficulty of forming a *we* is horridly aggravated when the prescription and the norm take the summary form, *Die, I decree it*, which the SS authorities pronounced to the deportees. The content of the command would be the cause for the failure of the *we*.

The case is far from unique, however. Public authority (familial, political, military, partisan, denominational) does on occasion address the order to die to its own addressees. But if they are *its own* addressees, it is because, through some procedure whose institutional form is not important here, this authority is *their own*. Here again then, a *we* acts to unite the addressee of the command with the addressor of the phrase that makes of that command a norm. This *we* makes it possible for one to die both on command and "freely" or "knowingly." The command, *Die*, can undergo different modalities: *Die rather than escape* (Socrates in prison), *Die rather than be defeated* (Thermopylae, the Paris Commune), and so on. These modalities in no way alter the principle according to which the command is executory as long as the commutation of instances in the two phrases is said to be possible. (But in which phrase in this said?)

Whatever the modality (including degree zero) that affects it, the prescription, *Die*, nevertheless presents a difference between itself and other phrases of the prescriptive family. For the content of the command, if we follow the logic of phrase games, is such that if the addressee obeys, his proper name will no longer be able to figure among the instances of addressor and addressee in ulterior unmediated phrases. It will only be able to figure on them at the referential instance. If, however, this proper name can still be found upon the instances of addressor or addressee, it will be in mediated phrase universes (citations, prosopopoeia, chronicles, accounts of all kinds) in which are reported phrases wherein this proper name was, or will supposed to have been, the addressor and addressee. This immobilization clause in the game (that is, death) in particular prohibits the addressee of the command *Die*—if he obeys it—from later shifting to the position of addressor in a normative phrase of the type, *I decree as norm that*

The only exit offered him as an escape from the situation of exclusive (whether mediated or unmediated) referentiality that is his death is to identify with a *we* (whatever the latter's name might be, the issue being unimportant here) capable, as the instance of addressor and addressee, of legitimizing all possible commands starting with the one ordering him to die. By shifting from one phrase universe to another, by rebounding from that of the final prescription to that of the first legitimation, he eludes the death sentence and is able, for that very reason, to die. He exchanges his particular name for a collective pronoun.

As opposed to the moment of the life-or-death struggle and of domination

described in the *Phenomenology of Mind*, "self-consciousness" does not here have to discover that "life is as essential to it as pure self-consciousness" (PM, p. 234), for the life in question here is that of the *we*. In the cities of ancient Greece, this identification formed the outline of funeral orations pronounced in honour of citizens dead for the city. The "beautiful death," the epideictic theme *par excellence*, the one Plato lampoons in *Menexenus*,[25] is what reconciles the two ways a man can meet his end: his *eschaton* and his *telos*, his ending as incompletion and his completion as un-ending, his *Die* and his *Do not die*, his finitude as living being and his infinitude as legislator, as speaker of the law.

(To put the final touch on the *Zweideutigkeit*, on the equivocation dear to speculative language, and thus to give wit its due measure of enjoyment, it will be noted that the respective semantic fields of the two Greek words encroach on each other: not only does *telō* correspond to Latin *perficere*, accomplishment, but *telos* also means death, as well as the tax payment which is the price for the passage to citizenship. In this passage, what passes away is finitude and what comes to pass is the recognition of the citizen's infinitude as legislator.)

In "Auschwitz," it is not the *Die* which remains nameless and leaves no result, but the fact that the reconciliation of the name in the prescription and the pronoun in the norm, of the finitude of death and the infinity of law, is prohibited. The one who commands the death is exclusively other than the one to whom the command is addressed. The former does not have to account to the latter, and the latter does not have to legitimize the former. The two phrase universes have no common application. What the prescriptive phrase presents (the command to die), the normative phrase does not (whence the "We knew nothing about it" of the so-called legislators); what the normative phrase presents *(So says the law)* remains unknown in the universe of the prescriptive phrase *Die* (whence the "Why do they do it? This cannot be" of the victims).

Nevertheless, we are not dealing with an accident but with a death sentence. For want, however, of a *we* which would make of that command a law, it cannot obligate. The command cannot be obeyed. "It is proper to man to *know* his law," writes Hegel in the *Encyclopaedia*, and therefore "he can truly obey only such known law—even as his law can only be a just law, as it is a *known* law" (HP, p. 260; translation modified). "Auschwitz" would be the name of this impossible phrase wherein the law is not known, wherein it cannot be just, wherein the command cannot obligate, wherein man loses what is proper to him, namely, his *we*. At Auschwitz and afterwards, one does not "know" how to die (ND, pp. 365–373). It is the death of the beautiful, infinite death: finite death. One administers *(On administre)*.

Why then say "*after* Auschwitz"? Because out of the disjoining—or unlink-

ing—of legitimation and obligation (which is what prohibits the formation of a *we* or destroys its figure), it would not even result that *we* are condemned to browse and ruminate over the nullity of determinations. For, what would be this *we*? From merely negative dialectics, deprived of the operators of positive reason, a *we*—no more than any other result—cannot *result*, in order to say or do anything at all. There would not even be a spirit, a spirit of the people or a spirit of the world, which are *wes*, to repossess the name "Auschwitz," to think it and to think itself inside it. The name would remain empty, in a mechanical memory, abandoned by the concept. It is in this way that that name would be anonymous. And that "after Auschwitz" would not mean a rebound, but the repetition of a *Metrum* to which no accent would come to provide rhythm:[26] and it would not mean anything *(il ne voudrait rien dire)*.

VI.

Is it not possible to try, however, through some painful paradox, through some inhuman—other than human—exertion, to draw a result from this irreparable death? (But would this be a result?) The result would be drawn by saying that this death's sense, the identification of another *we*, proceeds from its non-sense, from the impossibility for the addressee of the Auschwitz *Die* to identify himself with the legislator who makes of that command a norm. By saying that, the impossibility of the reversal bears witness to the disparity between the finite and the infinite, that the failure of the mediation reveals the infinitude of that which decrees this death. By daring to say that within the extermination order emanating from the SS (an order to which it is impossible to be obligated, and in relation to which one can only be a victim), a request nevertheless makes itself heard thanks to this impossibility, an identification thanks to nonidentification. What if the abhorrent buffoonery, as David Rousset has called it,[27] of administered genocide, had existed negatively, *in order to* recall that it is only through a dialectical imposture that there is a *we* capable of bringing together the obligated one and the legislator? What if the abasement and the abject dispossession of which the deportees were victims had been marks of the absolute alterity and transcendence of every request (of every prescription) for the addressee it enjoins? Is infinitude not that which escapes identification? Does it not take place as the absurd, as what is beyond one's capacities, as the intolerable, as the command Abraham received, as the "marvel" in Emmanuel Lévinas's sense of the word? A *we* can perhaps identify itself on the basis of this nonidentification: a community of addresses alert to the "marvel," the condition Lévinas calls that of the "hostage."[28]

This *we* would not be ethical in the sense of *Sittlichkeit* [ethical life—tr.],

nor even in the sense of morality, if by morality one persists in identifying, as Kant does, pure will with reason in its practical use. This identification, objects Lévinas, turns out to preserve a basic intelligibility at the addressor's pole of the moral law,[29] even if Kant himself admits that the power there is an "inscrutable one."[30] The new *we* is founded upon the ruins of positive reason and its attendant humanism. This prohibits philosophy from describing the prescriptive situation. The true *we* is never *we*, never stabilized in a name for *we*, always undone before being constituted, only identified in the nonidentity between *you* — the unnameable one, who requests — and me, the hostage. This *we* relation to infinitude is not at all to understand the law, but to let itself be possessed by it in the mode of a dispossession, to be "passive" to the request the law makes.[31] Is this a result, that which results from "Auschwitz"?

It cannot be a speculative result. Even when dialectical thought is not constituted speculatively, it proceeds to reduce the thought of the absolutely other. The infinity of the Jews, writes Hegel (in Frankfurt, a little before 1880), is a purely "ideal" master, a master who does not make one work and who is merely the reverse image of his servant. The latter, Abraham, cannot have a mediated relationship with nature because "he wants *not* to love"; his finitude is that of an animal, but a denatured one. Judaism is what does not arrive at the contradictory unity of determinations. The mind and nature, a people and outsiders, domination and servitude, the family and the State, hate and love, the finite and the infinite are maintained in their unmediated exteriority the one to the other.[32] Henri Meschonnic writes that the phrases devoted to Judaism in *The Spirit of Christianity and its Fate* perpetrated an "anthropological murder" which Hegel never repudiated.[33] Which he could not repudiate, so much does speculative thought always need to exclude the otherwise-than-being *(l'autrement qu'être)* in order to leave the field clear for mediation.

It is at least advisable to concede that this exclusion can only proceed through inclusion. The Frankfurt phrases, which denied *relevance* and result to Judaism, were not inscribed in the project of a "Final Solution" to the Jewish question. They were inscribed in a dialectical movement according to which thought judged oppositional and discontinuous, the thought of finitude and of the bad infinity (to which thought, according to Hegel, Kantianism also belongs), can only find expression because "we," Greeks and Christians who are in possession of the beautiful totality and of love, can give it that expression, albeit in a contradictory way. This movement is fully expressed, and takes on its properly speculative turn thirty years later in the Berlin *Lectures* on the philosophy of history and the philosophy of religion. There, Judaism becomes necessary in its place; it is not yet what we are, but we needed it to have been what it is: "In this process which

detaches it from its abstract particularly and situates it in its rank among the figures of universal mind, Judaism thus obtains its relative justification." Mr Bernard Bourgeois writes this without further ado *(sans phrases)*.[34]

Speculation inflicts upon the figure of the marvel and of the hostage, as it does upon all figures, a defiguration which supposedly commutes that figure into its properness *(son propre)*. The phrase *Listen, Israel, par excellence* and by its own avowal, does *not know* what it says. To know what it says is to report it, that is, to bring it into a rapport with other phrases. The command contained in the phrase is then suppressed and gives way to a description of the command, something not contained in that phrase. This description, however, reciprocally alters the value of the command: it ceases to be executory, becoming a merely reported prescription. It is not a matter of obeying the prescription or not, but of understanding it and of acquiescing or not to its description. Speculative description takes the command as the referent of its phrase; and the phrase of the impossible commandment (of the impossible *we*), stripped of its referential and pragmatic, that is, practical value, conserves only its value of signification: it becomes the image or autonym of itself. The speculative argument (but, as has been stated, speculation does not even need to be argued) says that if knowledge is the issue, the neutralization of the object is its necessary condition. This neutralization also takes place, so the argument goes, in the reflection of a Kant or a Lévinas, but it takes place badly, because it is ignorant of itself. If "Auschwitz" speaks, it is in order to say not the unintelligible but the intelligible, and it becomes necessary to speculate. It if does not speak, if death is senseless *(insensée)* there, it is because one does not speculate.

VII.

What would be a speculative analysis then, that is, with result and gain, of the *Die* at "Auschwitz"? And what happens in that analysis to the *we*?

Die, I decree it is understood as an unmediated, presupposed phrase. As has been seen, a first analysis dissolves it into two phrases: *Let them die, it's our law*, and *Let us die, it's their law*. From this, one cannot pass directly to the *we*, contrary to what subjective thought (philosophy of enunciation) affirms. For the *I* of the deportee, the *he* of the legislator remains exterior. This exteriority is that of every situation of obligation posited in terms of subjectivity. The opposition between the infinitude (or the universality) of the law and the finitude (or the particularity) of the obligee cannot be overcome.

The *I* of the one would have to become a *he for himself* and not only for the other. The infinity of the legislator would have to become *for itself* the finitude (of a good conscience, of the absence of risk, of force); the finitude

of the obligated one would have to become *for itself* the infinity (that he knows and wants the law ordering his death).

The two poles of the opposition disappear then, however; they become identical, each one containing the finitude and the infinity of the other. They can be confused. But the obligation and the command have also disappeared. There is a *we*, but it is empty, or abstract, the mere addition of an *I* and an *I*. This abstraction is the work of a thought which is exterior to the obligation, which has transformed each of the *I*s into a *he*, which has placed them within its own phrase universe as its referent. This external thought is that of the philosopher of understanding, who stands above the battle between the command and its impossibility. It is he who effaces the differences, he for whom the respective points of view are inessential and become interchangeable, he through whom the *we* is instituted as an abstract solution.

This separate *we* cannot be one wherein the contradiction of obligation expresses itself in its resolution. What "we" have just said, "we" have said *as if* "we" were in turn the legislator and the obligee, the infinity of the one and the finitude of the other, then the finitude of the first and the infinity of the second. "We" have thus effected what we were seeking. "We" were seeking a *we*, that *we* was what was sought, and therefore what sought itself. It expresses itself at the end just as it effected itself from the beginning. It is not the sum of the *I*s comprehended within the command of the norm; it is the contradictory movement that goes from one to the other.

The name of this movement is obligation, for the latter is nothing more than the contradiction that has just been traversed. This contradiction can only be traversed because "we" are able to traverse it, that is, because there is already obligation. But the obligation is at first only "near itself" and "for us," for an external, abstract *we*. It is only truly what it is when it is "for itself," in the expression of itself, when the movement by which it is effected names itself.

In exploding the contradiction of *Die, I decree it*, "Auschwitz" does not fall into unintelligibility; it effects the obligation, but in its impossibility. Its speculative result is . . . the analysis that has just been carried out; the anonym "Auschwitz" receives therein its speculative baptism.

It would not be very opportune to object that this dialectical deduction in turn presupposes what it deduces, that is, the *we*. One could look for the *we* that packs the *Phenomenology of Mind*; one could show that "it articulates natural and philosophical consciousness with each other," that it "is the unity of absolute knowledge and anthropology, of God and man, of onto-theo-teleology and humanism."[35] Such is without a doubt its at once presupposed and supposed equivocacy within the phenomenological field. But this is because this field is that of the experience of consciousness, wherein,

as the *Encyclopaedia* states, "[the 'I'] is one side of the relationship and the whole relationship" (HP, p. 153). This equivocacy vanishes when logic, or objective mind, is involved, that is, when speculative discourse is extended to objects which are not part of consciousness. In these cases, the *we* is seen to occupy the necessary though subordinate place of the abstract moment, of the moment of exteriority. The place of the other of speculation (that is, the understanding) within speculation. On the other hand, the *we* does not appear in the supreme moment, that of the Idea of philosophy, which is said to be "near and for itself *[an und für sich]*" (HP, p. 315; translation modified). No *we* is needed, then, in order for this idea, which is God, to express its relation to itself.

In the 1830 edition of the *Encyclopaedia* , the expression *für uns*, (for us), is generally combined with the expression *an sich*, (near itself) *(auprès de soi)*. Together, these expressions mark the abstract moment in the development of the concept, wherein is maintained the exteriority between the object of thought (the *self [le soi]* which is near itself) and the subject (the *we* that posits this self). The speculative moment, on the contrary, comes when this exteriority is dissolved, when the *self* comes "in the place of" the *we* (which is no longer there), when the object of thought becomes the thought which objectifies itself as well as the object which thinks itself, the *für sich*, the *for itself (pour soi)*. This distinction is evidenced by, among others, the difference between a cause and an aim: "It is only when near itself, or for us, that the cause is in the effect made for the first time a cause, and that it there returns *into itself*. The aim, on the other hand, is expressly stated as containing the determinations *in its own self*—the effect, namely, which in the purely causal relation is never free from otherness. . . . The aim then requires to be speculatively apprehended. . . ." (HL, p. 268; translation modified). Similarly, in the case of reciprocal action, *die Wechselwirkung*, it is at first just "near themselves" and "in our reflection" that the determinations of this form of actuality are "null and void" *(nichtige)*; the *Wechselwirkung* only attains its unity when the unity of the determinations "is also *for itself*," when reciprocal action itself suppresses each determination by inverting it into its opposite (origin and effect, action and reaction, and so on. [HL, p. 218; translation modified]). The price paid for speculation is the suppression of the *we* as an identity that thinks or speaks for the outside.

The first *Realphilosophie* of Jena teaches that "the sign as *something actual* (must) thus directly vanish" and that "the name is in itself something, it *persists*, without either the thing or the subject. In the name the *self*-subsisting reality of the sign is nullified."[36] The *I*, the *he*, the *you*, the *we* are signs, as are all pronouns; identity cannot take place in them. Identity takes place in names, in the case of "Auschwitz" the name of obligation, and it takes place at the cost of the designification of signs, of the destruction of pronouns. This is how "the thing works."

And if there is not even a name, if the name of "Auschwitz" is a nameless name, does it follow that the thing does not work? The thing is more complicated, it also devours names. For names are again only what memory makes out of signs.[37] Memory, though, is itself "the onesided mode of thought's *existence*," its "mechanical" side, thought which is "for us or near itself," as the *Encyclopaedia* recalls (HP, p. 223; translation modified). On the contrary then, if there were nothing but names, the thing could not work precisely because the machine of names, nominalism, would work in its place and because, as Jean-Luc Nancy has written, "the disappearance of sense would resemble the death of Molière."[38] Derrida "risks" the "proposition" according to which "what Hegel *could never think*, is a machine which would work."[39] Machines work through a loss. Speculation is a machine that gains, and it is therefore a deranged machine. The "thing" only works by throwing its gains—including names and pronouns—out of kilter.

This throwing out of kilter is a necessity which is itself a purposiveness *(finalité)*. "Reason," it is written in the Preface to the *Phenomenology*, "is *purposive activity," (das zwechmässige Tun)* (PG, p. 26, PM, p. 83). The model for this purposiveness is borrowed from Aristotle. The speculative game only appears monstrous from the perspective of the understanding, but the understanding fails to recognize its presuppositions accepting them as evidences, as axioms, or as conditions of possibility. It admits first phrases. There are none. The first is also the last. One begins with philosophy's need for a figure in which the mind is only "near itself," but every phrase is needed in order to express this object of need and to suppress the need, in order for the mind "to become for itself what it is near itself" (HP, p. 25; translation modified). In the speculative phrase, the purposiveness of the for-itself is what guides the rebound. The aim is the "reconciliation of the self-conscious reason with the reason which *is* in the word—in other words, with actuality" (HL, p. 8). This aim is *ceaselessly* attained, and for that reason it is never attained. If it is attained, it is not attained. When it is not attained, it is attained nonetheless. This rule is that of immanent derivation and of negative dialectics. Here, the rule has been applied to the aim, that is, to the result. But a dialecticalized aim is still just as much an aim. The teleology has merely sophisticated itself.

VIII.

The *we* is not what resists; what resists is mind proceeding towards itself. The latter's infinitude throws the phrase-stages out of kilter in order to express them. The *we* phrase is such a phrase-stage. The linkages are always made on the same side, that of expression, of gain over infinity, of infinite gain.

There is nevertheless something presupposed in this way of proceeding.

In the Preface to the first edition (1817) of the *Encyclopaedia*, Hegel criticizes "a *manner* of dealing with philosophical objects which has become habitual, and which consists in *presupposing a schema*" in such a way that "by the strangest of misunderstandings, the necessity of a concept will have been sufficiently demonstrated by means of fortuitous and arbitrary connections."[40] The presupposition of speculation is that one is the aim; or, to state it better, that the aim should be set on the one. This presupposition supports the third of the rules we isolated, the rule of expression. To make two out of one is negative reason; to make one out of two is positive reason.

Now, this is the presupposition only of speculative discourse. *One* is the aim because the aim of this discourse is its own origin, its engenderment, as true. The only true *Umkehrung*, the one ceaselessly found in all the figures of this discourse, is the one which shifts the entire universe of the unmediated phrase, not onto the referential pole of the philosophical phrase (that is the operation of the understanding), but onto its addressor and addressee poles. There, the phrase is transformed into its for-itself, that is to say, it is transformed into the philosophical phrase. The *Resultat* is to be had for this price.

This is a rule in a phrase game, namely, the rule of expression in the speculative game. This rule is permitted by individual languages. It violates Aristotelian logic and propositional logic. It endows the philosophical phrase, however, with something these logics cannot give it: the engenderment of itself as true.

One cannot object to the functioning of this rule on the grounds that "it doesn't really work that way." Only the following objection can be raised: that although it is a rule in a phrase game where the self-engenderment of the phrase is, in fact, what is at stake, *this rule cannot itself engender itself.* The objection is not that of a logical paradox as in Russell, but that of the limitation of formal systems as in Gödel.[41] If one says that the rule of engenderment *results* from the analysis of what happens in dialectical analysis (as we have suggested in the case of obligation), then one presupposes the rule, under the name of result.

The condition whereby the engenderment of the rule is what is at stake in a language game is the rule in the philosophical game insofar as it has, as one says, "imperfect information" with regards to its rules.[42] But insofar as the rule is what is at stake in the game, *it is not* the rule, and the game is played without its consideration. And when it is "identified" as the rule of the game that is being played, that rule *is no longer* whatever is at stake in the philosophical game.

One will recognize in this last statement the dialectical phrase *par excellence.* The dialectical phrase is not, however, the speculative phrase. The above statement excludes the game where *the loser wins.* At the level of rules,

there operates one where *the winner loses*; it is called Maxwell's Demon, Brillouin's Argument, Gödel's Theorem.[43]

The position of the third rule, the speculative rule, remains necessarily presupposed. This is not the case for the rule of equivocacy and of immanent derivation. A rule like, *Equivocate (or dialecticalize) every phrase, including the present one*, implies that the operators of equivocacy and of dialectics apply to the rule itself. This self-application corresponds to the following rule: in philosophical discourse, every phrase which presents itself as its rule can be put back into play through equivocation and dialecticalization.

This rule is only permissive. It corresponds to scepticism. Philosophical discourse entails another rule, which is prescriptive. This rule prescribes that philosophical discourse identify the rule which is its own. In no way does it declare what this last rule might consist in. In particular, it does not presuppose that this rule is that of identity (*Selbst*). Nor even that this rule is identical to itself (the prescriptive rule). In the philosophical game there can be no rule which anticipates the nature of the aim.

The fact that identity is the aim cannot be engendered from the rule that makes identity into an aim. The speculative rule, *Engender every phrase as the expression or identity of the preceding ones, including the present one*, is impossible. For taken as a rule, this phrase is logically the first one, and has no precedent. It cannot then be the expression or identity (*Resultat*) of those phrases which precede it. It is understood that, for Hegel, this "beginning" can only come at the end, as a result, after the phrases of which it presents itself as the expression or final identity. Moreover, it can only appear as this final result because it has been presupposed from the beginning, as the rule for the linking of the first phrase (itself) with the following phrase and those afterwards. Now, taken as a first phrase, it is senseless. If, however, it is not applied from the beginning (to itself), there is no need to find it at the end, and thus it is not the *Resultat*; not having been engendered as such, it is not the rule that is sought.

All that the rule for philosophical linkage can prescribe is that what is at stake in philosophical phrases is a rule (or rules) to be sought, without it being possible to announce yet what this rule says. It follows that from one phrase to the next, the alterity each time stays intact. The *one* implied in *One phrase* (see above, Section IV) is not a one abstracted from all other phrases, through which it would lose itself in order to rejoin itself, but one with others. *With* indicates at least two types of relation: the others within the one, the one amongst the others.

The others within the one: the qualitative infinity. As it stands, a phrase is perfect, its sense is complete (thus Hegel can write that "in a concept there is nothing further to be thought than the concept itself" (HL, pp. 6–7; translation modified)). Thus, a phrase is finite; it only presents what it

presents. This *only* implies therefore that a phrase also copresents something else, which it does not present. Other possible universes are copresent with the one it presents. They are copresent, not as something missing in it (for why would a phrase "want" to present everything?), but as what exceeds it (its equivocacy): copresent universes are always implied, presupposed, connoted, and so on. The interrogative, *Can you come see him*? copresents, among others, a universe which could also be presented by a prescriptive such as, *Come see him*. This last universe, however, is not presented by the interrogative.

The other phrases are incommensurable with this phrase; otherwise, each would be indiscernible from the others. The fact that the others would be *with* the phrase in question—*in* it—turns the latter into an infinity of thought, an *infinitum actu*, analogous to the one which Spinoza describes to Lewis Meyer[44] and which Hegel reconsiders in his *Science of Logic* under the title of the "good infinity."[45]

The other phrases' heterogeneity in relation to the phrase in question consists in their incommensurability or untranslatability. The abyss which separates the two Kantian *Critiques* is a trace of this heterogeneity at the very moment when it is annihilated by the project to present complementarity. The "late" Wittgenstein is more radical: one language game cannot be translated into another. But Wittgenstein keeps to (empirical) descriptions, leaving aside only his notion of an inexpressible.

The one amongst the others: the quantitative infinity. The surplus of others within the one indicates a necessity, the only one, which is to link up the other phrases to the one. The linkage is regressive-progressive, dialectical in the paralogistic sense, when and only when it *aims* (here is the aim) to formulate the other phrases that are within the one (the philosophical language game). Were those phrases already there? To apprehend them is to formulate them; and formulated, they are *there no longer*. The precursor arrives too late. This phrase here is destroyed. Another, which is now this phrase here, presents a universe reputedly copresented by the "preceding" one. (Here, Hegel would write that the concept "suppresses its presupposition, but at the same time, it is the concept alone which, in the act of positing itself, makes its presupposition" [HL, p. 221; translation modified]).

But the linkage does not have to be linked this way. To *Can you come see him?* can be linked the following phrases: *Why not?; You think so?; My car isn't working; Of course; I can't;* and many others, including, *How is Chantal?* So goes conversation, the *Konversation*, the chat, the aggregate *(Aggregat)* of phrases rejected in the Preface to the *Phenomenology*. A conversation is also a diversation.

To link is to disjoin. The calm completeness of the infinity *actu* at rest within a phrase becomes discontinuous. (There is still too much substantialism, too much *rest*, in the idea that a phrase is deferred from itself *[se diffère]*.)

The one (a phrase) is not first, nor last, nor both; it is amongst the others which are within it.

The *absolutely other* is a phrase which designates the incommensurability between the universe of the prescriptive phrase (request) and the universes of the descriptive phrases which take it as their referent.

"Auschwitz" is an abhorrent model for this incommensurability. The notion of incommensurability has been elaborated by Kant, by Wittgenstein (in his "Lecture on Ethics"[46]), by Lévinas. But in a one-sided way. For this lack of measure *(démesure)* (in the sense that rational activity is an activity measured by its aim, *zweckmässig*) is not the exclusive privilege of prescriptive phrases. It can be at work in all linkages, in all the alterities between phrases, to the extent that each of these alterities is *what happens*, is the case, *der Fall*. And perhaps every phrase, even if it is "well known," recognizable, harbors the force of what falls *(fallen)*, of what runs you over *(ce qui vous court dessus) (occur)*. This lack of measure indicates that the being-with of phrases is neither a being-as nor a being-together, nor even a being-without. It indicates that reason is not sufficient (to make links in accordance with an aim); that the joust, the *agōn*, of phrases is perpetual; that justice is— nevertheless and *justly* because it is a matter neither for treastises nor for systems (for simple repetitive linkages)—always possible, albeit as prudence (what Aristotle calls *phronesis*): the prudence to make or speak the linkage "that suits" in a particular case, without there being known what the rule of suitability is.

"If there are margins, is there still *a* philosophy, *the* philosophy?" asks Derrida.[47] There is no longer any philosophy if it presupposes the phrase of self-engenderment. If that phrase is not presupposed, is philosophy aimless, endless, and therefore truthless? Is it nihilistic? empiricist? modest? It might be as follows: with a phrase, the attempt to link on a phrase which presents universes copresented by the former; and thus to "invent" rules for the linkings of phrases; and with a rule, in turn, to link on a phrase. . . .

The following remarks, transcribed by Jean-François Lyotard, are taken from the discussion which took place after the reading of "Phrasing 'After Auschwitz'" at Cerisy.

Derrida states that he finds himself in agreement with the talk, that he does not want to "yield to this pathos" (of agreement), that he seeks to "link on, no, not to link on, but to add phrases." He wonders if "the question" is not that of "the multiplicity of proper names," if "the very grave stakes of what Lyotard has given to think" are not "the fact that there are several proper names." He wonders, first of all, about the "schema" presupposed by Lyotard's discourse centered upon Auschwitz; and he thinks he perceives that

173

"in referring to this nameless name, in making a model of it, that discourse risks reconstituting a kind of centrality," a *we* for this occasion, one which is certainly not that of speculative dialectics, but which is related to the unanimous privilege "we Western Europeans" grant Auschwitz in "the combat or the question" we oppose to speculative dialectics, to "a certain kind of Western reason, etc." The risk is that this *we* "would consign to oblivion or would brush aside *(latéraliserait)* proper names other than that of Auschwitz and which are just as abhorrent as it," names which have names, and names which don't. "And my worry," says Derrida, "is that a certain *we* reconstitutes itself in reference to what you have said so admirably about Auschwitz."

Derrida then formulates "another worry," which resembles the less dramatic or "more formal" one he feels when he reads Lévinas: "Despite all the indisputable things he says about the utterly-other gives rise to linkings of phrases." This difficulty, Derrida calls in a text devoted to Lévinas, "*sériature.*" By the same token, we have "to make links historically, politically, and ethically with the name, with that which absolutely refuses linkage." Derrida asks: "If there is today an ethical or political question and if there is somewhere a *One must*, it must link up with a *one must make links with Auschwitz . . . (Il faut enchaîner sur Auschwitz).* Perhaps Auschwitz prescribes— and the other proper names of analogous tragedies (in their irreducible dispersion) prescribe—that we make links. It does not prescribe that we overcome the unlinkable, but rather: because it is unlinkable, we are enjoined to make links. I do not mean to say that one must make links in spite of the linkable; I mean to say that the unlinkable of Auschwitz prescribes that we make links." If Lyotard was able to move us, it is because the presupposition shared by all is that Auschwitz is intolerable and therefore that one must say and do something, so that it does not, for instance, start over again. . . .

Finally a couple of 'ancillary' words on difference. Refusing the nascent pathos of this subject, Derrida states:

> I would say with a smile that of course the word seems to imply some nostalgia. It is nonetheless an economical word which has a *Zweideutigkeit* upon which I do not wish to dwell but with which I can reckon *(compter)*. One of the two senses can imply nostalgia, but the other does not imply nostalgia very much, if at all; I have explained myself on this point elsewhere. I do not say this in order to correct an interpretation—that would be absolutely ridiculous here—I say it in order to break with the kind of pathos of agreement in which I have been up until a little while ago, and in order to try to understand, no matter how far this agreement may be pursued, what the fundamental difference of tone or affect is between what you say and what I would say. In regards to nostalgia, I said that I

wanted to break with it, but I guard (and I assume this guardedness because that's the way it is), I guard a nostalgia for nostalgia, and that is perhaps a sign that when I say, "Nostalgia would be better," I continue to, etc. You, on the other hand—and I was very sensitive to this again today, I have always been sensitive to this in reading you, but I was again even today when I have never felt myself closer to you—you have a style, a mode and a tone of rupture with nostalgia (and with everything it brings or connotes) that is resolute, trenchant, wilful, etc., and I thought to myself that perhaps this, and nothing more, was what was fundamentally at play in this question.

Lyotard recalls, first of all, that he was tempted to suggest, perhaps in "too resolute" a fashion, that "every phrase, if it is apprehended as an occurrence in the strong sense of the term, can become a model" (German: *Modell (mold)* specifies Maurice de Gandillac). In this sense, there can be innumerable name-models, and Derrida is right to underscore this, because there ensues a considerable displacement in how one thinks about history. Then, to the objection of breaking too quickly with dialectics, Lyotard answers: "On the contrary, while working on this talk, I had the feeling of making a enormous effort to try not to break with dialectics." Whence the accent on the "One must make links," presented as the sole necessity and sole enigma. He strove not to let this "One must" slip into a philosophy of the will. But neither does he believe that it arises *(relève)* from ethics: "the 'One must' is much more stupid than that." One must make links after Auschwitz, but without a speculative result. As for the question about the *we*, he is inclined to think in the Hassidic tradition reported by *Gog and Magog*, in the sense of the impossibility for a community to conceive the following: "We would merely be hostages of the 'One must make links', *we* are not in possession of its rule, *we* seek it, *we* make links in seeking it; it is thus the stakes but not the rule for the linkage." This *we* works, or has to work no matter where, "to vary all the rules of linkage whatever they might be, in music, in painting, in film, in political economy" in a way not unrelated to Derridean dissemination. This quest for the rule of linkage is a quest for the intelligible. Adorno speaks of the legible, Derrida of the illegible. This is a radical divergence, and yet "if *we* are the community of hostages of the 'One must make links', it is that we are learning to read, therefore that we do not know how to read, and that for *us*, to read is precisely to read the illegible."

As for the question of nostalgia, Lyotard says to Derrida: "I will not intervene because, after all, you have turned it into an affair of idiosyncrasy." Derrida: "Something like that." Lyotard: "Then, I would be indiscreet if I were to intervene in your nostalgia just as you were indiscreet to intervene in my resoluteness" (laughter). Derrida: "It was a little more than an idiosyn-

cratic comparison . . . : in the resolute break with nostalgia, there is a psycho-analytic-Hegelian logic, a rigid relation, not very well regulated" (laughter); "there is perhaps more nostalgia in you than in me" (laughter). "This is the suspicion rooted in the question about style" (laughter). Lyotard: "Do you have the right rule then?" Derrida: "No." Lyotard observes that he did not speak about Heidegger, even though ontology is evidently what is implicated in the idea of a phrase game wherein what is at stake is that a phrase present the entailed presentation. This omission is not due to an excess of "resolution"; rather, it is that the interest of phrases (in the Kantian sense of the interest of reason) does not appear to him to be on the side of ontology. The notion of interest is a little narrow, but it introduces what is at stake in a justice or justness *(justesse)* where one did not expect to find it. Derrida observes that the relation to nostalgia is always badly regulated, and that "to dismiss it purely and simply" is a case of a bad rule. Lyotard says he had hoped to evoke Derrida's agreement by proposing a less nostalgic acceptation of difference (laughter), which he sees emerging in the development of his work. Derrida acknowledges this shift, but he repeats that "in your case it is the face that breaks away from nostalgia" that is mostly seen.

Notes

1. Translator's note: This paper is a transcript of a lecture given by Jean-François Lyotard in 1980 on the occasion of the colloquium, "Les fins de l'homme: à partir du travail de Jacques Derrida," Cerisy-la-Salle.

2. Hegel, *Aphorismen über Nichtwissen und absolutes Wissen im Verhältnisse zur christlichen Glaubenserkenntnis. Von Karl Friedrich Göshel,* in *Werke in zwanzig Bänden* (Frankfurt: Suhrkamp Verlag, 1970), XI, pp. 380–381.

3. Translator's note: At the risk of some awkwardness and confusion, I will translate the French word *phrase* by its English cognate rather than by the semantically more correct *sentence.* English *phrase* like French *phrase* can be used without appreciable semantic difference either as a noun or as a verb, whereas *to sentence* is a verb used only in a juridical sense, as when one speaks of "sentencing someone to death." The explicit content of this essay would seem to make even a neologistic use of the verb, *to sentence,* undesirable and possibly dangerous. *Phrase,* on the other hand, is a term of very wide extension and encompasses utterances at various levels between word and sentence. My hope, then, is that wide applicability of the term, *phrase,* will open a space wherein Lyotard's notion of phrase can more forcefully take on the precise formulations he gives it in the course of the essay. These formulations (especially those in Section IV) show that what is being considered under the rubric "phrase" is *not* a grammatical—not even a linguistic—entity, but a *pragmatic* one, and that the essay's central concern is with the possibility or impossibility of phrasing certain things, that is, of being able or not to make certain phrases. As Lyotard says at the end of Section IV, "the rules for phrase games are not structures of language."

4. Jacques Derrida, *Margins of Philosophy,* trans. Alan Bass (Chicago: University of Chicago Press, 1982). The citations are taken from, respectively, "Différance," p. 27;

"Ousisa and Grammē," p. 67; "The Pit and the Pyramid," p. 107; "The Ends of Man," p. 121.

5. Derrida, "Tympan," p. xxvi.

6. Derrida, "Signature Event Context," p. 329.

7. Theodor Adorno, *Negative Dialectics*, trans. E. B. Ashton (New York: The Seabury Press, 1973), pp. 406–408. Hereafter cited as ND in the text.

8. Derrida, "The Pit and the Pyramid," p. 107.

9. Hegel, *The Phenomenology of Mind*, trans. J. B. Baillie (New York: Harper and Row, 1976), pp. 144, 142. Hereafter cited as PM in the text.

10. Hegel, *Phänomenologie des Geistes, Werke III*, p. 92; hereafter cited as PG. Also PM, p. 160.

11. Translator's note: *Supprimer* is how Jean Hyppolite translates *aufheben* into French.

12. *Hegel's Philosophy of Mind: Being Part Three of the Encyclopaedia of the Philosophical Sciences (1830)*, trans. William Wallace (Oxford: Clarendon Press, 1971), paragraph 386, pp. 22–23. References to the German text will be to *Enzyklopädie der philosophischen Wissenschaften in Grundrisse*, eds. F. Nicolin and O. Pöggeler (Hamburg: Felix Meiner, 1959). Hereafter cited as HP in the text.

13. Derrida, "Tympan," p. xviii.

14. Hegel, *Texte zur Philosophischen Propädeutik, Werke IV*, 12. The passage is from paragraph 12 of the section entitled "Philosophischen Enzyklopädie."

15. *Hegel's Logic: Being Part One of the Encyclopaedia of the Philosophical Sciences (1830)*, trans. William Wallace (Oxford: Clarendon Press, 1975), para. 81, p. 115, and paragraph 82, p. 119; translation modified. Hereafter cited as HL in the text.

16. Hegel, "Verhältnis des Skeptizismus zur Philosophie." *Aufsätze aus dem Kritischen Journal der Philosophie, Werke II*, p. 229.

17. Hegel, *Wissenschaft der Logik, Werke V*, pp. 82–84; *Science of Logic*, trans. A. V. Miller (London: George Allen & Unwin, 1969), pp. 82–84.

18. See Jean-Luc Nancy, *La remarque spéculative* (Paris: Galilée, 1973).

19. Translator's note: The antinomy in question is more commonly known by the "paradox of the liar" wherein it becomes impossible to know whether a liar who claims to be lying is telling the truth or lying. See Lyotard's discussion of this paradox in his "Sur la force des faibles," *L'arc 64* (1976), pp. 4–12.

20. The reader will forgive this synopsis. Its excuse is the brevity of life, as Protagoras would say—the brevity of even a long lecture. A slightly less summary exposition is given in "Analysing Speculative Discourse as Language-Game," trans. G. Bennington, *Oxford Literary Review*, 4, 3 (1981), pp. 59–67.

21. Translator's note: The word *relevance* here is to be understood not only in the English sense of pertinency but also as a neologism derived from Derrida's translation of *Aufhebung*, as *relève*.

22. Derrida's "Tympan," p. xiv.

23. See Georges Kalinowski, *La logique des normes* (Paris: PUF, 1972).

24. Emile Benveniste, *Problems in General Linguistics*, trans. Mary E. Meek (Coral Gables: University of Miami Press, 1971).

25. See Nicole Loraux, *L'invention d'Athènes: Histoire de l'oraison funèbre dans la "cité classique"* (Berlin: Mouton/De Gruyter, 1981).

26. I refer to the threat which, by Hegel's avowal, hangs over the speculative phrase, and which Jean-Luc Nancy has studied in *La remarque spéculative*. The concept's unity always threatens the difference between the subject and the predicate of a proposition, just as meter threatens accent (PM, p. 120).

27. David Rousset, *Le pitre ne rit pas* (Paris: Christian Bourgois, 1979). See also *Les jours de notre mort* (Paris: U.G.E., 1974).

28. Emmanuel Lévinas, *Totality and Infinity*, trans. A. Lingis (Pittsburgh: Duquesne University Press, 1969), p. 292; *Otherwise Than Being, or Beyond Essence*, trans. A. Lingis (The Hague: Martinus Nijhoff, 1981), pp. 117–118.

29. Lévinas, *Totality and Infinity*, pp. 216–219.

30. *"Unerforschlichen"* in the German. Immanuel Kant, *Critique of Practical Reason*, trans. L. W. Beck (Indianapolis: Liberal Arts Press, 1956), p. 49.

31. Lévinas, *Otherwise Than Being*, pp. 111–112; *Quatre lectures talmudiques* (Paris: Gallimard, 1968).

32. Hegel, *The Spirit of Christianity and Its Fate*, trans. T. M. Knox, *Early Theological Writings* (Chicago: University of Chicago Press, 1948), pp. 182–205, 253–261.

33. Henri, Meschonnic, *Le signe et le poème* (Paris: Gallimard, 1975) pp. 109–110.

34. Bernard Bourgeois, *Hegel à Francfort* (Paris: Vrin, 1970) p. 118. Lévinas protests against this in *Difficile liberté* (Paris: Albin Michel, 1963).

35. Derrida, "The Ends of Man," p. 121.

36. Hegel, *First Philosophy of Spirit*, ed. and trans. H. S. Harris, *System of Ethical Life and First Philosophy of Spirit* (Albany: State University of New York Press, 1979), pp. 221–222.

37. Hegel, *First Philosophy of Spirit*, p. 221.

38. *La remarque spéculative*, p. 157. Nancy's commentary deals particularly with paragraph 462 of the *Encyclopaedia*. Translator's note: It will be recalled that Molière met his death on stage while performing *Le malade imaginaire*. Nancy explains his analogy as follows: "To play knowing that it is only a play *and* that a fearful, mortal actuality is at play in this play, such would be the almost intolerable experience of Hegelian discourse . . ." (p. 157).

39. Derrida, "The Pit and Pyramid," p. 107.

40. Hegel, "Vorrede zur ersten Ausgabe (1817)," *Encyclopaedia*, pp. 20–21.

41. Translator's note: According to Gödel's theorem, the internal logical consistency of a formal system cannot be proved within the system.

42. Translator's note: The reference is to Anatol Rapoport, *Fights, Games, and Debates* (Ann Arbor: University of Michigan Press, 1960), pp. 152–154.

43. Translator's note: The problem of Maxwell's Demon posits a case wherein the Second Law of Thermodynamics (commonly known as the theory of entropy) could be reversed by the existence of a being small enough to separate and redirect individual molecules according to their velocity. Brillouin solved this problem by his notion of information as negative entropy of "negentropy." In other words, the information gained in a scientific experiment is itself only gained by an even greater gain in entropy.

44. Spinoza, letter to Lewis Meyer, April 20, 1663, letter 29 in *Correspondence, The Chief Works of Benedict de Spinoza*, trans. R.H.M. Elwes (New York: Dover Publications, 1951), II, pp. 317–323.

45. Hegel, *Wissenschaft der Logik*, pp. 291–293; *Science of Logic*, pp. 249–251 ("The Specific Nature of the Mathematical Infinite").

46. Translator's note: "A Lecture on Ethics," *The Philosophical Review*, 74 (1965), pp. 3–12.

47. Derrida, "Tympan," p. xvi.

Translated by Georges Van Den Abbeele

11

Difficult Freedom

Emmanuel Lévinas

Judaism

In the present day, the word "Judaism" covers several quite distinct concepts. Above all, it designates a religion, the system of beliefs, rituals, and moral prescriptions founded on the Bible, the Talmud, and Rabbinic literature, and often combined with the mysticism or theosophy of the Kabbalah. The principal forms of this religion have scarcely varied for two thousand years, and attest to a spirit that is fully conscious of itself and is reflected in a religious and moral literature, while still being open to new developments. "Judaism" thus comes to signify a culture that is either the result or the foundation of the religion, but at all events has its own sense of evolution. Throughout the world, and even in the state of Israel, there are people who identify with Judaism but who do not believe in God and who are not practicing Jews. For millions of Israelites who have been assimilated into the civilization around them, Judaism cannot even be called a culture: it is a vague sensibility made up of various ideas, memories, customs, and emotions, together with a feeling of solidarity towards those Jews who were persecuted for being Jews.

This sensibility, this culture, and this religion are nonetheless seen from the outside as being aspects of a strongly characterized entity that cannot easily be classified. Is it a nationality or a religion, a fossilized civilization that somehow lives on, or the passionate desire for a better world? The mystery of Israel! This difficulty reflects a sense of presence to history that is unique in its kind. In fact, Judaism is the source of the great monotheistic religions, on which the modern world depends just as much as ancient Greece and Rome once did, and also belongs to the living present not only through the concepts and books it has supplied, but equally through real men and women who, as pioneers of various great ventures or as victims

of great historical convulsions, form part of a direct and unbroken line of descent from the people of sacred history. The attempt to create a state in Palestine and to regain the creative inspiration of old whose pronouncements were of universal significance cannot be understood without the Bible.

Judaism has a special essence: it is something that is laid down in square letters and something that illuminates living faces; it is both ancient doctrine and contemporary history. But this runs the risk of favoring a mythical vision or a spirituality that can still none the less be analyzed. Objective science, such as sociology, history, or philology, tries to reduce the exception to the rule. Western Jews promoted this kind of research. At the end of the seventeenth century, Spinoza's *Tractatus Theologico-Politicus* inaugurates a critical reading of the Scriptures. At the beginning of the nineteenth century in Germany, the founders of the famous "science of Judaism" (*Wissenschaft des Judentums*) transformed the Holy Scriptures into pure documents. The paradoxes of an unequaled destiny and an absolute teaching slot easily into the scientific categories created for every spiritual reality and all other idiosyncrasies. Everything can be explained by its causes; and by methodically tracking down and logging every influence, many original features dissolve. Judaism emerges, perhaps, more aware of what it has received, but less and less sure of its own truth.

We may nonetheless ask whether the scientific categorization of a spiritual movement can ever reveal its real contribution and significance. Can wisdom ever bare its soul and reveal its secret without displaying a power that imposes itself on us as a message or appeals to us as a vocation? The Jewish conscience, in spite of its different forms and levels, regains its unity and unicity in moments of great crisis, when the strange combination of texts and men, who often cannot speak the language of these texts, is renewed in sacrifice and persecution. The memory of these crises sustains the quiet intervals.

During these extraordinary moments, the lucid work of the science of Judaism, which reduces the miracle of the Revelation or the national genius to a series of influences, loses its spiritual significance. In place of the miracle of the unique source, there shines the marvel of confluence. The latter is understood as a voice calling form the depths of converging texts and reverberating in a sensibility and a form of thought that are already there to greet it. What does the voice of Israel say and how can it be translated into a few propositions? Perhaps it announces nothing more than the monotheism which the Jewish Bible brought to humanity. At first, we might recoil from this hoary old truth or this somewhat dubious claim. But the word denotes a set of significations based on which the shadow of the Divine is cast beyond all theology and dogmatism over the deserts of Barbary. One must follow the Most High God and be faithful to Him alone. One must

be wary of the myth that leads to the *fait accompli*, the constraints of customs or locale, and the Machiavellian State and its reasons of state. One follows the Most High God, above all by drawing near to one's fellow man, and showing concern for "the widow, the orphan, the stranger, and the beggar," an approach that must not be made "with empty hands." It is therefore on earth, amongst men, that the spirit's adventure unfolds. The traumatic experience of my slavery in Egypt constitutes my very humanity, a fact that immediately allies me to the workers, the wretched, and the persecuted peoples of the world. My uniqueness lies in the responsibility I display for the other. I cannot fail in my duty towards any man, any more than I can have someone else stand in for my death. This leads to the conception of a creature who can be saved without falling into the egotism of grace. Man is therefore indispensable to God's plan or, to be more exact, man is nothing other than the divine plans within being. This leads to the idea of being chosen, which can degenerate into that of pride, but which originally expresses the awareness of an indisputable assignation from which an ethics springs and through which the universality of the end being pursued involves the solitude and isolation of the individual responsible. Man is called before a form of judgment and justice which recognizes this responsibility, while the rigors of the Law are softened without being suspended by a sense of mercy. Man can do what he must do; he can master the hostile forces of history by helping to bring about a messianic reign, a reign of justice foretold by the prophets. The waiting for the Messiah marks the very duration of time.

This is the extreme humanism of a God who demands much of man. Some would say He demands too much! It is perhaps in a ritualism regulating all the gestures of the complete Jew's day-to-day life, in the famous yoke of the Law, which the pious experience as something joyful, that we find the most characteristic aspects of Jewish existence. This ritualism has preserved Jewish existence for centuries. While itself remaining completely natural, it keeps this existence alive by maintaining a distance from nature. But perhaps, for that very reason, it maintains a presence to the Most High God.

Translated by Seán Hand

Judaism and the Present

On the mean and petty level of day-to-day reality, a human community does not resemble its myth. It responds to a higher vocation, though, through its intellectuals (its elders), who are concerned with *raison d'être* and its youth, who are ready to sacrifice themselves for an idea, who are capable, in other words, of extremist ideas. Western Jews between 1945 and

1960 will not have displayed their essence by converting, changing their names, economizing, or forging a career for themselves. What they did do was carry on the Resistance, in the absolute sense of the term. A career is not incompatible with a rigorous intellect or a sense of courage, something that is always difficult to display. The young uprooted themselves and went to live in Israel as they had done in Orsay or Aix or Fublaines; or else, in other ways, they accepted whatever inhuman dogmatism promised to free Man. To situate Jews in the present is something that leads us, therefore, into a radical mode of thinking, one whose language is not always a lie. I should like to undertake such an analysis with all the due modesty and prudence dictated by the writing of a mere article on the subject. For, without even this brief study, the position of Judaism, in the latter half of this century, would be further reduced to the interminable question of anti-Semitism.

A religious age or an atomic age—these characterizations of the modern world, whether slogans or imprecations, hide a deeper trend. In spite of the violence and madness we see every day, we live in the age of philosophy. Men are sustained in their activities by the certainty of *being right (avoir raison)*, of being in tune with the calculable forces that really move things along, of moving in the direction (*sens*) of history. That satisfies their conscience. Beyond the progress of science, which uncovers the predictable play of forces within matter, human freedoms themselves (including those thoughts which conceive of such a play) are regulated by a rational order. Hidden in the depths of Being, this order is gradually unveiled and revealed through the disorder of contemporary history, through the suffering and desire of individuals, their passions and their victories. A global industrial society is announced that will suppress every contradiction tormenting humanity. But it equally suppresses the hidden heart of man. Reason rises like a fantastic sun that makes the opacity of creatures transparent. Men have lost their shadows! Henceforth, nothing can absorb or reflect this light which abolishes even the interiority of beings.

This advent of reason as an offshoot of philosophy—and this is what is original about this age—is not the conquest of eternity promised to the Logos of ancient wisdom. Reason does not illuminate a thought which detaches itself from events in order to dominate them in a dialogue with a god, the only interlocutor of any work, according to Plato. There is nothing in reality that can be encountered in its wild or pure state; everything has already been formed, transformed, or reflected by man, including nature, the sky, and the forest. The elements show up on the surface through a civilization, a language, an industry, an art. Intelligibility is read in the mark left on things by the work of mortals, in the perspectives opened up by cities and empires that are doomed to fall. From that point, in the epic, or

drama of intelligence, man is an actor prior to being a thinker. Reality appears—that is to say radiates intelligible light—within the history in which each human undertaking takes its place, a work of finite freedoms which, by virtue of being finite, betray their projects even as they carry them out, and do not dominate their work. The individual's destiny consists in playing a role (which has not yet been assigned him) in the drama of reason, and not of embracing this drama.

What matters is to be authentic and not at all to be true *(dans le vrai)*, to commit oneself rather than to know. Art, love, action are more important than theory. Talent is worth more than wisdom and self-possession. Is it not the case that, a few years ago, a British Jewish intellectual conducted a very successful lecture tour throughout England in which he measured the value of Judaism in terms of the talent and originality of dejudaicized Jews?

Within the indulgent attitude towards mortality which we call the historical conscience, each of us has to wait for that unique if perishable moment in which it falls to our lot to rise to the occasion and recognize the call addressed to us. To respond to the call of the perishable instant! It must not come too late. Such was the case of the Angel who, according to the Midrash, had only one song to sing before the Throne of the Lord, at one single moment, which was his and his alone, in the whole of God's eternity. But this Angel, who was an antagonist of Israel, had a bad encounter, and his story took place on the night before the unique instant of his destiny.

In the wake of the Liberation, Jews are grappling with the Angel of Reason, who often solicited them, and who for two centuries now has refused to let go. Despite the experience of Hitler and the failure of assimilation, *the great vocation in life resounds like the call of a universal and homogenous society.* We do not have to decide here if the nature of modern life is compatible with respect for the Sabbath and rituals concerning food, or if we should lighten the yoke of the Law. These important questions are put to men who have already chosen Judaism. They choose between orthodoxy and reform, depending on their idea of rigor, courage, and duty. Some are not necessarily hypocrites, others do not always take the easy way out. But it is really a domestic quarrel.

Jewish consciousness is no longer contained within these questions of choice. Like a house without a *muzuzah*, it exists as an abstract space traversed by the ideas and hopes of the world. Nothing can halt them, for nothing hails them. Interiority's act of withdrawal is undone before their unstoppable force. The Judaism of the Diaspora no longer has an interior. It enters deeply into a world to which it is none the less opposed. Or is it?

For the reason that shines forth from the Angel (or the Seducer) frees Judaism from all particularisms. Visions of ancient, crumbling things trouble our hazy dreams. Surely a greater, virile dream is born in this way. The

cheap optimism of the nineteenth century, whose idealism was produced by isolated and ineffectual beings who had little grasp of reality, gives way to a transformation of being that derives its nobility from the attention it pays reality. It becomes an uncompromising logic that tolerates no exceptions, and is universal like a religion. Our age is defined by the major importance which this transformation of things and societies takes on in the eyes of men, and the attention that established religions pay to the transformations of life here below. The religious and the profane have perhaps never been so close. So how can one withstand the winds of change which threaten to sweep the Jewish personality away? When Reason tolls the knell for privileged revelations, isn't the sound as seductive as the song of the Sirens? Will Judaism raise the banner against what we tautologically term free thought, and the achievements of the concrete world? Is it not different from the religions it has spawned in that it questions whether personal salvation can be something distinct from the redemption of the visible world? And yet those other religions have every opportunity of doing the same. They offer supernatural truths and sacraments and consolations that no science can dispense. The reason that conquers the world leaves them with an extraterritoriality. Judaism unites men in an ideal of terrestrial justice in which the Messiah represents a promise and a fulfilment. Ethics is its primordial religious emotion. It does not found any church for transethical ends. It insists on distinguishing between "messianism" and a "future world." Every prophet has only ever announced the coming of the messianic age; as for the future world, "no eye has seen it outside of You; God will bring it to those who wait" (*Synhedrin*, 99a).

This struggle with the Angel is therefore strange and ambiguous. Isn't the adversary a double? Isn't this wrestling a twisting back on oneself, one that may be either a struggle or an embrace? Even in the most impressive struggle that Israel undertakes for the sake of its personality, even in the building of the State of Israel, even in the prestige it holds for souls everywhere, this sublime ambiguity remains: is one trying to preserve oneself within the modern world, or to drown one's eternity in it?

For what is at stake is Israel's eternity, without which there can be no Israel. The combat is a very real one. The modern reason which transforms the world threatens Judaism to an unparalleled degree, though Judaism has been threatened before. Cosmology and scientific history in their time had compromised the Bible's wisdom, while philology had questioned the special character of the Bible itself, dissolved in a sea of texts, pitching and rolling through its infinite undulations. Apologetics chose to reply to these attacks by discussing the arguments put forward. But believers have above all resisted them by interiorizing certain religious truths. Why worry about science's refutation of Biblical cosmology, when the Bible contains not

cosmology but images necessary to an unshakable internal certainty, figures that speak to the religious soul that already dwells in the absolute? Why worry about philology and history challenging the supposed date and origin of the sacred texts, if these texts are intrinsically rich in value? The sacred sparks of individual revelations have produced the light needed, even if they were thrown up at different points in history. The miracle of their convergence is no less marvellous than the miracle of a unique source. Eternity was rediscovered within the fortresslike inner life which Israel built on an unshakeable rock.

At this point, modern thought denounces the eternity of Israel by questioning whether the inner life itself is a site of truth. Truth is henceforth manifested in the development of a society, which is the condition for every idea that arises in an individual brain. Only pipe dreams and ideologies have no social founding. Those elements in the Jewish revelation open to reason are obtained from economic and social determinism. Those ideas imbued with the force of inner conviction emerge as an impersonal and anonymous destiny that holds men in its grip. Reason just toys with them. They imagine they are thinking for themselves, when they are really carrying out its plans. Prophecies are produced by the play of historical forces in the same way as synthetic oil and rubber are manufactured in the laboratory.

This time, the blades of reasonable history erode the very rock of Israel. This is what causes the erosion of the Absolute.

But this eternity of Israel is not the privilege of a nation that is proud or carried away by illusions. It has a function in the economy of being. It is indispensable to the work of reason itself. In a world that has become historical, shouldn't a person be as old as the world? Deprived of any fixed point, the modern world feels frustrated. It invoked reason in order to have justice, and the latter surely needs a stable base, an interiority, or a person, on which to rest. A person is indispensable to justice prior to being indispensable to himself. Eternity is necessary to a person, and even in our own day, it has been sought by the most lucid thinkers. Those who stress commitment (*engagement*) in Sartre's work forget that his main concern is to guarantee disengagement (*dégagement*) in the midst of engagement (*engagement*). This results in a nihilism that is given its most noble expression—a negation of the supreme commitment which, in man's case, is his own essence.

But dumping ballast in the face of the problems posed by existence, in order to gain even greater height over reality, leads ultimately to the impossibility of sacrifice, that is to say to the annihilation of self. Here, Judaism filters into the modern world. It does so by disengaging itself, and it disengages itself by affirming the intangibility of an essence, the fidelity to a law, a rigid moral standard. This is not a return to the status of thing, for such fidelity breaks the facile enchantment of cause and effect and allows it to be judged.

Judaism is a noncoincidence with its time, within coincidence: in the radical sense of the term, it is an *anachronism*, the simultaneous presence of a youth that is attentive to reality and impatient to change it, and an old age that has seen it all and is returning to the origin of things. The desire to conform to one's time is not the supreme imperative for a human, but is already a characteristic expression of modernism itself; it involves renouncing interiority and truth, resigning oneself to death and, in base souls, being satisfied with *jouissance*. Monotheism and its moral revelation constitute the concrete fulfilment, beyond all mythology, of the primordial anachronism of the human.

It lies deeper than history, neither receiving its meaning from the latter, nor becoming its prey. This is why it does not seek its liberation with respect to time, where time has the status of dead civilizations such as ancient Greece or Rome. Even in the grave, these do not escape the influence of events. When he lay dying, 'Rabbi Jose b. Kisma said to his disciples: "Place my coffin deep (in the earth), for there is not one palm tree in Babylon to which a Persian horse will not be tethered, nor one coffin in Palestine out of which a Median horse will not eat straw."

Judaism, disdaining this false eternity, has always wished to be a simultaneous engagement and disengagement. The most deeply committed (*engagé*) man, one who can never be silent, the prophet, is also the most separate being, and the person least capable of becoming an institution. Only the false prophet has an official function. The Midrash likes to recount how Samuel refused every invitation he received in the course of his travels throughout Israel. He carried his own tent and utensils with him. And the Bible pushes this idea of independence, even in the economic sense, to the point of imagining the prophet Eli being fed by crows.

But this essential content, which history cannot touch, cannot be learned like a catechism or resumed like a credo. Nor is it restricted to the negative and formal statement of a categorical imperative. It cannot be replaced by Kantianism, nor, to an even lesser degree, can it be obtained from some particular privilege or racial miracle. It is acquired through a way of living that is a ritual and a heartfelt generosity, wherein a human fraternity and an attention to the present are reconciled with an eternal distance in relation to the contemporary world. It is an asceticism, like the training of a fighter. It is acquired and held, finally, in the particular type of intellectual life known as the study of the Torah, that permanent revision and updating of the content of the Revelation where every situation within the human adventure can be judged. And it is here precisely that the Revelation is to be found: the die is not cast, the prophets or wise men of the Talmud know nothing about antibiotics or nuclear energy; but the categories needed to understand these novelties are already available to monotheism. It is the eternal anteriority of wisdom with respect to science and history. Without

it, success would equal reason, and reason would be just the necessity of living in one's own time. Does this sovereign refusal of fashion and success come from the monks who render unto Caesar the things that are Caesar's? Or from the left who do not dare carry through their political thought to its logical extremes, but are seized with an attack of vertigo and grind to a senseless halt at the edge of their own conclusions?

It is not messianism that is lacking in a humanity that is quick to hope and to recognize its hopes in everything that promises, builds, and brings victory and presents itself as the fulfilment of a dream. Seen in this light, every nationalism carries a messianic message and every nation is chosen. Monotheism has not just a horror of idols, but a nose for false prophecy. A special patience—Judaism—is required to refuse all premature messianic claims.

These young people, who are eager to behave reasonably, and turn their backs on Judaism because, like a waking dream, it does not offer them sufficient enlightenment concerning contemporary problems, that "vast reality taking place outside Judaism," forget that the strength needed to resist the importance that high society places on itself, is the privilege of Judaism and the absolutely pure teaching that it offers man; they forget that the Revelation offers clarification but not a formula; they forget that commitment alone—commitment at any price, headlong commitment that burns its bridges behind it, even the commitment that ought to permit withdrawal into the self—is no less inhuman than the disengagement dictated by the desire to be comfortable which ossifies a society that has transformed the difficult task of Judaism into a mere confession, an accessory of bourgeois comfort.

No doubt the advocates of commitment resemble those disciples of Rabbi Jose b. Kisma who asked the Master: "When will the Master come?" They were already probably denouncing the sterility of *Halakhah*-style discussions, which remain aloof from the burning issues of messianism, of the meaning and end of history. Rabbi Jose shied away from the question: "I fear lest ye demand a sign of me." The disciples will continue to find the Master's wisdom too general and abstract. Already they are thinking that the messianic age is heralded by the events of history, as the fruit is by the seed, and that the blossoming of deliverance is as predictable as the harvest of ripe plums. Will the Master speak?

The disciples will not ask for a sign. Rabbi Jose then speaks of the periodic structure of history, the alternating periods of greatness and decline from which the messianic age will ensue neither logically nor dialectically, but will enter from the outside: "When this gate falls down, is rebuilt, falls again, and is again rebuilt, and then falls a third time, before it can be rebuilt the son of David will come."

Does the Master perhaps bury himself in generalities in order to evade the issues? History is separated off from its achievements, as is politics from morality. The rigorous chain of events offers no guarantee of a happy outcome. No sign is inscribed here. So be it. But can the Master withhold the signs necessary to those who reject the good if false news, and from which the Jew would derive the strength of his rejection, and the certainty of his *raison d'être*, in a world crossed by currents of energy and life in which he is nothing, overflowing with joyful waters which rise from the depths of the elements and which joyously sweep up the builders of states, regimes and churches? A *No* demands a criterion. Rabbi Jose gives the required sign: " 'let the waters of the grotto of Paneas turn into blood'; and they turned into blood."

Paneas, the source of the Jordan, is one of the three legendary sources that remained open at the end of the flood. The waters from all the ends of history and from every nationalism (even the Jewish one) gush forth like the irrepressible force of nature, the waters of every baptism and every effacement, the waters of every messianism! Those men who can see cannot turn their gaze from the innocent blood which these waters dilute.

Translated by Seán Hand

The State of Israel and the Religion of Israel

The idea that Israel has a religious privilege is one that ultimately exasperates everyone. Some see it as an unjustifiable pride, while to others it looks like an intolerable mystification which, in the name of a sublime destiny, robs us of earthly joys. To live like every other people on earth, with police and cinemas and cafes and newspapers—what a glorious destiny! Despite being scarcely established on our own land, we are happy to emulate all the "modern nations," and have our own little problem of the relationship between state and church to resolve.

The satisfaction we can experience when, like a tourist, we can see a Jewish uniform or a Jewish stamp, is certainly one of our lesser delights. But it is difficult to resist. It imposes itself by way of contrast. It places great value on the very presence of the past which we refuse. It reveals both the obsessions of the traditional Jewish ideal and everything that is phony about its by-now literary perfection. It also reveals the prestige that men, whether or not they are Jews, attach today to anything bearing the stamp of the state.

The point is not that people are free to denounce such idolatry. We need to reflect on the nature of the modern state. The state is not an idol because it precisely permits full self-consciousness. Human will is derisory. It wishes

to be of value, but cannot evaluate the universe it repulses. The sovereignty of the state incorporates the universe. In the sovereign state, the citizen may finally exercise a will. It acts absolutely. Leisure, security, democracy: these mark the return of a condition, the beginning of a free being.

This is why man recognizes his spiritual nature in the dignity he achieves as a citizen or, even more so, when acting in the service of the state. The state represents the highest human achievement in the lives of Western peoples. The coincidence of the political and the spiritual marks man's maturity, for spiritual life, like political life, purges itself of all the private, individual, sentimental chiaroscuro on which religions still nurture themselves. Elevation to the spiritual no longer equals possession by the Sacred. A spiritual life with no sacred dimension! Only a superficial analysis could claim that when men forget God, they are merely changing gods. The decline of church-constituted religions is an undeniable historical phenomenon. It stems not from man's mendacity but from the advent of states. When set against the universality of the political order, the religious order inevitably takes on a disordered or clerical air. Modern humanist man is a man in a state. Such a man is not merely vulgar; he is religion's true antagonist within the State of Israel itself.

But is it enough to restore the State of Israel in order to have a political life? And even if it were a life of the spirit, could it contain Judaism? A small state—what a contradiction! could its sovereignty, which, like the light of satellites, is merely borrowed, ever raise the soul to a state of full self-possession? It is obvious that Israel asserts itself in a different way.

Like an empire on which the sun never sets, a religious history extends the size of its modest territory, even to the point where it absorbs a breathtaking past. But, contrary to national histories, this past, like an ancient civilization, places itself above nations, like a fixed star. And yet we are the living ladder that reaches up to the sky. Doesn't Israel's particular past consist in something both eternal and ours? This peculiar right, revealed by an undeniable Jewish experience, to call our own a doctrine that is nonetheless offered to everyone, marks the true sovereignty of Israel. It is not its political genius, nor its artistic genius, nor even its scientific genius (despite all they promise) that forms the basis of its majority, but its religious genius! The Jewish people therefore achieves a state whose prestige nonetheless stems from the religion which modern political life supplants.

The paradox would be insoluble if this religious genius did not consist entirely in struggling against the intoxication of individual forms of enthusiasm for the sake of a difficult and erudite work of justice. This religion, in which God is freed from the Sacred, this modern religion was already established by the Pharisees through their mediations on the Bible at the

end of the Second Temple. It is placed above the state, but has already achieved the very notion of the spirit announced by the modern state.

In an anthology of essays written in Hebrew which appeared in New York, Chaim Grinberg, the head of the Cultural Section of the Jewish Agency, brought together articles by several Israeli authors on the relation between religion and state. Reading these texts, which are above all eyewitness accounts, one is struck by the ease with which the move from religion to ethics is carried out. We do not get the impression of a morality being added to the dogma, but of a "dogma" that is morality itself. The grand terms, "love," or "the presence of God," achieve a true grandeur even as they are given concrete expression in the sordid questions of food, work, and shelter. Contrary to all the fervent mysticism that overexcites the orthodox or liberal tendencies of the Diaspora living alongside Christianity, an Israeli experiences the famous touch of God in his social dealings. Not that belief in God *incites* one to justice—it *is* the institution of that justice. Moreover, is this justice just an abstract principle? Doesn't religious inspiration ultimately aim to bring about the very possibility of society, the possibility for a man to see the face of an other?

The thing that is special about the state of Israel is not that it fulfills an ancient promise, or heralds a new age of material security (one that is unfortunately problematic), but that it finally offers the opportunity to carry out the social law of Judaism. The Jewish people craved their own land and their own state not because of the abstract independence which they desired, but because they could then finally begin the work of their lives. Up until now they had obeyed the Commandments, and later on they fashioned an art and a literature for themselves, but all these works of self-expression are merely the early attempts of an overlong adolescence. The masterpiece has now finally come. All the same, it was horrible to be both the only people to define itself with a doctrine of justice, and to be the meaning incapable of applying it. The heartbreak and the meaning of the Diaspora. The subordination of the state to its social promises articulates the significance of the resurrection of Israel as, in ancient times, the execution of justice justified one's presence on the land.

It is in this way that the political event is already outstripped. And ultimately, it is in this way that we can distinguish those Jews who are religious from those who are not. The contrast is between those who seek to have a state in order to have justice and those who seek justice in order to ensure the survival of the state.

But surely the religious Jews are those who practice their faith, while the irreligious Jews are those who do not? Such a distinction was valid during the Diaspora, when religious rites, isolated from the work sustaining them,

miraculously preserved Judaism, but is it still valid at this dawning of a new age? Is it not the case that a revolt against ritualism stems from a rejection of any magical residue it may still possess, and so opens up the way to its real essence? We cannot doubt the absolute link that exists between justice and the fully developed civilization of Jewish ritualism, which represents the extreme conscience of such justice. It is in the justice of the *kibbutz* that the nostalgia for ritual is once again to be felt. This is provided that we wish to think of this sort of justice, because of our suspicions regarding any unconscious fervor. Religious liberalism moved back from ritual to a feeling of vague religiosity, hoping to move history back. It happens in the best families. But if ritual is valuable, it will only be reborn in the virility of action and thought.

Religion and religious parties do not necessarily coincide. Justice as the *raison d'être* of the state: that is religion. It presupposes the high science of justice. The State of Israel will be religious because of the intelligence of its great books, which it is not free to forget. It will be religious through the very action that establishes it as a state. It will be religious or it will not be at all.

But how are we to read these books? The studies collected by Chaim Grinberg in the aforementioned volume show that the spirit of the Torah proclaims the essential values of democracy and socialism, and can inspire an avant-garde state. We had had slight misgivings. But why, after all, should we get lumbered with the Torah? And how can we apply it to a contemporary situation that is so different politically, socially, and economically from the order envisaged by the Law? This is a question put by one of the contributors, Dr. Leibovitz, in an article entitled "Religion and State." Carrying out the Law does not involve the precondition of restoring outmoded institutions; nor does it allow you to ignore the modern forms of life that exist outside Judaism. The social and political situation described by the Bible and the Talmud is the example of a given situation that is rendered human by the Law. From it we can deduce the justice required for any and every situation.

This is an idea which we consider fundamental. The great books of Judaism do not in fact express themselves as parables that are open to the whims of a poetic imagination, or as concepts that are always schematic, but as examples that betray nothing of the infinite relations that make up the fabric of the social being. They offer themselves up as an interpretation that is as rigorous as parables are vague, and as rich as concepts are poor. Whosoever has encountered the Talmud, especially if the encounter is with a real master, notices this immediately. Others call this splitting hairs! We must isolate the ancient examples and extend them to the new situations, principles and categories which they contain. This means that between the Jewish State and the doctrine which should inspire it, we must establish a science, a

formidable one. The relationship between the Jewish State and the Jewish religion—we do not dare to say church—is that of study.

The progressive drying up of Talmudic and Hebraic studies in the West in the course of the nineteenth century broke just such a secular contact between Judaism and this prophetic morality to which Judaism claimed an exclusive right. Separated from the Rabbinic tradition which already guaranteed this contact through the miracle of its very continuity, and then absorbed into the so-called scientific mechanisms of the prestigious Western universities, through the philosophies and philologies of the day, this morality, like a translated poem, certainly lost its most typical and perhaps its most virile features. By reducing it to what everyone knows, we lost what it had to teach us.

Henceforth we must return to what was strongest in Rabbinical exegesis. This exegesis made the text speak; while critical philology speaks *of* this text.

The one takes the text to be a source of teaching, the other treats it as a thing. Despite its method and its apparent modesty, critical history already claims to have gone beyond the archaeological curiosities which have been exhumed, and no more invites us to use these ancient truths than it asks us to cut wood with a Stone Age axe. On the other hand, the apparent artifice and ingeniousness of the other method consists in saving the text from being turned into a mere book, that is to say just a thing, and in once more allowing it to resonate with the great and living voice of teaching.

Translated by Seán Hand

Means of Identification

The very fact of questioning one's Jewish identity means it is already lost. But, by the same token, it is precisely through this kind of cross-examination that one still hangs on to it. Between *already* and *still*, Western Judaism walks a tightrope.

What identity does it cling to? One that refers only to itself, and ignores all attributes: one is not a Jew by being this or that. Ideas, characters, and things can be identified insofar as they differ from other ideas, characters, and things. But people do not produce evidence in order to identify themselves. A person is not who he is because he was born here rather than there, and on such and such a day, or because he has blond hair, a sharp tongue, or a big heart. Before he starts comparing himself to anyone else, he just is who he is. In the same way, one just is a Jew. It is not even something one adheres to, for that already suggests the possibility of estrangement. It is not something one is possessed by, for adherence to a doctrine soon turns

into fatalism. Through the ill that it inflicts on itself, this extreme intimacy linking the Jew to Judaism is like a day-to-day expression of happiness or the sense of having been chosen. "You are born a Jew; you don't become one." This half-truth bears out the ultimate feeling of intimacy. It is not a racist remark, thank God. For one can indeed become a Jew, but it is as if there had been no conversion. Can one subscribe to whatever is human? Certain Jews have a way of saying "Jew" instead of the word "mankind," as if they took Judaism to be the subject and humanity the predicate.

But this absolute and unshakable sense of identity, which is founded on an adherence that preexists any form of allegiance, is not expressed in uncontrollable terms, as being a subject that is stirred by unfathomable feelings. On the contrary, it is alien to any sense of introspection or complacency. Instead of just paying attention to the outside world, it exhibits a perpetual attentiveness that is exclusive and monotheist. It listens and obeys like a guard who never expects to be relieved (relève). This was recognized by Rabbi Hayyim Volozhiner, the favourite disciple of the Gaon of Vilna, when, in 1824, in the Nefesh ha'Hayyim (a work little known in the West but one in which the living elements of Judaism converge) he wrote that a Jew is accountable and responsible for the whole edifice of creation. There is something that binds and commits (engage) man still more than the salvation of his soul. The act, word, and thought of a Jew have the formidable privilege of being able to destroy and restore whole worlds. Far from being a serene self-presence, therefore, Jewish identity is rather the patience, fatigue, and numbness of a responsibility—a stiff neck that supports the universe.

This primordial experience is expressed in a more tolerable way by Zionism, even if it gets turned into politics and nationalism in the process. For many Israelis, their identity card is the full extent of their Jewish identity, as it is, perhaps, for all those potential Israelis who are still in the Diaspora. But here Jewish identity runs the risk of becoming confused with nationalism, and from that point on, a loss of Jewish identity is probably the price to be paid in order to have it renewed.

The Western mentality to which the Jew became assimilated, to such a degree that henceforth he touched only the surface of Judaism, is perhaps defined by its refusal to adhere to anything unless it performs an act of adhesion. In the nationalist movements which it has promoted, this mentality uncovers something savage. Any special attachment is marked by the feeling that it is shared by all. From that point on, one must not simply accept one's own nature spontaneously; instead, one begins by stepping back, looking at oneself from the outside, pondering about oneself. To compare oneself to others involves analyzing and weighing oneself up, reducing the personal identity that one *is* to a series of signs, attributes,

contents, qualities, and values. The institution that embodies such a mentality is called the university.

To the extent that the loss of an immediate Jewish identity proceeds from such a feeling and such demands, it does not represent a merely regrettable moment in the evolution of Judaism. A Western Jew must still pretend, as Descartes puts it, that he has still to be converted to Judaism. He feels duty-bound to approach it as a system of concepts and values that are being presented for his judgment; even the exceptional fate of being the man who supports the universe is one he sees petrified in the statue of Atlas. It is his duty, then, to reformulate everything in the language of the university. Philosophy and philology are the two daughters of this universal speech (wherein we must guard against the younger devouring the elder). It is up to Judaism to support this language, even if it was important one day to turn this language back on the civilization nurturing (and nurtured by) the university.

But this legitimate demand for a system or doctrine—in short, for a conscience—is shown to be completely naïve when it proceeds as though it were drawing up an inventory of values in the attempt to discover something original in Judaism. A great civilization does not make an inventory of itself, but opens itself up to study through grammar, the dictionary, and scholarship. It does not define itself in a cut-and-dried manner on the basis of a few facile antitheses which are inevitably going to be fallacious. It is universal, that is to say it is precisely capable of whatever can be found in any other civilization, of whatever is humanly legitimate. It is therefore fundamentally nonoriginal, stripped of all local color. Only those civilizations labelled exotic (or the exotic and perishable elements of civilizations) can be easily distinguished from one another. To the extent that they lose their "curiosity" value, they find it increasingly difficult to define themselves, since it is only through them that everything is defined. It is not to originality that civilizations owe their excellence, but to their high degree of universality, to their coherence, that is so say to the lack of hypocrisy in their generosity. We can tolerate the pluralism of great civilizations, and even understand why they cannot merge. The very nature of truth explains how this is impossible: truth manifests itself in a way that appeals to an enormous number of human possibilities and, through them, a whole range of histories, traditions, and approaches. But even when this multiplicity is acknowledged, it does not absolve the individual from a rational choice. Such a choice cannot be based on the vagaries of subjective taste or some sudden whim. At such moments the amateur and the brute come together again. The only criteria on which we can base the rational examination that is required are those of the maximum degree of universality and the minimum degree of hypocrisy.

This examination cannot be reduced to the level of testimony: it is not

enough to take stock of what "the rest of us as Jews" are, and what we feel these days. We should run the risk of taking a compromised, alienated, forgotten, ill-adapted, or even dead Judaism to be the essence of Judaism. We cannot be conscious of something in whatever way we wish! The other path is steep but the only one to take: it brings us back to the source, the forgotten, ancient, difficult books, and plunges us into strict and laborious study.

Jewish identity is inscribed in these old documents. It cannot be annulled by simply ignoring these means of identification, just as it cannot be reduced to its simplest form of expression without entering into the discourse of the modern world. One cannot refute the Scriptures without knowing how to read them, or muzzle only philology without doing the same to philosophy, or put a halt, if necessary, to philosophical discourse, without still philosophizing.

Is this worm-eaten Judaism to be preferred to the Judaism of the Jews? Well, why not? We don't yet know which of the two is the more lively. Are the true books just books? Or are they not also the embers still glowing beneath the ashes, as Rabbi Eliezer called the words of the Prophets? In this way the flame traverses history without burning in it. But the truth illuminates whoever breathes on the flame and coaxes it back to life. More or less. It's a question of breath. To admit the effect that literature has on men is perhaps the ultimate wisdom of the West in which the people of the Bible may recognize themselves. King Josiah ordered a kingdom to be established around an old lost book which was rediscovered by his clerks (*The Book of the Torah* in 622 BCE). It is the perfect image of a life that delivers itself up to the texts. The myth of our Europe as being born of a similar inspiration was called the Renaissance.

Translated by Seán Hand

Assimilation and New Culture

In good sociology, assimilation appears as an objective process, controlled by strict laws, even to the extent of being the social process par excellence. Among its factors figure the attraction exerted by a homogeneous majority over the minority, the difficulties of every kind that await those who obstinately make themselves the exception to this rule—and even to mere customs—and the economic necessities that, in modern society at least, break down these differences. The individual needs courage and strength to resist the natural current that would bear him away.

But, despite the evident constraints that determine such movement, assimilation is condemned as betrayal or decadence. The subject's intentions are put on trial. The defendants are suspected of egoism and opportunism,

of aspiring to nothing more than a trouble-free life, and of being afraid to live dangerously.

I should not think of contesting this judgment when assimilation means dejudaicization. But I should like to recall, or at least to underline the fact that, insofar as assimilation to Western culture is concerned, it cannot be thought to result only from its causes: it also involves spiritual reasons and necessities that impose themselves on active consciousness. This creates a serious problem for those who, whether they are educators or men of action, are concerned for the future of Judaism. The solution supposed more than simply a "reorganization of communal services," more than a reform of the school curriculum, more than a new pedagogical politics: it requires an effort to create a culture, in other words a new Jewish life.

Insofar as they reflect the spiritual excellence of universality, the different forms of European life have conquered the Israelis. They have become the norm in thinking and feeling, and the source of science, art, and modern technology. They are equally the origin of any reflection concerning democracy and the foundation of those institutions devoted to the ideal of liberty and the rights of man. Of course no one could forget the events of the twentieth century: two world wars, Fascism, and the Holocaust. The doctrines and institutions of Europe come out of it all highly compromised. But this does not stop us referring to them in order to distinguish between ourselves and their monstrous offspring, or between a perversion and the good seed from which it sprang. We continue to admire universal principles and whatever can be deduced by sound logic from them.

Consequently, the problem of assimilation is still with us, and is so to the exact extent that we all—in Israel and among the Diaspora, Zionists and non-Zionists—acknowledge Western civilization and lay claim to all that it has contributed and contributes still to our public and intellectual life, open as it is to the world's vast compass. But our belonging to a religious, or national, or linguistic Judaism is not something purely and simply to be added to our Western inheritance. One or other of the two factors becomes discredited. We must ask ourselves if there is not a permanent risk of the traditional aspect of our existence sinking, despite what affection and good-will may attach to it, to the level of folklore.

The value-judgment that bears upon the public order to which we belong is not of the same force as that which is summoned up from our depths. It is the public order that counts. The maxim of the nineteenth-century Jewish *Haskalah*, the Jewish Enlightenment, "Be a Jew at home and a man outside," no doubt was able to slow down the process of assimilation and guarantee the Jews of Eastern Europe a double culture, and, in their consciousness, the happy coexistence of two worlds. But that had been possible only for as long as the Slavic civilization remained closed, socially and politically,

to the Jews and did not, intrinsically, elevate themselves from the outset to the heights of Western universalism. There, assimilation could be confined to a superficial adherence or adaptation to the surrounding world without requiring the soul's complete submission to it. The place of folklore was perhaps not on the Jewish side. It was sometimes the assimilating world that took on such an aspect in the popular imagination: the belonging to such a world of a collectivity that continued in practical terms to be excluded from it could sometimes seem like the unfolding of a masquerade.

Now, whatever may be, at the present time, our residual or acquired awareness or knowledge of the spiritual originality and richness of our Judaism, we cannot forget the eminence of the universal, to which we have been recalled in our passing through the West, where universality has been admirably explicated. This is a civilization, we might say, that is doubly universal. It displays itself as the common inheritance of humanity: every man and all peoples can enter on the same terms to occupy a place at the level suited to their innate powers and to their calling. And, at the same time, it bears the universal within itself as content: sciences, literature, plastic arts. The universal is elevated to the point of formalism, and in it this civilization discovers its values and the principle of its will, in other words its ethics. Above all it discovers philosophy, which is principally a certain language whose semantics encounter no incommunicable mystery, or object without resemblance, but equally a language that has been able to sublimate metaphors into concepts and to express all lived experience, whatever the original language veiled by the experience, and whether or not such a language were unutterable.

The nations that make up the West have as their particular features only those elements that, logically, appertain to any individual member of a species. Their belonging to humanity signifies precisely the possibility, to which each one of them aspires and accedes, of being translated into and spoken in this language of philosophy, a kind of Greek generously distributed around Europe within cultivated discourse. The rest is no more than local color. On the other hand, the congenital university of the Jewish mind, recorded in the riches of Scripture and by Rabbinical literature, involves an ineradicable moment of isolation and distancing, a peculiarity that is not simply the fruit of exile and the ghetto, but probably a withdrawal into the self essential to one's awareness of a surfeit of responsibility towards humanity. It is a strange and uncomfortable privilege, a peculiar inequality that imposes obligations towards the Other which are not demanded of the Other in return. To be conscious of having been chosen no doubt comes down to this. Nevertheless, in the eyes of the nations and to ourselves as assimilated individuals, this inequality happens to take on the air of an

irremediable characteristic, that of a petitioning nationalism. This misunder-standing is held both in general and among ourselves.

Despite the many criticisms made of assimilation, we benefit from the enlightenment it has brought, and we are fascinated by the vast horizons it has revealed to us, breathing in deeply the air of the open sea. As a result, Jewishness, that difficult destiny, is constantly in danger of appearing archaic and of having the effect, in the growing ignorance of Hebrew characters and the inability to make them speak, of diminishing our vision. It seems something which can no longer be justified in the modern world we have entered, a world belonging to all in which, up until the Holocaust, our presence was never seriously called into question.

This is the opposite of a religious particularism. Instead, it presents the excellence of an exceptional message, albeit addressed to all. This is the paradox of Israel and one of the mysteries of the Spirit. Of this we are persuaded, and this is at the heart of the present argument. But who, within assimilated Judaism and among the nations, still believes that a singularity is conceivable beyond universality, that it could incorporate the irrefutable values of the West, but also lead beyond them? A thinking and a singularity of which Judaism, as fact, as history and as Passion, is actually the mode of entry and the figure, made manifest long before the distinction between the particular and the universal makes its appearance in the speculations of logicians. But—and this too is a point that matters—never, since our emancipation, have we formulated in Western language the sense (*sens*) of this beyond, whether despite or because of our assimilation. Until now all we have attempted is an apologetics limited, without great difficulty, to bringing the truths of the Torah into line with the West's noble models. The Torah demands something more.

What have we made of certain other themes? And, to give as examples only the best known of them, what have we made of: "a people dwelling alone, and not reckoning itself among the nations" (Numbers, 23: 9)? Of Abraham, who shall be called *Hebrew* "because he is able to remain alone to one side (*me-eber ahad*) when others remain on the other side" (*Bereshit Rabah*, 42: 8)? Of the 613 commandments constraining the children of Israel, whereas only seven sufficed for the children of Noah? To owe the Other more than is asked! A cursory glance, blinded by the too-bright sun of the West, sees in this only separation and pride. This is fatal. For it would be our right to ask if this apparent limiting of universalism is not what preserves it from totalitarianism, if it does not awaken our attention to the murmur of inner voices, if it does not turn eyes towards those faces that illuminate and allow the control of social anonymity, towards the defeated in the reasonable history of humanity, where the proud are not all that fall.

For as long as this fatal confusion persists, none of us, not even the strongest advocate of Hebraism, will overcome the temptation of assimilation. And this is true however tenderly we look upon the traditional memories and the moving accents of familiar but disappearing dialects, upon all that folklore which our assimilation has taught us—for good reason!—not to mistake for the essential.

We Jews who wish to remain Jews know that our heritage is no less human than that of the West, and is capable of integrating all that our Western past has awakened within our own potential. Let us be grateful to assimilation. If, at the same time, we oppose it, it is because this "withdrawal into the self" which is essential to us, and which is so often disparaged, is not the symptom of an outmoded phase of existence, but reveals a "beyond" to universalism, which is what completes or perfects human fraternity. In the singularity of Israel a peak is attained that justifies the very perenniality of Judaism. It is not a permanent relapse into an antiquated provincialism.

But this is a singularity that the long history from which we are emerging has left at the level of sentiment or faith. It needs to be made explicit to thought. It cannot here and now furnish rules for education. It still needs to be translated into that Greek language which, thanks to assimilation, we have learnt in the West. We are faced with the great task of articulating in Greek those principles of which Greece had no knowledge. The singularity of the Jews awaits its philosophy. The servile imitation of European models is no longer enough. The search for references to universality in the Scriptures and in the texts of the spoken Law still derives from the process of assimilation. These texts, across two thousand years of commentary, still have something other to say.

In offering these remarks in this exalted place, the palace of the President of the State, in Jerusalem, I am certainly addressing the right audience. Only a Jewish culture called upon to develop itself on the basis of a new life in Israel could put an end—for the Jews above all but also for the nations—to a persistent misunderstanding. It will open our closed books and our eyes. That is our hope. To this effect also, the State of Israel will be the end of assimilation. It will make possible, in all its plenitude, the conception of concepts whose roots reach down to the depths of the Jewish soul. The explication and elaboration of these concepts are decisive for the struggle against assimilation, and are preliminaries necessary to any kind of effort on the part of generous organizations, or abnegation on the part of the masters of an elite. This is a task that is not only speculative but rich in practical, concrete, and immediate consequences.

Translated by Roland Lack

IV

Writing After Auschwitz:
Literary Representations

12

Beyond Psychoanalysis
ELIE WIESEL'S *NIGHT* IN HISTORICAL PERSPECTIVE
Ora Avni

Night is the story of a young boy's journey through hell, as he is taken first to a ghetto, and then to Auschwitz and Buchenwald. It is a story of survival and of death: survival of the young narrator himself, but death of the world as he knew it.[1] It is therefore a negative *Bildungsroman*, in which the character does not end up, as expected, fit for life in society, but on the contrary, a living dead, unfit for life as defined by his community.

Its opening focuses not so much on the boy, however, as on a foreigner, Moshe the Beadle, a wretched yet good-natured and lovable dreamer, versed in Jewish mysticism. When the town's foreign Jews are deported by the Nazis to an unknown destination, he leaves with them; but he comes back. Having miraculously survived the murder of his convoy, he hurries back to warn the others. No longer singing, humming, or praying, he plods from door to door, desperately repeating the same stories of calm and dispassionate killings. But, despite his unrelenting efforts, "people refused not only to believe his stories, but even to listen to them" (p. 4).

Like Moshe the Beadle, the first survivors who told their stories either to other Jews or to the world were usually met with disbelief. When the first escapees from Ponar's killing grounds tried to warn the Vilna ghetto that they were not sent to work but to be murdered, not only did the Jews not believe them, but they accused the survivors of demoralizing the ghetto, and demanded that they stop spreading such stories.[2] Similarly, when Jan Karski, the courier of the Polish government-in-exile who had smuggled himself into the Warsaw Ghetto so that he could report the Nazi's atrocities as an eyewitness, made his report to Justice Felix Frankfurter, the latter simply said, "I don't believe you." Asked to explain, he added, "I did not say that this young man is lying. I said I cannot believe him. There is a

difference."[3] How are we to understand this disbelief? What are its causes and effects, and above all, what lesson can we learn from it?

Shoah Narratives and the Scene of Narration

In this episode, the actual tales of Nazi atrocities occupy only a fraction of the narrative. Most of the section deals with Moshe the Beadle's easy manners and deep faith *before* his ordeal, and his desperate and obsessive storytelling *after* his return. This section mirrors the narrator's account in reverse: while the boy's account of his adventure is the actual story of death and survival with no "before" or "after," the opening section calls our attention precisely to the difference between "before" and "after," when after means both *after the event* and *after the telling of the event*. It thus steers us towards the scene of narration (all but absent from the main story of the boy's experience), that is, not only *what* actually and factually happened, but *how it affects* those who come in contact with the story of what happened. In so doing, it moves us towards the scene of narration of all *Shoah* narratives, towards the effects these narratives had and still have on their readers and listeners, and, in turn, towards the narrator's reaction to these effects. We may thus say that the opening episode of *Night* stages the performing or performative aspects of survivors' narratives, their effectiveness, and the consequences they may entail.

We must also note that Moshe the Beadle's narrative does not only *open* the boy's narrative as it first appears, but frames it on both ends: once the reader is aware of the consequences of telling such a story, he or she extends this awareness to the story told by the boy. The opening episode thus invites the reader to read beyond the abrupt end of *Night*, all the way to the moment absent from *Night* proper, when the newly freed boy tells his own tale of survival: will this story, too, meet with hostility, disbelief, and denial? (And who better than the reader knows that the boy did eventually tell his story, and that this tale constitutes the very text he or she is reading?) The scene of narration of the opening episode thus prefigures the scene of reading of *Night*. It is a pessimistic *mise en abyme* of the novel's scene of reading; as such, it warns the reader of the consequences of disbelief no less than it warns the town folks.

Shoah narratives have given rise to a host of false problems. Faced with the horror of the *Shoah* and the suffering of its survivors, some have felt overwhelmed and, overcome with a sense of simple human decency, have questioned their right to examine an extreme experience in which they had no part.[4] These scruples are, I think, misplaced: no one questions the right, or even the need of survivors to sort out their experience, or to bear witness. We readily concede survivors' wish and right to bear witness, to leave a

historical account of their ordeal for posterity. But what about this posterity (ourselves), what about the recipients of those narratives? We—the latecomers to the experience of the *Shoah*—shall never be able to fully grasp the abysmal suffering and despair of the survivors. And yet, not only do we share with them a scene of narration, but our participation in this scene of narration may have become the organizing principle of our lives and our own historical imperative. How, then, are we going to face up to this task? Like the town folks, we have gone through disbelief and denial. But today, two generations later, we have rediscovered the *Shoah*, as the numerous publications on the subject will attest (some even claim that we have trivialized the *Shoah* with excessive verbiage). How, then, are we to dispose of the knowledge conveyed by survivors' narratives? How can we integrate the lesson of their testimonies in our historical project—at least, if ours is a project in which there is no room for racial discrimination, genocide, acquiescence to evil, passive participation in mass murder; a project in which "get involved" has come to replace "look the other way"?

Wiesel often mentions Moshe the Beadle in other works. Invariably he insists on Moshe's need to commune with the town folks. In *One Generation After*, for example, Wiesel writes that upon his return, Moshe:

> was unrecognizable: gone were his gentleness, his shyness. Impatient, irascible, he now wore the mysterious face of a messenger pursued by those whose message he carried. He who used to stutter whenever he had to say a single word, suddenly began to speak. He talked and talked without pity for either his listeners or himself . . . he alone survived. Why? So that he could come back to his town and tell the tale. And that is why he never stopped talking. But his audiences, weary and naïve, would not, could not believe. People said: Poor beadle, he has lost his mind. Finally he understood; and fell silent. Only his burning eyes reveal the impotent rage inside him. His muteness bordered on madness.[5]

On the one hand, Moshe's distress is undoubtedly Wiesel's. Like Moshe, Wiesel came back; like Moshe, he told his story; and like Moshe, he told it again and again. It is therefore not merely a question of informing others (for information purposes, once the story is told, one need not tell it again). Like Moshe, Wiesel clearly does not set out to impart information only, but to *tell the tale*, that is, to share a scene of narration with a community of readers. This explains why, while the *Shoah* is in fact the subject of all his texts, Wiesel, wiser than Moshe, never recounted his actual experience in the death camps again. Like the opening episode of *Night*, his other works deal with "before" and "after": before, as a premonition of things to come; after, as a call for latecomers to see themselves accountable for living in a

post-*Shoah* world. The opening episode thus encapsulates Wiesel's life project, in that it invites us to reflect not only on the nature of the *Shoah* itself, but first, on living historically (that is, on living in a world of which the *Shoah* is part), and second, on transmitting this history from one person and one generation to the other.

I suggest therefore that we read the first episode for its exemplary value, as a beacon guiding our reading from the horror of the past to the imperatives of the present, all the while illuminating the Charybdis and Scylla of *Shoah* narratives: excessive distrust, as well as easy empathy; resentment of those who cannot let bygones be bygones, as well as a morbid and voyeuristic obsession with *Shoah* details; impatience with survivors' pain, as well as glib recognition of the alienating effect of the survivors' experience that frees us from partaking in their burden; an excessively inclusive approach that leads to an undiscriminating identification with *Shoah* participants ("We are all German Jews" of Cohn-Bendit), as well as excessive exclusiveness that frees all non-Jews (or even post-*Shoah* Jews) from deeming the *Shoah* experience relevant to one's being-in-the-world today; trivializing the *Shoah* with a host of comparisons, as well as insisting on its uniqueness so much that it becomes alien and irrelevant to our reality.

To what, then, does this episode owe its exemplary value? Why has Moshe, the ultimate *Shoah* survivor-narrator, come back? Why does he feel compelled to endlessly repeat his story? Why does he no longer pray? On the other hand, why are his listeners so recalcitrant? Why do they not believe him? Why do they accuse him of madness or of ulterior motives? Why do they all but gag him? That this episode illustrates widespread attitudes towards all accounts of Nazi atrocities and Jewish victimization is unquestionable. We shall therefore focus on the *self-positioning* of the subject (teller or listener, knowledgeable or uninformed) in the face of accounts of the *Shoah*, be it at the dinner table, in the classroom, on the psychoanalyst's couch, in academe, or in the morning paper. It is at once a positioning vis-à-vis one's self, one's interlocutors, and one's community.

Therapeutic explanations

Attempts to account for failed communication of survivors' experience follow roughly two major lines, the first psychotherapeutic, the second cognitive.[6] Among the first, we can cite collections of case studies of survivors who went through some form of extended therapy and, perhaps more interestingly for our purpose, of similar case studies of their children. The problems may vary from case to case, but certain themes prevail: denial, fear, survivor's guilt, psychic numbing, derealization, depersonalization, paranoid attitudes, shock, identification either with a lost loved one or with the

perpetrators, inability to mourn. These analyses are predicated on a strong belief in the healing virtue of therapy and in its ability to resolve the post-*Shoah* anxieties. In a now-classic collection of such case studies, the writer-editors state:

> Elie Wiesel has repeatedly stated that survivors of the Holocaust live in a nightmare world that can never be understood. Although his opinion has its stark and bitter truth, *we believe that the nightmare can be dispelled*; that, through words, analysis can penetrate the shadowy inner world of the patient, which operates in metaphor, and, *by illuminating it, diminish pain, and heal*. Furthermore, analysis can demonstrate *how* the tragedy of one generation may be transmitted to the next, and then *break the chain of suffering*.[7]

I doubt that healing the victims or their children will heal the wound inflicted on our vision of man and society. The *Shoah* has shaken our vision of man so profoundly that, half a century later, we are still grappling with its aftermath, with our urgent albeit terrifying need for a radical reevaluation of our concept of man-in-the-world. And, as the reluctance to believe the stories or even to listen to them shows, this reevaluation does not befall only those who were the subjects of the event or their children (victims, perpetrators, or even bystanders). It extends to an entire generation. As Terence des Pres rightly notes, "the self's sense of itself is different now, and what has made the difference, both as cause and continuing condition, is simply knowing that the Holocaust occurred."[8] There is no denying that this "difference" may take the various forms inventoried by psychoanalysts—but it would be a mistake to reduce the aftermath of the *Shoah* to those forms alone.[9]

I shall therefore focus on approaches that do not regard the survivor in the privacy and intimacy of his or her personal experience only, but contextualize this experience in a community (and its modes of representation), in a narrative, and in a multi-generational culture. Now, since clinical therapy deals mostly with individuals, few therapists have adopted this path, and even fewer have done so with either rigor or consistency. Among the most interesting, and the most representative of the strengths and the limitations of individual therapy, I shall briefly mention two essays, one by Dori Laub and Nanette Auerhann, and the other by Martin Wangh.

Laub and Auerhann[10] focus on the second generation—but on children of people not directly affected by the *Shoah*, Jews and non-Jews alike. They make two points: The first is that the *Shoah* has provided a handy metaphor, a linguistic mold subsequently used by patients to couch their non-*Shoah* related hostilities and violence. The second point goes further, in that it

suggests that the patient cannot help but notice that his so-called metaphor is in fact quite literal: it denotes a past reality. This unavoidable literalization of the metaphor then grafts an external referent onto an internal conflict. Furthermore, in using such a metaphor, the patient (who is after all the author of the fantasized violence) finds himself identified with the Nazi perpetrators and, consequently, guilty of much more serious crimes than he would have been, had he used a more literal language to describe his limited experience.

We may wish to infer from these two points that the cumulative effect of *Shoah* narratives, its historic and referential effect on the representations by which a community defines itself, is such that not only would it determine the linguistic and cognitive tools available to the patient, but, going beyond the patient's personal experience, it would impose on his experience a different referent which it would force him to appropriate, thus invading the space of his subjectivity and robbing him of what was previously his own experience or fantasy. The patient would thus be projected outside his own life narrative into a different one, shared by his community; but one in which he would play a role at which he balks (since it exceeds his fantasies) and, more importantly, into one in which he could no longer recognize himself or his fantasy. Ultimately, the *Shoah* metaphor would become a wedge driven into the relationships that constitute the conscious self, threatening to split the neatly bundled relationships on which the self is built: first, between the patient and his community, and second, within the subject himself, by substituting the *Shoah* narrative (and its terrifying effects) for the patient's experience (or fantasy) of limited violence.

At this point however, that is, at the point in which they might have drawn the conclusions I have just suggested regarding the relationship between the individual and the historico-cognitive and linguistic molds through which that individual lives his inner experience and couches its expression, the authors stop short of examining the social and philosophical implications of their analysis and, shunning generalizations that might take them beyond the four walls of their offices and the pragmatics of their trade, prudently withdraw to the safety of their clinical experience:

> Our point of view is in no way intended to replace the centrality of psychic reality or of psychosexual developmental themes. Rather, our purpose is to supplement them *by acknowledging* the significance and permanence of the permeating metaphors and images in which these themes are couched and take shape in the post-Holocaust era. It is to appreciate, too, the extent to which reality may confirm fantasy and to *recognize* that whenever fantasy is given reality reference, an *acknowledgment* of the reality is required before one can analyze its use as defense. If such *acknowledgment* does not take place—that is, if profound, conflict-laden perceptions of the patient are ignored or regarded as fantasy only—then the patient will feel that his

sense of reality is assaulted. He will need to protect himself from feeling crazy by closing off communication and insight all together. (p. 164; italics mine)

The individuated cognitive approach suggested here—unorthodox as it may be from a strictly Freudian viewpoint—still falls short of addressing the collective dimension of the problem: "acknowledging" in the privacy of one's confrontation with one's self or one's analyst hardly suffices when the root of the problem is not the self but the *dynamics* between the self (already partly constructed through its interaction with others) and its community (or its community's narratives).[11]

Wangh's essay goes Laub and Auerhann one better, in that it does not stop at patients in treatment, but attempts to sketch a broader social pattern.[12] Like Laub and Auerhann, Wangh does not limit his study to *Shoah* survivors: since Nazi atrocities are public knowledge, since they constitute a chapter of our shared stories and history, since, today, we have to integrate that knowledge into this shared history in and by which we define our social and ethical selves, the conflicts of those who were directly affected and of those who were not "differ only in magnitude" (p. 198). Like Laub and Auerhann again, Wangh points out that the past pervades the present, and that, unless its effects are properly worked through, it may surreptitiously confuse present stimuli with the past trauma. Eventually, writes Wangh, "crises may spring from judgments that were correct for past experience but which, applied in the here and now, impede clear sight of present reality" (p. 202).

Unlike Laub and Auerhann, however, Wangh does not stop at case studies, at patients in need of a cure. The kind of "working through" he recommends does not befall a few deviant individuals only, prime candidates for the analyst's couch.[13] It applies to a whole culture: the *Shoah* was an event of such magnitude that we all need to work through the shattering of our values and our world. The task is difficult, however, since the intensity of the trauma is such that any subsequent violence is perceived and reacted to in terms of the past, as if it were a reenactment of the initial horror. Hence, whereas the passing of time is normally beneficial, in this case, the present's misperceptions perpetuate the lingering pain of the past and exacerbate all-too-real anxieties. If working through is the solution to this catch-22, what, then, should this working through consist of?

In comparison to the complexity of his analysis, Wangh's solution is surprisingly simple:

For any kind of curative relief that aims at keeping a rational stance in an irrational world, the sensitizing past trauma *together* with the stimulating

present-day residue have to be simultaneously lifted into full conscious-
ness, and separated out from each other. (p. 203)

In other words, he adds a pragmatic, quasi-behaviorist twist to the cognitive
approach advocated by Laub and Auerhann: once we become aware of the
pervasiveness of the past, we should be able to keep past- and present-related
affects distinct, and to impose some order on our chaotic world. Therapy
is, of course, privileged ground for the recommended "lifting into full con-
sciousness" and "separation" of the intertwined time sequences, but it is
not the only one. The classroom is another: "The nexus of past-present
sequences, their facts and affects, should be taught as a basic sociological
principle from every cathedra in history, philosophy, and political science
and conveyed from every pulpit (p. 203). Eventually, this teaching would
thus reach everyone: "the psychohistorian hopes that such knowledge of,
and alertness to, this intertwining circuitry [of past and present] can help
the social scientist, the people at large and thence the decision-making
politician to obtain self-understanding and thus get a clearer vision of pres-
ent day reality" (ibid).

I find it surprising that, having convincingly demonstrated the psychoana-
lytic intertwining of the time sequences, and having given pointed examples
illustrating the grasp of the past on the present, Wangh concludes with such
a positivist invitation to sort them out. Is it so simple? I doubt that one can
put the past to rest simply by labelling it "past." We can no more know the
past without seeing it through all the subsequent experiences of our life
(all the subsequent "presents"), than we can know the present without
submitting it to the lessons of the past: if we did not know from past
experience that the sun would rise in the morning, we might be terrified
anew by its disappearance every night. The solution is therefore not to
separate out the past from the present. Past and present are irremediably
intertwined. Whereas Wangh recommends an excessive and unrealistic anal-
ysis, what we need is a synthesis, that is, a balanced integration of past and
present, one that projects the lesson of the past on the present, without
obfuscating this present. This too, of course, may sound like wishful think-
ing, but a synthetic approach has at least the advantage of reflecting normal
(that is, sometimes successful) processes of assimilation of past into present
and vice versa—including all cognitive learning processes—and thus has a
better chance of identifying the difficulty when these processes are ham-
pered.

The Subject in History

Our critique of the psychoanalytic approach relies on our view of the
subject's self-positioning in history, at once in the privacy of his inner world,

in the limited exchange set with one's interlocutor (say, a therapist), and mostly, in the larger context of stories we tell ourselves versus stories into which we are born. The exemplary value of *Night*'s opening episode hinges upon its containing the narrative of the boy, and by extension of any survivor, within the problems raised by this self-positioning.

Prior to his own encounter with Nazism, the boy asks Moshe: "Why are you so anxious that people should believe what you say? In your place, I shouldn't care whether they believe me or not . . ." (p. 5). Indeed, in comparison with the ordeal from which he has just escaped, there seems to be little reason for Moshe's present distress. What, then, hangs upon the credibility of his story? Why do the town people refuse to listen to the beadle? What effect does their reaction have on the *project* that brought him back to town? Somehow tentatively, Moshe answers the boy's query:

> "You don't understand," he said in despair. "You can't understand. I have been saved miraculously. I managed to get back here. Where did I get the strength from? I wanted to come back to Sighet to tell you the story of my death. So that you could prepare yourselves while there was still time. To live? I don't attach any importance to my life any more. I'm alone. No, I wanted to come back, and to warn you. And see how it is, no one will listen to me. . . ."

Moshe's anguished insistence on being heard undoubtedly illustrates the well-known recourse to narrative in order to impose coherence on an incoherent experience (a commonplace of literary criticism), to work through a trauma (a commonplace of psychoanalysis), the laudable drive to testify to a crime (a commonplace of *Shoah* narratives), or even the heroics of saving others (a commonplace of resistance literature). Although such readings of *Night* are certainly not irrelevant, I do not think that they do justice to the gripping urgency of his unwelcome and redundant narrative, unless we read the text literally: Moshe came back "to tell you the story."

We must rule out simply imparting knowledge, since Moshe's undertaking clearly does not stop at communicating the story. A scenario in which the town folks gather around him to listen to his story, and then go on about their business would be absurd. In this case, to "believe" the story is to be affected by it. Moshe's story is therefore a speech act. Allow me an example to clarify this last point: Paul Revere tearing through the countryside and screaming "The British are coming!" His message was immediately understood. No one suspected him of either madness or excessive need of attention. Unlike Moshe and the town folks, and unlike *Shoah* survivors and ourselves, Paul Revere and his New Englanders lived in the same world, a world in which British might and probably would come; a world in which

that would be a very bad thing indeed; and a world in which should they come, clear measures must be taken. If the story is to realize its illocutionary force, not only does it have to be integrated into its listeners' stock of "facts they know about their world," but it must also rely on a known formula (a convention) by which an individual reacts to such knowledge. For example, one has to know that if the British are coming, one is expected to arm oneself and prepare for resistance (a clean shave would be a highly inappropriate reaction to Paul Revere's message). Revere could therefore speedily spread his message while never dismounting his horse, and still secure its uptake. In short, to be a felicitous speech act, the story must affect its listeners in an expected, conventional manner (that is, following clear precedents). Until it does, its force is void.

Speech act theorists unanimously agree on the conventional aspect of a speech act, that is, on its reliance on a preexisting convention shared by the community of its listeners. But sometimes, such a precise convention does not exist. It has to be inferred and activated out of the stock of beliefs and conventions that both utterer and listeners find workable, plausible, and altogether acceptable. In invoking their shared beliefs, the felicitous speech act thus becomes a *rallying point* for the utterer and the listeners. It binds them together. A community is therefore as much the *result* of its speech acts as it is the necessary condition for their success. In other words, if, as he claims, Moshe came back to town in order to tell his story, and if indeed he is determined to secure the felicitous uptake of his narrative's illocutionary force, then this determination reveals yet *another project*, one that is even more exacting in that it affects his (and his fellow villagers') being-in-the-world: his return to town is also an attempt to reaffirm his ties to his community (its conventions, its values), to reintegrate into the human community of his past — a community whose integrity was put into question by the absurd, incomprehensible, and unassimilable killings he had witnessed.[14] Through his encounter with Nazism, Moshe has witnessed not only the slaughter of a human cargo, but the demise of his notion of humanity — a notion, however, still shared by the town folks. As long as they hold on to this notion of humanity to which he can no longer adhere, he is, *ipso facto*, a freak. Coming back to town to tell his story to a receptive audience is therefore Moshe's way back to normalcy, back to humanity. Only by having a community integrate his dehumanizing experience into the narratives of self-representation that it shares and infer a new code of behavior based on the information he is imparting, only by becoming part of this community's history, can Moshe hope to reclaim his lost humanity (the question remains, as we shall see, at what price to that community). It is therefore not a question of privately telling the story (to oneself, to one's editor or to one's analyst) as of having others — a whole community — *claim* it, *appropriate* it, and *react* (properly) to it.

The closing scene of *Night* echoes this concern. Upon his liberation by American troops, the narrator first rushes to a mirror to look at himself. Is he still himself? Can the mirror show him unchanged since the last time he looked at himself in the mirror, before he was taken out of his village? Can he reintegrate into himself? Will the mirror allow him to bridge over pain and time, and reach the cathartic recognition that will bracket out the horror of the death camps and open the way for a "normal" life; or will it, on the contrary, irreparably clinch his alienation not only from the world but from the supposed intimacy of his self-knowledge? Like Moshe then, the boy leaves it to a third party (a willing community or a mirror) to mediate between his present and past selves, and cancel out the alienating effect of his brush with inhumanity. Just like the town folks, however, the mirror does not cooperate. Instead of the familiar face that would have reconciled him with his former self (and consequently, with a pre-*Shoah* world), his reflection seals his alienation: "From the depth of the mirror, a corpse gazed back at me. The look in his eyes, as they stared into mine, has never left me" (p. 109).

Night is the story of a repeated dying, at once the death of man and of the *idea* of man. The final recognition never obtains. Instead, the subject is propelled out of himself, out of humanity, out of the world as he knew it. It is a double failure: both Moshe and the boy fail to recover their selves' integrity and to reintegrate into the community of the living; both fail to assimilate the traces left by their experience (either in a narrative or in a physiognomy) into a coherent picture to be accepted by the other(s) they so wish to reach.[15] But the story goes on: *Night* is a first-person narrative. Like Moshe, the boy will try again to reintegrate the human community, this time, by telling his story (and many others). Like all survivors' narratives, *Night* is thus yet another plodding from door to door to solicit listeners, so as to reclaim one's ties to the community of the living by inscribing oneself into its shared narratives.

On Communities

Night's opening episode thus raises two major questions, stretched over the two ends of the communication process: Why did Moshe so desperately need to be listened to; and why do the town folks obtusely refuse to take in his story (at the risk of their lives)? Clearly, something crucial must be at stake for both parties, something that defies storytelling, "lifting to consciousness," or literalized metaphors. Whether we address the question from one end of the scene of narration or from the other, I suggest that the answer is one and the same.

We may approach it through two often-overlooked truisms: on the one hand, whatever horrible trauma an individual may have experienced, he or

she remains an individual, no more, no less. That person will retain and exercise all or any of the psychological and psychoanalytic processes by which one normally sorts out experiences or fantasies. So much for the idiosyncratic treatment of psychic traces, however, since, as we have seen, no individual lives in a vacuum. Our second truism is, therefore, that we live in society, that is, we are born into a world in which our options are predetermined and limited: we are born into an already existing language, into social, ethical and legal codes; we are born into a world rife with events, narratives, histories—in short, *memories*—which are as constitutive of our selves as are our fantasies or experiences. Moreover, as education and the media have tightened their grip on our lives, societies have become increasingly permeable to each other; we share more stories, more myths, more histories than ever before. And as Robinson Crusoe illustrates, should we try to escape to a desert island, these social norms are so deeply imprinted on us that we necessarily reproduce the absent society within ourselves and our solitude.

The two truisms I am describing underlie Saussure's well-known distinction between *langue* and *parole*. On the one hand, I am free to choose my expression, my words, my metaphors. Each of my utterances indisputably reflects my free will and psychological profile. On the other hand, however, *langue* is the limit of my personal freedom and expression, since whatever I say will be governed by and limited to what is accepted by the community, that is, determined by the usage of that *langue*. A private language is no language. I am not free to rename objects, for example; nor am I free to change syntax. Or, rather, I am free to do so only within the limits of communicability: despite irregularities and agrammaticalities, I have to retain enough of the lexical and syntactical rules in place in my community to ensure communication. Furthermore, unless my interlocutors plug their ears or turn away from me (which is exactly what the town folks did), my sentence will bridge my subjectivity and theirs: no longer mine alone, it will have become the object of our shared attention. "My" expression is therefore never mine alone. It is "ours." It connects and binds me, first, to my immediate interlocutor, of course, but more importantly, to the community for and in which my language and my utterance are intelligible. Every sentence I utter confirms this bond, just as any historical narrative would confirm my historical bond with my community, and would transform "my" narrative into "our" narrative.

Now, the dynamics of *Night's* opening episode may be clearer: Moshe and the town folks occupy two opposite ends of a transaction. Moshe wants the community to assimilate his story, to take it in and learn its lesson, in the hope that it will allow him a way out of the unbearable solitude into which his experience has cast him, and bridge over the tear that his encounter

with the dispassionate force of evil has introduced in his life. In other words, he wants the agrammaticality of his experience, his odd and deviant *parole*, to become part of their *langue*. The town folk, however, do not want to take up this horror, to make it theirs, to make this story the *rallying point* between themselves and the narrator, since if they did, his burden would become theirs: it would then behoove *them* to mend the tear, and to assimilate an unassimilable experience (an experience that is not, but would become, theirs, should they be forced into a shared scene of narration with Moshe). To integrate Moshe's *parole* into their *langue* would demand such an extensive review of the rules of the *langue* by which they live that it could put its very structure and coherence in question. They would rather risk their lives than tamper with their cognitive framework. Moshe's compulsion can thus be understood only within the dynamics of his interaction with his community, just as the denial of each member of the community can only be understood as an attempt to maintain the integrity of this community.[16]

It is in this respect that psychotherapeutic approaches are the most vulnerable to criticism: by treating the individual who steps into a therapist's office as if the problem were contained in him or her, as if this trauma was merely personal (like any other trauma), as if it did not partake in a whole culture's convulsion and the ensuing need for a cognitive overhaul on a scale unmatched in world history, the therapeutic practice (especially psychoanalysis) risks taking part in yet another variant of the generalized denial illustrated by the town folks. In accepting an individual for treatment, a therapist implicitly recognizes that the burden of dealing with the *Shoah*'s legacy falls upon this individual—otherwise, why should he or she be treated in private? Consequently, this therapist (and his ailing and trusting patient) releases the community (and the historical consciousness of each "normal" individual in this community) from having to alter its shared narratives and representations and from integrating the incompatible lesson (our capacity for indifference, cowardice, stupidity, moral detachment, cruelty, and so on) into its historical project.[17]

Conclusion

It has often been said that *Night* is the gloomy story of a loss for which no solace, no solution is offered. Indeed, "Elie Wiesel has repeatedly stated that survivors of the Holocaust live in a nightmare world that can never be understood. . . ." (see No. 9). But it should also be noted that, although *Night* is the only novel in which he dealt directly and explicitly with his experience of the *Shoah*, Wiesel's whole life has been dedicated to its ensuing moral and historical imperatives. Moshe the Beadle (Wiesel's spokesman) thus offers a critique of facile answers to post-*Shoah* difficulties—narrowly

individualized answers that, despite their limited usefulness, nonetheless overlook the collective dimension and its impact on the individual's self-positioning. Excessive separateness of past and present is yet another form of repression, another defense mechanism. The historical imperative today is not to "sort out" but, on the contrary, to find a way of *taking in* the reality of industrialized killing, knowing fully that this reality contradicts every aspect of our historical project, everything we would like to believe about ourselves. To date, we have not resolved this incongruity. If we are to deal with the legacy of the *Shoah*, we must make room in our project for the disturbing truths of the *Shoah*. Our historical imperative is to go beyond this contradiction and to integrate the lesson of the *Shoah* into the coherence of the stories and histories by which we define our sociohistorical project (by "project" I mean the future we wish upon ourselves as a society, and according to which we shape our present perception and representations of ourselves[18]). None of us, therefore, escapes the need to "deal" with the *Shoah*; but none of us can do it alone, or be led to believe that he or she can.

Yes, we want to "heal." Society wants to heal; history wants to heal. But no, a simple "life goes on," "tell your story," "come to terms with your pain," or "sort out your ghosts" will not do. It will not do, because the problem lies not in the individual—survivor or not—but in his or her interaction with society, and more precisely, in his or her relationship to the narratives and values by which this community defines and represents itself. It would be more optimistic, indeed, to think that each hurting person could solve his or her problem privately, with or without a therapist's help, so that the sum of the healed parts will eventually bring about a newly healed whole. Although there is some undeniable value (and sometimes even a measure of success) in attempting to help each part, in attempting to alleviate individual suffering so as to restore a semblance of normalcy (but precisely, "normalcy" is hurting; it is no longer normal), neither "healing" nor "breaking the chain of suffering" will ensue. The *Shoah* legacy remains a case in which the whole does not amount to the neat sum of its parts. A "successful" analysis will still leave the patient to deal with the integration of the lesson of the *Shoah* into the project he or she shares with his or her community. On the whole, despite the laudable optimism of its practitioners, psychotherapy cannot heal the historical, shared dimension of this wound. History is not psychotherapy's proper field of application. This misconception is a moving and tragic testimony to the urge of therapists themselves to wrestle with the evil of the past, and negate the nefarious effects of the *Shoah*; but it misses the historical imperative of our times.[19]

Notes

1. Wiesel, Elie, *Night*, trans. Stella Rodway (New York: Bantam Books, 1982). Page references will appear in the text.

2. Similar accounts of disbelief abound in survivors' testimonies.

3. Walter Laqueur, *The Terrible Secret* (Boston: Little, Brown, 1981; New York: Penguin, 1982), pp. 3, 237. Half a century later, although the *Shoah* is one of the best documented episodes of recent history, negationists can still harness a similarly deep-seated reluctance to believe these narratives to their effort to deny the genocide.

4. Henry Raczymow, to cite one of many examples, asks "What right does one have to speak if, as in my case, one has been neither victim, nor survivor, nor witness of the event?" Henry Raczymow, *"La mémoire trouée," Pardès*, 3 (1986). Cited by Ellen Fine, "The Absent Memory: The Act of Writing in Post-Holocaust French Literature," *Writing and the Holocaust*, Berel, Lang ed. (New York: Homes & Meier, 1988), p. 51.

5. Elie Wiesel, *One Generation After*, trans. Lily Edelman and Elie Wiesel (New York: Random House, 1965), pp. 19–20. See also *L'oublié* (Paris: Seuil, 1989), pp. 152–155, ending with "They felt sorry for him, they avoided him, they thought he was crazy" (translation mine).

6. I deal with cognitive approaches in another essay.

7. Martin S. Bergman and Milton E. Jucovy, eds., *Generations of the Holocaust* (New York: Basic Books, Inc., Publishers, 1982), p. 119 (italics mine). See also, Randolph L. Braham, ed. *The Psychological Perspectives of the Holocaust and of its Aftermath* (New York: Columbia University Press, 1988); Steven A. Luel and Paul Marcus, eds., *Psychoanalytic Reflections on the Holocaust: Selected Essays* (New York: Holocaust Awareness Institute Center for Judaic Studies, Univ. of Denver, 1984); Robert M. Prince, *The Legacy of the Holocaust: Psychological Themes in the Second Generation* (Ann Arbor, Michigan: UMI Research Press, 1985).

8. Terrence Des Pres, "The Dreaming Back," *Centerpoint*, 4, No. 1 (Fall, 1980), p. 13; quoted by Steven A. Luel, "Living with the Holocaust: Thoughts on Revitalization," in *Psychoanalytic Reflections on the Holocaust*, p. 169.

9. See also my "Narrative Subject, Historic Subject: 'Shoah' and 'La place de l'étoile,' " *Poetics Today*, 12:3, (Fall, 1991), pp. 495–516.

10. Dori Laub and Nanette Auerhann, "Reverberations of Genocide: Its Expression in the Conscious and Unconscious of Post-Holocaust Generations," *Psychoanalytic Reflections on the Holocaust: Selected Essays, op. cit.*

11. It must be noted here that, in a complete turn about, Dori Laub's recent work insists heavily on the collective dimension of *Shoah* traumatism.

12. Martin Wangh, "On Obstacles to the Working-Through of the Nazi Holocaust Experience and on the Consequences of failing to do so," in *Psychoanalytic Reflections on the Holocaust, op. cit.*

13. See Wangh: "While 'working through' is a term coined specifically for the process of overcoming resistance in the quiet stability of the psychoanalytic situation, the insights that emerge from it may occur during ordinary life as well, at least in regard to 'normal traumatization,' in 'normal' development during a 'normal' life span" (p. 200).

14. Psychoanalytic studies of survivors focus on the shattered universe of the survivor himself—not on the threat the survivor's experience represents for society's integrity. I shall not dispute the past and present suffering of the survivors and the need to alleviate it. No healing can be complete, however, unless the collective sociohistorical dimension is addressed. Well-meaning therapists who ignore this dimension risk contributing to the survivor's suffering and perpetuating it.

15. Primo Levi, for example, tells the same story in an anticipatory mode, as the worst nightmare of prisoners in death camps: "Almost all the survivors, orally or in their written memoirs, remember a dream which frequently recurred during the nights of imprisonment, varied in its detail but uniform in its substance: they had returned home and with passion and relief were describing their past sufferings, addressing themselves to a loved one, and were not believed, indeed were not even listened to. In the most typical (and cruelest) form, the interlocutors turned and left in silence. . . ." *The Drowned and the Saved*, trans. Raymond Rosenthal (New York: Summit Books, 1986), p. 12.

16. Cf. Terrence Des Pres: "The survivor, then, is a disturber of the peace. He is a runner of the blockade men erect against knowledge of 'unspeakable' things. About these he aims to speak, and in so doing he undermines, without intending to, the validity of existing norms. He is a genuine transgressor, and here he is made to feel real guilt. The world to which he appeals does not admit him, and since he has looked to this world as the source of moral order, he begins to doubt himself." Terrence Des Pres, *The Survivor: An Anatomy of Life in the Death Camps*, (Oxford: Oxford University Press, 1980), pp. 42–43.

17. The term "reintegration into society" used by psychoanalysts is revealing. It implies that society itself has not changed (nor does it need to change): the patient is the one who has stepped out of the norms of society and who now has to undo the effect of the time spent outside those norms in order to "reintegrate."

18. Wiesel asks the exact same question in different terms: "How do you tell children, big and small, that society could lose its mind and start murdering its own soul? How do you unveil horrors without offering at the same time some measure of hope?" "The Holocaust: Three Views." *ADL Bulletin*, November 1977, p. 6. Cited in *Generations of the Holocaust*, p. 3. Indeed, child-rearing epitomizes what I intend by our project: it includes the values we teach our children, the future we wish for them and for which we try to prepare them, the self-positioning vis-à-vis society and history that we try to encourage in them. What we tell our children is, I think, our ultimate test.

19. It should be noted that many therapists deeply committed to the treatment of survivors and their children are, themselves, either survivors or children of survivors.

13

On the Holocaust Comedies of "Emile Ajar"

Jeffrey Mehlman

Throughout the 1970s, a period during which American academics seemed poised to absorb from France ever more "radical" doses of literary "theory," the readership of France itself unwittingly embarked on an unprecedented literary experiment, of remarkable speculative import, under the tutelage of a French man of letters so apparently conventional as to identify his years of service as French consul general in Hollywood as a high point of his career.[1] For these were the years during which Romain Gary published a series of three tonally innovative novels under the pseudonym "Emile Ajar": *Gros-Câlin* (1974), *The Life Before Us* (*La vie devant soi;* 1975), and *King Solomon* (*L'angoisse du roi Salomon;* 1979). The critical success of the books was such that attempts were made, beyond what all took to be a fabricated biography on the book jacket of *Gros-Câlin* (a *pied noir* physician and sometime abortionist, living in Latin America, in flight from French authorities), to identify the actual author of books that were emerging as *the* literary achievement of France in the 1970s. Press speculation concerned only the highest echelon of the French literary pantheon: Raymond Queneau and Louis Aragon.[2] "Ajar" 's publisher, Mercure de France, as much in the dark as everyone else, prevailed on its author, through an intermediary, to grant an interview to the press. Gary requested his "nephew," one Paul Pavlowitch, to play the role of "Ajar" in an interview with a journalist from *Le Monde*, in an apartment in Copenhagen, and to do so on the condition that his "actual" identity not be divulged.[3] Pavlowitch, however, revealed enough of his own life for an old acquaintance to be able to identify him as Ajar. When that (astute, but erroneous) attribution surfaced in the French press, shortly after "Ajar" himself, in what seemed to many a parody of Sartre's rejection of the Nobel Prize, had refused the Prix Goncourt for *The Life Before Us,* Gary's sublime reaction was to write *Pseudo,* the memoirs of Pavlowitch, *alias* Ajar, now

revealed to be a psychotic, writing for reasons of therapy, and paranoiacally obsessed with his uncle, referred to only as Tonton Macoute, and the nefarious designs that relative seemed to have on "Ajar' "s emerging career.

With *Pseudo*, the Ajar enigma appeared to be solved. What France seemed to be witnessing was a twentieth-century replay of Diderot's *Rameau's Nephew:* a wildly talented and unstable nephew venting his rage against an all-too-established uncle. *Romain's Nephew,* as one critic called it, seemed additionally to infuse the Diderot scenario with a tone oddly akin to the paranoid Céline's: it was not for nothing, apparently, that "Ajar-Pavlowitch" wrote from Denmark.[4] The paradox, of course, lay in the fact that what was received as the nephew's book about the uncle was in fact the uncle's unrelievedly self-denigrating book about the nephew. There were, of course, ample reasons not to suspect that Gary was "Ajar": not only did Gary continue to write and publish at his usual pace during the Ajar years, but he even managed to publish a novel, *Les Têtes de Stéphanie* (1974), under a *different* pseudonym, which was soon revealed to be such. His output alone seemed to militate against any attribution of the Ajar books to Gary—even as that motif came to be inscribed as a principal obsession of what all failed to see was Gary's most daring creation: the heteronymous couple, "Ajar-Pavlowitch."

Finally, the entire fabrication was revealed as such in a manuscript left behind by Gary, at the time of his suicide in 1980, *Life and Death of Emile Ajar* (*Vie et mort d'Emile Ajar*).[5] In that work, Gary revealed his motivation as a desire to escape from his going image as a successful professional. Given the laziness of prevailing habits of reading, only a mystification such as the one he put together would allow his recent books, allegedly by Ajar, to be read with the sense of excitement (or novelty) without which he would not have written them. And yet all of Ajar, he claimed, was already present in one of his first novels, *Tulipe.* Pity the author for having to make do with so sclerotic a reading public. And allow him, now that the demonstration had been completed, now that the whole Ajar "phantasm" had unfortunately nested in another subject ("nephew" Paul), to exit as diplomatically as possible from the premises. In the last, posthumously published words of the author: "I've had a lot of fun. Good-bye [*au revoir*] and thank you" (p. 43).[6]

Gary's claim that all of Ajar is already in Gary, however, makes short shrift of a tonal rift between the two that can be ignored only at the expense of the piquancy of the entire project. Consider two instances. During the Ajar years, Gary published, under his own name, a novel about the onset of sexual impotence in an aging French businessman. Its title, *Au-delà de cette limite votre ticket n'est plus valable,* is a witty recall of the ominous signs announcing one is leaving the Parisian *métro* system, and that one's ticket will no longer be honored: such, metaphorically, would be the plight of

the sixty-year-old protagonist, Rainier, in Gary's novel. Compare that to the following observation by Cousin, the sympathetically portrayed lost soul of an incipiently psychotic narrator, toward the end of the first Ajar novel, *Gros-Câlin*: "Leaving the *métro*, the ticket didn't throw me away and held on to my hand sympathetically (it knew I was going through some difficult moments)" (p. 212). A certain invalidity upon leaving the *métro* is the stuff of both images, but the expertly chosen metaphor in Gary has, in Ajar, become an unthinkable scramble, a dream image, in which a nightmarish loss of agency is experienced as the premise of an episode that can only be construed as comforting. Or take the following line from Gary's *récit, The Night Will Be Calm* (*La nuit sera calme*): "The men from the American television networks began heaving from laughter like a couple of whales" (p. 198). We are invited to savor the grotesqueness of the convulsed and blubbery producers—sympathetically. Toward the end of the final Ajar novel, *King Solomon*, we read: "Then we really began to heave, like a couple of whales about to be exterminated" (p. 348). Here the appended phrase adds to the sympathetically grotesque image the twin motifs of human cruelty (extermination) and a measure of delusion hard to fathom: laughing just *that* hard at one's own destruction. The Ajar version, that is, in a burst of laughter, manages to shatter the very value the Gary image seemed to be advancing.

It is as though Gary and Ajar during the 1970s were two distinct literary personalities: one the mature man of letters, obsessed with the waning of his own energies, finding no more appropriate setting for the beginning of one of his better novels of the period than Venice in the process of going under; the other, at once more desperate and funnier, the first and most distinguished literary harvest of the libertarian (and antipsychiatric) excesses of May 1968.[7] Whence the interest, in the literary-"theoretical" context evoked above, of the longest passage of his work quoted by Gary in *Life and Death of Emile Ajar*. It is a page Gary published in 1971, about a ninety-six-year-old Spaniard of Toledo, whose specialty, in the shadow of the Alcazar, is sculpting statuettes of Don Quixote for the tourist trade, and who has the quixotic habit of seeing a fortune-teller every day for news about his future. Gary quotes it as a blunder of his, since he unwittingly incorporated that very episode, with minor changes, in Ajar's *King Solomon*: "This was exactly Chapter XV, in which Monsieur Solomon goes to consult a clairvoyant!" (p. 36). Now, the reference to Don Quixote is eloquent, for these were the very years in which Borges's celebrated fable on the speculative interest of erroneous attribution, "Pierre Menard, Author of *Don Quixote,*" was settling in as a *locus classicus* of literary "theory." Borges invites us to imagine how different our interpretation of the Spanish novel would be if we could think of it as the achievement of a man of a very different generation: the meaning of a brief paragraph is variously analyzed by the narrator according to its

assumed authorship (by Cervantes or by the Nîmes Symbolist Menard).[8] But the entire Ajar experiment executed Borges's quixotic wager on a far grander scale. Readers were forced to assess the interpretative consequences of reading three major novels and a pseudomemoir by Gary as though they had been written by an entirely different author—and then, after Gary's death, to reverse themselves. It is one thing, that is, to read of the mix of revulsion and tenderness experienced by the young narrator of *King Solomon* upon sleeping with a sixty-five-year-old female has-been, and to interpret those sentiments in terms of the narrator's status as surrogate for the novel's young author. It is another to be forced into the realization that the actual author, Gary, not only was busy writing about the travails of becoming a has-been, but was the exact age of the woman in his book at the time of its writing.

Now, nowhere is the shift in readerly perspective resultant from the attribution of Ajar's works to Gary more telling than with regard to the persistent reference to Jewish tragedy throughout the pseudonymous works. And it is to a reading of those works (and specifically to their treatment of Jewish suffering during the Occupation), within the space of the reversal effected by their attribution to Gary, that these pages are devoted.

But first a word on the end, then the beginning of the Ajar experiment. "I've had a lot of fun. *Au revoir* and thank you," as we have seen, is Gary's own final line on the project. The appearance of consummate urbanity— *au revoir,* indeed!—is belied by the suicide apparently prerequisite to a revelation designed to be posthumous. Moreover, the very terms of the project's end seem menacing: "I had been *expropriated.* There was now someone else [Pavlowitch] living the fantasy [*phantasme*] in my place. . . . The dream was at my expense. . . ." (p. 14). With the discovery that (one's own) fantasy is crucially the province of an other, that one's dreams are perhaps essentially constituted at the expense of ego or self, the resolutely anti-Freudian Gary appears, through "Ajar," to be edging undogmatically toward particularly unsettling insights. The name Lacan is perhaps by now too associated with scholastic recastings of his thought to capture the sinister freshness of the discovery Gary, on the eve of his suicide, seems close to backing into here, and yet, as I shall attempt to demonstrate, one is hard put to adduce a better one.

Romain Gary, we have said, invented "Emile Ajar," ultimately, in his words, at his own expense. But that formulation, or statement of origin, overlooks a consideration that most readers of Ajar in the 1970s no doubt had already forgotten: namely, that "Romain Gary" itself was a *nom de plume.* Before being a pen name, however, it was a *nom de guerre,* the name assumed by our (future) author upon joining the Free French as an aviator in 1940, and one later legalized in 1951. Romain Gary, by the time the Ajar

books began appearing, was a well-known, even notorious figure. A member of the Resistance decorated by de Gaulle; the author of the book (*Forest of Anger* [*Education européenne*]) Sartre had described as perhaps the best novel of the Resistance; a winner of the Prix Goncourt in 1956 (*The Roots of Heaven* [*Racines du ciel*]); a diplomat both at the United Nations and in California; the husband of Jean Seberg; the figure of the successful professional novelist. There was, of course, a downside to almost all these aspects: loyalty to de Gaulle seemed by the late 1960s to be a mark of political "incorrectness"; a lingering affection for his old aviator's jacket aroused suspicions of "fascist" leanings; the Jean Seberg affair, the pro-American tendency, seemed to cast him in the role of a sub-Arthur Miller to Jean Seberg's Marilyn. Add to that his authorship, in 1965, of *For Sganarelle* (*Pour Sganarelle*), a somewhat heavy-handed essay attacking both Sartre and the *nouveau roman,* and the figure of the consummate "reactionary," to resort to the idiom of the day, seems complete.

The forging of Romain Gary's identity is, in fact, the subject of one of the author's most striking books, *Promise at Dawn* (1960). It is something of an autobiography of the author, in the form of a recounting of the dreams of his unmarried mother, Nina Kacew, a Russian Jew, first in Vilnius, then in Warsaw, for the future of her son. A worshipper of French values, she conceived in Lithuania the extravagant dream that her son, Romain, would some day be a great French diplomat and writer. And the book is Gary's record of his fidelity to that delirious project: we observe Romain literally "becoming" the laughter of Polish acquaintances jeering at Nina's Franco-philic projects for him; making his way, with his impoverished mother, to Nice; observing her physical decline; reacting to de Gaulle's fabled call to resistance of June 18, 1940, as though it were ventriloquized by his mother; and finally returning, something of a military hero and already an author, to Nice at the war's end. As the war proceeds, something of a fusion takes place between mother and son: "I truly believe that it was my mother's voice which had taken over my own, because, as I continued to speak, I myself was dumbfounded by the astonishing number of clichés coming out of me. . . ." (p. 296). Then: "in truth, it was not I who was wandering from plane to plane but a resolute old lady, dressed in gray, a cane in her hand and a Gauloise hanging from her lips, who had decided to make the trip to England and continue the struggle. . . ." (p. 297). The Gauloise in the second example, the clichés in the first are useful illustrations of just how effective Gary is in the difficult business of eschewing sentimentality.

The tempo of the book, in its last third, is dictated by the author's realiza-tion that if he is to fulfill his apparent destiny, to be Nina's "happy end," his life must be a race against the clock (p. 48). For she has already begun falling prey to hypoglycemic comas, a harbinger of early death. The rush

is thus on to turn her, through his talents, into the "great artist" she had always dreamed of (his) being (p. 346). It is largely through the encouragement brought him throughout the war by his mother's impassioned letters that he is able to bring his (or her) dreams to fruition. And it is thus with a particular sense of shock that "Gary," returning home to Nice at the war's end, learns that his mother had in fact died three and a half years earlier, toward the beginning of the war, but had written on her death bed 250 letters which she arranged to have sent to her son, in weekly installments, from Switzerland.

Consider now the configuration informing *Promise at Dawn.* For the Eastern European (half-?) Jew Romain Kacew to become "Romain Gary" meant becoming the "happy end" of his abandoned mother insofar as it was imaginable as a figure of exemplary Frenchness. That such a figure was fundamentally imaginary is underscored by the unreal (because posthumous) epistolary underpinning of the author's entire wartime phantasia. Exemplary Frenchman, military hero, and above all a hallucination of his abandoned mother's "happy end," the "Romain Gary" of *Promise at Dawn* figures nothing so much as what Lacan has called the maternal phallus.

Enter Emile Ajar, in the guise of the narrator of his first novel, *Gros-Câlin.* For if *Promise at Dawn,* as we have seen, presents a certain mythology of imaginary integration into the French community, Cousin, Ajar's protagonist-narrator, seems to be characterized above all by his total alienation from the France in which he lives. The novel's plot is relatively simple: Cousin, a statistician working in Paris, has two obsessions, his pet python and his barely articulated love for a black coworker in his office, Mlle Dreyfus. A series of episodes, at once hilarious and sad, concerning the python, culminates in Cousin's panic at learning that Mlle. Dreyfus has quit her job to return to Guyana. He then meets her by chance during one of his regular visits to a brothel, and finally decides to donate his python to the zoo. At novel's end, Cousin himself seems to be metamorphosing into his abandoned pet.

If *Promise at Dawn* records an imaginary integration into "France," *Gros-Câlin,* it would seem, all but depicts a reversal of that process. Here the key figure is Cousin's nemesis, the "office boy," adrip with Beaujolais, whose "demagogical" moustache, *vieille France* airs, and complicitous leers are regularly evoked (or hallucinated) as a dreamt-out dream of *francité* (p. 85). With his caricature Frenchness ("sly winks *à la française,* with occasional flashes of irony"), he is the precise obverse of Cousin, and of many another of Ajar's narrator-surrogates (p. 66). And to the extent each of those apparent surrogates figures a manner of expulsion from the French community, a virtual disintegration of the achievement named "Romain Gary" in *Promise at Dawn,* is it not, we may already wonder, as though the anti-Gary named

"Ajar" were at some level the return of the Eastern European Romain Kacew, whose very repression it may have been the purpose of the name Gary to consolidate?

"Romain Gary," in *Promise,* as Lacan's *maternal phallus:* the suggestion is sustained by one's realization that *Gros-Câlin* offers nothing so much as the protopsychotic confessions of a man turning into a pet python, which is itself confused throughout the book with a male organ. Consider the case of the Portuguese cleaning lady (who, like the python itself, is referred to, untranslatably, as *"l'immigration sauvage"*). When she finds the python, Gros-Câlin, rising out of the basket to which Cousin routinely consigns his love letters after writing them, one feels she is only half-wrong in running off to the police prefecture with Franco-Portuguese shouts of *"monsieur sadista, monsieur exhibitionnista."* Other examples of the python-phallus confusion abound.[9] What is striking is just how maternal a phallus Gros-Câlin proves to be: his great skill is not penetration but embrace, envelopment: *il s'enroule.* And the great dilemma he imposes on the narrator is less genital than oral: pythons eat only live flesh, and Cousin spends most of the novel agonizing over whether to feed his snake his pet mouse, Blandine. So this enveloping and devouring male organ is the most maternal of phalluses, toward whom Cousin, in a striking *"ajarisme,"* waxes touchingly (because idiotically) maternal: "Well pythons don't really purr, but I do a good imitation so he can express his contentment. It's what's called dialogue" (p. 51). And it is this maternal phallus into which Cousin, traumatized in his love life, metamorphoses at the end of the novel. Having given his python over to the zoo, he is found popping down mice and slithering around his apartment. It is all as though the unconscious subtext of *Promise at Dawn*—"Romain Gary," Frenchman *par excellence* and/as maternal phallus—had decided to speak (and undo) itself in a quasi-Kafkan fable by "Emile Ajar": the maternal phallus bespeaks the humiliations of its life as a pseudo-Frenchman (or bogus human) and slithers off into clandestinity.

Cousin's would-be fiancée, whom he discovers, in the novel's climax, working in a brothel, is named Mlle Dreyfus:

> a black from French Guiana, as her name indicates, Dreyfus, which is quite frequently adopted by the natives there, for reasons of local glory and to encourage tourism. Captain Dreyfus, who wasn't guilty, spent five years in jail there for no reason at all and his innocence seems to have left its mark on everyone. (p. 15).

It was, in brief, in the interest of any black family to adopt the name Dreyfus as a kind of protective ploy: "that way, no one would dare touch them." Gary had already forged an ironic link between the tragedy of the Jews and

antiblack racism in *Tulipe* (1946), a not-very-successful treatment of the adventures of a Buchenwald survivor living in Harlem. The more interesting connection between the Ajar-surrogate Cousin's aspirations toward (Mlle.) Dreyfus and the work of Gary, however, is to be made rather by way of *Promise at Dawn*. For that work contains its own degrading miniature of the Dreyfus Affair. Just prior to World War II, Romain Kacew entered the French air force academy at Avord: the prospect of at last attaining his (mother's) goal or end (*but*), returning to Nice in a French officer's uniform, seemed imminent. And yet out of a graduating class of nearly three hundred, Kacew was alone in not receiving an officer's commission. Informally, he was given two reasons: first, that his French naturalization was too recent ("but I am French"); then, more unanswerably: "The reason you've been screwed is that they just don't like you" (p. 245). Thus does the young Eastern European Jew come face to face with the forces of intolerance in the very citadel of the French military he had been taught to adore. Invoking a god out of his imaginary pantheon, he writes: "But it was above all Filoche, the petty bourgeois god of mediocrity, contempt, and prejudice, whom I recognized and who was breaking my heart because he had opted to dress up for the occasion in the uniform and striped helmet of our Air Force" (p. 246). One could imagine these words, suitably transposed to another branch of the military, as being pronounced by a more sensitive and astute version of Captain Alfred Dreyfus. What is striking, in *Promise at Dawn*, however, is that no sooner are they pronounced than the author retreats from the Dreyfus-like role into which French prejudice seems to have cast him. First, a pirouette: from the time of that incident on, he writes, he felt more French than ever. Why? "It finally dawned on me that the French were not a race apart, that they were not superior to me, that they too could be stupid and ridiculous—in short, that we were brothers, undeniably" (p. 248). Then a vow: what was to be spared injury, at whatever cost, was his mother's image of France as the homeland of justice. And finally, a petty lie: he tells his mother that if he was denied his commission it was only because he had seduced the wife of the academy's commandant. His humiliation, in brief, was to be chalked up to his virility. The identity of "Romain Gary," maternal phallus and/as exemplary citizen of France, is thus forged out of the denial of another identification which circumstances had imposed on the young Romain Kacew: one with Alfred Dreyfus.

Returning now to *Gros-Câlin*, we can perceive the significance of the humiliation which Mlle Dreyfus, whose very name is born out of the degradation of the exemplary saga of Alfred Dreyfus, inflicts on poor Cousin. To the extent that Ajar-Cousin is a return of all that was repressed by "Romain Gary," the return of the half-Jew Romain Kacew, it is fitting that it be "Dreyfus," his own shunted identity in *Promise at Dawn*, that should effect

his undoing. As though Cousin were telling us, in the voice of Ajar: I, "Romain Gary," maternal phallus, declare myself to be such, and hereby come undone, declaring my bankruptcy as human, through a disintegration of the Dreyfus Affair, [Mlle] Dreyfus in a brothel. I *am* Gros-Câlin, "the Jewish python" (p. 181).[10]

The Life Before Us (*La vie devant soi*), Ajar's next novel, attains a kind of zero degree of political correctness. It is the desperate love story of an Arab orphan, Momo, and Madame Rosa, the former prostitute and inmate of Auschwitz, a Jew who has made it her clandestine business, in old age, to take care of the children of prostitutes in her apartment in the Belleville section of Paris. The novel's pathos comes in large measure from Madame Rosa's confusion, in her advancing senility, between the Nazis, who had threatened her life during her youth, and the welfare-medical establishment of contemporary France, which seems intent on using inhuman means to extend a life she no longer thinks worth living. But the book's piquancy is entirely a function of Momo's narrative voice, for he is condemned to recount what he would never think of calling his love for the decrepit Jewess in the only idiom at his disposal: the street clichés of prostitution and anti-Semitism. Here, for instance, is Momo on the infamous "Orleans rumors," reports of a white slave trade run by Jews out of the dressing rooms of Orleans retail shops: "It was when the Jews in the dry goods business didn't drug white women to send them to brothels and everybody held it against them; they always manage to get credit for what they haven't done" (p. 29). Wherein the debunking of an anti-Semitic "rumor" turns into new grounds for resenting the Jews. Or consider Momo's marvelously wrongheaded response to news that Madame Rosa is no longer receiving funds for his support: "You can count on me, [Madame Rosa]. I won't drop you just because you're not getting any money" (p. 79). Here the language of love and loyalty, against all economic sense, speaks the only language available to it: that of the pimp. Such are the bizarre stylistic turns which make *The Life Before Us* a particularly powerful tool for challenging the canons of what is currently termed "political correctness."

Momo, then, is one more slightly crazed narrator in the Ajarian series beginning with *Gros-Câlin's* Cousin: fundamentally estranged, in his beleaguered multiracial ghetto, from what he calls "the French neighborhoods" (p. 76). The relation between *The Life Before Us* and *Promise at Dawn* is particularly striking. As Momo, in terror, attends to the dying—and irredeemably grotesque—Madame Rosa, hiding her corpse in the cellar retreat she has prepared in the event of a return of the Gestapo, dousing her body with cheap perfume to abate the stench, it is as though he were performing a labor of mourning which we have seen *Promise at Dawn* deny to "Romain

Gary." Whereas the mother-son dyad of the Gary book seemed to culminate in an imaginary integration into the community, "Ajar," on the contrary, repeats the scenario of the earlier work only to undo it: his Momo emerges as fundamentally excluded.

Late in *The Life Before Us*, there occurs an episode one is tempted to call the hidden center of Ajar's literary production. It concerns the sudden arrival, after many years, of Kadir Youssef, Momo's father, bearing a receipt for his child, at Madame Rosa's door. Having recently been released from a psychiatric hospital, where he had been interned after murdering his prostitute wife, he now wants to see (and perhaps reclaim) his son. Madame Rosa snaps out of her near-comatose state long enough to concoct a saving stratagem. She is willing to reunite father and son, she says, but, after consulting her stash of (forged) papers, pretends that through a clerical error, she had confused two children left to her on that same day in 1956, and as a result has raised the son of Kadir Youssef ("Youyou for the nurses"!) as a Jew: *Kashrut, Bar Mitzvah,* and all (p. 188). She thereupon calls on "Moïse (Moses)," the only other child beside Momo (Mohammed) left in her declining enterprise, to embrace his father. The Arab's reaction at finding his son a Jew is one of sheer horror. Upon seeing "Moïse," and just before succumbing to a heart attack, he utters, in one of Ajar's most memorable formulations, "something terrible for a man who didn't know he was right: 'This is not my son!' " (p. 200). The self-dramatizing performative the father believes he is delivering is rendered splendidly beside the point by its constative validity: Moïse, the other child, is indeed not his son. Whereupon the father collapses and dies.

One imagines the pleasure taken by Gary, caught up in the adventure of forging a new identity for himself, in this tale of false papers. More significant, however, is the obvious subtext of the episode: the judgment of Solomon. For in the celebrated sequence in the first Book of Kings, chapter 3, Solomon resorts to a ruse (agreeing to cut a live child in two) in order to determine who his natural and rightful parent is. Here we also have a dispute among would-be "parents" (Madame Rosa and Kadir Youssef), a confusion between children (Momo-Mohammed and Moïse), and a ruse invoked to arrive at a just settlement: Madame Rosa, that is, plays not only the rightful "parent," but King Solomon himself. Moreover, even as the Biblical dispute is between "harlots," the Ajar sequence pits an ex-prostitute against a pimp. Now what makes the passage in *The Life Before Us* nodal in Ajar's *oeuvre* is that the author's next and final novel, after the pseudopsychiatric memoir *Pseudo*, is *King Solomon* (*L'angoisse du roi Solomon*). As though the final novel itself had arisen from the sequence just discussed. *Angoisse*—be it anxiety or anguish—is, of course, not wisdom, and it may indeed be suggested that the function of wisdom is in fact to repress such anxiety. Nevertheless, at

the conclusion of *King Solomon* we find an oddly displaced recasting of the episode from *The Life Before Us,* a version so oblique that it would be impossible to trace it back to Biblical Solomon's judgment, had it not been for the Madame Rosa episode. And yet the overdetermined "Solomonic" bond between the two sequences leads one to speculate on the sequence's final version as hidden *telos* of the entire Ajar experiment.[11]

It will be helpful to sketch the plot of *King Solomon,* Ajar's second and final Holocaust comedy, at this juncture. It is narrated by Jeannot, a young cabdriver and autodidact of vaguely *gauchiste* sympathies. In the course of the novel, he is engaged by a retired and supremely ironic philanthropist, Salomon Rubenstein, the retired "pants king," an eighty-year-old dandy of astonishing vigor. "King Solomon" has an almost Virgilian sense of the sadness inherent in the passing of time, runs a switchboard service ("S.O.S. Benevolence") to comfort a variety of desperate souls, and hires out Jeannot to deliver presents to one Cora Lamenaire, *chanteuse réaliste,* a would-be Edith Piaf whose brief but promising career seems to have come to an end during World War II. In the course of the novel, Jeannot is stunned to learn that Salomon had been Cora's lover before the war, had refused to make use of a visa to Portugal so that he might stay in hiding in a "cellar" on the Champs Elysées and be with her. No sooner had the Nazis invaded, however, than Cora fell in love with Maurice, a handsome thug working for the Gestapo on "Jewish matters." During the war, she thus neither visited Salomon—nor mentioned him. For which reason, it befell King Solomon to testify on her behalf at her trial for collaboration: her silence had indeed "protected" a Jew during the war. Such is the source of Salomon's sense of the bitter irony—or vanity—of things. After the war, he makes money, and takes pleasure in bestowing some of it on an impoverished Cora—as punishment. If he has sent Jeannot her way, it is because he is the physical double of Maurice, her former collaborationist lover. Jeannot, too, has a measure of Salomon's "piety" (as opposed to pity)—and ends up sleeping with Cora out of sheer rage at what life (or time) has done to her. The novel comes to a happy end when Jeannot brokers a marriage between Cora and Salomon, who then take off to Nice, leaving Jeannot to his newfound love for a bookseller friend, named Aline.

The episode which displaces the sequence in *The Life Before Us* harking back to the judgment of Solomon occurs toward the end of *King Solomon.* Jeannot feels it is his destiny to reunite Cora and Salomon; he tells her of his own love for Aline. Shortly thereafter, word comes to Salomon and Jeannot that Cora has attempted suicide. Salomon's only response is to ask whether the suicide was because of Jeannot or because of himself: "for him or for me?" (p. 333). Such is the content of his anxiety. Jeannot realizes that all will depend on her answer. Cora's suicide note is too ambiguous to

be of use, and so he secretly destroys it. He then enters into elaborate negotiations with her to get her to rewrite the note, as though her suicide had been dictated by unrequited love for her old *beau,* Salomon. She can't quite bring herself to produce such a self-forgery, but ten days of negotiations between Cora and Salomon are sufficient to hammer out a nuptial agreement. The only condition stipulated in the marriage arrangement is that their wartime misadventure never be mentioned by either of them.

If we superimpose this sequence on the episode from *The Life Before Us,* we find Cora, with her would-be forged document, in the position of Madame Rosa; the nearly indistinguishable twins Jeannot/Maurice in that of Momo/Moïse; and paternal Salomon in that of Kadir Youssef. The configuration would be as follows:

Mme. Rosa	Momo/Moïse	Kadir Youssef
Cora	Jeannot/Maurice	Salomon

It will be seen that whereas the earlier sequence seemed to be concerned with eliminating a father (to protect a child), the later one is intent on marrying off a mother (to protect a child). In fact, in *The Life Before Us,* that possibility had already been broached. For there is another "Arab father," aside from Momo's natural one, in the earlier novel. His name is Monsieur Hamil, a senile sage, who has increasingly begun confusing lines of the Koran with those of Victor Hugo, and whom Momo dreams of marrying off to Madame Rosa. Moreover, he too, like Salomon, bears the affective wound of an abandonment by a beloved woman as a determining event in his life. So that once one adds the name of Monsieur Hamil to the paternal column, it begins looking as though *King Solomon* has succeeded in carrying off a project which the irredeemably pre-Oedipal earlier novel could not: Madame Rosa and Monsieur Hamil were too old and senile (if not comatose), and Momo too young to bring it about.[12]

Ultimately both episodes bring us back to the Gary *ur*text, *Promise at Dawn.* For there we find a sequence that combines our two motifs of saving the child, and marrying off the mother. A painter, Monsieur Zaremba, enlists Romain's aid in convincing his mother to marry him. With a Gauloise hanging from her lips and an air of "facetious benevolence," she dismisses him in words as castratory as those used by Madame Rosa with Kadir Youssef (p. 189). What is striking in the case of Zaremba, however, is his reason for wanting to marry Nina Kacew:

> There was in this sophisticated aristocrat, with his seeming maturity, a child who had never received enough affection and who was now aroused to an almost frantic hope by the maternal love that shone so splendidly

and uninhibitedly before his eyes. He had obviously decided that there was room for two. . . . (p. 185).

Thus Zaremba fits simultaneously into the columns of the rejected father and the twin sons. Our schema may be completed as follows:

Promise at Dawn		
Nina	Romain/Zaremba	Zaremba
The Life Before Us:		
Mme. Rosa	Momo/Moïse	Kadir Youssef
		(Monsieur Hamil)
King Solomon:		
Cora	Jeannot/Maurice	Salomon

It is only in Ajar's final novel that the project of defending the child by marrying off the mother is carried off. The broader significance of that project, and specifically the chiasmus that has Jews (Madame Rosa, Salomon) and anti-Jews (Kadir Youssef, Cora) switching positions between Ajar's two Holocaust comedies remains, however, to be gauged.

King Solomon comes replete with its own equivalent of a Greek chorus: Monsieur Tapu, the vilely *Poujadist* concierge of Salomon's apartment house. He is, to be sure, also an anti-Semite, and allows Jeannot in to see the man he refers to as "the king of the Jews" only because he is certain, in his cynicism, that Jeannot will eventually murder his employer. That observation is particularly precious because it allows us to link Ajar's last novel to a major work by Gary during the same period, *Your Ticket Is No Longer Valid* (*Au-delà de cette limite votre ticket n'est plus valable;* 1975). In that work, Ruiz, a chauffeur and the would-be murderer of the protagonist, Rainier, serves to fuel the latter's erotic imagination, thus forestalling a threat of psychic impotence. Simultaneously, the novel develops a meditation on France being revived by the energy and grace of the Third World: in Gary's heterosexual revision of a Gidean motif: "the castles of the Loire dream of African workers. . . ." (p. 138). But that observation allows us to align Rainier scouring the streets of the Goutte d'Or section of Paris in search of a fantasy of Ruiz with Gary's similar search in the same neighborhood for the fantasies of "Emile Ajar."[13] Ruiz is thus to Rainier as Ajar is to Gary, and the onslaught against Uncle Romain (referred to ominously as "Tonton Macoute") in *Pseudo,* the pseudomemoir by Ajar-Pavlowitch, confirms the point emphatically. But that superimposition, we have seen, may in turn be superimposed on the figures of Jeannot and Salomon as imagined by Monsieur Tapu.

Which is to suggest that his vile ramblings implicitly contain a speculation about the Ajar project in its entirety.

Tapu is the consummate figure of what the French call a *con*—a jerk, whence the special *frisson* felt by Jeannot upon beholding him. Jeannot's experience with Tapu is commented on by a friend: "Chuck says that the reason *la Connerie* has such an effect on me is that it fills me with respect for the sacred and the infinite. He says I'm in the grip of a feeling of eternity, and he even quoted a line from Victor Hugo: *yes I come to this shrine the Eternal to adore*" (95). Chuck indeed suggests that the fact that there are no theses being written on the sacred potential of "*la Connerie*" is a sure index of the decline of Western spirituality. Now perhaps the most striking aspect of Ajar's—or Chuck's—quip is that the line said to be by Victor Hugo is in fact by Racine. For whatever the importance of Hugo to Ajar's project— Momo dreams of writing the only book worth the effort, which he calls, in touching lowercase, "*les misérables,*" and Salomon imagines himself a latter-day Booz—the line of verse quoted is in fact a slight modification of the beginning of *Athalie: "Oui je viens dans son temple adorer l'Eternel."*

Now, the significance of the Racine line is that *Athalie,* like our novel, pits a Jewish patriarch, Joad, against an aged woman, Athalie, guilty of causing Jewish suffering. For the queen in fact is the architect of a policy of Jewish genocide that ultimately comes to ruin, at the play's end, with her death. During World War II, I have argued elsewhere, Giraudoux revives the *Athalie* scenario only to reverse it: the Madwoman of Chaillot, at the play's end, sets a trap for the "President" and his alien "race" of speculators, and lures them to their doom.[14] The "President," moreover, is a character borrowed from Giraudoux's own play of 1938, his modern-dress transposition of the *Song of Songs,* entitled *Cantique des cantiques.* He is, that is, a surrogate for King Solomon. (But the "President" of the 1938 play is in significant respects derived from the arch-Jewish banker Moïse, in Giraudoux's 1927 novel, *Eglantine:* the alien "race" of speculators to be exterminated in the 1943 play, that is, is at some level the Jews.) Thus, whereas Racine, in his last play, has his genocidal *vieillarde* (as Giraudoux called her) done in by the Jews, and Giraudoux, at the end of his career, reverses the scenario and has his mad old lady lure a Solomon-surrogate and his alien race to their doom, "Ajar," in *his* final novel, succeeds in marrying off *his* Solomon to Cora, the mad old lady who during the war had abandoned him for a French agent of the Gestapo.

Salomon's marriage to Cora could be arranged, we have seen, only upon agreement that the wartime experiences of the two never be mentioned. For the compulsively Gallic ex-songstress (a would-be Piaf) and the Jewish patriarch, the marriage was thus in a broader sense an act of amnesty: the end of the Holocaust. At the same time, we have seen, the imaginative

marrying off of an intrusive "mother" (Nina, Madame Rosa, Cora) is the successful culmination of a project that we have observed since *Promise at Dawn*. The Oedipalization of the plot here coincides with an amnesty for collaboration. Rarely has the forgetting or repression of "castration" received a more striking political content.

Gary himself had written a novel of the Holocaust in 1967: *The Dance of Genghis Cohn* (*La danse de Gengis Cohn*). On its final page, Gary and Jean Seberg appear under their own names to evoke their strange trip, Gary's return to Warsaw in 1966. Gary, upon approaching the ghetto, fainted and proceeded to mutter in Polish. In the book, his wife explains to his astonished hosts that he had in fact done his "humanities" in the ghetto. Their response: "Oh! we didn't know he was Jewish. . . ." Hers: "Neither did he" (p. 272). It is tempting to see the Ajar project as being born in that swoon. Kacew returns, against the myth of "Romain Gary," as Ajar. In *Gros-Câlin*, the maternal phallus bespeaks his plight, relives the repressed humiliations of his own Dreyfus Affair. In *The Life Before Us*, the memory of Auschwitz presides over the brilliant unraveling of all that had been *forged* in *Promise at Dawn*. *Pseudo*, allegedly by Pavlowitch, stages a "half-Jew" 's onslaught against an imaginary "Gary." And finally, the *drive* energized by that "half-Jew" or "partial object" is integrated or symbolized in an act of Oedipalization which is also a form of amnesty: the end of the Holocaust, but also the end of "Emile Ajar."[15]

Notes

1. Concerning Romain Gary's years in Los Angeles, see his *La nuit sera calme* (Paris: Gallimard, 1974), pp. 238–288.

2. See Jean-Marie Catonné, *Romain Gary/Emile Ajar* (Paris: Belfond, 1990), p. 102. In addition, a journalist, rummaging through police files, discovered the existence of a Lebanese terrorist named "Hamil Raja," who was temporarily suspected of being Ajar. For details of the Gary/Ajar saga, Katonné's intelligent and imaginative book, on which I have drawn in this paragraph, is the best guide.

3. Pavlowitch, who has written his own version of the Ajar affair, *L'homme que l'on croyait* (Paris: Fayard, 1981), was in fact the son of Gary's cousin Dinah, but was frequently referred to by Gary as his nephew.

4. See Catonné, p. 103.

5. Paris: Gallimard, 1981.

6. Page references to works of Gary in the text are to the following editions: *Vie et mort d'Emile Ajar* (Paris: Gallimard, 1981); *Gros-Câlin* (Paris: Mercure de France, 1974); *La nuit sera calme* (Paris: Gallimard, 1974); *L'angoisse du roi Salomon* (Paris: Mercure de France, 1979); *La promesse de l'aube* (Paris: Gallimard, 1960); *La vie devant soi* (Paris: Mercure de France, 1975); *Au-delà de cette limite votre ticket n'est plus valable* (Paris: Gallimard, 1975); *La danse de Gengis Cohn* (Paris: Gallimard, 1967).

7. The pseudopsychiatric memoir *Pseudo* appears to be in part indebted to Louis Wolfson, whose *Le schizo et les langues* (Paris: Gallimard, 1970) had recently been prefaced by Gilles Deleuze. Concerning Wolfson, see my "Portnoy in Paris," in *Diacritics*, II, 4 (1972).

8. Jorge Luis Borges, "Pierre Menard, Author of *Don Quixote*" in *Ficciones* (New York: Grove Weidenfeld, 1962), pp. 45–55. For a discussion of French intertexts of the Borges fable, see my " 'Pierre Menard, Arthur of *Don Quixote*' Again" in *L'Esprit créateur*, XXIII, 4 (1983), pp. 22–37.

9. Thus, when the python temporarily disappears, Cousin wonders if it is not a result of the "emotion" aroused by Cousin's would-be fiancée, who has announced her intention to pay him a first visit. *Gros-Câlin*, p. 148.

10. See also *Pseudo* (Paris: Mercure de France, 1976), p. 16: "I then asked the good doctor if I had not been inclined to become a python because the Jews had been propagated for two thousand years as usurers and boa constrictors, and he answered me that it was quite possibly the case, that I was capable of anything in order to produce literature, including of myself."

11. The nodality of the King Solomon motif for our author during his Ajar years is further sustained by an examination of Gary's play of 1979, *La bonne moitié*. Adapted from his early novel *Le grand vestiaire* (1948), it plays with the Solomonic motif of cutting a human being in two. Vanderputte, like Madame Rosa, is an ailing benefactor, running a clandestine "orphanage." A member of the anti-Nazi resistance, he takes care of children of the Germans' victims after the war is over. In mid-play we discover that he had *also* spent half the war *collaborating* with the Gestapo. Whence the impossible Solomonic imperative: "He should be cut in two: decorate one half and execute the rest" (Paris: Gallimard, 1979), p. 81.

12. It may be added that whereas Aline is a contemporary of Jeannot's and erotically available to him, Nadine, her counterpart in the earlier novel, is no more than a (married) adult companion and guide for Momo.

13. See Pavlowitch, *op. cit.*, p. 74.

14. See Jeffrey Mehlman, *Legacies: Of Anti-Semitism in France* (Minneapolis: University of Minnesota Press, 1983), p. 61.

15. One risk of the allegorical amnesty implemented by the completion of the Ajar project is apparent in Michel Tournier's essay "Emile Ajar ou la vie derrière soi" (in *Le vol du vampire: Notes de lecture* [Paris: Mercure de France, 1981]). To speak of the author's philo-Semitism, as Tournier does, as "a certain Semitophilia (*sémitophilie*)," is to suggest (through contamination by the more common term *hemophilia*) a pathological condition. Speaking of Ajar's interest in the Occupation period, Tournier continues: "Madame Rosa and King Solomon are for Ajar the irreplaceable witnesses of a dubious tragedy, immersed in a glaucous light, but which paradoxically had the power to reveal beings in their truth" (p. 339). To affix the epithet "dubious" (*douteuse*) to the Jewish tragedy of the generation of Madame Rosa and Solomon is to align oneself with the "revisionist" mystifications of Robert Faurisson. Although Gary/Ajar in no way shared such a tendency, it is clear that the final Ajar novel, with its allegorical amnesty, is available to such a misreading.

14

Georges Perec and the Broken Book

Warren Motte

Holocaust and its consequences—death, separation, absence, loss, nul-
lity—are inscribed with insistence throughout Georges Perec's writings.[1] Yet
these inscriptions adopt very different shapes. In *Récits d'Ellis Island* and
Espèces d'espaces, there are direct and unequivocal allusions to the Holocaust;
in *Je me souviens,* that order of reference is bound up in (and largely obscured
by) other sorts of intertextualities, as the quotidian exerts a tyrannical force
over history; in *La vie mode d'emploi,* stories of the Holocaust take their place
in a grid of other stories elaborated with a view toward creating a new,
ameliorated reality; as to *La disparition,* Perec's three-hundred-page novel
written without the letter E, it can (and, I would argue, *must*) be read as an
account of radical privation and loss. Even in those texts which appear most
colored by formalist intransigence—crossword puzzles, heterogrammatic
poetry—Perec disposes lacunas, figural of absence and loss, as the central
integers in the otherwise flawless structure that is erected around them.
Among his various writings, *W ou le souvenir d'enfance* distinguishes itself
as the text where Perec grapples with the topoi of catastrophe in the most
sustained and powerful manner.[2]

Published in 1975, perhaps not coincidentally in the same year that Perec
finished his psychoanalysis, *W* is a text which juxtaposes discourses of aston-
ishing candor and others of the most utter duplicity. Fiction and autobiogra-
phy compete in *W ou le souvenir d'enfance,* creating a dialogue that places
both those scriptoral modes severely into question. Chapters of fictional
narrative, set in italic characters, alternate with chapters of autobiographical
narrative, set in roman. The fictional narrative, concerning a voyage to the
island of W, whose society is dedicated to the Olympian ideal of sport, is itself
a sort of *souvenir d'enfance,* according to Perec; early in the autobiographical
narrative, he situates the fictional narrative for the reader: "When I was
thirteen I made up a story which I told and drew in pictures. Later I forgot

it. Seven years ago, one evening, in Venice, I suddenly remembered that this story was called W and that it was, in a way, if not the story of my childhood, then at least a story of my childhood" (p. 14; p. 6).[3] As Perec describes it, the constitution of the fictional narrative involved a rather long process of archaeology and rewriting:

> Later I came across some of the drawings I had done around the age of thirteen. With their help I reinvented W and wrote it, publishing it as I wrote, in serial form, in *La Quinzaine littéraire* between September 1969 and August 1970.
>
> Today, four years later, I propose to put an end—by which I mean just as much "to mark the end of" as "to give a name to"—this gradual unraveling. W is no more like my Olympic fantasy than that Olympic fantasy was like my childhood. But in the crisscross web they weave as in my reading of them I know there is to be found the inscription and the description of the path I have taken, the passage of my history and the story of my passage. (p. 14; p. 7)

The juxtaposition of the two narratives in *W ou le souvenir d'enfance* is the first order of doubling upon which the text is grounded. But this doubling is itself highly duplicitous, as is evident even in the passage quoted above. There is a caesura in the middle of the book that in effect breaks *both* narratives in two. This is reflected in the fictional narrative by a curious shift: in the first part, a narrator named Gaspard Winckler tells the story of his voyage to W in the first person; in the second part, an unnamed omniscient narrator describes the island of W in the third person. There is a suggestion, moreover, that Winckler is not the *real* Winckler (pp. 35–36; pp. 22–23), which obviously serves to attenuate narrative authority. The autobiographical narrative is also bipartite, irrecuperably broken in a variety of ways. Narrative voice is likewise shifting and uncertain, as the distinction of Perec-narrator and Perec-narrated is deliberately blurred.

Moreover, the relation of the two narratives is very unstable, as each seemingly doubles back upon the other, if in different manners. The autobiographical narrative glosses and serves apparently as a corrective to the fictional narrative. Yet the latter echoes the former more and more frankly, as the fictional narrative converges upon Perec's life story. Just as the autobiographical narrative moves ineluctably toward the concentrationary universe into which Perec's mother disappeared, along with other members of his family, so the Olympian society of W gradually reveals itself to be based on systematic injustice and arbitrary oppression, one where games and sports are essential to the carceral regime: "But the Men must stand up and fall in. They must get out of the compounds—*Raus! Raus!*—they must start

running—*Schnell! Schnell!*—they must come into the Stadium in impeccable order!" (pp. 209; pp. 155).

Demonstrating an extraordinary attentiveness to text as textuality, *W ou le souvenir d'enfance* constantly turns in upon itself, playing with the norms and conventions of autodiegetical literature. The beginning of the fictional narrative, "For years [*longtemps*] I put off telling the tale of my voyage to W" (p. 9), firmly places what follows within a specular frame. It also recalls the incipit of *A la recherche du temps perdu* (indeed the Proustian *longtemps* resonates insistently in *W*, appearing thrice on the first page alone[4]), and inscribes itself thus unequivocally, from the outset, in the high tradition of literary remembrance. Yet the first sentence of the autobiographical narrative would seem to negate the very possibility of rememoration and, more locally and vitally, it would appear to deny, at its point of inception, the project announced in the title of the book: "I have no childhood memories" (p. 13; p. 6).

Almost immediately, Perec turns back upon this remark and puts it into question:

> "I have no childhood memories": I made this assertion with confidence, with almost a kind of defiance. It was nobody's business to press me on this question. It was not a set topic on my syllabus. I was excused: a different history, History with a capital H, had answered the question in my stead: the war, the camps. (p. 13; p. 6)

This is the fundamental problem that Perec encounters as he sets out to write his life: his story has been engulfed in history. In an imperial manner, history has appropriated any significance that Perec's early life might otherwise have had, effectively trivializing the latter. Thus, when Perec comes to write his story, he finds, initially, that there is not much to say:

> Up to my twelfth year or thereabouts, my story comes to barely a couple of lines: I lost my father at four, my mother at six; I spent the war in various boarding houses at Villard-de-Lans. In 1945, my father's sister and her husband adopted me. (p. 13; p. 6).

The form that this telling adopts is eloquent; yet it is more suited to a postcard than a book. Once again, this constitutes a severe interrogation of the very premises of *W ou le souvenir d'enfance,* and establishes a pattern which Perec will follow throughout, that of writing under erasure. The erasure here is itself double: first, Perec suggests that his summary tells the whole story, that nothing else can have any real pertinence. This serves to undermine all of what follows, *before* its articulation; the story, then, will

be told within brackets of doubt and uncertainty. Secondly, the truncation that characterizes Perec's summary is directly and materially figural of the themes of absence and loss that will dominate the rest of *W*. For, after all, it is the *story* that is absent, Perec suggests:

> For years, I took comfort in such an absence of history: its objective crispness, its apparent obviousness, its innocence protected me; but what did they protect me from, if not precisely from my history, the story of my living, my real story, my own story, which presumably was neither crisp nor objective, nor apparently obvious, nor obviously innocent? (p. 13; p. 6).

As Perec tries to locate a niche for his story within history, he encounters anachronism and absurdity. "For years I thought that Hitler had marched into Poland on 7 March 1936," (p. 31; p. 19) he says, telling of his attempts to find logical correspondence between his date of birth and the beginning of the war; between, that is, story and history. Here once again, however, significance is refused, as Perec is forced to realize that Hitler was already in power when he was born, "and the camps were working very smoothly" (p. 31; p. 19). When Perec reviews the newspaper headlines of his birthdate (pp. 32–34; pp. 20–21), his failure to connect is equally dismal: there is, on the one hand, no point of ingress into the momentous events trumpeted on the page; on the other hand, the minor headlines proclaim the absolute triviality of the quotidian. Perec is thus suspended between an empyrean whose access is denied him and a lower order whose banality revolts him.

On a practical and yet far more vital level, the same order of problem arises as Perec tells of his father's death. Having joined the army the day the war broke out, Perec's father died the day the armistice was declared, mortally wounded in the stomach, one casualty among many others: "My father had died a slow and stupid death" (p. 44; p. 29). An event that should, by all rights, enjoy transcendent importance is rendered banal by sheer force of numbers. And, as collective history subsumes personal story, that which ought to have been exceptional and aberrant becomes fused into the norm. For history recounts the inevitable (inevitable precisely because it is history), leaving no room for other possibilities: "I don't know what my father would have done had he lived. The oddest thing is that his death, and my mother's, too often seems to me to be obvious. It's become a part of the way things are" (p. 45; p. 29).

It is crucial to note that Perec's account of separation is itself characterized by distance and alienation. This is apparent even on the level of the telling. For Perec first alludes to his father's death in a text which he claims to have written fifteen years prior to the narrative "now" of *W*. Perec presents that

early text with deliberate skepticism, denying it any real narrative authority. Indeed, he scrutinizes it rigorously, and glosses it in a note, pointing toward infelicities and outright errors of fact. Thus, for instance, the first text claims that Perec's father died on the day after the armistice, accidentally, rather than in combat, lapses that Perec corrects without ceremony. He is setting the record straight; he is writing history in spite of himself. But he is also drawing away from that story in a process of objectification: the early text is affective; the manner in which the son describes the father is touching. That element has been erased, however, in the definitive account, precisely because, fifteen years later, there is no longer any room for it.

As Perec tells his story, then, it is forcibly drawn toward history, and appropriated thereby. Clearly, for him, this process of appropriation begins with his birth: "What is certain is that a story had already begun, a history which for me and for all my people was soon to become a matter of life and for the most part a matter of death" (p. 32; p. 19). This is to say, his story is not his own; it is the story of his family that quickly becomes, further, the story of all the persecuted: the story, in short, of an age. As such, it may be a story that cannot really be told *as* story. For if story is progressively engulfed by history, neither can history be used to reconstruct story. That tactic, too, fails, as Perec finds that historical back-bearings are of little or no use to him. That which Gaspard Winckler says of his story might effectively translate Perec's own despair: "For years I sought out traces of my history, looking up maps and directories and piles of archives. I found nothing, and it sometimes seemed as though I had dreamt, that there had been only an unforgettable nightmare" (p. 10; p. 3).

The unequal battle of story and history waged within *W ou le souvenir d'enfance* is considerably complicated by the fact that Perec is dealing with yet another agonistic relation, one which pits interdict against imperative. For a certain discourse recasts the "cannot" of telling the Holocaust as "must not." The classic formulation of such a perspective is, of course, Theodor Adorno's assertion that to write poetry after Auschwitz is barbaric, a position that had (and indeed continues to have) enormous influence, in spite of the fact that Adorno later recanted.[5] That position and others contiguous to it are frequently articulated in Holocaust literature as a stark displacement of representation. Thus, for example, the radical fragmentation of Edmond Jabès's books; thus, the refusal to use contemporary archival material in Claude Lanzmann's *Shoah.*[6] On the other hand, another discourse postulates the moral responsibility of telling the Holocaust, the imperative of testimony.[7] And this imperative is undoubtedly equally as strong as the proscription it refutes. Once again, Perec is caught—*suspended*—between two apparently irreconcilable poles.

That sort of dilemma accounts for much of the duplicity of *W ou le*

souvenir d'enfance; it is made manifest in a curious oscillation effect in the text. It illuminates the shuttling between concealment and revelation that, cast as childish interplay of desire and fear, animates the book: "Once again the snares of writing were set. Once again I was like a child playing hide-and-seek, who doesn't know what he fears or wants more: to stay hidden, or to be found" (p. 14; p. 7). Yet I would argue that this oscillation is unbalanced, significantly asymmetrical, and that Perec in fact chooses to *tell,* even if that telling is by turn masked, obscured, and faulted. He renders this apparent in a pact that he proposes to the reader. That pact, however, like many other textual elements, has been displaced within *W,* in this case from the autobiographical narrative (which it serves to guarantee) to the fictional narrative. There, the doubt expressed in the opening words, "For years I put off telling the tale of my voyage to W," is immediately rationalized: "Today, impelled by a commanding necessity and convinced that the events to which I was witness must be revealed and brought to light, I resolve to defer it no longer" (p. 9; p. 3). The narrator of the fictional half of *W* leaves no doubt that testimony is the motor of his telling, the justifying force of his story: "That, more than any other consideration, was what made me decide to write" (p. 10; p. 4). Granted the myriad reciprocities and mutual affinities of the two narratives, and the fact that in many instances one half of *W* clearly says what the other cannot, it is legitimate to read this passage through the autobiographical narrative, as a grounding and a justification of the latter.

With this pact, Perec announces an enterprise that, out of constraint and vital necessity, will be based neither on story nor history, but rather on memory. Yet here, too, Perec is careful to place brackets of skepticism and impossibility around his project: "My childhood belongs to those things which I know I don't know much about" (p. 21; p. 12). Of his father, Perec retains only one memory, one in which his father gives him a gold key or coin. Characteristically, Perec is quick to put the remembrance into question, pointing out its oneiric quality; declaring that, even to him, it seems fabulated; saying that the memory comes to him in variant versions which, superimposed, make it seem more and more illusory (p. 23; pp. 13–14). Of his mother, he has also a single memory, that of the last time he saw her, as she put him on a train for the *zone libre.* But that memory, as Perec scrupulously notes, is also flawed. Memory, for Perec, is *singular:* the transcendent figures and events of his life are not available to him in their original plurality of detail; rather, they are reduced, starkly, to a single image. There, where a wealth of pertinent detail should be forthcoming, Perec finds only *le souvenir d'enfance.* And he is moreover confronted with the fact that singular memory is itself speciously grounded and consequently unreliable.

Granted this seeming impasse, Perec will on occasion construct memory; that is, he will invent memory as it rightfully should be. Thus, contemplating a photograph of himself and his mother, and noting that his hair has been carefully combed, he says: "of all my missing memories, that is perhaps the one I most dearly wish I had: my mother doing my hair, and making that cunning curl" (p. 70; p. 49). But this sort of memory is just as unsatisfactory (and perhaps more so) than the other, and remains marginalized, bracketed in the conditional mode. It is, in any case, rather dubious ground on which to build an autobiographical edifice. This is precisely the point that Perec wishes to convey, however: the radical loss that he describes in *W* is in fact *double:* loss of life, first; and, second, absence of memory.

Absence is in fact the dominant *topos* of the second half of the autobiographical narrative, where Perec recounts his life after the death of his parents. There, too, memory is shifting and problematic:

> What marks this period especially is the absence of landmarks: these memories are scraps of life snatched from the void. No mooring. Nothing to anchor them or hold them down. Almost no way of ratifying them. No sequence in time, except as I have reconstructed it arbitrarily over the years: time went by. (pp. 93–94; pp. 68–69)

Among the various images that Perec evokes are memories of the Catholic boarding school in Villard-de-Lans where he spent the latter years of the war. Themes of alienation and injustice recur frequently, but the most striking vision of the school that Perec offers is that of a closed space, a place of exile: "I remember it as a frightfully far off place where no one ever went, a place which news never reached, whence those who crossed its threshold never returned" (p. 125; p. 94). Once again, it is a case of constructing memory, but this time in a rather different manner. The second part of the autobiographical narrative is dominated *in absentia* by Perec's mother; and here, Perec comes sharply up against a problem that is even more irreducible than those he confronted in the first part: he simply does not know what became of his mother, other than that she disappeared into the world of the camps. This can largely explain the fact that the society described in the fictive narrative converges so obviously in the second part of the book upon that of the camps. But it can also illuminate the way in which Perec *tells* his life as an orphan: at every point, as Perec details instances of childish brutality, arbitrary injustice, and oppression, his narrative calls out to the concentrationary universe. As if he had in fact followed his mother into the camps.

Thus memory is itself displaced, and made to function as it should: memory is, in this sense, *repaired.* Perec recalls a later time in his life, when,

living with his aunt in Paris, he visited an exhibition on the concentration camps. His memory of photographs depicting, for example, the lacerated walls of the gas chambers, comes to repair the truncation of his life: it allows him to "remember" what his mother experienced. This remembrance is, of course, inherently unstable, constructed as it is on such tenuous foundations; it is, however, the best that Perec can offer, granted the circumstances. It should be noted, also, that the mechanism that allows Perec to build these sorts of associations is not memory itself, but rather, most significantly, the *writing* of memory.

In this perspective, it is not surprising that the first memory that Perec offers in *W ou le souvenir d'enfance* should deal with the first integer of writing, the letter. He remembers sitting among his family, at age three, identifying a letter in a Yiddish newspaper, to the great delight of all (pp. 22–23; p. 13). Perec recalls this letter as a square open at its lower left angle,[8] sketches the letter as he remembers it, and says that its name was *gammeth*, or *gammel*. Not surprisingly, in view of the fact that all memory is subject to correction and outright erasure in *W*, Perec turns back upon this *souvenir* in a note. There, he suggests that the letter as he sketches it does not resemble a *gimel*, but rather a *mem*. Here displacement functions as a material sign of distance, the distance between Perec and his first language, Yiddish. The letter, in all its strangeness, is clearly a sign of alienation, of marginality. And it is intimately related to the letter that dominates this text, the W. Indeed the most detailed memory that Perec offers in *W ou le souvenir d'enfance* involves a staging of the W, and a rehearsal of the manner in which it conjures up, for him, the principal *literal* semiotics of the Holocaust:

> My memory is not a memory of the scene, but a memory of the word, only a memory of the letter that has turned into a word, of that noun which is unique in the language in being made of a single letter, unique also in being the only one to have the same shape as the thing it refers to (the draftsman's T-square is called a *Té* in French, pronounced like the letter it resembles, but its name is not written "T"), but it is also the sign of a word deleted (the string of x's crossing out the word you didn't mean to write), the contrastive sign of ablation (as in neurophysiology, where, for example, Borison and McCarthy [*J. appl. Physiol.* 34 (1973): 1–7] compare intact cats [*intact*] with cats with an excised vagus [VAGX] or carotid [CSNX]), the sign of multiplication and of sorting (the x-axis), the sign of the mathematical unknown, and, finally, the starting point for a geometrical fantasy, whose basic figure is the double V, and whose complex convolutions trace out the major symbols of the story of my childhood: two Vs joined tip to tip make the shape of an X; by extending the branches of the X by perpendicular segments of equal length, you obtain a swastika (卐), which itself can be easily decomposed, by a rotation of 90 degrees

> of one of its \int segments on its lower arm, into the sign ; placing two
> pairs of Vs head to tail produces a figure (XX) whose branches only need
> to be joined horizontally to make a Star of David (). In the same line of
> thinking, I remember being struck by the fact that Charlie Chaplin, in *The
> Great Dictator,* replaced the swastika with a figure that was identical, in
> terms of its segments, having the shape of a pair of overlapping *X*s ().
> (pp. 105–106; p. 77)

The W is deployed in the text as a powerful sign of alterity. An alien letter
historically refused in French, the W defines in a sense the margins of
language. In its very form, it recapitulates the binarity (and indeed the
duplicity) of the text it designates, and it serves literally to trace the narrative
structure of Perec's experiment, which is based upon juxtaposition and
convergence. It must also be read as a material token of vocation: the letter
is the smallest denominator of writing. Yet here it is important to distinguish
between the isolated letter and the literal combinatorics of writing. If the
individual, precombinatory letter functions in the text as a sign of loss and
alienation,[9] writing functions partially to *repair* that state. Perec himself
suggests as much, as he alludes to his juvenile script:

> From this point on, there are memories—fleeting, persistent, trivial, bur-
> densome—but there is nothing that binds them together. They are like
> that disjointed writing, made of separate letters unable to forge themselves
> into a word, which was my writing up to the age of seventeen or eighteen.
> (p. 93; p. 68)

W ou le souvenir d'enfance deals, to a large degree, with the passage from
undecipherable aggregate to legible whole. Perec mentions that his mother
barely knew how to write French (p. 56; p. 40), and finds her handwriting
on the back of a photograph naïve and childlike (p. 74; p. 52). Yet this
scriptoral situation may be seen to encapsulate many of the concerns in *W,*
and many of the difficulties that Perec encounters. He recalls an incident
twenty years prior to the narrative present of *W,* where he attempted unsuc-
cessfully, one evening when he was drunk, to write on the back of a photo-
graph of his father. The message would seem to be clear: the *souvenir* cannot
be scripted directly; it demands rather (if it is to be written at all) a far more
canny approach.

Perec insistently argues the mutual affinity (and indeed the practical
indissociability) of autodiegesis and writing, stating further that they ema-
nate from largely the same point in his experience: "The idea of writing the
story of my past arose almost at the same time as my idea of writing" (p.
41; p. 26). In this light, another order of duplicity rapidly becomes apparent:
the autobiographical narrative in *W* may also be read as a *Künstlerroman.*

As I have mentioned, Perec chooses to present the two *souvenirs* of his parents in an interpolated text dating from fifteen years prior to the narrative present. He turns back upon this text in a gloss, correcting and completing it. But the object of this rectification is not only the story; it is also the writing of the story. And this commentary is cast in a most equivocal manner. On the one hand, Perec loftily distances himself from those early texts, saying, "I would not put things that way now, obviously" (p. 56; p. 39); on the other hand, he draws them into the scriptoral present:

> Fifteen years after drafting these two passages, it still seems to me that I could do no more than repeat them: whether I added true or false details of greater precision, whether I wrapped them in irony or emotion, rewrote them curtly or passionately, whether I gave free rein to my fantasies or elaborated more fictions, whether or not, moreover, I have made any advances in the practice of writing, it seems to me that I would manage nothing more than a reiteration of the same story, leading nowhere. (p. 58; p. 41)

The effect of this discourse, and its point in *both* cases, is to focus the reader's attention squarely upon the writing itself. Perec will argue at times that writing is the place of juncture between apparently irreconcilable discourses and intentions, a place where radical dissonance is resolved into harmony. Thus, he points toward the two purportedly antagonistic discursive modes of *W,* and suggests that they find resolution in the *writing:*

> It is not—as for years I claimed it was—the effect of an unending oscillation between an as-yet undiscovered language of sincerity and the subterfuges of a writing concerned exclusively with shoring up its own defenses: it is bound up with the manner of writing and the written matter, with the task of writing as well as with the task of remembering. (p. 58; p. 42)

In another instance, Perec sketches a reconcilation of memory and *écriture* not by conflation, but rather through the use of an organic model. Memory gives rise to writing, he says, feeding into the latter and nourishing it. Memory in a sense *becomes* writing, directly and, for once, unproblematically:

> I write: I write because we lived together, because I was one amongst them, a shadow among their shadows, a body close to their bodies. I write because they left in me their indelible mark, whose trace is writing. Their memory is dead in writing; writing is the memory of their death and the affirmation of my life. (p. 59; p. 42)

The writing not only guarantees the efficient reconciliation of apparently irreducible antinomy, then; it also promises to save the writer.

The notion of salvation through art strikes an astonishingly dissonant note in *W*, and deserves, I think, to be tested on the local level of the textual representation of experience. The place where the latter is put most severely into question (and consequently where its strengths and flaws become most obvious) is in Perec's account of his mother, most of which is contained in the short interpolated text I have already alluded to. Granted that he can claim only one real memory of his mother, Perec bases his account of her life on the few objective facts that he possesses, and on family legend. Writing in the narrative present, he interrogates the interpolated text in a series of fourteen notes. There, Perec corrects the errors in the fifteen-year-old text, indicating with understated poignance, for example, the three orthographical mistakes he made in transcribing his mother's maiden name (p. 55; p. 38). He points out as well, more significantly still, that certain parts of his account are simply invented, and that most of the details are "given completely at random" (p. 56; p. 40), thus effectively stripping his story of authority, while at the same time suggesting the irrelevance, indeed the worthlessness, of his writerly license.

What remains of Perec's account is starkly administrative, shorn of affect and nuance, narrated in a flat, declarative style:

> She was picked up in a raid, together with her sister, my aunt. She was interned at Drancy on 23 January 1943, then deported on 11 February following, destination Auschwitz. She saw the country of her birth again before she died. She died without understanding. (pp. 48–49; p. 33)

As little as Perec knows about his mother's life, he knows still less about her death: "We never managed to find any trace of my mother or of her sister. It may be that they were deported towards Auschwitz and then diverted to another camp; it is also possible that the entire trainload was gassed on arrival" (p. 57; p. 40).

These, then, are the details of his mother's life that remain to Perec. Decidedly, they leave little room for embellishment or literary flourish. The most privileged detail is the one arising from Perec's own lived experience, the only unmediated remembrance of his mother that he retains:

> My only surviving memory of my mother is of the day she took me to the Gare de Lyon, which is where I left for Villard-de-Lans in a Red Cross convoy: though I have no broken bones, I wear my arm in a sling. My mother buys me a comic entitled *Charlie and the Parachute:* on the illus-

> trated cover, the parachute's rigging lines are nothing other than Charlie's trousers' braces. (p. 41; p. 26)

This memory is of such import to Perec that he recounts it three separate times in the text (the other two passages are p. 48; p. 32, p. 76; pp. 54–55). And yet, even here, he is forced to recognize that his memory is inexact: rather than a sling, Perec wore in fact a hernia truss (p. 78; pp. 55–56), an apparently small error of detail which nonetheless, granted the transcendent significance of the event in which it figures, suffices to cast the whole into doubt.

Perec's account of his separation from his mother precipitates the crucial incident of *W ou le souvenir d'enfance*. The autobiographical narrative breaks down after that account, in a manner that is radical and uncompromising. There follows a page which is empty except for three points within parentheses, a suspended ellipsis as it were. Only after that does Perec reconvene his story in a second part. The instant of fracture is crucial in the fullest sense of that term, moreover: it is there, too, that the fictive narrative in *W* breaks down, and it is there, finally, that the two narratives cross themselves and each other, in a confrontation that refuses resolution. Just as there seems to be no relation between Gaspard Winckler's first-person narrative in the first part of *W* and the third-person account of the island in the second, so Perec suggests that there is no relation between his life as a son and his life as an orphan. There is nothing that can bridge the two states, and the *telling* of them must be, by vital imperative, different. The point that demarcates that difference, then, cannot be assimilated, traversed, or otherwise recuperated: it is the material vestige of loss.

As such, I would like to read that lacunary moment as the key statement of the book. Perec himself takes pains to draw the reader's attention towards it in the jacket notes of *W:* "In that rupture, that break which suspends the story around an uncertain anticipation, the source from which this story emanates is to be found: these *points of suspension* upon which are hitched the broken threads of childhood and the web of writing." The notion of *suspension* is a key construct which rejoins a sort of existential metaphysics elaborated by the young Perec. In his memory, it should be recalled, he went to take the train to Villard with his arm in a sling; he later corrects this to read a hernia truss, a *suspensoir,* precisely. He recounts the experience of having broken his shoulder blade in Villard; Perec remembers that his arm was bound behind his back in order to let the fracture heal, and confesses that this incident procured him an ineffable happiness. Yet, upon examination, he realizes that he has displaced the event: in fact it happened not to him, but to a young friend of his. Perec concludes that the imaginary therapeutics he projected upon himself, which he qualifies as *points de*

suspension, designated a palliative of the very real pain of privation (p. 110; p. 80).

The three points within parentheses that stand alone in the middle of *W ou le souvenir d'enfance* are the very image of the suspensory condition that Perec describes. Even graphically: by their form, the parentheses recapitulate the suspenders that attach Charlie Chaplin to his parachute on the cover of the magazine that Perec's mother bought him before she put him on the train (p. 41; p. 26, p. 76; pp. 54–55); Chaplin's suspension, in that image and at that moment, figures Perec's own. The suspenders themselves serve, curiously, as one of the points of convergence between the fictive narrative and the autobiographical narrative, between phantasm and reality. For the *bretelles* resemble phonically the *bretzels,* or pretzels, that Gaspard Winckler refuses in a café (p. 26; p. 16); in the autobiographical narrative, Perec tells us that his family name was originally "Peretz," which means "pretzel" in Hungarian (p. 51; p. 35). The *bretelles* can thus be read as the fragile identity by which Perec is himself suspended. From the ineluctable accretion of these images, Perec will draw an equally fragile lesson:

> A triple theme runs through this memory: parachute, sling, truss: it suggests suspension, support, almost artificial limbs. To exist, I need a prop. Sixteen years later, in 1958, when, by chance, military service made a parachutist of me, I suddenly saw, in the very instant of jumping, one way of deciphering the text of this memory: I was plunged into nothingness; all the threads were broken; I fell, on my own, without any support. The parachute opened. The canopy unfurled, a fragile and firm suspense before the controlled descent. (p. 77; p. 55)

Perec is saved, then, by this suspension, but it is a highly tenuous, contingent salvation. For the problem in *W ou le souvenir d'enfance* is, after all, one of radical dislocation and fracture: "I don't know where the break is in the threads that tie me to my childhood" (p. 21; p. 12). And that is precisely what the broken middle of *W* signifies. An ellipsis within parentheses: bracketed suspension, an eloquent figure of nullity. Yet it is important to recognize that Perec's eloquence here escapes from language. The crucial point of *W* is suspended in a locus of distance and absence upon which words finally have no hold; it is a flawed gesture toward the unsayable, a mute token of catastrophe:

> I do not know whether I have anything to say, I know that I am saying nothing; I do not know if what I might have to say is unsaid because it is unsayable (the unsayable is not buried inside writing, it is what prompted it in the first place); I know that what I say is blank, is neutral, is a sign, once and for all, of a definitive annihilation. (pp. 58–59; p. 42)

Notes

1. Perec's major works are: *Les choses: Une histoire des années soixante* (Paris: Julliard, 1965); *Quel petit vélo à guidon chromé au fond de la cour?* (Paris: Denoël, 1966); *Un homme qui dort* (Paris: Denoël, 1967); *La disparition* (Paris: Denoël, 1969); *Petit traité invitant à la découverte de l'art subtil du go*, with Pierre Lusson and Jacques Roubaud (Paris: Bourgois, 1969); *Die Maschine*, trans. Eugen Helmlé (Stuttgart: Reclam, 1972); *Les revenantes* (Paris: Julliard, 1972); *La boutique obscure: 124 rêves* (Paris: Denoël/Gonthier, 1973); *La littérature potentielle: Créations, re-créations, récréations*, with Oulipo (Paris: Gallimard, 1973); *Espèces d'espace: Journal d'un usager d'espace* (Paris: Galilée, 1974); *Ulcérations* (Paris: Bibliothèque Oulipienne, 1974); *W ou le souvenir d'enfance* (Paris: Denoël, 1975); *Alphabets* (Paris: Galilée, 1976); *Je me souviens* (Paris: Hachette, 1978); *La vie mode d'emploi* (Paris: Hachette, 1978); *Un cabinet d'amateur* (Paris: Balland, 1979); *Les mots croisés* (Paris: Mazarine, 1979); *La clôture et autres poèmes* (Paris: Hachette, 1980); *Récits d'Ellis Island: Histoires d'errance et d'espoir*, with Robert Bober (Paris: Sorbier, 1980); *Atlas de littérature potentielle*, with Oulipo (Paris: Gallimard, 1981); *Théâtre* (Paris: Hachette, 1981); *Epithalames* (Paris: Bibliothèque Oulipienne, 1982); *Tentative d'épuisement d'un lieu parisien* (Paris: Bourgois, 1982); *Penser/classer* (Paris: Hachette, 1985); *Les mots croisés II* (Paris: POL/Mazarine, 1986); *La bibliothèque oulipienne*, with Oulipo (Paris: Ramsay, 1987); *"53 Jours"* (Paris: POL, 1989); *L'infra-ordinaire* (Paris: Seuil, 1989); *Voeux* (Paris: Seuil, 1989); *Je suis né* (Paris: Seuil, 1990); *Cantatrix sopranica L. et autres écrits scientifiques* (Paris: Seuil, 1991); *L. G.: Une aventure des années soixante* (Paris: Seuil, 1992).

2. Ample readings of *W ou le souvenir d'enfance* include: Claude Burgelin, *Georges Perec* (Paris: Seuil, 1988), pp. 137–172; Catherine Clément, "Auschwitz, ou la disparition," *L'Arc*, 76 (1979), pp. 87–90; Andy Leak, "W/Dans un réseau de lignes entrecroisés: Souvenir, souvenir-écran et construction dans *W ou le souvenir d'enfance*," in Mireille Ribière, ed., *Parcours Perec* (Lyon: Presses Universitaires de Lyon, 1990), pp. 75–90; Philippe Lejeune, *La mémoire et l'oblique: Georges Perec autobiographe* (Paris: POL, 1991), pp. 59–138; Bernard Magné, "Les sutures dans *W ou le souvenir d'enfance*," *Cahiers Georges Perec*, 2 (1988), pp. 39–55; Robert Misrahi, "*W*, un roman réflexif," *L'Arc*, 76 (1979), pp. 81–86; Warren Motte, *The Poetics of Experiment: A Study of the Work of Georges Perec* (Lexington: French Forum Monographs, 1984), pp. 97–113, and "Embellir les lettres," *Cahiers Georges Perec*, 1 (1985), 110–124; John Pedersen, *Perec ou les textes croisés* (Copenhagen: Revue Romane, 1985), pp. 71–82; Anne Roche "SouWenir d'enfance," *Magazine Littéraire*, 193 (1983), pp. 27–29; Paul Schwartz, *Georges Perec: Traces of his Passage* (Birmingham: Summa, 1988), pp. 45–55.

3. The first page number refers to the French edition of *W*, the second to David Bellos's English translation, which I have used here, silently emending it when it seemed necessary: *W or the Memory of Childhood* (Boston: Godine, 1988).

4. See also pp. 10, 13, 21–22, 31, 95 in the French edition. Proust's "Longtemps, je me suis couché de bonne heure" is clearly an obsessional phrase for Perec; see, for example, his "35 Variations sur un thème de Marcel Proust," in Perec, "Qu'est-ce que la littérature potentielle?" *Magazine Littéraire*, 94 (1974), pp. 22–23.

5. See Theodor Adorno, *Prisms*, trans. Samuel and Shierry Weber (London: Spearman, 1967), p. 34. See also Adorno, *Negative Dialectics*, trans. E. B. Ashton (New York: Seabury, 1979), p. 362: "Perennial suffering has as much right to expression as a tortured man has to scream; hence it may have been wrong to say that after Auschwitz you could no longer write poems."

6. See for instance Edmond Jabès, *Le petit livre de la subversion hors de soupçon* (Paris: Gallimard, 1982), p. 45: " 'Why,' he asked him, 'is your book only a series of fragments?' 'Because the interdict doesn't apply to the broken book,' he answered"; and Lanzmann's remark about *Shoah's* lack of images, in Catherine David, "Enfin *Shoah!" Le nouvel observateur,* 1181 (June 26, 1987), p. 50: "Obviously that's a crucial point. No images. No archival documents. No striped pyjamas. The extermination of the Jews cannot be illustrated. One doesn't represent the Holocaust. What do you see in *Shoah?* Beautiful countryside. Trains. Faces. The film is constructed around this constant refusal of images." My translations, as elsewhere, unless otherwise noted.

7. See, for example, Rabbi Israel Spira's remark, in Yaffa Eliach, *Hasidic Tales of the Holocaust* (New York: Avon, 1982), p. 136: " 'God manages a strange world; at times it is difficult to comprehend', the rabbi reflected to himself as he told the story some thirty years later in his Brooklyn home. 'Yet it is our duty to tell the story over and over again. Telling the tales is an attempt to understand and come to terms with a most difficult reality.' " See also Raymond Federman, "Displaced Person: The Jew/ The Wanderer/The Writer," *Denver Quarterly,* 19, 1 (1984), p. 89: "The writer, however, the Jewish writer at any rate, cannot, must not evade his moral responsibilities, we are told, nor can he avoid dealing with his Jewishness. It is demanded of him. And the writer himself feels obligated to tell and retell the sad story, lest we forget. He must become the historian of the Holocaust. He must tell the truth—the 'real story.' But how? That is the fundamental question that confronts us today."

8. As such, this figure should be compared to a variety of other infero-sinistro-lacunary structures in Perec's writings, most notably the scar on his left upper lip that he alludes to in *W,* pp. 141–143 of the French edition. See also Bernard Magné, "Le puzzle, mode d'emploi," *Texte,* 1 (1982), pp. 84–86; Ewa Pawlikowska, "La colle bleue de Gaspard Winckler," *Littératures,* 7 (1983), pp. 80–82; Motte, "Embellir les lettres," p. 110.

9. This is apparent not only in the case of the Hebrew letter and the W, but also (and perhaps most eloquently) in the dedication of *W ou le souvenir d'enfance,* "Pour E." The E may be read homophonically, as the tonic pronoun *eux,* designating, on a first level, Perec's parents. The role of the E in *La disparition* should also be recalled, for therein, by virtue of its very absence, the letter inscribes loss and irrecuperable alterity upon the text. Finally, in a similar perspective, it is not without significance that the E occurs four times in Georges Perec's name.

15

Exiled from the Shoah

ANDRÉ AND SIMONE SCHWARZ-BART'S *UN PLAT DE PORC*
AUX BANANES VERTES

Ronnie Scharfman

One can die in Auschwitz after Auschwitz.
<div style="text-align: right">Elie Wiesel, One Generation After</div>

"If I am not for myself, who will be for me? If I am only for myself,
what am I? If not now, when?"
<div style="text-align: right">Hillel</div>

In *Paroles suffoquées,* Sarah Kofman's meditation on her father's death in
Auschwitz, she dialogues with the writings of Maurice Blanchot, particularly
with *L'écriture du désastre,* as she grapples with the post-*Shoah* paradox of
having to speak the unspeakable. Perhaps it is in the radical, absolute incom-
prehensibility of the disaster that we can begin to look for a means to
communicate (with) it. Paraphrasing Blanchot, she tells us:

> It is what separates, leaves at an insurmountable distance . . . that puts
> into authentic relation; the proximity and the strength of the communica-
> tion depend on the strength of the separation . . . only the strangeness of
> what could not be held in common founds the community. (p. 36 in the
> French. Translation mine.)

Further on, she elaborates on this paradox as she expresses her admiration
for the ethical exigency of Robert Antelme's book, *L'espèce humaine,* which
articulates the double bind of the survivor:

> . . . an infinite demand to speak, a must-speak to infinity, imposing itself
> with an irrepressible force—and a quasi-physical impossibility to speak; a

suffocation, a knotted word, demanded and forbidden, because contained, arrested for too long, stuck in the throat and which makes you suffocate, lose your breath, asphyxiates you, takes away from you the very possibility of beginning. (p. 46)[1]

Both of these reflections are, it seems to me, emblematic of the strange and ambitious project that André Schwarz-Bart, first alone, and then in collaboration with his wife Simone, sets out to create in writing what was to be a seven-volume cycle of novels to be known, collectively, as *La Mulâtresse solitude.* The first novel in this cycle, *Un plat de porc aux bananes vertes,* published in Paris by Le Seuil in 1967, will be the subject of this essay.[2]

How are we to read this disconcerting text, dedicated to both Elie Wiesel and Aimé Césaire, sketched out painstakingly over many years first by a white, European, Jewish male, and then completed with his black, Antillean wife, if not as a paradigm for those impossible yet urgent gestures that seek to communicate (among) disasters even as, according to Kofman and Blanchot, they speak to the gap, the distance, the radical strangeness that exiles us from them? How can we position, or reposition today, this problematic story of an obscure, old, black woman from Martinique facing death among other deteriorating bodies in the loneliness and isolation of a Parisian nursing home? What could have prompted Schwarz-Bart's crossing of gender lines, as well as those of race, religion, geography, culture, and even language, in creating such a protagonist as Mariotte? In order to explore these questions as they are textualized in the novel, it is important to historicize them in relation to Schwarz-Bart's greater project as a whole.

In 1959, André Schwarz-Bart, a French Jew born in Metz in 1928 into a Yiddish-speaking family of Polish origin, was awarded the Prix Goncourt, France's most prestigious literary prize, for his novel, *Le dernier des justes.* In this novel, Schwarz-Bart, who had lost his family to the Nazi genocide, reconstructs the history of Jewish persecution in Western Europe, beginning with the massacre in York, England, in 1185, and ending in Auschwitz. The fictional device he employs for this enormous fresco is the tracing of one family, the Levys, through the ages. Weaving the ancient Jewish legend of the *"Lamed Vov,"* or thirty-six just men, around the Levy family, one of whose members incarnates a Just Man in each generation, Schwarz-Bart inscribes Jewish memory as reaching back "to the source of the centuries, to the mysterious time of the prophet Isaiah," (*The Last of the Just,* p. 4), at the same time that he moves his narrative forward to the ineluctable, irremediable eradication of that memory, that history, that tradition, as Ernie Levy, the very last of the Just Men, is gassed in Auschwitz.

If the magnificent saga of the Levy family serves not only as synecdoche for the richness of European Jewish life forever extinguished by the *Shoah,*

but also, in its refiguring of the *Lamed Vov* tradition, as a condition for the legibility of all human suffering, then the abrupt and tragically irreversible death of both family and tradition points to the problems that will confront Schwarz-Bart as a writer after *Le dernier des justes*. For, despite the reknown of this novel that ends in Auschwitz, Schwarz-Bart has always insisted that it is not a Holocaust novel. It is, rather, a text that bears witness to the irreparable loss. The loss itself cannot be told. But after the loss, what is there to tell? By placing the Nazi genocide of the Jews at the end of a long history of persecution, Schwarz-Bart raised questions about conceptualizing the *Shoah* as the most horrific in a series of victimizations throughout the centuries, rather than a unique, radical break in human history. Or is it the very nature of the *Shoah* that it cannot be represented except, perhaps obliquely, from a distance?

If post-*Shoah* philosophical and literary theory question how narrative (or poetry) can survive after Auschwitz, Schwarz-Bart seems to be exploring what kind of survivor is a narrator, what kind of narrator is a survivor. Unlike the members of the Levy clan, rooted in their identity, Mariotte, the narrator of *Un plat de porc* is alienated, uprooted, marginal, isolated. And yet she is compelled to tell, to write, literally, in her case, to ex-press. This is not only to exorcize repressed material in order to understand it, not only because writing is figured here as a means of knowledge, of mastery, but also to give form to, to coincide with what might otherwise remain the inarticulate, decorporealized, dehumanized screams of the opening pages of the novel:

> The clamors were there, against my throat, and I attributed my extreme trouble to the nightmare from which I was emerging . . . the screams had torn me from sleep and held me several minutes suspended to them, like on a butcher's hook . . . you'd think it was a dog howling at death . . . screams which were still echoing, somewhere, I didn't know where, without my being able to truly attach them to my own self. . . . When the past comes back up this way, along my throat, it seems to me sometimes, upon awakening, that I am prey to an attack of croup. . . . Still haunted by the screams, I thought it would be better to relive certain horrors than to submit to them during the impotence of the night, my entire mind given over to the Beasts. (pp. 13–14 in the French. All subsequent translations mine.)

To repeat in order to master. To coincide with the scream. And who could doubt, anymore, that we are in the post-*Shoah* universe of Maurice Blanchot's *L'écriture du désastre?*

Stripped of the lyrical grandeur and mythic dimension of *Le dernier des justes*, *Un plat de porc*, seemingly diametrically opposed to the first work in

the narrowness of its focus and otherness of its subject, is nonetheless a continuation of it, a reformulation of the unspeakable from a completely different, yet deeply connected point of view. What constitutes the fragile bridge over the gap of the *Shoah* is Schwarz-Bart's scrupulousness, his discretion and respect for the victims such that he does not dare to presume to tell their sacred story, at the same time that he is compelled to reveal an imagination haunted by nothing else but that catastrophe. It is my contention here that *Un plat de porc* can be read as the Holocaust novel Schwarz-Bart did not write, did not dare to write, in *Le dernier des justes*. It is only by writing as other, through the other, that he can obliquely represent the horror in its materiality. In what ways does *Un plat de porc* function as mirror opposite, and therefore as constant reminder, of the trauma of Jewish history, and in what ways does it speak to the specificity of the trauma of Antillean history, as legacy of slavery?

To the legendary, historically glorified memory of the generations of *Lamed Vov,* Schwarz-Bart now opposes a totally obscure, amnesiac, old, black woman. The grand scale of Jewish life through the centuries has shrunk to the dimensions of a nursing home in Paris in 1952, a few streets around it, and a small village in Martinique. The third-person, omniscient narrator of the first novel is individualized into the first-person narrator of *Un plat de porc.* The rooted plenitude of the Levy family name has been reduced to the first name of the protagonist, Mariotte, who begs to have herself named in the Creole voice of her dead grandmother, since nobody in Paris does so. Ernie, the protagonist who is foregrounded at the end of *Le dernier des justes,* does not go gentle into the night of the gas chamber. Mariotte, beaten down, but not defeated, struggles to find some form of dignity in the living death of fragile old age. In the earlier novel, the weight of the pain of collective history focuses in on, bears down upon, and finally is condensed into Ernie Levy's extermination. In *Un plat de porc,* the utter meaninglessness of one isolated, marginalized, alienated life opens onto moments of collective memory.

The past bears the weight of suffering whose traces point to the confused consciousness of a narrator attempting to survive in a world where spirituality has become meaningless. And there cannot be any doubt that she is a survivor—indirectly of the Middle Passage and slavery in her native Martinique; more directly, a survivor of the disastrous 1902 eruption of the Mount Pelée volcano that wiped out her entire family, burying them under ashes; and, more metaphorically, a survivor of racism, sexism, exile, alienation, and the more subtle forms of victimization and exclusion to which she is constantly subjected by the white denizens of the nursing home. In its derisive power struggles and daily degradations, in its graphic, willfully obscene descriptions of putrefaction and deterioration of the human body,

Un plat de porc evokes nothing if not *"l'univers concentrationnaire"* which we do not see in the first novel.

The titles of the two narratives point to the different emphasis of the two projects. The vast temporal dimension evoked by *Le dernier des justes* is one way Schwarz-Bart inscribes the magnitude of what has been forever lost because of the *Shoah*. *Un plat de porc aux bananes vertes,* referring humbly, concretely, to one woman's yearning for the lost maternal cooking of her childhood, localizes and personalizes the loss. We might even read it as the signifier for the non-Jewishness of the novel's content, since pork is the emblematic non-kosher meat, and green bananas a specialty indigenous to the West Indies. Yet it is in these very differences that the two texts dialogue and that Mariotte's story prolongs Ernie's. If one's maternal cuisine is as irreducible as one's mother tongue, and figures a whole way of life forever lost—family, warmth, security, tradition, connectedness—then Mariotte's gustatory hallucination of this luscious dish which, Proust-like, helps bring back her childhood in Martinique. This is directly analogous to all the accounts we have from survivors in the camps whose own gustatory hallucinations of Sabbath meals kept them alive in their worst moments of despair and starvation.[3]

What I am arguing here is that, in *Un plat de porc,* Schwarz-Bart is deepening his exploration of the role of memory in relation to catastrophe, as well as responding to his own lifelong exigency to bear witness to the *Shoah,* but that, after *Le dernier des justes,* he could only do so by distancing himself further from the unwritable subject/object. Eight years separate the two novels—eight years during which Schwarz-Bart remained silent and private. Deeply wounded by the ways in which *Le dernier des justes* was misconstrued, despite its Prix Goncourt, by many different constituencies, he withdrew from the literary scene.[4] Yet it is the radical sense of being exiled from the unrelatable that allowed him to conceptualize a bridge to another genocide, and through the one, to imagine the other. Without trying to universalize man's inhumanity to man, and thereby reduce the tragedy of one group by collapsing it into an identification with another, Schwarz-Bart sought to articulate between the tragic histories of the European Jewish and the Caribbean black communities.

In a seminal interview given to *Le Figaro littéraire* on January 26, 1967, on the eve of the publication of *Un plat de porc,* Schwarz-Bart outlined the genesis of the second novel. The article bears the arresting headline, "André Schwarz-Bart explains his eight years of silence: 'Why I wrote the *Mulâtresse solitude'.*" As Schwarz-Bart's first public pronouncement of any kind since he won the Prix Goncourt in 1959, this apologia constitutes a pre-text that should be considered in its own right before we pass on to a reading of the novel proper. Although the headline points to the subsequent confusion over both title and authorship of the novel, the content of the piece clarifies

how and why Simone finally intervened in the project, and that the title refers to a whole planned cycle of novels which, in fact, was never completed. However, it is Schwarz-Bart's discussion of *his* choice of subject, as well as the excruciating account of how he brought the project to fruition, that inform my reading of the novel in a crucial way. It explains why I have referred only to him thus far in my essay as the author of *Un plat de porc*. I have also heard Simone state that *he* wrote the novel.[5]

In this article he states clearly that his new work is the novel of the *Shoah* that he did *not* write in *Le dernier des justes*. In what way, then, does this project, not in any ostensible way "about" the genocide of the Jews, define, or perhaps fail to define, the parameters of such fiction? Are we equipped, in 1994, to read this text in ways the public was not, in 1967? What is at stake in the debates in cultural and multicultural studies today is dramatized precisely in that space Schwarz-Bart opens for allegorical reading on the one hand, and respect for contextual specificity on the other. Does this little-known novel, still ahead of its time in France, still untranslated in English, and virtually unrecognized by our critical community, speak to us perhaps more urgently today, as Jews and blacks have once again been polarized by the hatemongers of racism? Schwarz-Bart's project, as outlined in the *Figaro* article, is simply, and impossibly, to relate. To relate is both to narrate or tell, on the one hand, and to establish a connection, on the other. The survivor's dilemma—I cannot; I must; I will—symbolized by all of Beckett's narrators, is compounded and complicated by Schwarz-Bart's efforts to relate two ordinarily exclusive discourses: the postcolonial and the post-*Shoah*. Although he is scrupulous about never assimilating one to the other, he posits the commonality of the ancient Jewish and more recent black experience of slavery as the very condition of possibility for his book.

The article begins with Schwarz-Bart describing his attraction to the French West Indian community living in Paris in the fifties, not as an abstract sense of solidarity with oppressed "brothers of color," but rather as a visceral admiration for the "not-I": "I liked and I admired the West Indians for those qualities which I do not possess." In other words, the "other" here is not the menace of difference but, rather, ego ideal. Moreover, his account moves immediately from the perception of (idealized) difference, to one of identification. He recounts what must have been the last Passover *Seder* celebrated with his parents in 1941. They were deported shortly thereafter. Schwarz-Bart conflates the memory of his identification with the ancient Jewish slaves, reenacted through the ritualized dialogue with his father, with that other community of ex-slaves, the West Indians:

> I remembered that in 1941, on the evening of the first Passover seder, it was to me that the honor fell to ask the ritual question of the head of the family . . . 'Why is this night different from other nights?' And I remem-

ber the answer my father gave me in Hebrew: 'Child, it was on a night just like this that our ancestors went out of Egypt, where they had been made into slaves.' And I believe that it was this Jewish child, whose fathers were slaves under Pharoah before becoming enslaved again under Hitler, who was taken by a definitive fraternal love for West Indians. (*Figaro,* translation mine.)

The common experience of slavery and its concomitant suffering is what draws Schwarz-Bart to the Caribbean community. It is what allows him to dare to speak from within their voice—an audacious experiment whose dubious chances for success he will question for eight troubled years, seeking the benediction of Aimé Césaire.[6] This may be the only form of representation in which he can continue to articulate those themes that will forever obsess him, exiled as he must be, as a survivor, from the very central experience of his life. When he states in the article, "it would be a question not so much of writing this book as of making myself other in order to be able to write," he seems to be imposing upon himself an exile from his Jewish identity that is the condition of possibility of his deepening that identity. In the course of his research for the novel, he travels to the French Caribbean, where he discovers the historical dimension—"the phantomlike shadow of slavery"—of these people as it informs their every gesture, exactly as he says it does for the Jews. And yet he learns for the first time how the West Indian has no history to trace himself back to beyond the radical rupture that was the Middle Passage: "sons of a mutilated people, cut off, sliced from itself." The character of the grandmother begins to emerge: "It had to be a being as vast as the world, as profound as history, to enclose the old black world and its story."

The exploration of old age as another form of marginality opened up the possibility for a different articulation of the same theme:

It seemed to me that at this extreme level of white sub-humanity the theme of racism might possibly lose its particular, sentimental, even folkloric character, that it had the chance to melt into a more general meaning. Let's say into the great universal flow of violence and the degradation of man by man. In this way, then, through the intercession of the old age home, it seemed in my eyes that the delicate joint was established between slavery and the concentration camp theme that has been preoccupying me for a very long time. Since 1945, the greatest part of my intellectual life has developed under the sign of the world of the camps. But for diverse reasons, of which terror, the sense of the sacred, and that of my own limitations are not the least, I have never really said a word about it. The *Mulâtresse solitude* may be considered as a fearful, oblique approach to the concentration camp world. I believe, to sum this all up, that if the world

of the camps were absolutely different from that world we call "normal," it would be an impossible world, in an absolute sense.

But perhaps the crux of this article lies in the dialectical tension Schwarz-Bart expresses in his efforts to mediate from the general to the particular:

> I believe in the fundamental unity of the species. I believe in the eternal possibility of communication. I believe, in the terms Lévinas uses in relation to Martin Buber, that the essence of dialogue is not in universal ideas common to all interlocutors, nor in the ideas that one creates of the other, but in the very encounter itself, in the invocation, in the power that the I has to say You. I believe, finally, with my dear Jean-Jacques, that every human mind is the site of experimentation with validity in relation to what happens in all other minds.

Similarly, Mariotte, at the end of the novel, wallowing in self-pity after having humiliated herself in public, finds liberation in a dialogue with herself in which her suffering is joined to that of the human community:

> ... you carry within yourself one of each kind ... a beast named Jesus, another beast called Hitler, an anonymous Hindu coolie, the cannibalistic butcher on the corner, a Roman gladiator, one of our local women pregnant for the ninth time ... a newborn, all white, yellow, black or red ... you are you, as well ... all men, women, children, without exception, all creatures from first to last today and always, in the century of centuries. And tell me quite frankly, Mariotte, my little Mariotte mine, known by nobody: What is a negress's sigh in the infinite? (*Un plat de porc*, pp. 204–206 in the French.)

Far from trivializing Mariotte's suffering, her connecting it beyond herself will be what allows her finally to articulate a moment of intense longing and to recuperate her self-esteem. Yet in the *Figaro* article, Schwarz-Bart recounts the painful confrontation with the limitations of such a philosophy. Scrupulous both about his subject matter and the community he felt responsible towards, he had to admit to himself that he had not gotten to the specificity of Antillean culture, what he calls the "unfathomable core." He discovered that he was condemned to be exiled from the inalterable alterity of the authentically Antillean:

> I discovered, in despair, that there is one way to respect a people entirely: that is to be one of them. And, to speak in a lighter vein, it seemed to me then and only then, that if I were, for about ten years now, up to smelling the perfume of the Antilles, to appreciating it, to describing it, if need be, it was impossible for me to become perfume myself. (*Figaro*)

Fortunately, his wife revealed herself to be not only perfume, but savor, flavor, an author who discovered her vocation when asked to supply an anecdote to help Schwarz-Bart, now blocked on his novel. It is not in the scope of this essay to sort out her contribution, and the two of them have refused to identify which parts are "his" and which are "hers," stressing the unity of the text. Suffice it to say that, at the level of the language itself, Mariotte's sensibility could not have been rendered without Creole working its way into the French at strategic moments where she must reconstitute herself in discourse.

"When Memory Comes"—The Writing Cure

In the novel itself, what motivates the protagonist's discourse is her urgent need to transform her passive subjectification to the monstrous screams and nightmares that haunt her sleep and have made her into a zombie, into a humanized articulation of what has been lost. In other words, writing in a notebook will allow her to bring unconscious, repressed material to the surface. Memory has been repressed—"*les paroles suffoquées*"—both as a strategy for survival on the part of Mariotte, and as Schwarz-Bart's way of underlining the isolation and alienation of his character. With whom can a survivor communicate? And yet, it is precisely this imaginative leap on the author's part, his textualization of marginality in terms of old age, female gender, and blackness, all identities other from his own, that functions as the condition of his communicating (with) the incommunicable.

When the narrative opens, Mariotte's strategy to cut herself off from feeling because it is too painful has begun to crumble. Having tried to live as if she were born in the old-age home, as if only its *hic et nunc* existed, she finds that the past she is denying has begun to mount its assault on the defended fortress of the self. Confused, frightened, lonely, she succumbs to the temptation to let in life again by confronting her past when she goes to the valise under her bed. Her tangible memories, stacked and buried, are implicitly compared to the bodies of genocide victims: "Five to six kilos of photographs and letters piled up like old women in a common grave: the present weight of my destiny" (p. 40).

But what will actually release the flow of memory, Schwarz-Bart's analogue here for Proust's madeleine, is not a photo nor a letter, but a tactile object, a "*siguine*" leaf she has hidden among her personal effects. Its velvety black skin used to be compared by Martinican "*galants*" to that of "the fifteen-year-old negresses," so that it functions as a metonymy both for the "*pays natal*" and for Mariotte's girlhood. In the concentration camp universe that the author evokes through the metaphor of the nursing home, privacy is an unheard-of luxury. Part of the sense of dehumanization and depersonal-

ization that is conveyed in this text in such alarming and repugnant ways comes from the herding aspect, which leaves all inmates perpetually exposed to each others' cruelties, weaknesses, and uncontrolled bodily functions. The only place to be alone, to retrieve or maintain any sense of personal dignity is, ironically, in the derisive sanctuary of the toilet. It is here that Mariotte hides to be alone with her leaf. The scene, in its pathetic reductiveness and degradation of the human need for any kind of closeness, could be grotesque. And yet, its function is conciliatory, its effect communicative, recuperative, even resistant. In this diminished context, Mariotte's reconnecting with her leaf-as-transitional-object takes on significance. Schwarz-Bart is focusing here on the minute, concrete, physical details of the material world through which we maintain our identity. The leaf functions as the sensory medium of the beginning of Mariotte's disalienation:

> I took out the leaf, which I found still so lovely in its flesh that one would recognize it above all the anemic plants of Europe. To finish, I placed it against my cheek and we stayed that way, one with the other, for I don't know how long . . . forgotten sisters of a same exile, it seemed to me, curiously. (p. 41)

Starved for human contact from her own kind, Mariotte hallucinates closeness based on this physical contact with/of memory. The leaf reawakens her Martinican past which will be reconstituted in fragmentary flashbacks. For how can trauma, which is the fragmentation of self through wound, be related through the controlled, rational discourse of narrative diachrony?

The first character the protagonist will have to come to terms with is also the most terrifying one—her grandmother. On the one hand, she is unforgiving, rejecting of what she sees as her granddaughter's disloyalty and pretention. Of course, this form she takes is also a projection of Mariotte's survivor guilt. On the other hand, she is the living incarnation of another kind of survivor, forever burdened with memory because it is, literally, branded onto her breast. As an ex-slave, Man-Louise transmits the pain, the misery, and injustices of a system that had traumatized her forever. Having internalized the insults and accusations of the white master, grandmother passes on to Mariotte, in this first hallucinated interview, her bitter, deformed, self-hating version of history: in the eyes of the whites, any black who tries to assert agency, subjectivity, is viewed as garbage, and beaten down. Staged as a dialogue between the two women, who are, in their old age, mirror images of each other, the scene can be read as one where self-inflicted verbal violence leads to a cathartic demand for recognition and self-recognition. Having rendered herself vulnerable to Man-Louise's scathing criticisms, Mariotte also renders herself permeable to the tragedy of her

grandmother's slave past: " . . . she who carried the chains of her soul all through her life—more profoundly inscribed than the brand of the red iron on her right breast" (p. 47).

In connecting through her grandmother with the past suffering of her race, Mariotte can also identify with the sufferings of her sex. Subjected as she is, being the only black in the old-age home, to demeaning yet pathetic sexual insults and curiosity, Mariotte recognizes her grandmother as the "old white man's mattress." But it is, more significantly, around the issue of motherhood that Mariotte's bewildered and terrified empathy for Man-Louise is voiced. In the novel's primal scene of loss, fear, and powerlessness, Schwarz-Bart has found one of the most convincing metaphors linking the two communities for whom he has tried to speak. There is no terror or suffering greater than the arbitrary and irrevocable separation of parents and children from each other. At the moment of deportation, and then, upon arrival in the camps, at the moment of selection, this horror was lived by hundreds of thousands of Jewish families during World War Two. It is the story of Schwarz-Bart's own family. In *Un plat de porc,* Mariotte reexperiences and bears witness thereby to a terrifying and pitiful scene from her childhood, where her grandmother, just before dying, regressed deliriously to her former slave self and relived her terrors—of being whipped and, more tragically, of being severed from her babies. In her grotesque reenactment of the trauma, Man-Louise ironically takes her daughter to be her former white mistress, and prostrates herself at her feet, begging for mercy. Mariotte recounts in her notebook:

> And she grabbed one of Mama's legs, kissing it with fury, angrily, and going down to the naked toes that she licked with big, avid strokes like a cat. . . . And there she was screaming, with a piercing voice of a female from whom one is tearing away her little one: Oh, for the grace of God, don't take away my second son, don't go selling him to Mister Saint-James, leave him to me, leave him to me, or sell him to someone more Christian than Mister Saint-James. With all due respect, mistress, with all due respect, he nails ears too much, you know, too much, ears. . . . Whilst Mama, immobilized with terror, her face grey, contemplated with wide opened eyes the spectacle of Man-Louise hanging on her leg and covering her dusty feet with slave's kisses. (p. 65)

At the far end of personal and collective suffering for the Antillean is the history of the slave past, the image of self as "*nègre.*" Mariotte's distance in time and space from this scene, her re-presenting it through writing it, have allowed her to integrate into her own past, to forgive her harsh grandmother. Why suppress memory? Because it is memory of what has been lost. Desire,

if it is allowed to resurface, is revealed as desire for the irretrievable past. Yet what is the alternative to living with the painful memory of loss? It is a dehumanized defense against connection and, therefore, a loss of identity. The monster who cannot feel any longer—the portrait of the survivor of the *Shoah* so convincingly portrayed by Rod Steiger's "Pawnbroker," this could have been Mariotte. In her unsuccessful efforts to retrieve her native land through voluntary memory, Mariotte comes to understand her isolation, her alienation. Such a realization releases the floodgate of tears that lets memory come. Being able to cry signifies being able to mourn, and it is mourning that liberates the memory that has been locked away, mourning for those loved ones destroyed and buried under the ashes of Mount Pelée.

Schwarz-Bart effects this return to the land by uncovering its inscription on the body, so that it is articulated as a return *of* the native land. Now more like Proust's involuntary memory bringing back Combray in a cup of tea, Martinique is reactivated in Mariotte's mind through her senses—aural, visual, tactile, olfactory, and perhaps, most importantly, gustatory. She hears the *N'goka* drum and is transported in such a way that she coincides with herself once again. What is most significant for our purposes here, is that the return is figured as Mariotte's rediscovery of her own suppressed voice—she who is so silent in the asylum that she has taken to writing in notebooks—and with it, her capacity for song, and her mother tongue. Like the Yiddish of Eastern European Jewry, spoken only by those few who survived the camps, Mariotte's native Creole was her survivor's language, but is no longer a vehicle for communication for her, as the lone creolophone in the old-age home. At one point, she obsesses about losing it completely as a possible sign of senility. Finally, Mariotte's return to the native land is also figured as one of reexperiencing a primal, amniotic pleasure. Mariotte's metaphor for her alienation had been one of a "little black fish with a broken fin, lost in a corner of the terrestrial bowl, in the shadow of Paris" (p. 82). The corollary for reconnection with her past self, her original Antillean identity, is figured in terms of her "swimming home." In a lovely, lyrical moment of reconciliation with self, she invites herself back home. Having reinscribed herself as a member of that community, Mariotte can reminisce freely about her childhood, its mysteries, magic, solidarity, and also its struggles and deprivations.

At the novel's climactic ending, Mariotte begins to crave a taste of a little "home cooking" and ventures out of the asylum one night in the snow, just before Christmas. The triumph of the text is that she is, at last, able to recount this story, for it is the "event" she refers to in the opening pages of the novel. What she will have gained by allowing herself to go back, is the possibility to go forward. Although she is unsure of her audience, unsure, even, if anybody will read her at all, particularly in French, she summons

the courage to tell her own tale, to recast it in fiction, using the third person, and thus, reaches out beyond the limitations of self-pity to relate (to) the universality of human suffering.

What she goes on to recount is how she stood outside the window of a Caribbean restaurant in the snowy Paris night, imagining the welcome she would receive if she were to go in, savouring in her imagination the warmth and tenderness of finding her own people, coyly turning down invitations by the owner to join in all sorts of tastings, and then, requesting, after much cajoling by the owner, the *"plat de porc aux bananes vertes."* As she conjures up the images, the sights and sounds, and, especially, the smells of home, she realizes that she would not be able to keep from crying if she actually lived out this fantasy. Her renewed sense of self-esteem is intimately con-nected with her having been able to reappropriate her past history, both on a personal and on a collective level. For it is in front of her own people that she cannot bear to humiliate herself, and, despite the debased conditions in which she lives, she has maintained a core of selfhood intact. It will have been enough to have been able to imagine the joy of plenitude and reconcili-ation, and, especially, to have been able to articulate it in writing. The promised land that Mariotte envisions reaching at the end of her travails and her trajectory is none other than home. Once this positive connection has been made, the longing can remain unfulfilled. It will no longer be destructive.

It is not my purpose to attempt to judge whether Schwarz-Bart has realized his ambition of making *Un plat de porc aux bananes vertes* a diptych for *Le dernier des justes,* as he stated in the *Figaro* article. What I hope to have demonstrated is the dynamic at work in the text, such that it functions successfully as a respectful approach to one old, black, Antillean woman's life on the one hand, and as a metaphor for Jewish suffering during the *Shoah* on the other. If, in its strong etymological sense, a metaphor carries over, transfers meaning, then this novel deconstructs any ethnocentric no-tion of a Jewish monopoly on suffering in a positive, relational way. And yet, in so doing, has Schwarz-Bart not figured precisely that centrifugal force that is the radical unrepresentability of the *Shoah?* The writer's project Schwarz-Bart formulated in the *Figaro* article included a seven-volume cycle of which this novel was to be the first. But beyond that, he had imagined a volume that would serve as triptych to his other two projects, and which would treat the world of the concentration camps head on, not refracted through any other history. Schwarz-Bart's scruples are such that even in 1967, he thought the realization of this project highly improbable, due, he said at the time, to his doubts about being mature enough to bring it to fruition. It would have been called, *En souvenir du vingtième siècle.* André Schwarz-Bart has been "silent" since 1972, when *La mulâtresse* was published,

and the seven-volume cycle was never completed. The problematic status of *Un plat de porc aux bananes vertes,* its critical invisibility in terms of reception, as well as the impasse it seems to have brought its author to, attest to the profound difficulty of "remembering the twentieth century" for a Jewish writer. We are left with the disturbing question of whether Schwarz-Bart, in achieving one goal of not betraying the other's (hi)story, has not exiled himself further from the *Shoah.* We can only surmise that his integrity and his discretion have imposed silence, once again, in the face of the unspeakable.

Notes

1. Sarah Kofman, *Paroles suffoquées* (Paris: Galilée, 1987); Maurice Blanchot, *L'écriture du désastre* (Paris: Gallimard, 1980).

2. My own work here is indebted to an earlier essay by Bella Brodzki, "Nomadism and the Textualization of Memory in André Schwarz-Bart's *A Woman Named Solitude,*" in *Yale French Studies,* vols. 82–83, 1993. In this fine article, Brodzki puts forth a compelling discussion of the confusion of titles, authorship and, consequently, readership, surrounding André and Simone's *Un plat* and André's *La Mulâtresse.*

3. See, for example, Yaffa Eliach's *Hasidic Tales of The Holocaust* (New York: 1982), particularly, "A Prayer and a Dream," (pp. 201–202). There are many others, including the anonymous "The Third Sabbath Meal at Mauthausen."

4. For a thorough and painful discussion of what came to be known as "L'Affaire Schwarz-Bart," see Francine Kaufmann, *Pour relire Le dernier des justes* (Paris: Meridiens-Klincksieck, 1987).

5. When they both came to New York, in 1989, for the Ubu Repertory's production of her play, *Ton beau capitaine,* she participated in a question-and-answer period afterward. André was in the audience when she gave that answer.

6. A reciprocal identification with the slaves of antiquity can be found in Césaire's weary and prayerful verse: "*maître des trois chemins, tu as en face de toi un homme qui a beaucoup marché. Depuis Elam. Depuis Akkad. Depuis Sumer.*" *Cadastre,* trans. Clayton Eshleman and Annette Smith (Berkeley and Los Angeles: University of California Press, 1983).

16

The Writing of Catastrophe
JEWISH MEMORY AND THE POETICS OF THE BOOK IN EDMOND JABÈS

Richard Stamelman

In every name, there is a disturbing name: *Auschwitz.*
 Edmond Jabès, *Le Parcours*

How to philosophize, how to write, remembering Auschwitz, re-
membering those who told us, sometimes in notes buried near
the crematoria: Know what has taken place, do not forget, but at
the same time know that you will never know.
 Maurice Blanchot, *Notre compagne clandestine*

As from night's abyss the stars emerge, man in the second half of
the twentieth century is born from the ashes of Auschwitz.
 Edmond Jabès, *Désir d'un commencement, Angoisse d'une seule fin*

Memory is an impossible phenomenon, destined, perhaps, from its incep-
tion to finish ultimately in forgetfulness. So little of what one perceives or
experiences in the space of an afternoon, a day, or a week can be saved from
oblivion; so much of what a person sees, feels, or thinks must necessarily
be erased from memory if human consciousness is to negotiate efficiently
and freely in a temporal world subject to constant change. Like Kafka's
imperial messenger, entrusted with a message from a dying emperor, a
memory starts off confidently, with indefatigable energy and self-assurance,
on the long journey toward a far-off future; but as it struggles to get out of
the palace and reach the open road, its advance is slowed by the sheer
impossibility of the task it has undertaken:

> The multitudes are so vast; their numbers have no end. . . . How vainly
> does he [the messenger] wear out his strength; still he is only making his

way through the chambers of the innermost palace; never will he get to the end of them; and if he succeeded in that nothing would be gained; he must next fight his way down the stair; and if he succeeded in that nothing would be gained; the courts would still have to be crossed; and after the courts the second outer palace; and once more stairs and courts; and once more another palace; and so on for thousands of years; and if at last he should burst through the outermost gate—but never, never can that happen—the imperial capital would lie before him, the center of the world, crammed to bursting with its own sediment.[1]

The message and the memory are undeliverable, incommunicable, in Kafka's fable. They cannot travel into the future to be heard by other people in other places and times. The memory is trapped in the past, blocked from its advance into the future by the swarming crowds, the endless spaces, the impenetrable sediment of ruin. The writing and speaking—of death, of catastrophe, of disaster—are condemned to circulate in the labyrinthine corridors and palaces of lost times and places. They are imprisoned in an immemorial past from which only traces and fragments from time to time escape. So preoccupied is the memory-messenger with beginning his journey, with moving through the palace and out into the world, that the content of the message being carried, those words of the dying addressed to the living, seems less important than the struggle to communicate it, to carry it forth.

Another Eastern European voice that echoes Kafka's pessimism, affirming with equal despair the futility of all human efforts to master through memory the complexity of a past destined to oblivion, is that of Milan Kundera. "At some point far in the past a group of people had something important to say," observes the hero of his novel *The Joke*,

and they come alive again today in their descendants like deaf-and-dumb orators holding forth by means of beautiful and incomprehensible gestures. Their message will never be deciphered not only because there is no key, but because people lack the patience to listen in an age when the accumulation of messages old and new is such that their voices cancel one another out. *By now history is nothing more than the thin thread of what is remembered stretched out over the ocean of what has been forgotten.*[2] (Italics added)

The weight of ponderous discourses, the thickness of dense messages, the noise of so many different words speaking all at once assure the permanence of oblivion, in Kundera's pessimistic view of things. Forgetting is guaranteed by the cacophony of the past, by its reduction in the present to a babel of abstract and meaningless sentences. Powerless to change the past—"because

whatever happened happened and could not be reversed"—one has no choice but to forget it. Everywhere there is only a "vast and inevitable forgetting," which women and men, blind to its sovereign and irreversible dominion, refuse to accept:

> Most people willingly deceive themselves with a doubly false faith; they believe in *eternal memory* (of men, things, deeds, peoples) and in *rectification* (of deeds, errors, sins, injustice). Both are sham. The truth lies at the opposite end of the scale: everything will be forgotten and nothing will be rectified. All rectification (both vengeance and forgiveness) will be taken over by oblivion. No one will rectify wrongs; all wrongs will be forgotten.[3]

If Kafka's imperial messenger can never hope to deliver his message, if Kundera's ostracized hero can never hope to remember the injustices of a political system bent on repression and revision, and if memory is destined to fall into oblivion, then how can an event of history and memory, an event unique in its unspeakable horror and savagery, be saved from oblivion? Are Kafka and Kundera right? Do we have no choice but to watch the past as it is swallowed up by the abyss of forgetfulness? Is history indeed, as Kundera writes, "nothing more than the thin thread of what is remembered stretched out over the ocean of what has been forgotten"? What allows this fragile thread to continue to exist? How long before it breaks, and the little of memory that remains falls forever into the sea of oblivion? As the years separating generations of men and women from the savage immediacy of the concentration camps grow, as the words of pain and suffering have to travel over longer and longer distances to reach the ears of future listeners, as the laments and the cries have to be shouted with greater and greater force, is the *Shoah*, "the *absolute* event of history,"[4] as Maurice Blanchot observes, doomed to become Kundera's thin thread, stretched to the breaking point over the undifferentiated ocean of what has been forgotten? We desperately want to answer "no." But will the Nazi genocide ultimately become a message imprisoned behind the walls of an impenetrable, unnarratable past? One, two, or even five centuries from now, will the message become "caught up in that vast and inevitable forgetting," that flattening of historical event, that blurring of lived time, that lessening of immediacy, that disfiguring of experience, which it is the nature of memory to cause?[5] Or will memory, even in the fragmented condition with which it has survived the concentration camp universe, remain forever vivid and indelible? It is with these questions—with the relation of memory to writing, remembrance to representation, anamnesis to poesis in this, the echoing *aftertime* of Auschwitz—that we will be concerned in what follows.

I. *"L'oublié inoubliable"*: The Writing of the Unforgettable Forgotten

Many are the survivors and the writers who, in the *afterwards* of Auschwitz, speak about the unspeakability of the Holocaust, who point with despair to the fog of forgetfulness that envelops the *Shoah,* changing the outlines of the past, blurring the immediacy of time and place. Although we can see the fog, we cannot see what it hides. Auschwitz is a name that refers to an emptiness, that brings into view an immense absence, and that designates the limitlessness of nothingness itself. It evokes a past in which memory itself has been exterminated and where an indelible forgetfulness is all that can ever be remembered. "Auschwitz," as name, is a monument to the unforgettable forgotten, *"l'oublié inoubliable,"*[6] to the reality of a forgetting that no memory can overturn but that it can ultimately commemorate, as Jean-François Lyotard remarks. Auschwitz declares that a monstrous act of forgetting took place before memory could begin to gather up fragments of the traumatized past.[7] What Auschwitz "remembers" is the forgetting that has annulled memory. For how can one remember an event whose very monstrosity surpasses recall, whose unthinkability negates thought, whose silence suffocates language, whose absolute senselessness destroys the possibility of human meaning? What can in fact exist *after* Auschwitz, in "this utter void in our history,"[8] if not silence and ineffability? What can be thought, said, remembered, or affirmed, if not the very absence of thought, word, memory, and affirmation? For, as Blanchot asks, "How can it be preserved, even by thought? How can thought be made the keeper of the Holocaust where all was lost, including guardian thought?" (ED, p. 80; WD, p. 47). The extremity of the genocidal condition, its unimaginability and horror, generates a Difference, a Strangeness, an Alterity lying beyond the powers of thought, language, and memory, phenomena of representation hopelessly incapable of registering such catastrophic enormity, such limitless negativity. "I call disaster," Blanchot writes, "that which does not have the ultimate for limit, that which bears the ultimate away in the disaster" (ED, p. 49; WD, p. 28).[9] There is no containing, or encircling, or encompassing, through the usual means of linguistic, mental, or mnemonic circumscription, that borderless land, that limitless country that is called Auschwitz. It is beyond reference, a name whose signified is so immense, so ineffable, so much more scream than word, that the name cannot contain it: "We have no words for the extreme," Blanchot observes; "dazzling joy and great pain burn up every term and render them all mute" (ED, p. 165; WD, p. 106). Between human beings and the experience they have of their past a yawning chasm has opened; the landscape of memory is fissured by an irreparable fault.[10] Auschwitz is

the name of this wounded memory, of this remembered amnesia. It is both *memory* of and *memorial* to what has been forgotten.[11]

To come "after Auschwitz" means to live in an epoch where everything has changed: where words, hounded by the falsehoods of the past, can no longer be written as they once were; where language, haunted by silence, can no longer articulate the meanings it once confidently conveyed; where thought, indicted by the perversions of a monstrous imagination, bears the scars of a bestiality that thought itself once invented; where memory, devastated by nightmare, bears witness to its own muteness, its own amnesia. After Auschwitz, everything is forever different. The very relationship of language to reality and to the world is dramatically and for all time called into question: "How is it possible to say: Auschwitz has happened?" asks Blanchot (ED, p. 216; WD, p. 143). And it is not merely that the signs and ciphers of expressibility have changed, that the words have been adapted to carry a heavier, a darker, burden. More tragic still, these signs and words have lost their memory and therefore their power to represent the past. After books of heart-wrenching testimony, after stories of lacerating pain and loss, after histories of irrefutable and terrible fact, everything still remains to be said. Memory, by a cruel twist of fate, risks becoming amnesia. What is remembered makes all the more clear what has been forgotten. The disaster will always be there as an inexhaustible, endless "unspoken," dominating the millions of words and images that have tried to represent it, to reveal its enigma, to explore the labyrinth of its truth, without ever finding the exact figuration. This is because the scope of no representation is wide enough to encompass the disaster. Auschwitz destroys totality. Memory and thought, and the words used to express them, become sites of dislocation, undermining certainty and subverting knowledge. These fragments of words and memories refer to the past, as road signs point to a village, but their manner of reference does not offer any coherent, unified, or meaningful representation of that past.[12] Surviving the disaster, the fragment designates a language laden with absence and otherness, a memory pregnant with forgetfulness and loss. In the post-Auschwitz world, the fragment alone speaks. But what it tells us is that meaning and knowledge, as traditionally expressed in the fullness of language and recalled through the preciseness of memory, can no longer exist. Where there was certainty there now exists doubt, where totality, now fragmentation, where knowledge, now inde-terminancy. The fragment assumes the difficult task of giving loss words, of allowing forgetfulness to speak in its own name, of making silence audible, but without reversing the lostness of the loss, the blankness of the forgotten, and the muteness of the silence.[13]

If language as well as memory are to remain faithful to the immense loss

and forgetfulness that Auschwitz names and situates, if language as well as memory are to give voice through the writing of fragments and the fragments of writing to what is, in truth, lost beyond telling and forgotten beyond memory, then they must allow themselves to become as impoverished, naked, diminished, mute, inarticulate, and traumatized as the experience they seek to represent. They must seek a mimesis of absence and emptiness, of deprivation and destitution. The narrative of the *Shoah* must point to the impossibility of its enterprise, to the impossibility of telling an untellable tale. Therein lies its potential claim to truth. The narrative of extermination must reveal during the course of its narration the ultimate and ineluctable failure of narrative language. Consumed from within by doubt and uncertainty, advancing by fits and starts through a fragmented, discontinuous writing of paradox and contradiction, post-Auschwitz narrative must seek to undermine its modes of presentation, to shake the foundations of logic and meaning, of cause and effect, of coherence and clarity, of beginnings and ends, of chronology and *dénouement* that have traditionally structured narrative discourse. For Auschwitz announces the death knell of narrative as it has traditionally been known.[14]

A writing of catastrophe, more fragment than whole, more exile than home, more desert than oasis, more forgetfulness than memory, more silence than speech, more absence than presence—which is to say, a discourse of disaster that rejects the chronological sequences of narrative, that presents a story without a story, a memory without memories, in keeping with the displacement and dislocation of post-Auschwitz language—can be found in the wandering, endless writing of Edmond Jabès, the French writer, who was born in 1912 and who died in 1991. Here, among quotations from imaginary rabbis, among questions whose answers are further and deeper questions, among aphorisms whose laconic density augments the mystery of a continuously deferred meaning, among printed letters and white margins that hide other, potential verbal and graphic configurations, and among books that seek an invisible, never-to-be-written Book, there appears in bits and pieces the fragmented, discontinuous "story" of Sarah and Yukel, two young lovers destroyed by the *Shoah*. Through a wandering, never-stilled writing (which obeys no chronological or preestablished order, acknowledges no beginning or end, follows no clear path in the shifting sands of a desert coincident with the white pages of the book) and through a labyrinth of questions, resemblances, dialogues, margins, fragments, otherness—as much in exile from Truth, Knowledge, and Meaning as the displaced Jew who wanders the exilic spaces of book and world—Sarah and Yukel tell "a story" with very little anecdote or detail. It is a story that can only be spoken in a fragmented, opaque, and circuitous language, a self-interrupting

discourse of tentative, ephemeral, almost frightened words which rise into the air as inarticulate cries before being carried away by the winds of loss, death, and madness.

II. *"Le récit éclaté"*: The Book of the Fragmented Story

Since Auschwitz, every word, every syllable, carries a dark halo, hides a black guilt, is in silent mourning. No writing has remained unmarked and unmarred by the horrors of extermination. Every memory is inhabited by a hollow, by a void which represents the erasure of remembrance and the remembrance of erasure. "In every name," Jabès writes, "there is a disturbing name: *Auschwitz.*"[15] The history, memory, and countermemory of the *Shoah* are engraved in the aphoristic discourse, the white spaces of silence, the typographical diversity, the enigmatic voices from a timeless past, the unanswerable questions, incessant dialogues, and nomadic meditations that constitute the endless writing of Jabès's self-engendering, open-ended, spiralling books: the seven volumes of *The Book of Questions* (1963–1973), the three volumes of *The Book of Resemblances* (1976–1980), the four volumes of *The Book of Limits* (1982–1987), the two volumes of *The Book of Margins* (1975–1984), and the single volume works, *A Foreigner Carrying in the Crook of His Arm a Tiny Book* (1989) and *The Book of Hospitality* (1991), as well as other meditative texts on dialogue, sharing, otherness, strangeness, racism, subversion, and the conjunction of Judaism and writing.[16] These are books whose absence of closure repeats the endlessness of Jewish exile and the irreducible, unassimilable reality of Jewish alterity. To be Jewish is to live a life of continuous displacement—no matter how deep in the native soil one's roots may go—and to exist in a condition of irreversible otherness or estrangement—no matter how "assimilated" into the national culture one's existence may be—as Jabès learned firsthand in 1957, when he, the member of a family that had resided in Egypt for many centuries, was forced in the aftermath of the Suez crisis to leave Cairo forever and seek asylum in France.

For Jabès, Jewish history begins with a scream that no event or reality has ever silenced: "The light of Israel is a scream to the infinite."[17] Or, as one of the hundreds of fictional rabbis quoted in Jabès's books declares, "The Jewish soul is the fragile casket of a scream" (LQ, p. 186; BQ, p. 165). The echoes of Jewish memory and history reverberate through this cry. "I have given your name and Sarah's to this stubborn scream," the narrator of *The Book of Questions* says to Yukel, "to this scream wedded to its breath and older than any of us,/to this everlasting scream/older than the seed" (LQ, p. 39; BQ, p. 33). And Sarah, having returned insane from the camps, says, " 'I do not hear the scream. . . . I am the scream' " (LQ, p. 187; BQ,

p. 166). The scream is what happens to language when it passes through the nothingness of Auschwitz, when it witnesses unnameable atrocities, when it is struck by inarticulateness. Language can never again be the same.[18] Words are born, Yukel explains to Sarah, "so distant, so forgotten by our brothers, that they are perhaps no longer even human words, but distorted echoes of our buried screams."[19] Henceforth, word becomes wound: "The word 'Jew" is born and dies with every Jew, word of an immemorial wound renewed at every moment."[20] And within the book this "incurable wound"[21] remains forever open; the written text is, Jabès writes, the "enclosure of wounds not to be bandaged, but endlessly reopened" (LQ, p. 195; BQ, p. 173).

If words lose their power to name, to describe, to explain, and to relate, if they become wounds, cries, screams, and laments, then is language helpless before the fact and the reality of Auschwitz? From Jabès's perspective, words, as long as they remain nomadic, unattached, tentative, suspicious, decentered, and full of doubt, are capable of confronting the *Shoah,* of looking into the void of what he calls *"le non-pensable"* (the unthinkable). And the words best suited to this awful task are interrogative; they are questions: " 'We must question the ungraspable, unthinkable, grasped and thought in their arbitrary absence, their jealously protected not-knowing, in failure, pain and blood,' " Jabès writes.[22] As Didier Cahen has pointed out, "only questions that are barely questions, that remain barely formulated," that are continuously undone and replaced by other half-formed and barely articulated questions, can attempt to echo the murmur of six million dead women, men, and children.[23] Only questions can look into the abyss of Auschwitz, because only questions, especially those Jabès poses, renounce the search for answers. The history of the Jews, Jabès remarks, is "the history of the sea transformed into sand so that from this sand, from the changing immensity of this sand, a word will come forth and become the book."[24] Out of the vastness of the desert that was the *Shoah,* from the ashes of the crematoria, a question arises, and from these fugitive, interrogative words Jabès forms his never-ending book of questions.

Through the question, the "story" of the *Shoah* can be presented, or, more precisely, the fragmented or shattered antinarrative (*le récit éclaté*) can tentatively proceed. For language, placed in the service of an interrogative imperative, becomes the site not for the assertion of a fact or the affirmation of a truth, but for the experience of absence, of the void: "Bit by bit I discovered [Jabès observes] that—no matter what one may say about it— writing never is a victory over nothingness, but, on the contrary, an exploration of nothingness through the vocable."[25] The fragmented story, as close to silence and erasure as syntactically possible, as precarious and vulnerable

as a narrative about nothingness can be, is presented in the most minimal manner imaginable. "Little by little, as if in spite of me," Jabès explains to an interviewer:

> this thing began to emerge, the book I had been pursuing in total darkness began to take shape . . . by means of questioning, by means of a dramatic story I wanted to present in the same way I felt it inside me, a story I wanted to tell without ever really telling it. It was as if there were stories that didn't have to be told in order to be known and understood. And this was something quite new in a formal sense: that wasn't the way you were supposed to tell a story. But the idea of a story in itself didn't satisfy me . . . that really wasn't what I was after. But around the story I had in mind, there was the questioning, and more and more that became what haunted me about the book.[26]

Jabès never talks about Auschwitz; rather, he talks *around* it, encircling it with questions and oblique rabbinic commentaries. As for his two young lovers, Sarah and Yukel, only the faintest outline of a story emerges. As a result, since only the barest of facts appear, these do not in themselves constitute a life or even a biography. Sarah Schwall, whose initials ironically evoke the abbreviated name of her tormentors, has the burning desire at fourteen to become a teacher. Her grandfather, Salomon Schwall, born in Corfu, marries Léonie, a rabbi's daughter, in Portugal. He opens an antique shop in the south of France called "Aux mille articles." Moïse Schwall, Sarah's father, fights in the French infantry during World War One, sails around the world as a cabin steward, and then marries Rébecca Sion in Cairo. They return to France and are eventually sent to one of the concentration camps. Sarah is, herself, arrested on the street and deported. After the war she returns to France insane, and for twelve years is confined to a psychiatric hospital, where eventually she dies. About Yukel Serafi even less is known. He is arrested at the home of a friend, deported to one of the camps; after the war he returns to France and there commits suicide.

These anecdotal fragments do not a life make. They do not coalesce into a meaningful portrait. They are as skeletal and emaciated as the inhabitants of the camps. Sarah and Yukel, the former deranged, the latter dead, speak from beyond the world of the living, in a universe only victims can know. In the letters they exchange, the journals they keep, the words they utter, they seem to exist in a state of endless separation, for theirs is a love nourished by suffering and distance. The narrative details that might constitute the "story" of a character or the "life" of an individual are scattered over the four hundred pages of the first three books of *The Book of Questions* like the torn pieces of a letter blown over a field, which one tries to find and

reassemble. This is the *"récit éclaté,"* as Jabès calls it.[27] For not only does Jabès's writing fragment, splinter, and explode the traditional units of narrative emplotment; it reveals the extent to which after Auschwitz narration is extinguished. Nothing can be told except nothing itself. The nature of fact, the importance of biographical details to the telling of a life, to the affirmation of its chronological reality, to its presence in the world are called into question. Sarah and Yukel are mere ciphers of suffering, phantom-witnesses to a season in hell; it is their deaths alone that define them, because whatever paths their lives have taken, these paths all end in an absolute way at Auschwitz. The end alone counts, revising everything that has preceded it; for in the wake of Auschwitz, where human individuality was annihilated, and every person divested of the personal and collective history that had at one time defined her or his uniqueness as a human being, very little can be said about a human life, as this moving, poetic passage from *The Book of Questions* makes clear:

> The lives of one or two generations of men may fill one sentence or two pages. The gross outline of four particular or ordinary lives: "He was born in . . . He died in . . ." Yes, but between the scream of life and the scream of death? "He was born in . . . He was insulted for no good reason . . . He was misunderstood . . . He died in . . ." Yes, but there must be more? "He was born in . . . He tried to find himself in books . . . He married . . . He had a son . . . He died in . . ." . . . Yes, yes, but there must be more? "He settled in the South of France with his wife . . . He was an antique dealer . . . He was called "the Jew" . . . His wife and son were called "the wife and the son of the Jew." Yes, but there must be more? "He died, and his wife died . . . They were buried in ground which did not know their names, near some crosses . . ." Yes, but there must be more? "His son was French . . . He fought in the war for France . . . He was decorated . . ." . . . Yes, but there must be more? "He had a daughter, Sarah . . ." Yes, but there must be more? "He was still called "the Jew," and his wife and daughter, "the wife and the daughter of the Jew." Yes, yes, but there must be more? "He had lost his faith . . . He no longer knew who he was . . . He was French . . . decorated . . . His wife and daughter were French . . ." . . . Yes, yes, but there must be more? "He died in a gas chamber outside France . . . and his wife died in a gas chamber outside France . . . and his daughter came back to France, out of her mind . . ." (LQ, pp. 187–188; BQ, pp. 166–167)

These are details of a life which add up to and end in nothing. The gaps in the narrative sequence which are like unrecoverable lapses of memory, the elliptical lacunae which point to an absent, untellable story, the crescendo of fragments which are the remnants and remains of a lost, recalcitrant past unwilling to make itself known, the halting, hesitant pieces of a puzzle that

leave the listener, and the reader, avid for more narrative detail ("Yes, yes, but there must be more?")—as if it were unimaginable that such a story could be so faltering and incomplete, that such language could be so slow to come—constitute a discourse of impoverished speech that in a formally mimetic way captures the drama of absence, lack, and annihilation that ends in the absolute void of Auschwitz. In the skeletal tale of the Schwall family, narrative becomes a collection of fragmented memories scattered over the blank desert of forgetfulness. The story is erased before our eyes, disappearing into the empty spaces of the page, swallowed up by marks of ellipsis, choked and paralyzed by words that just do not come, or at best must be pulled from the speaker.[28] The voices drop off into silence, into the "unspoken." This is a narrative of perpetual interruption, of continual omission, of unfathomable loss.

Amidst the fragments of the Sarah and Yukel tale, which appear at irregular intervals in *The Book of Questions,* a host of voices, aphorisms, questions, quotations, commentaries, letters, prayers, songs, parables, paradoxes, poems, and other different forms of writing and typography circulate. A flood of language courses through the book without, however, swamping the trickle of fragmented, blurred details that emerge from time to time to tell the "story" of Sarah and Yukel. A torrent of words testifies simultaneously to a burning need to speak and to the impossibility in the aftermath of Auschwitz of such speaking. In his twenty-five or so books, Jabès uses so much language—thousands upon thousands of pages of words—and yet the infinitely open textual spaces of his books, where loss and forgetfulness reign and meaning is perpetually deferred, seem strangely unfilled. The book swallows up the caravans of words that move through it. Forgetfulness effaces Jabès's pages the way the wind blows away footprints in the sand. Each new quotation erases words just quoted; each new paragraph, new page, new book effaces an earlier text. The disappearance of language demands more and more language in an endless struggle between volubility and silence. For, as Jabès writes,

> No closure makes sense in the desert, in the void; no thought, no book which means closure of thought.
> To speak of the book of the desert is as absurd as to speak of the book of nothing.
> And yet, on this nothing I have built my books.
> Sand, sand, sand to the infinite.[29]

III. *"L'hymne d'outre-mémoire"*: The Book of Shattered Memory

So much of Jabès's reiterative, circular, never-ending writing works against memory. The flow of language by which one book seems to uncoil itself in

search of the elusive book-behind-the-book, that unrepresentable Book that every work hopes to discover, produces an excessive and ec-centric writing that is fundamentally antimnemonic. The divergent voices of hundreds of rabbis and of characters whose names are various combinations of the letters a, e, l, y (as in *Aely, Elya, Yaël, El*), the innumerable forms of fragmented writing (interrogative, dialogical, hermeneutic, poetic, aphoristic), and the various kinds of typographic reproduction (italics, parentheses, dashes, quotation marks, ellipses) create a heterocosm of changing linguistic and verbal forms nearly paralyzing the kind of memory that is necessary to the reading process. The fragmented discourse of Jabès's nonnarrative writing, and the sheer diversity of the commentaries which his rabbis make in voices that seem to blend together into one — as if their words were all spoken by the same faceless *rebbe*, living in no precise place or time, having no identity other than his name, and possessing no characterological presence other than what can be mined from the few enigmatic words he utters — conspire to make memory elusive and problematic. It is difficult to remember Jabès's gnomic aphorisms unless you can recall the exact position of each word in its dense syntactic environment. It is even difficult to remember what is taking place in Jabès's books, because the primary "event" or action of the text is the wandering of words across the page. Memory is challenged by the incessant and insistent movement of words whose ephemeral passage across the textual landscape is effaced by the advent of more words. In Jabès's books, writing does not labor to accumulate or bring together memories, and those that do appear are fragmentary, at best. Memory is difficult in Jabès's world because one book, rewriting a previous book by unwriting it, tends to merge with it; all books blend into one. Retrospective reading is limited, since the narrative markers, which compel a reader to remember an earlier event or character or detail, are missing. Because sentences turn back on themselves, thus making knowledge, unity, or coherence nearly impossible, because language wanders along decentered paths of paradox, enigma, and indeterminancy, because speakers are often not persons but only congeries of words, and because questions do not elicit answers but only provoke further questions, memory in the Jabèsian text-world remains tentative and precarious. How, after all, does one remember the invariably white landscape of a desert, with its shifting configurations of sand? If all writing is errancy, how can one remember the movement of words from line to line, from book to book, for " 'White like a page, is the Jewish soul,' said Reb Assayas. 'On it, our intermittent wanderings are printed in the typeface of lost places'."[30]

Jabès's universe is one of *countermemory*. Writing moves too swiftly to leave behind anything but the indeterminate trace of memories. "All memories," he writes, "are bound to death" (LQ, p. 191; BQ, p. 170), connected not only to that death of the past, which becomes the pretext for remember-

ing, but also to that death, or disaster (like Auschwitz), which effaces memory and opens the way to forgetting. There is indeed memory in Jabès, but it is enveloped by questions, by silence, by the blankness of the desert page; it is "the most faltering of all traces."[31] Yet, in that very questioning, that very silence, that very blankness memory persists; for as Jabès writes of the poet Paul Celan, "There is, I am now convinced, no history of the word; but there is a history of the silence that every word relates."[32] Perhaps, memory, too, lies buried in the silence and forgetfulness that articulate it. To put it in a more aphoristic form, one could say that the silence of memory expresses the memory of silence, which is the memory of words and of *their* silence.

Auschwitz is a word that consumes writing, vaporizes meaning, and incinerates memory. It is "that utter-burn where all history took fire," as Blanchot writes (ED, p. 80; WD, p. 47). How can one see when blinded by the searing flash of inhuman death? How can one speak when the vocal cords have been burned? How can disaster ever be written and catastrophe spoken? Auschwitz is, indeed, "the erasure, the ultimate erasure, of Nothingness."[33] Perhaps there is nothing to remember and nothing to say except the memory and the saying of this nothing, a *nothing-speech* flowering like Celan's "no one's rose."[34] We are condemned to use the word Auschwitz, but are powerless to go beyond the nothingness that is its referent and ultimate signified. There is no other name but Auschwitz, synonym of death and void, a tautology beyond which language cannot venture, for ultimately all that can be affirmed is that Auschwitz is Auschwitz. Nothing else can be said because in the *afterwards* of the *Shoah,* as Jabès observes, "words have disemboweled words" (LQ, 279, BQ, p. 247). Silence and oblivion envelop Auschwitz; but there is, nevertheless, to be found in its black ashes the memory of this silence and oblivion, "a hymn from the other side of memory to a memory that is spellbound," as Jabès writes (LQ, p. 361; BQ, p. 326). In imitation of the paradoxical, chiastic, sometimes Talmudic language Jabès favors, one could say that the nothingness of memory is the memory of nothingness, that memory is forgotten only insofar as it remembers, memorializes, and reflects the forgotten. For, as Jabès remarks in the final pages of *The Book of Questions,* "I have told of the desert through the indestructible memory of the void whose every grain is a tiny mirror" (LQ, p. 436; BQ, p. 400). After Auschwitz there is only ash, desert, effacement, ruin, and nothingness, but each of these catastrophes, each of these voids, has its own way of being reflected, of being spoken, and of being remembered, in the always open and forever unfinished book.

Notes

1. Franz Kafka, "An Imperial Message," *The Complete Stories,* ed. Nahum N. Glatzer (New York: Schocken Books, 1946), p. 5.

2. Milan Kundera, *The Joke,* trans. Michael Henry Heim (Harmondsworth: Penguin Books, 1982), p. 244.

3. Kundera, p. 245.

4. Maurice Blanchot, *L'écriture du désastre* (Paris: Gallimard, 1980), p. 80. *The Writing of the Disaster,* trans. Ann Smock (Lincoln: University of Nebraska Press, 1986), p. 47. Hereafter cited as ED for the French original and WD for the English translation. (I have taken the liberty, in a very few places, of making slight changes to the translations.)

5. "Paradoxically," Saul Friedländer remarks, "the 'Final Solution,' as a result of its apparent historical exceptionality, could well be inaccessible to all attempts at a significant representation and interpretation. Thus, notwithstanding all efforts at the creation of meaning, it could remain fundamentally irrelevant for the history of humanity and the understanding of the 'human condition.' In Walter Benjamin's terms, we may possibly be facing an unredeemable past." ("The 'Final Solution': On the Unease in Historical Interpretation," *Lessons and Legacies. The Meaning of the Holocaust in a Changing World,* ed. Peter Hayes [Evanston: Northwestern University Press, 1991], pp. 35, 34, resp.).

6. Jean-François Lyotard, *Heidegger and "the Jews,"* trans. Andreas Michel and Mark Roberts (Minneapolis: University of Minnesota Press, 1990), p. 26.

7. "Can we," asks Roger Laporte, "retain an exact memory of an awful truth that we have never known, of a nameless tragedy that was erased before being written and therefore doomed from the beginning to oblivion?" Roger Laporte, " 'L'Ancien, l'effroyablement ancien,' " *Etudes* (Paris: P.O.L., 1990), pp. 60–61. (Unless otherwise noted, all translations from the French are mine.)

8. Maurice Blanchot, "Thinking the Apocalypse: A Letter from Maurice Blanchot to Catherine David," trans. Paula Wissing, *Critical Inquiry* 15 (Winter, 1989), p. 479.

9. "Disaster," for Blanchot, transcends any Western notion of closure, *telos,* or death. Beyond limits or ends of any kind, it is beyond language, memory, and representation. It is "beyond what we understand by death or abyss, or in any case by *my* death, since there is no more place for 'me': in the disaster I disappear without dying (or die without disappearing)" (ED, p. 182; WD, p. 119). "Disaster" is a death-beyond-death, an endless dying on the other side of death itself, what Blanchot refers to as *le mourir* (dying) as opposed to *la mort* (death): "There is in death, it would seem, something stronger than death: it is dying itself. ... Death is power and even strength—limited, therefore. It sets a final date. ... But dying is unpower. It wrests from the present, it is always a step over the edge, it rules out every conclusion and all ends, it does not free nor does it shelter" (ED, p. 81; WD, pp. 47–48).

10. Lyotard suggests that Auschwitz may be compared to a powerful earthquake that in its awesome devastation destroys all instruments of measurement. "The silence that surrounds the phrase 'Auschwitz was the extermination camp' is not a state of mind (*état d'âme*), it is a sign that something remains to be phrased which is not, something which is not determined." Jean-François Lyotard, *The Differend: Phrases in Dispute,* trans. Georges Van Den Abbeele (Minneapolis: University of Minnesota Press, 1988), pp. 56–57.

11. Forgetfulness is the link to an immemorial past. It is the umbilical cord connecting us to lost and irretrievable memories. As an absence that remains paradoxically present as absence, forgetfulness dwells in language, where it evokes not what has been lost—that would be to recall what can no longer be remembered—but rather

the fact, the event of forgetfulness. "Being," as Blanchot affirms in *L'attente, l'oubli* (Paris: Gallimard, 1962), "is another name for forgetfulness" (p. 69).

12. For further discussions of the concentration camp universe, the place of language and silence in it, and the Jew's identity as other, as stranger, see Blanchot's essays, "Tenir parole," "L'interruption. Comme sur une surface de Riemann," and "L'indestructible" in his *L'entretien infini* (Paris: Gallimard, 1969), pp. 84–93, 106–112, 180–200. A lengthy, detailed, and provocative discussion of the question of the historical and artistic representability of the *Shoah* can be found in several of the essays collected by Saul Friedländer in *Probing the Limits of Representation. Nazism and the "Final Solution"* (Cambridge: Harvard University Press, 1992).

13. On the literary and artistic figuration of loss, see my *Lost beyond Telling: Representations of Death and Absence in Modern French Poetry* (Ithaca: Cornell University Press, 1990), pp. 1–46.

14. "It is the impossibility of speaking or writing such an event [as the Holocaust], the absence of an adequate language which becomes the primary concern, the 'urgent and obsessive' concern of the writer today, and especially the Jewish writer," Raymond Federman observes. "To say that it is impossible to say what cannot be said, is indeed a dead end in today's literature, unless one makes of this gap, this lack, this linguistic void the essential moral and aesthetic concern which displaces the original event towards its erasure, and thus transcends 'the story'." ("Displaced Person: The Jew/ The Wanderer/The Writer," *Denver Quarterly* 19 [Spring 1984], pp. 92, 97). Regarding the impossibility of narrative after Auschwitz, see also Lyotard, *Heidegger and "the Jews,"* pp. 47–48, 79; and Sarah Kofman, *Paroles suffoquées* (Paris: Galilée, 1987), p. 21. For a discussion of the problems inherent in this notion of narrative unfigurability, see Saul Friedländer, "Introduction," *Probing the Limits of Representation,* pp. 1–21; and, in the same collection, Hayden White, "Historical Emplotment and the Problem of Truth," pp. 37–53. For an intruging discussion of the ethical superiority of historical representation over artistic or literary figuration, see Berel Lang, *Act and Idea in the Nazi Genocide* (Chicago: University of Chicago Press, 1990), pp. 117–161.

15. Edmond Jabès, *Le parcours* (Paris: Gallimard, 1985), p. 43.

16. On the spiralling, decentered movement of Jabès's books and their tendency to avoid beginnings and ends, see Edmond Jabès, *From the Desert to the Book. Dialogues with Marcel Cohen,* trans. Pierre Joris (Barrytown, NY: Station Hill Press, 1990), p. 53.

17. Edmond Jabès, *Le livre des questions,* collection L'imaginaire (Paris: Gallimard, 1963), p. 185; *The Book of Questions.* Volume I: *The Book of Questions, The Book of Yukel, Return to the Book,* trans. Rosmarie Waldrop (Middletown: Wesleyan University, 1991), p. 164; hereafter cited as LQ for the French edition and BQ for the English translation.

18. "I deeply believe that since Auschwitz in general, the word is wounded," Jabès tells an interviewer. "And that our speech is different. It's as if we're speaking with someone who has an injury. We cannot escape it. . . . And what has been deeply affected is *in* that speech. The words say the same thing obviously, but at the same time they tell their injury, in a certain way" ("An Interview with Edmond Jabès," *Conjunctions* 9 [1986], p. 147). See also Philippe de Saint Cheron, "Entretien avec Edmond Jabès," *La nouvelle revue française,* 464 (September 1991), pp. 68–69.

19. Edmond Jabès, "Letter from Yukel to Sarah," *The Book of Margins,* trans. Rosmarie Waldrop (Chicago: University of Chicago Press, 1993), p. 105.

20. *The Book of Margins,* p. 173.

21. Edmond Jabès, *The Book of Dialogue,* trans. Rosmarie Waldrop (Middletown: Wesleyan University Press, 1987), p. 20.

22. Edmond Jabès, *The Book of Resemblances,* trans. Rosmarie Waldrop (Middletown: Wesleyan University Press, 1990), pp. 48–49.

23. *Edmond Jabès* (Paris: Belfond, 1991), p. 50.

24. *Le Parcours* p. 91.

25. Jabès, *From the Desert to the Book,* p. 42. "Making the book," Jabès notes, "could mean exchanging the *void of writing* for *writing the void*" (*The Book of Margins,* p. 106).

26. Paul Auster, "Book of the Dead: An Interview with Edmond Jabes," in Eric Gould, ed., *The Sin of the Book: Edmond Jabès* (Lincoln: University of Nebraska Press, 1985), pp. 12–13.

27. "Book of the Dead," p. 14.

28. For an extraordinary description of the paralysis of language in the post-Holocaust era, where words become inadequate to the images and memories they are called on to express, see Robert Antelme, *L'espèce humaine* (Paris: Gallimard, 1957), p. 9.

29. *The Book of Resemblances,* p. 112.

30. *The Book of Resemblances,* p. 85.

31. Edmond Jabès, *The Book of Questions,* Volume II: *Yaël, Elya, Aely, El, or the Last Book,* trans. Rosmarie Waldrop (Middletown: Wesleyan University Press, 1991), p. 177.

32. Edmond Jabès, "The Memory of Words (How I Read Paul Celan)," trans. Richard Stamelman, *Tel Aviv Review* 3 (1991), p. 141.

33. Edmond Jabès, *Le livre de l'hospitalité* (Paris: Gallimard, 1991), p. 28.

34. Paul Celan, "Psalm," in *Paul Celan: Poems.* A bilingual edition, trans. Michael Hamburger (New York: Persea Books, 1980), p. 143: "A nothing/we were, are, shall/ remain, flowering;/the nothing-, the/no one's rose."

V

Cinematic Images

17

La vie en rose

IMAGES OF THE OCCUPATION IN FRENCH CINEMA

Naomi Greene

It has become a truism to observe that historical films tell us as much, and often more, about the era in which they are made than the one they choose to portray. Jean Renoir's portrait of the French Revolution, *La marseillaise*, raises issues which confronted the Popular Front in 1938; Sergei Eisenstein's medieval epic, *Alexander Nevsky*, reveals the fear of invasion which haunted the Soviet State of 1936. Set in the past, historical films bear witness to the present even as they help form our vision of the future. No one could deny, for example, the role played by the Hollywood Western in shaping America's continuing sense of a mythic past, an imperial destiny.

French historical films set in the Vichy era are no exception to these general observations. In the immediate postwar years, the dearth of films dealing with the Occupation certainly bespoke a widespread need to forget one of the blackest periods of French history. Later, in the mid-1960s, the upsurge of films exalting the Resistance reflected de Gaulle's rise to power. As far as *les années noires* are concerned, moreover, the relationship between film and history has a further, indeed unique, dimension. Far more than any other single document or event it was a *film*, Marcel Ophuls' 1971 work, *Le chagrin et la pitié* ("The Sorrow and the Pity") which first brought into question historical perceptions which had remained virtually unchallenged since the Liberation.

Taking *Le chagrin et la pitié* as a point of departure, in these pages I would like to examine, first, some of the ways in which this film reexamined history so radically that an entire generation was prompted to see the Vichy era in a new light. And, second, against the background afforded by this "rereading," I would like to analyze the portrayal of the Occupation found in several key films of the 1970s and 1980s. It is my conviction that, even as these

films distanced themselves from the troubling issues raised by Ophuls's work, they offered important insights into the way the collective memory of the Vichy years has been revised, progressively, in the course of the last twenty years. Assuming that film offers a special reflection of the collective unconscious, and that the way we view the past is a barometer of the present, then these films reveal nothing less than a disturbing and even dangerous desire to return to the comforting myths of the postwar years.

When it appeared in 1971, the impact of *Le chagrin et la pitié* was so profound that French historian Henry Rousso—author of *Le syndrome de Vichy* (*The Vichy Syndrome*) a work which analyzes the ever-persistent repercussions of the Vichy trauma—deemed it nothing less than an "explosion." Cries of outrage evoked by the film in certain quarters made it clear that the wounds of the 1940s had by no means healed. For example, inditing *Le chagrin et la pitié* for its use of "gimmicks, omissions, and deliberate falsifications," the critic for *Le Monde* condemned it, in particular, for its portrait of French anti-Semitism. "*Il est toujours gênant,*" wrote Alfred Fabre-Luce, "*de voir les survivants [les juifs] accabler un homme [Pétain] a` qui ils doivent la vie.*" ("It is always disturbing to see survivors [i.e., the Jews] gang up on someone [Pétain] to whom they owe their life" [Cited by Rousso, p. 122].) And the French government apparently found the film so disturbing, so potentially dangerous to national morale, that although it was widely shown on television throughout much of Europe, it was not allowed into French homes for nearly a decade, that is, until 1981, the year when, for the first time since the Popular Front, the Left returned to power.

The controversial nature of *Le chagrin et la pitié* stemmed, clearly, from the fact that it focused on the most unpalatable, and most repressed, aspects of the Vichy years: that is, on the extent and consequences of French anti-Semitism and collaboration. Its view of the past was so different from that generally accepted after the war that, in Rousso's eyes, the film established nothing less than a "counterlegend" of the Vichy years. It was a legend that broke sharply, deliberately, with the so-called "myth of the Resistance" that had been carefully launched by de Gaulle even before the Liberation. In a famous 1944 speech, de Gaulle set forth the main themes of this "myth" as he rallied the French citizenry thus:

"Paris! Paris outraged! Paris broken! Paris martyred! But Paris liberated! Liberated by itself! Liberated by its people with the help of the armies of France, with the support and the help of all of France, of the France which fought, of the only France, of the true France, of eternal France! (Miller, p. 140)

The image of a France that had been "martyred" and "liberated," but not defeated and divided, was one calculated, of course, to restore the unity and morale of a nation that had been shaken to the core. De Gaulle carefully avoided any mention of the fratricidal ideological struggles which had marked the period of the Occupation and Liberation, struggles which—reaching back into the revolution and the Dreyfus Affair—were deeply rooted in France's past. Acting as if the right-wing, antirepublican, and collaborationist government of Vichy had never existed, de Gaulle described his country as one where a united people, confronted only by a foreign invader, had rallied behind the active cadres of the Resistance and liberated "eternal France." Discussing the widespread, persistent acceptance of this view of history, Henry Rousso describes it concisely as:

> a process which sought, first, to downplay the essence of the Vichy regime, *including its most negative aspects,* and to systematically reduce its hold on French society; second, to construct an *object* of memory, that is, the "Resistance," which instead of limiting itself to the active . . . groups which actually resisted, celebrates and embodies itself in *places* and especially in the bosom of ideological groups, such as Gaullists and Communists; third, to assimilate this "Resistance" with the whole of the nation. (Rousso, p. 21; my translation)

It is, precisely, this heroic view of the past that *Le chagrin et la pitié* felt impelled to challenge. To do so, it presented a huge mound of documentary evidence: interviews with ordinary French men and women as well as historical figures (Anthony Eden, Pierre Mendès-France) are juxtaposed with newsreel and film clips of the era. Significantly, de Gaulle himself—the central figure in the postwar view of history—is virtually absent from the film. Constantly moving between the past (documentary footage, newspaper clippings) and the present (interviews), the film concerns the very process of memory as much as it does the fact of the Vichy era itself. The national portrait that emerges from this process is of an occupied people characterized not by resistance and unity, but, instead, by widespread indifference and pettiness, by daily fears and small acts of cowardice, by active and passive collaboration. We begin to see the deep-seated attitudes that encouraged collaboration, that made France, as we are reminded several times, the only European country which actively collaborated. Witnesses may deny the widespread enthusiasm that was felt for Pétain, but newsreel clips repeatedly show us the cheering crowds that hailed the Marshal wherever he went. Moments of collective history are constantly interspersed with individual reminiscences, confessions, denials. By playing witnesses off against one another, by confronting their recollections with objective evidence to the

contrary, those interviewed—and, implicitly, many of their countrymen and women—are forced to face buried truths.

Undoubtedly the darkest of these truths concerns the deep-rooted current of French anti-Semitism which played into Nazi hands. Here, denials are particularly shrill and insistent; objective evidence, particularly damning. For example, in one revealing sequence, a shopkeeper by the name of Klein in Clermont-Ferrand (a town which serves Ophuls as a microcosm of the Unoccupied Zone) is asked about the fate met by Jewish merchants during the Occupation. At first, his recollections are vague; the issue, it seems, never concerned him. But then he is shown a notice that he placed in a 1941 newspaper declaring that, despite his name, he was not Jewish. Confronted with this piece of evidence from the past, he is startled and exclaims "Oh, you know that"—thus revealing all the cowardice, the dissimulation, that he (and how many others?) displayed during the Occupation. Attempting to explain, justify, his behavior he makes it worse when he says that he simply wanted people to know that he was "French" not "Jewish."

The merchant's attitude, his insistent distinction between "Frenchmen" and "Jews," is echoed—against a far broader canvas—by Comte René de Chambrun, son-in-law of the archcollaborationist, Pierre Laval. Ardent in his defense of Laval, Chambrun extravagantly describes him as a "resistance" fighter who did his utmost to save French Jews. Ophuls, citing the terrible numbers of those deported, is forced to "remind" Chambrun that even if Laval defended *French* Jews, he willingly traded foreign Jewish refugees for French workers detained in Germany. And this "reminder" is followed by a chilling sequence which contradicts and undermines all of Chambrun's strident denials. As newsreel clips pass before us, we hear a description of one of the most notorious deportations: that is, when Jews were assembled in the stadium of the Vel d'Hiver before being sent to Germany. During this roundup, the zealousness of the French police led them to include Jewish children, whom the Nazis had not demanded, among the deportees. And when Laval was informed about the mistake, we are told, he apparently remarked that the inclusion of the children served a beneficial, that is, prophylactic, purpose.

In contrast to the merchant and Chambrun, one of the most moving witnesses in the film, Christian de la Mazière, does not not deny his early anti-Semitism. Raised in a traditional right-wing family, he shared its overwhelming fear of Communism, its sense that, as the slogan had it, Hitler was preferable to Stalin. Conviction prompted him, he recalls, to join a special division of the German Army composed of *French* volunteers. Compelling and lucid, his reminiscences indicate the often determining role played by ideology in those years, even as they demonstrate that, *contrary to popular conception,* in many cases collaboration stemmed not from moral

turpitude or greed, but, indeed, from political passion and even (as in his case) idealism.

It is clearly no accident that *Le chagrin et la pitié*, with its controversial reexamination of history, appeared in 1971. By that time, the Gaullist era (in whose interest it was to preserve the "myth of the Resistance") had ended; and a new generation—a generation which had no need to forget or repress certain truths—had come of age. Moreover, the film was made in the aftermath of the upheavals of May 1968—upheavals which called into question social structures and institutions, received truths and orthodoxies. Reflecting this new climate of skepticism and interrogation, *Le chagrin et la pitié* was clearly, as film historian Jean-Pierre Jeancolas notes, "a work of nonbelievers, a work where one no longer believes in de Gaulle or Stalin; one no longer believes in the history of monuments, of sepulchres, and of textbooks" (Jeancolas, p. 209).[1]

Soon after the appearance of *Le chagrin et la pitié*, it became clear that Ophuls's work both embodied, and helped stimulate, a renewal of interest in the Vichy past. Revisionist histories of the Occupation were matched, in the world of cinema, by numerous films set at the time of Nazism-Fascism. (Concurrently, Vichy cinema itself became the subject of scholarly attention as long-forgotten films were rediscovered, assembled in retrospectives.) The gamut of these films—which constituted, collectively, what became known as the *"rétro"* phenomenon—varied greatly: for example, the year 1974, alone, saw *Stavisky*, Alain Resnais's stylized and cerebral portrait of a shady financier whose downfall sparked fascist riots; *Les violons du bal*, Michel Drach's sentimental reminiscences of the era; and *Lacombe Lucien*, Louis Malle's portrait of a young French collaborator. Rather than glancing rapidly at all, or even most of these films, at this point, I would like to examine some of the best-known and most successful among them: *Lacombe Lucien* (1974) and *Au revoir les enfants* (1988) by Louis Malle, *Le dernier métro* by François Truffaut, and *Une affaire de femmes* (1988) by Claude Chabrol. (Strictly speaking, *Au revoir les enfants* and *Une affaire de femmes* came after the *"rétro"* phenomenon). While their critical and popular success was certainly an indication of their artistic merit—they represent the work of some of France's finest directors—it also suggests that their portrait of the Occupation struck a sensitive chord in the viewing public. In this sense, they constitute a sensitive barometer to the changing perspectives of the Vichy era which emerged as the "revolution" of May, and the "explosion" of *Le chagrin et la pitié*, faded into the distant past.

There is little doubt, for example, that the portrait of a young French collaborator found in Louis Malle's *Lacombe Lucien* (1974) is still infused

with the lingering spirit of May 1968, with the revised view of history embodied in *Le chagrin et la pitié*. Even now, when hindsight has brought into sharper focus the subtle, yet vital, differences between the two films— differences that I would like to return to in a moment—it is not difficult to see why a number of critics were moved to compare the two films at the time.[2] Writing in the influential left-wing weekly *Le nouvel observateur*, Jean-Louis Bory, for example, declared that Malle's film was nothing less than "the first real film—and the first true film—about the Occupation. . . . I know. I was there" (Bory, pp. 56–57). On this side of the Atlantic, Bory's view was echoed by an enthusiastic Pauline Kael. *Lacombe Lucien* was, she remarked, a "long, close look at the banality of evil. . . . Without ever mentioning the subject of innocence and guilt, *Lacombe Lucien*, in its calm, leisurely, dispassionate way, addresses it on a deeper level than any other movie I know" (Kael, p. 97).

The problem of "evil," as Kael has it, is embodied in the film's protagonist, a young peasant lad, Lucien, who joins the militia—the French arm of the Gestapo. As the film opens (we are in 1944) Lucien is seen performing menial tasks in a hospital ward while Pétain's voice issues from the radio. Hoping to escape from his oppressive job, Lucien returns to his mother's farm; but is quickly dismissed by her new boyfriend. (His father has been sent to Germany.) In much the same spirit of escape, he then attempts to join the Resistance. But here too he is rejected: the local leader, a schoolteacher, contemptuously brushes him aside, telling him he is both too young and ignorant. At this point, sheer happenstance intervenes. A bicycle accident causes him to violate the curfew, and he is apprehended by the French militia. Far more psychologically astute and cunning than the Resistance leader, members of the militia flatter him, ply him with drink, and press him for information. Naïvely, drunkenly, he tells them about the Resistance leader who, as a result, is captured and tortured. Seemingly indifferent to the consequences of this act of betrayal, imbued with a sense of power and importance for the first time in his life, Lucien becomes a member of the odious militia.

But soon we discover that there is another side to the brutal, amoral Lucien. A childlike simplicity and vulnerability come to the fore when he meets, and falls in love with, a young Jewish woman who has fled from Paris to the South of France with her father, the cultivated M. Horn, and her grandmother. The scenes with the young woman and her family depict Lucien as an awkward adolescent desperately in need of a father figure (he craves approval from M. Horn) and capable of romantic love. When, toward the end of the film, the young couple finally escapes to the countryside, there is no doubt that the "good" side of Lucien has finally triumphed. Against the lush greens of the French countryside, Lucien uses his peasant

skills to care for and protect the young woman. The viewer is thus brought up short when, after this idyllic, pastoral sequence, the film comes to a sudden, jolting halt: a freeze-frame of Lucien is followed by subtitles narrating his eventual capture and execution.

It was, certainly, Malle's focus on the issue of collaboration, his creation of a character in whom brutality and innocence coexist, that suggested to many the moral ambiguities, the "banality of evil," evoked in *Le chagrin et la pitié.* Only a few dissenting voices—almost all on the left—were heard. And yet, as suggested earlier, the passage of time has made it increasingly clear that these few voices raised essential issues. It is not merely that Lucien, as a marginalized peasant lad, is a most atypical collaborator. (It is noteworthy that, the Jewish family instead is painted in conventional terms. Indeed, improbably piling one stereotype upon another, Malle depicts M. Horn as both a cultured cosmopolite and a tailor.) Nor is it simply that Lucien's social oppression does much to excuse his collaboration or his more brutal actions; or even the fact that he is ultimately redeemed by the love he feels for the Jewish woman. It is, above all, that Lucien exists in an ideological vacuum. Little hint is given of the bitter political divisions which, as *Le chagrin et la pitié* had made clear, set Frenchman against Frenchman, leading some to collaboration and others to resistance. Commenting upon the absence of ideology and politics in *Lacombe Lucien,* Stanley Hoffmann, who spent the war years in a *lycée* in France, noted that it went directly counter to his own experience. In his view, the Vichy era was one in which "conflicting creeds" played an essential role in determining peoples' behavior. Noting that in his own *lycée* "even ten-year-olds often lined up aggressively on one or the other side of the barricades," he went on to say that the Occupation was a time when:

> ideology pushed people into collaboration, or pro-Vichy organizations, or the variety of Resistance movements. . . . Especially by 1944 [the time of the film] many of the French who worked with or for the Nazis did so out of belief more than out of social resentment—or at least they had rationalized and translated their class anger into ideological belief. (Hoffmann, p. 21)

It is, of course, precisely this "belief" which is lacking in *Lacombe Lucien.* Virtually defined by his ignorance of politics and ideology, Lucien's "opaqueness" (to use Malle's term) strains the imagination at times. After four years of propaganda and Occupation, could anyone still ask, as he does, "What is a Jew?" Or be unable to make any real distinction between resistance and collaboration? After joining the militia, Lucien does finally make some ideological pronouncements; but, even then they are always

attributed to someone else. "M. Tonin," he repeats mechanically, "says that the Jews are the enemies of France." His persistent refusal to take sides is underscored in one critical scene. When a Resistance fighter he is guarding demands to know what side he is on, Lucien's only response is to gag the prisoner and paint a mouth on the gag—as if, by this childish gesture, he could make the question, and all of ideology, vanish. Commenting on this particular scene, Pascal Bonitzer, writing in *Les cahiers du cinéma,* remarked: "What the prisoner asks of Lucien is to choose one camp or the other, to take a position. But the character of Lucien has no other function than to disappoint such a demand" (Bonitzer, p. 92). For Bonitzer, Lucien's fundamental ambiguity—an ambiguity which the French critic perceives at the heart of the film itself—means that, in the end, *Lacombe Lucien* "says nothing about collaboration, except that one could be involved in it by accident and without knowing anything about it" (p. 91).

Bonitzer's equating Lucien's ambiguity and that of the film itself may seem a bit extreme. But his argument is buttressed, I think, by the fact that no one in the film appears to choose sides for moral or political reasons. No one, not even those at militia headquarters, harbors ideological convictions of any sort. And not only are the French collaborators apolitical, but they also seem to constitute a race apart. Embittered souls and social misfits, their ranks include a nihilistic, aristocratic dandy and his hysterical girlfriend, a brutal ex-policeman, a repressed schoolteacher, and a slightly sadistic African. On the surface, they seem to embody a diverse spectrum of French society but, in truth, it is a spectrum very different from that found in *Le chagrin et la pitié.* While Ophuls's film made it clear that ordinary people collaborated, or were indifferent to collaboration, for a host of ordinary, banal reasons (fear, greed, apathy) as well as ideological conviction, in *Lacombe Lucien,* collaboration, limited to a group of strange, pathological individuals, is divorced both from ordinary life and from ideology.

Malle's portrayal of collaboration raises still another troubling issue. After all, if actions are always explained in the narrowest of personal terms, cut off from the surrounding political context, what happens to the moral dimension, the concrete historical cast, of choices made during those bleak years? To take the case of Lucien himself: can he really be faulted or held responsible for joining the militia if that decision was prompted solely by a combination of happenstance (the bicycle accident, the obtuseness of the Resistance leader) and class oppression? The last scenes of the film, in which Lucien appears as a noble savage martyred, in the end, by circumstances beyond his control, reinforce the notion that we are all good and evil, led into given paths not by individual choice but by chance, by destiny. Were it not for the war, it is suggested, Lucien might have lived happily and well. If Lucien is not totally blameless, neither is the society which kills him.

Historical choices are thus bathed in a kind of moral relativism; history and society become the culprits even as the individual is washed clean of sin.

Not surprisingly, it was this last message which most disturbed a number of critics on the left. Writing in *Les temps modernes*, Christian Zimmer, for example, declared that the absolution accorded Lucien signaled nothing less than the reemergence of the traditional right that, in fact, had welcomed collaboration.[3] In Zimmer's view, the last scenes of the film—scenes in which nature replaces history, even as all the good in Lucien comes to the fore—represented "an image of the reconciliation preached by the Right" (Zimmer, pp. 2494–2495). This message of "reconciliation" had been made possible, Zimmer argued, by the death of de Gaulle and the advent to power of the conservative regime of Giscard d'Estaing—a regime which, in his view, had traded in the idealistic visions of the past for the meager, pragmatic goals of technological capitalism. In a discussion of *Lacombe Lucien*, he wrote:

> The "*rétro*" mode is not a morbid attraction for a sinister period of history but the reflection, the manifestation of a political current. Gone are *great aims:* the Resistance was one, Gaullism another. . . . Gone are virtuous indignation, intransigeance, fidelity. . . . At the level of the individual there are only *personal* problems and, at the level of power, only *technical* ones. (Zimmer, p. 2496)

Zimmer's suggestion that *Lacombe Lucien* corresponded to an era which had turned its back on ideology, on the rereading of history implicit in *Le chagrin et la pitié,* was amply borne out by subsequent films. As the 1970s slid into the 1980s, the most difficult and unpalatable aspects of the Occupation years—in particular, the issue of French collaboration, as well as the conflicting political and ideological passions of the time—receded into the background, withdrew from history. While films continued to depict some of the worst events (that is, the deportations) of the Occupation, they tended to ignore the deep-seated attitudes, the troubled moral zones (such as anti-Semitism), which helped make those events possible. In this sense, if such films can be faulted for bias, charged with giving a softened portrait of the Vichy past, *it is less for what they say or show than for what remains invisible, repressed.* Leaving history and its anguish to documentary filmmakers such as Claude Lanzmann (*Shoah,* 1985), Marcel Ophuls (*Hotel Terminus,* 1988), and Pierre Sauvage (*Weapons of the Spirit,* 1989)—all of whom, significantly, are Jewish[4]—films set in the Occupation focused, instead, on private dramas, on internal worlds.

Nowhere is this process of repression better illustrated than in one of the most successful films of its time: François Truffaut's *Le dernier métro* (1980).

Starring two of France's most glamorous stars (Catherine Deneuve and Gé-rard Depardieu), *Le dernier métro* traces the fortunes of a theatrical troupe engaged in mounting a new production in the Paris of 1944. In this film, as always in Truffaut, not only is the world of performance more true and compelling than any other, but, significantly, it is also a world unto itself, a world hardly touched by external events. Here, the Occupation becomes little more than a source of conventional images (a beautiful Deneuve bravely rejects the advances of a Nazi officer; a Parisian nightclub singer entertains German soldiers; an actress draws pencil lines on her legs to simulate real stockings) and of difficulties which are easily overcome. For example, the Jewish director of the troupe, forced to disappear, soon finds that he can secretly direct the play from his hiding post in the theater's basement; the Fascist critic who threatens to halt the production is roundly thrashed by the leading man; a Jewish costume designer is able to violate the curfew by draping a scarf over her yellow star.

In short, never had the difficulties of the Occupation been more negligible (reduced, in fact, to the machinations of a hostile theatre critic) or, to use Rousso's term, more "trivialized." Even Truffaut's usual attention to *vraisemblance,* as critic Yann Lardeau observed, is noticeably missing (Lardeau, p. 4). For example, the Nazis do not recognize the leading man, although they have seen him with a captured Resistance fighter; the police, who urgently come to search the theater, wait for Deneuve to take them round herself (so that the director has time to hide). Struck by the improbable aspect of the film, Richard Grenier, one of its very few hostile critics, suggested that that its portrayal of *les années noires* owed less to personal memory (as Truffaut suggested) than to old Hollywood movies. "I suspect," wrote Grenier;

> that the notion of the hidden Jew in the cellar was suggested by *The Diary of Anne Frank* (the film, not the book); the idea of a stage director secretly guiding the performances in a stage production, by a comparable device in the Fred Astaire-Ginger Rogers musical *The Barclays of Broadway;* and the florid declaration of a minor actress's naked ambition by the character of Anne Baxter in *All About Eve.* (Grenier, p. 64)

Nourished, as Grenier suggests, by Hollywood film, *Le dernier métro* also taps into a uniquely French strand of inspiration—a strand embedded in the Gaullist vision of the Occupation that came under scrutiny in the early 1970s. Truffaut's film takes us back into that reassuring world of unity and resistance unmarked by ideological divisions and political passions. This tone is set in the opening scene: a German soldier touches a boy's head in a rough caress. Immediately afterwards, the boy's mother washes his hair

to remove the contamination of the Nazi touch. The mother's sentiments are shared, of course, by almost everyone in the world of the theater, a world hardly noted for courage and resistance during the Occupation. Even more improbable, perhaps, is the sympathy they all express for Jews. Members of the troupe do not hesitate to rally round the Jewish costume designer and her daughter; Jew and Gentile happily work together backstage; the leading man is surprised and outraged (this, in 1944!) that the theater might refuse to hire Jewish actors. Indeed, the only anti-Semite in the film is the Fascist critic who, not surprisingly, has a bizarre, perhaps homosexual, edge to him. Once more, the message is unmistakable: only twisted, pathological beings were anti-Semitic; the vast majority of the French did everything possible to aid the Jews.

The great success of *Le dernier métro* left no doubt that its view of the Occupation was a welcome one. Unlike most of Truffaut's films, in fact, *Le dernier métro* was a giant box office hit, leading all other French films of 1980, and even topping *The Empire Strikes Back*. And the vast majority of critics shared the public's enthusiasm. Expressing what seemed a widely held sentiment, one reviewer went so far as to confess: "Of all the films situated in the Paris of *les années noires, Le dernier métro* is the only one, I say the only one, that I was able to see with detachment, amusement, emotion . . . without feeling (nausea, shame, anger) a refusal of my whole being" (Cited by Garçon, p. 544). Commenting on the huge success of this rose-tinted, comforting, and totally unreal portrait of *les années noires,* François Garçon, critic for the left-wing review *Les temps modernes,* sadly concluded that, along with Fassbinder's *Lili Marleen,* Truffaut's film signaled an end to the era of self-examination launched by *Le chagrin et la pitié.* "In France," he wrote, "*Le dernier métro,* because of its unbelievable success, can be considered, we believe, as the negative image of the film of Marcel Ophuls" (Garçon, p. 545).

Truffaut's cheerful portrait of the Occupation was, in retrospect, an isolated phenomenon—probably due as much to the director's apolitical sensibility as to the climate of 1980. But if the unreal cast of the film was unique to Truffaut, its avoidance of difficult issues clearly represented more general trends. Indeed, it is noteworthy to what extent recent films such as Louis Malle's *Au revoir les enfants* (1987) and Claude Chabrol's *Une affaire de femmes* (1988)—films which strike a new note of realism in their depiction of the constant hardships which marked the years of Occupation—avoid the moral ambiguities, the troubled zones, which haunted French life during that somber time. The protagonists of these films may not live in the magical, self-enclosed realm of the theater, but they are almost as insulated from the world of politics and ideology, as untouched by the intense propaganda of

the time, as the performers of *Le dernier métro*. Their unawareness of the world about them, an unawareness which is carefully and repeatedly underscored, permeates each film, with the result that the dilemmas and choices of history give way to "eternal" truths about the human soul.

The two directors express, of course, radically opposed views of human nature. *Au revoir les enfants* exhibits such a benign faith in mankind that, were it made in Hollywood, it would doubtlessly have been deemed heart-warming. The film traces the growing friendship of two schoolboys, Jew and Gentile, who meet in a *lycée* run by priests courageous enough to hide Jewish refugees among their more affluent charges. Both boys are winning, but the Jewish lad, in particular, is portrayed in a way calculated to capture all our sympathy. Talented at math and music, he is sensitive as well as intelligent. He is so idealized, in fact, that an exasperated Pauline Kael was moved to note that:

> he's photographed as if he were a piece of religious art: Christ in his early adolescence. There's something unseemly about the movie's obsession with his exotic beauty—as if the French-German Jews had come from the far side of the moon. And does he have to be so brilliant, and a gifted pianist, and courageous? (Kael, p. 86)

The film does end tragically: a servant lad who has been unjustly dismissed from his job at the *lycée* decides to collaborate by denouncing the presence of the Jewish schoolboys. But in this resolutely uplifting film, not only is the collaborator (like Lucien) somehow excused (he too is victim of social oppression and injustice), but the drama of collaboration—which was, after all, at the heart of Malle's earlier film—has become distinctly secondary. Not surprisingly, when evil finally overtakes this world of schoolboy inno-cence and adult courage, it comes from the outside—in the shape of anony-mous German soldiers.

If evil is confined to the margins and the very end of *Au revoir les enfants*, in *Une affaire de femmes* its presence is, instead, all-pervasive. A somber portrait of social and moral corruption, the film, based on a real incident, concerns a young French housewife and mother who became an abortionist during the Occupation, and was made to pay for her crime with her life. In striking contrast to *Au revoir les enfants*, in this dark and disquieting film, no one is innocent. Not the woman herself, Marie (wonderfully played by Isabelle Hupert), who gradually succumbs to greed and sensuality; not her weak and jealous husband, who eventually denounces her to the authorities; least of all the hypocritical Vichy tribunal, which condemns her to death to set an example of French "morality."

At first glance, the sinister moral climate of *Une affaire de femmes*, its

portrait of spreading corruption and guilt, appear to capture an important aspect of the Vichy years. But closer examination, in particular a backward look at other films by Chabrol, suggests that the climate of *Une affaire de femmes* owes less to historical circumstance than to the outlook of a *moraliste* (some would say a Catholic *moraliste*) who has always been concerned with the problem of guilt and innocence, with the complicity that links criminals to "respectable" society, and with the flaws in human justice. *Une affaire de femmes* may be set at the time of the Occupation, but here, as in Chabrol's other films, these issues are seen primarily in absolute terms—in relation to eternal impulses of the human soul—rather than historical ones. The deprivations of the Occupation may trigger Marie's fall, but its real causes lie deep within her. Like all the fascinating criminals who people Chabrol's films—from Blubeard and the psychopathic butcher of *Le boucher,* to the young woman (also played by Isabelle Hupert) of *Violette* who slips poison to her parents—Marie is less the product of a specific time and place than the embodiment of human weakness.

Although, then, *Au revoir les enfants* and *Une affaire de femmes* are radically different in tone and outlook, the fact is that both films share an essentialist view of man and the world. Whether innocent (as in *Au revoir les enfants*) or guilty (as in *Une affaire de femmes*), people act in ways that are determined less by the world of history and ideology than by inner, unchanging, moral inclinations. But if, in this way, history is somehow banished from the world of these films, in still another, far less conscious fashion, it returns. And, as it does so, it creates one last, striking similarity between these two very different films. For, no less than Truffaut, both Chabrol and Malle take great care to emphasize the ignorance of their protagonists in one vital, ideological area: that of anti-Semitism. Indeed, judging by the schoolboys or Marie, France might never have been the scene of anti-Semitic propaganda, the racist films and clips seen in *Le chagrin et la pitié* might have been shown on another planet. And it is here, certainly, in the protagonists' repeated assertions of ignorance and innocence concerning the fate of Jews, that one senses the profound weight of a troubled past that refuses to be totally erased from memory.

Take, for example, *Au revoir les enfants.* It is not merely that the film focuses on a schoolboy friendship between Jew and Gentile. No one in this film seems to have heard of Jews, much less harbored any ill-will toward them. Even the intelligent Christian boy—who comes, after all, from a bourgeois, sophisticated family—remarks that he knows nothing about Jews except that they do not eat pork and "are smarter than we are." Deeming this ignorance "singular," critic Stanley Hoffman (who was generally enthusiastic about the film) voiced his scepticism thus: "In January 1944, after years of anti-Jewish propaganda and persecution, sheltered schoolboys could

conceivably have been that ignorant but they would hardly have been typical of young Frenchmen at that time" (Hoffmann, p. 21). And Hoffmann also expressed doubts about an important scene in which the upper-class clients of an elegant French restaurant start to protest, with murmured cries of "collabo," when a group of *miliciens* begin to harrass an elderly Jewish diner. Without denying that, by 1944, most of the French did hope for their liberation, Hoffman queried the credibility of this scene. "Wouldn't," he asked, "the heavy, guilty silence of fear have prevailed . . . especially in an expensive establishment, where German officers were also dining? (Hoffmann, p. 21).

No similar instance of collective resistance occurs in the tainted and claustrophobic universe of *Une affaire de femmes.* Still, it is noteworthy that once again we are presented with a protagonist who—despite all her cunning and cleverness about money—is as simple, as ignorant as Lucien or the schoolboys where Jews are concerned. Although, for example, Marie's best friend is named Rachel, and they live in a small town where, presumably, everyone seems to know everyone else, she learns that her friend is Jewish only when the latter is deported. And this is followed by something even more unlikely. When Marie learns of her friend's fate, this callous and scheming woman begins to cry as she displays—*for the first and only time in the film*—a hidden, sympathetic vulnerability.

It is significant that even Chabrol, whose view of human nature is so uncompromising, should include a scene such as this. For like all the assertions of innocence which mark these films—perhaps even more so because the surrounding context is so dark—it points to a sense of guilt which refuses to go away. This is not to say that individual dramas like those depicted did not take place, or that some people were not unaware of the ideological and political battles which raged about them. Nor is it to deny the fact that individual French men and women felt friendship for Jews, and even took heroic risks to save them. Pierre Sauvage's splendid documentary, *Weapons of the Spirit* (1989)—which depicts the Huguenot town of Chambon-sur-Lignon where almost everyone sheltered and protected Jews—provides eloquent testimony to the contrary. But these were, after all, noble exceptions. And the *pattern* which emerges from these films—a pattern composed of repeated assertions of innocence uttered in a kind of ideological void—indicate, above all, a compelling need to deny, repress, the evidence of history.

Nearly twenty years earlier, the witnesses of *Le chagrin et la pitié* who proclaimed a lack of anti-Semitism were confronted with objective proof that they were denying difficult truths, wiping them clean from the slate of history. Now, instead—and in very different kinds of films—similar denials are rendered as believable, as credible, as possible. Almost as if ignorance

could exorcize the spector of French anti-Semitism, the protagonists of all these films—Lucien, the schoolboys of *Au revoir les enfants,* the members of the troupe in *Le dernier métro,* the housewife-abortionist in *Une affaire de femmes*—know nothing about Jews, about anti-Semitism. Nothing, in short, about the agonizing choices and fatal ideological passions which brought Occupied France into a state of what Henry Rousso deems "civil war." "Perhaps," says a saddened Ophuls in *Hotel Terminus,* "no one cares about these issues any longer except for old Nazis and Jews." Perhaps. Still—as the rise to power of Le Pen suggests—the deep-seated attitudes which helped establish Vichy, and which flourished during that regime, have by no means disappeared. The scapegoat may have changed—Arab may have replaced Jew—although even that is not certain. But this much *is* certain: if we bury the past, as these films appear to do, how do we then come to terms with the present?

Notes

1. For a more extended analysis of the relationship between the spirit of May 1968 and *Le chagrin et la pitié,* see René Prédal, *Le cinéma français contemporain* (Paris: Editions du Cerf, 1984), p. 112.

2. In addition to their focus on the issue of French collaboration, both films also reflect the influence of the historical approach known as the *"histoire des mentalités."* Instead of presenting history from the viewpoint of great men and momentous events, both seek to grasp the spirit, the *"mentalité,"* of the past through the lives of ordinary people—i.e., the townspeople of Clermont-Ferrand, the peasant protagonist of *Lacombe Lucien.* It is noteworthy, too, that although *Lacombe Lucien* was a work of fiction, it resembled *Le chagrin et la pitié* in that it had the look and feel of a documentary: shot on location in the remote countryside of Southern France, it featured nonprofessionals who spoke with thick regional accents.

3. This view was seconded by French philosopher Michel Foucault. Discussing films such as *Lacombe Lucien* and Liliana Cavani's *Portiere di notte,* he remarked that "La vieille droite pétainiste, la vieille droite collaboratrice, maurrassienne et réactionnaire qui se camouflait comme elle le pouvait derrière de Gaulle, considère que maintenant elle a le droit de réécrire elle-même sa propre histoire." See "Anti-rétro: Entretien avec Michel Foucault," *Les cahiers du cinéma,* No. 251–252 (July–August, 1974), p. 6.

4. These films appear to confirm Rousso's suggestion that it took thirty years before Jews were able to recall the horrors they had experienced. But once begun, the process of recall became obsessive, spurred on by the knowledge that the generation of survivors had to speak before it was too late.

Works Cited

Bonitzer, Pascal. "Histoire de Sparadrap," in *Le regard et la voix,* Paris: 10/18, 1976. Originally in *Les cahiers du cinéma,* No. 250 (May, 1974).

Bory, Jean-Louis. "Servitudes et misères d'un salaud," *Le nouvel observateur* (January 28, 1974).

Garçon, François. "Le retour d'une inquiétante imposture: *Lili Marleen* et *Le dernier métro*," *Les temps modernes*, No. 422 (September, 1981).

Grenier, Richard. "The Aging of the New Wave," *Commentary*, vol. 71, No. 2 (February, 1981).

Hoffmann, Stanley. "Neither Hope nor Glory," *The New York Review of Books* (May 12, 1988).

Jeancolas, Jean-Pierre. *Le cinéma des français: La Ve république, 1958–1978.* (Paris: Stock, 1979).

Kael, Pauline. Review of *Au revoir les enfants, The New Yorker* (February 22, 1988).

———. Review of *Lacombe Lucien, The New Yorker* (September 30, 1974).

Lardeau, Yann. "Une nuit au théâtre." *Les cahiers du cinéma*, No. 315 (October, 1980).

Miller, Judith. *One, by One, by One: Facing the Holocaust* (New York: Simon and Schuster, 1990).

Rousso, Henry. *Le syndrome de Vichy* (Paris: Seuil, 1987).

Zimmer, Christian. "La paille dans le discours de l'ordre," *Les temps modernes*, No. 336 (July, 1974).

18

The Languages of Pain in *Shoah*

Nelly Furman

L'insoutenable pour moi n'est pas l'image: elle évoque, elle ac-
cable; mais la parole et le silence où vivent les morts.
Daniel Sibony, *Ecrits sur le racisme*

Shoah, a nine-and-a-half-hour-long film, contains no photographs of peo-
ple wearing yellow stars, no pictures of children with their hands raised, no
images of skeletal bodies, no spanning of rooms filled with piles of eyeglasses
or valises. Not a visual documentary, Lanzmann's film forces us first of all
to hear, to listen; *Shoah,* as its subtitle underscores, is *An Oral History of The
Holocaust.* Entirely filmed in the present, Lanzmann asked those who lived
through the events, whether as torturers, victims, or bystanders, to speak,
to testify to what they saw, to what they did, to how they felt—to recall for
us their experiences. The result is a film of incomparable reach that tugs at
every emotion, displaces our notions of facts, questions our perceptions,
our understanding of history—a film that destabilizes our previously held
opinions, values, and attitudes. As *An Oral History of the Holocaust, Shoah*
demands that we listen: to the ex-Nazis speaking in German, to the Poles
speaking in Polish, to the survivors speaking in many different languages.
In its multiplicity of languages, *Shoah* enacts the rebuilding of a shattered
Tower of Babel in an obsessional attempt at grasping an event beyond human
imagination, beyond the communicative powers of language. A viewer com-
mented: "Having to grapple with interviews in one language, translated into
another, with subtitles in another, reinforced the sense of there being a wall
which kept language out—if you spoke all the languages in the world, you
would still not be able to convey what happened."[1]

In a remarkable study of the film, Shoshana Felman underscores the fact
that, beyond presenting testimonies about the genocide, Lanzmann's film
itself testifies to its own historical present: "*Shoah,*" she writes,

embodies the capacity of art not simply to witness, but to *take the witness stand:* the film takes responsibility for its times by enacting the significance of our era as an *age of testimony,* an age in which witnessing itself has undergone a major trauma. *Shoah* gives us to witness a *historical crisis of witnessing,* and shows us how, out of this crisis, witnessing becomes, in all the senses of the word, a *critical* activity."[2]

In the film, the sound track tells a story that the images flashed on the screen seem to belie. The voices recount past experiences, while the camera films the present; the disjunctions between past and present, the disconnections between the ostensive and the aural short-circuit our sense of time and space, our perceptions and understanding. In a bucolic clearing in the forest, Simon Srebnik, a survivor of Chelmno, tells us: "It's hard to recognize, but it was here. They burned people here. A lot of people were burned here. Yes, this is the place. No one ever left here again" (p. 5).[3] In the forest of Sobibor, Jan Piwonski points to a row of trees as he tells us: "You couldn't guess what had happened here, that these trees hid the secret of a death camp" (p. 10). Later, Richard Glazar, a survivor of Treblinka, evokes the horror of the extermination camp against the backdrop of a well-to-do urban waterfront with leisure boats cruising back and forth. At another moment, the camera follows, then zeroes in on, a modern Saurer truck on the highway, while Claude Lanzmann reads wartime directives on how to improve the killing efficiency of the Saurer vans. Past and present converge on the screen, unsettling the spectator's sensory perceptions and cognitive knowledge, thus allowing a disquieting and unexpected sentience to affect the very process of intellection. The hiatus produced by these temporal-spatial discontinuities create in the viewer the "sense of being swallowed up in a black box."[4]

Claude Lanzmann conducts the interviews in one of three languages: in his native French, or in German or English—two languages in which he is fluent. For the other languages spoken in the film—Polish, Yiddish, and Hebrew—he relies on interpreters, who at times appear on camera, and at other times are only voices on the sound track. We see and hear all those interviewed, and whether we understand the language spoken or not, the words uttered are embodied in a visible human presence. Furthermore, Lanzmann limits the focus of the film to a handful of places: Chelmno, Sobibor, Treblinka, Auschwitz-Birkenau, and the Warsaw Ghetto. The same events are thus described by several persons, with distinct viewpoints in a multiplicity of voices and languages.

Interestingly enough, *Shoah*'s oral history begins silently with a written document. It tells us that four hundred thousand Jews were gassed at Chelmno in a region of Poland "annexed to the Reich after the fall of Warsaw, germanized and renamed Wartheland. Chelmno was changed to Kulmhof,

Lodz to Litzmannstadt, Kolo to Warthbrücken, etc." (p. 3). The silent screen alerts the spectator to the fact that languages hold historical and political significance, and that each idiom is also imbued with emotive resonance: for a Jew, the names Chelmno and Lodz may be the signifiers of irretrievable loss, whereas for a Pole, Kulmhof and Litzmannstadt may be the markers of pain. Lanzmann recalls in an interview that he was not particularly moved as he walked through the campsite of Treblinka, but that he lost his sense of reality at the sight of name "Treblinka" on a signboard at the train station.[5] In contrast to Treblinka, Auschwitz no longer exists under the name which marks its place in Jewish history: the German name Auschwitz having been replaced by the city's Polish name of Oswiecim.

The Nazi regime did not limit its linguistic war machinery to geographical appropriation; the linguistic medium made the enactment of its racial ideology possible. Before killing them, the Nazis dehumanized the Jews through locutionary acts: defining for the Jews a social status different from that of the Aryans, legalizing the expropriation of Jewish property, comparing the Jews to vermin, before decreeing that they must be deported, and then annihilated. By a series of verbal acts that steadily ruptured the link between the linguistic sign and its human referent, the Nazis virtually transformed the Jews—as well as the Romany people, homosexuals, and others who were also deemed undesirable—into nonpeople, into vermin and pollutants.

In the film, we learn that the survivors of Sobibor were forced to use a new lexicon to refer to the thousands of corpses they had to unearth: "The Germans even forbade us to use the words 'corpse' or 'victim'. The dead were blocks of wood, shit, with absolutely no importance. Anyone who said 'corpse' or 'victim' was beaten. The Germans made us refer to the bodies as *Figuren,* that is, as puppets, as dolls, or as *Schmattes,* which means 'rags' " (p. 13). Insofar as Jews were nonpeople, their remains could not logically be referred to as "corpses" or "victims," for these terms usually denote human beings, and their use might have conveyed something of the "human"—held an emotional charge, stirred up an affect—possibly brought up a residuum of "the human" in the Jewish labor force or even in their torturers. Many have pointed out the neutral aspect of the key terms associated with the annihilation of the Jews: the "Final Solution," "*Aktion,*" "Transport," "Resettlement Program." One can also add to this list the premeditated lies that allowed the Nazis to maintain order, such as the announcements concerning delousing, disinfecting, or showering as veiled proclamations of imminent death. For us today, these signifiers have become the linguistic markers where the remains of the victims of the genocide lie encrypted.

There is an extraordinary moment in the film when it is neither the Germans nor the Poles who abuse language as a means to an end, but Claude Lanzmann himself. While interviewing with a hidden camera the

SS Unterscharführer, Franz Suchomel, Lanzmann promises not to use his name, and yet at the same time the name appears on the screen for all to see. Not only are we suddenly faced with an unexpected role reversal between the Nazi and the Jew, but we are made keenly aware, once again, of the performative power of language, and of the dual aspects of *Shoah*'s testimonial: as a visual, ostensive document, and as an oral, auditory report. In the exchange between Lanzmann and Suchomel, the spectator becomes—by dint of having unwittingly eavesdropped on this conversation—the eyewitness to the breach of an oral promise. Manipulated, interpellated by the film, the spectator becomes—willy-nilly—involved in the drama unfolding on the screen.

To prompt the survivors to speak, to allow the words to come forth, Lanzmann asked them to return to the places where they escaped death, to reenact, hence relive, what happened. Memory has a physical dimension as well as a mental one: "What is remembered in the body is well remembered," says Elaine Scarry.[6] Hence, the mnemonic techniques used by Lanzmann, such as the staging of some of the interviews, as well as the questions concerning the exact spot, the weather, what was actually heard or really seen, whose purpose is to let the pain somatically testify to the trauma which in itself remains beyond expression. For Gertrud Koch, "That is *Shoah*'s criterion of authenticity, and the basis of the film's tremendous visual power."[7]

If the body remembers by repeating, the mind mitigates the pain by displacing the event into a different linguistic medium. Srebnick, who lives in Israel, recounts the gassings of Chelmno in German; Inge Deutschron, who also resides in Israel, revisits Berlin in English; Rudolph Vrba speaks of Auschwitz in English; Abraham Bomba, while enacting his gestures in a Tel Aviv barbershop, recounts his experience in English; Ruth Elias, a Theresienstadt survivor, speaks from Israel in English; as for Armando Aaron, the president of the Jewish community of Corfu, he answers in French; and in the final sequence, Simha Rottem recalls the last days of the Warsaw Ghetto, not in Yiddish, which was the language of the ghetto, but in Hebrew.

In *Shoah*, the Nazis and the Poles speak their national language, whereas most of the victims speak in a language different from their own native tongue. The visual history of *Shoah* begins in Poland and ends in Israel, and on the sound track, we first hear Polish, then German; the film's concluding sequence is in Hebrew. From Poland to Israel, from Polish and German to Hebrew, Lanzmann's film retraces the geographical and linguistic trajectories that led to the creation of the Jewish state after World War II. But in the European theater of war, it was not Hebrew, the sacred language, but its spoken companion, Yiddish, which was the most common vernacular of the majority of European Jews. Not all unassimilated European Jews

spoke Yiddish; around the rim of the Mediterranean, Sephardic Jews spoke Judezmo or Ladino. But for every Ladino-speaking Jew, there were nine unassimilated Jews for whom Yiddish was their native, maternal tongue. Yiddish was the language of the unassimilated Ashkenazi Jews of Western, Central, and Eastern Europe, the most widely used language of the Diaspora, the language of the majority of those who died.

Yet Yiddish is one of the languages least spoken in Lanzmann's film. While most survivors testify in a language different from the language or languages in which they lived the events, not all survivors testify in "translation"; some speak in Yiddish, and if they can't evoke for us the events themselves, they still bear witness, although they do so otherwise, in a mode different from narrative discursivity. This is perhaps why Yiddish is the language most commentators have failed to hear when reviewing Lanzmann's film. Despite its Hebrew title, *Shoah* is very much a French film, the work of an assimilated French Jew who, through his questioning of others, reveals the ethnic and national parameters of his own hermeneutic space. In *Shoah*, Yiddish and French present two different forms of testimony; it is to these distinctive narratives that I now want to turn my attention.

<p style="text-align:center">* * *</p>

Written on the screen at the start of the film is the information that at Chelmno, four hundred thousand Polish Jews were gassed, and only two survived: Simon Srebnik, the singing boy, who returns to Chelmno with Claude Lanzmann and speaks in German, and Mordechaï Podchlebnik, who, like Srebnik, also lives in Israel, but answers Lanzmann's questions in Yiddish from his home. In his interview with Podchlebnik, Lanzmann addresses his questions in French to the interpreter, who in turn translates the answers. Indicated in brackets are translations from the Yiddish spoken, when it differs from the interpreter's rendering.

> *What died in him in Chelmno?*
> Everything died. But he's [I am] only human, and he wants [I wanted] to live. So he [I] must forget. He thanks [I thank] God for what remains and that he [I] can forget. And let's not talk about that. . . .
> *Why does he smile all the time?*
> What do you want him [me] to do, cry? Sometimes you smile, sometimes you cry. And if you're alive, it's better to smile. (p. 7)

While the use of the third person respects the distancing inherent in translation, nonetheless the exchange between Lanzmann and the interpreter about "him," the obliteration of the first person from Podchlebnik's account, places Podchlebnik literally in the realm of the living dead, not only in reference to his experience at Chelmno, but also in his present

testimony, as he is erased from his position of first-person subject in his own narrative. On the sound track, this exchange corresponds to the visual scene that portrays the only other survivor of Chelmno, Srebnik, standing as the ghost of the past among the Poles gathered around him in front of the church.

Yet, in spite of his reservations, Mordechaï Podchlebnik will speak briefly about the first period of extermination at Chelmno. He recalls that in the cellar where he was being held names had been written on the walls, and that there was a graffito in Yiddish that read, "No one leaves here alive" (p. 78). Podchlebnik is the only survivor who actually testifies in Yiddish, although Yiddish is mentioned several times and heard on two other occasions in the film. Richard Glazar, a survivor of Treblinka, recalls that at the end of November, 1942, when the flames first shot up from the death camp, an opera singer from Warsaw suddenly stood up in the barracks and, facing the blaze, sang in Yiddish (p. 14). Glazar recounts this in German. Later, he again notes the words he had heard in Yiddish as he was working alongside a "Squad Leader": "What's going on? Where are the ones who stripped?" And he replied: 'Dead! All dead!' But it still hadn't sunk in, I didn't believe it. He used the Yiddish word. It was the first time I'd heard Yiddish spoken. He didn't say it very loud, and I saw he had tears in his eyes" (p. 47). Filip Müller recalls hearing the old men and women from Upper Silesia speaking in Yiddish of the *fachowitz* (skilled workers), the *Malach-ha-Mawis* (Angel of Death), and *harginnen* (being murdered). The Polish farmer whose land was adjacent to the Treblinka death camp recalls that the Jews in the trains were talking in their language, and he proceeds to imitate the sound: "ra-ra-ra" (p. 30).

In one particularly unbearable moment, Abraham Bomba, the barber from Tel Aviv, collapses in tears as he recounts how he and several other barbers were cutting the hair of women as they stood naked in the gas chamber. One day a transport of his own town arrived—he knew the women. "And when they saw me," he tells us, "they started asking me, Abe this and Abe that—'What's going to happen to us?' What could you tell them? What could you tell?" At that moment, Abraham Bomba switches from his story to that of another barber: "A friend of mine worked as a barber—he was a good barber in my home town—when his wife and his sister came into the gas chamber." This is the moment when words fail him. Overcome with emotion, unable to continue to speak, he first pleads with Lanzmann: "I can't talk. It's too horrible. Please. I won't be able to do it. Don't make me go on, please. I told you today it's going to be very hard" (p. 117). His appeal is uttered in perfectly correct English sentences. Then, communication is shattered. He says this English sentence: "They were taking that in bags and transporting it to Germany." While syntactically correct, this sentence is

out of sequence; logically, it would follow the answer he gave a moment
earlier to Lanzmann's previous question, and be placed after: "What we had
to do was chop off the hair; like I mentioned, the Germans needed the
hair for their purposes" (p. 116). Yet, "They were taking that in bags and
transporting it to Germany" appears in the middle of his response to Lanz-
mann's question about how he felt the first time he saw these naked women
arriving with children: "I tell you something," he answers, "to have a feeling
about that . . . it was very hard to feel anything, because working there day
and night between dead people, between bodies, your feeling disappeared,
you were dead. You had no feeling at all" (p. 116). Emotion surges up at
the moment when, asked to talk about pain, he testifies to the absence of
feelings. At that moment, Abraham Bomba, in tears, pronounces a few words
in Yiddish; the words are audible, although his lowered voice and the street
noise make it difficult to understand them. First the pleas, the silences, and
the tears, followed by a splitting in the narrative sequence and a displacement
into a different linguistic space as indicated by words uttered in Yiddish.
Moments later, having regained his composure, Abraham Bomba continues
the recollection of his experience in the gas chambers of Treblinka, again in
perfectly articulated English. In Lanzmann's film, the testimony of Abraham
Bomba bears witness to the fact that, forty years after the war, it is still nearly
impossible for him to recall the pain linked to the events that destroyed
his life. A detached observer to his Jewish experience in English, Abraham
Bomba's "inaudible" testimony in Yiddish provides symptomatic evidence
of the pain embodied in his very being, in his Jewish identity. In the case
of trauma, the experience of the traumatic event is first forgotten, only to
occur in a delayed and displaced form.[8] Like most other survivors, Abraham
Bomba finds himself confronting several traumas: the witnessing of the
mass deaths, but also the trauma of his own survival, a survival possible
only at the cost of his labor, that is to say, his participation in the Nazi
death machinery.

 Yiddish will be heard only once more in *Shoah,* in the last section of the
film, the section devoted to the Warsaw Ghetto. In New York, sitting on a
sofa, Gertrude Schneider and her elderly mother do not speak to Claude
Lanzmann; they simply sing a Yiddish ballad:

צי געדענקסטו װען איך האָב דיך געלאָזן אין װעג?
מײַן גורל האָט געזאָגט איך מוז פֿון דיר אַװעק.
װיל אין דעם װעג װעל איך שוין קיינמאָל ניט שטערן
װיל אַזוי מוז זײַן.

In this sequence, there is no talk, no narration of events, no interaction
between interviewer and interviewee—one sees two women sitting side by

side, the daughter carrying the tune, the mother in tears joining in. At different moments in the film, we hear songs, which play a significant role as a tangible, factual element of a lost reality. In Shoshana Felman's words, the song appears then as a "concrete, material residue of history."[9] Thus, she comments at some length on the songs heard or evoked in the film—the Polish and German folk songs sung by Srebnik, the Treblinka hymn repeated by the former SS guard, the voice of the opera singer which marks the first time the bodies were burned at Treblinka, the Czech national anthem and the *Hatikvah* that suddenly resonated in the crematorium. But drowned out by the male voices, seemingly forgotten or unheard amid the male "historical" chorus, the mother-daughter duet does not catch Felman's attention. In New York, Gertrude Schneider and her mother, both survivors of the ghetto, sing:

> Do you remember when I left you on the road?
> My fate told me I had to leave you,
> Because I never want to stand on that road again.
> Because that's how it must be. (p. 195)

This song offers a visual testimony of tears, and speaks of separation, of the necessity of accepting one's fate, of a departure whereby one simultaneously loses and finds oneself. "The trauma is a repeated suffering of the event, but it is also a continual leaving of its site," writes Cathy Caruth, and she adds, "to listen to the crisis of a trauma, that is, not only to listen for the event, but to hear in the testimony the survivor's departure from it."[10] The mother-daughter duet offers both auditive and visual testimony to the trauma of survival, and its sequel. Survival happens; it is an unpredictable, inexplicable, and for the survivor, an incomprehensible event: "My fate told me I had to leave you," the song tell us, "Because that's how it must be." But, as the presence of the daughter suggests, the trauma of survival proposes itself as an event that is not just simply the mother's own; rather, like a family heirloom, the trauma of survival is passed on from mother to daughter, inscribing itself from one generation to the other as an encrypted family legacy.

The last witness to appear in Lanzmann's film is Simha Rottem, a member of the Jewish Combat Organization of the Warsaw Ghetto. He recounts in Hebrew his return to the ghetto after the uprising: "I suddenly heard a woman calling from the ruins," he recalls.

> It was darkest night, no lights, you saw nothing. All the houses were in ruins, and I heard only one voice. I thought some evil spell had been cast on me, a woman's voice talking from the rubble. I circled the ruins. I

didn't look at my watch, but I must have spent half an hour exploring, trying to find the woman whose voice guided me, but unfortunately I didn't find her. (p. 199)

Like the barber Abraham Bomba, the survivor of the ghetto expresses his story in a language different from that in which it was experienced. Here Yiddish, the spoken language of the ghetto, is replaced by modern Hebrew.

Simha Rottem, the ghetto fighter, speaks in Hebrew from Israel; the woman entombed in the Warsaw Ghetto has no language, she is just a voice, a guiding voice, a voice that cannot be localized, a voice without a language, a voice without a country—a voice that is the last vestige of a culture that disappeared along with its people. Mordechaï Podchlebnik, the only survivor who testifies in Yiddish, says very little when compared to Vrba, Glazar, and Müller, who seem to be unable to stop talking; the other Yiddish speakers do not actually testify; their tears and their inaudible phrases testify for them. Yet, to be heard, even if not comprehended, the muffled and unformulated evidence of the noise of pain requires a listener. As Dori Laub points out, "The absence of an empathic listener, or more radically, the absence of an *addressable other,* an other who can hear the anguish of one's memories and thus affirm and recognize their realness, annihilates the story."[11]

While a plethora of languages allow the victims to testify to the horrors of the genocide, Yiddish provides the audible axis, the sonorous vortex of the deaths being evoked. Written in Hebrew characters, Yiddish is a language whose syntactic structure is rooted in medieval Rhineland German, with a lexicon that combines, in addition to words of Germanic origin, a vocabulary borrowed from Hebrew and Aramaic, French, and the Slavic languages. While its sonorous materiality may seem at times uncannily reminiscent of High German, between German and Yiddish, as John Geipel pointedly remarked, "the familiar coexists incongruously with the totally unfamiliar."[12] Related to the other languages of Central Europe, Yiddish flourished alongside and outside the national languages; as a pan-European linguistic medium, Yiddish contains and reflects something of the languages of the genocide. To the assimilated Ashkenazi Jews, Yiddish stigmatized the Jew of the ghetto and bore the marks of class differences. For the secular, nonassimilated Jew, Yiddish was the language of the European Jewish community, the articulation of Jewish identity and its mark of otherness. For the religious Jew, Yiddish was the weekday medium, as opposed to the Hebrew of the Sabbath services. Last, but not least, Yiddish was *the* language used by nonassimilated Jewish women, who, having been historically excluded from reading the Torah, had only a very rudimentary knowledge of ancient Hebrew. For Ashkenazi Jews, Yiddish is literally the mother tongue, that is to say, *mame loshn.* Once the cultural transmitter of the life of the *shtetl,* and

now the signifier of a world forever lost, Yiddish reverberates throughout Lanzmann's film, yet remains virtually unheard, practically unnoticed, an uncanny noise, "a trivial phenomenon" in a cataclysm that is beyond understanding.[13]

The last words spoken in the film are those of Simha Rottem, the ghetto fighter:

> Yes, I was alone all the time. Except for that woman's voice and a man I met as I came out of the sewers. I was alone throughout my tour of the ghetto. I didn't meet a living soul. At one point I recall feeling a kind of peace, of serenity. I said to myself: "I'm the last Jew, I'll wait for morning, and for the Germans" (p. 200).

Like a phoenix risen from the ashes, the fighter of the ghetto speaks in modern Hebrew from a postwar Jewish nation, courageous in the face of danger, vibrant, virile, born out of intolerable suffering, haunted by the repressed voice of an unforgettable absence.[14] Between the German song that marks the start of Lanzmann's *Oral History of the Holocaust* and the description in modern Hebrew of the destruction of the Warsaw Ghetto, there is still a trace of audible evidence—the faint murmur of the language of the majority of those who died. In the static of a language heard only as mere noise, Lanzmann's memorial reveals traces of a historical and cultural trauma: the forgotten reality that between modern and ancient Hebrew lies buried a Yiddish culture. In its fragmentary pieces of oral evidence, Lanzmann's *Shoah* details a cultural ethnocide within the history of the Jewish genocide.

*　　*　　*

"I didn't make an idealistic film. It is not a film imbued with deep metaphysical or theological thoughts about why this happened to the Jews, why they were killed. It is a film that is down to earth, the film of a topographer, of a geographer."[15] From Israel to Poland (in the film, Lanzmann tells us that he found Srebnik in Israel and persuaded that onetime boy singer to return with him to Chelmno), then back from Poland to Israel (the last witness testifying from the Lohame Haghettaot Kibbutz Museum), Lanzmann's topographical voyage doubles a spiritual itinerary born out of historical necessity. Yet, interestingly enough, Lanzmann's retrospective itinerary from Poland to Israel bypasses France—the birthplace of the filmmaker himself. Witnesses speak from many places, from the United States, from Israel, from Poland, from Germany, and from Greece, but none from France. The only witnesses who express themselves in French are assembled in Corfu, on the square, where sixteen hundred Greek Jews were rounded up for deportation. Yet French is very much the language of the film: Lanzmann asks questions in French and reads documents translated into French. But

whereas those interviewed in the film speak in different languages, and from different locations, French appears chiefly as the language of inquest, the purveyor of the questioning. The absence of any "French" testimonial — either in French or from France — sets France apart as an unmarked country in the European theater of war, a place seemingly without direct association to the events.

The difficulty of presenting a historical account of the genocide, as Dominick LaCapra has argued, lies precisely in the fact that it is an event that cannot yet be appropriated according to the conventional tools of historiography: for historians of the genocide are subject to transferential cathexes that are acted out or worked through in a variety of ways.[16] No one is more aware of this than Lanzmann himself, who declared: "This film is built around my personal obsessions, it couldn't have been made otherwise."[17] In all forms of historicization of the genocide — *hic et ubique*, language, in its modes of articulation as well as in its silences, presents the symptomatic evidence of one's relationship to the events. "History, like the trauma," writes Cathy Caruth, "is never simply one's own, . . . history is precisely the way we are implicated in each other's traumas."[18]

In the Babel of *Shoah's* languages, the absence of any French eyewitness to Lanzmann's *Oral History of The Holocaust* is especially notable, particularly since it is estimated that, from among the nearly 76,000 French and foreign Jews who were deported from France between 1942 and 1944 — 71,000 of them directly to Auschwitz — 2,600 had survived the camps.[19] In addition, eyewitnesses to the genocide could also have been found among the estimated quarter of a million Jews who lived in France before the war and had eluded deportation, or the countless French men and women who lived through the war years as either involved resisters or indifferent spectators.

After the war, assimilated French Jews faced an identity crisis: not knowing whether they were French, or Jews, or whether they could be both. France, which during the French Revolution extended the rights of citizenship to its Jews, *de facto* stripped French Jews of their nationality during the war by initiating their deportation. Yet, after the war, French Jews seem to have become full citizens again, as evidenced by the official commemorations which merged the genocide of the Jews with the deportation of 63,000 non-Jewish French men and women sent to camps because of their political activities, or simply because they were deemed undesirables. But whereas most Jews were sent directly to Auschwitz, and extermination, French deportees were bound for labor camps such as Buchenwald and Ravensbrück.[20] In fact, for several decades, Buchenwald was the name which in France became the archetypal signifier for all Nazi camps. Thus, while the French deportations were memorialized, the Jewish genocide was forgotten. Until now, for France's civil administration the Jewish genocide was a tabooed

subject, foreclosed, settled in its nonstatus, barred from public recognition, relegated in France's national consciousness to official amnesia. France's wartime policies toward its Jewish citizens and its Jewish hosts are still — fifty years later — sensitive issues which French officials find difficult to confront.[21] For an assimilated French Jew, the genocide created an identity crisis that expressed itself through differing inflections of one's sense of nationality and one's markings of Jewish ethnicity. It is not surprising, then, that, for a French Jew born before the war, questions concerning the genocide could at first only be articulated from an elsewhere, a venue where nationality and ethnicity were not in conflict with each other. The notable absence of any French witnesses to answer Lanzmann's questions about the death camps calls attention to its own muteness, a silence that marks Lanzmann's *Shoah* as a "French" film of the postwar period. In *Shoah*, silence — as the soundless beginning of the film made clear — is an integral part of the textual politics played out on the sound track. In the absence of any French interlocutor, in its French unanswerability, Lanzmann's film — first shown in Paris in 1985 — mutely testifies to the then-unacknowledged, unrecognized, historical fate of the Jews from France.

Among Yiddish speakers, the annihilation of half of Europe's Jewish population is known as the *hurbn* (דער חורבן), meaning destruction, the very term used to designate two other momentous events of Jewish history, the destruction of the First and Second Temples. In French, the annihilation of the Jews was first referred to as "*le génocide des Juifs,*" an expression which in its etymology kept a trace of the racial hatred that led to the murderous events. Later, the genocide of the Jews became known in French as "*l'Holocauste.*" In choosing for the title of his film the Hebrew word "*Shoah,*" meaning annihilation, in order to distinguish the uniqueness of the Jewish genocide from all other instances of horrendous mass killings, Lanzmann, while avoiding the sacrificial theology attached to the word "holocaust," still relates biblical Hebrew to the Jewish nation created as a result of the war. In Israel, "*Shoah*" now denotes the day of remembrance; in France, since Lanzmann's film, "*Shoah*" is also often used to name the genocide of the Jews. Michel Deguy, in an article written in homage to Lanzmann's film, suggests the associative implications that this mysterious, foreign word elicits in French:

> The very term "*Shoah*" has become this opaque and mysterious name that has *entered* into our conversations, our whispers, our meditations, our allusions, like a sad house-guest whom we can no longer forget, whose given name we remember in a murmur, an utterance so close to the sound of the French word used to hush a noise, and which corresponds *in the film* to the reappearance of Simon Srebnik, silent and smiling, in Chelmno among the Polish parishioners.[22]

The term *"Shoah,"* like a ghost of the past, appears in the French idiom as the return of the repressed of French thought. Beyond the testimonies that Lanzmann's film brings to the archives of history, its other extraordinary achievement will be to have left in the French lexicon the imprint of a Hebrew word—the linguistic trace symptomatic of a historical trauma— which marks, at one and the same time, the departure and the return of the Jews of France.[23]

An Oral History of the Holocaust, Shoah tells us in its many languages and in its silences of both the past and the present. It stands as a testimony to the interminable effects of the genocide. It bears witness to an event that still cannot be relegated to the memory of history. For Lanzmann, the genocide is not an event of the past, but a historical trauma that defines the reality and the context of our present and draws the horizon of our future. He has been adamant in this opinion:

> When it comes to creating a work about the Holocaust, the worst crime— both morally and artistically—is to consider it *past.* Either the Holocaust is a legend, or it is current; in any case, it is not in the realm of memory. A film about the Holocaust can only be a counter-myth, that is to say an inquiry into the Holocaust in the present day; or at the very least in relation to a past whose scars are so recently and so vividly inscribed in certain places and in our minds that it appears in its hallucinating atemporality.[24]

As exemplified by Lanzmann's film, but just as factual in every document about these events, the trauma of the war continues to reverberate in the textual unconscious of our culture. In the materiality of each of its appella- tions—the Final Solution, the genocide of the Jews, the Holocaust, the *Shoah,* or the *Hurbn*—lie entombed the perpetually incandescent ashes of Jewish history, each designation signifying a past that can only be apprehended in its ever-present endlessness.

Notes

1. Jacqueline Castles, *Encounter,* Letter to the Editor, July/August, 1988.

2. Felman, Shoshana and Dori Laub, M.D. *Testimony. Crises of Witnessing in Litera- ture, Psychoanalysis and History.* (New York and London: Routledge, 1992), p. 206.

3. In parentheses are page numbers for all quotations taken from the published text of the film: Claude Lanzmann. *Shoah. An Oral History of the Holocaust.* (New York: Pantheon Books, 1985).

4. Gertrud Koch. "The Angel of Forgetfulness and the Black Box of Facticity: Trauma and Memory in Claude Lanzmann's Film *Shoah,*" *History and Memory,* 3.1 (Spring, 1991): 119–134; p. 130.

5. *Au sujet de Shoah, le film de Claude Lanzmann.* Présenté par Michel Deguy. (Paris: Editions Belin, 1990), p. 288, my translation.

6. Elaine Scarry. *The Body in Pain: The Making and Unmaking of the World.* (New York and Oxford: Oxford University Press, 1985), p. 110.

7. Koch, p. 131.

8. Cathy Caruth. "Introduction." *American Imago. Studies in Psychoanalysis and Culture,* 48.1 (1991), pp. 1–12.

9. Felman, p. 270.

10. Caruth, p. 10.

11. Felman, p. 68.

12. John Geipel. *Mame Loshn. The Making of Yiddish.* (London and West Nyack: Journeyman Press, 1982), p. 5.

13. In *Jokes and Their Relation to the Unconscious,* trans. James Strachey (New York: W. W. Norton), p. 81, Sigmund Freud recounts the story of a baroness in childbirth whose attending physician was able to diagnose the exact moment of birth by noting "an apparently trivial phenomenon," the switch in the languages of the baroness's cries from French, to German, to Yiddish.

14. For a study of the role of women in the film, see Hirsch, Marianne and Leo Spitzer, "Gendered Translations: Claude Lanzmann's *Shoah,*" in *Gendering War Talk,* edited by Miriam Cooke and Angela Woollacott (Princeton, NJ: Princeton University Press, 1993).

15. *Au sujet de Shoah,* p. 294, my translation.

16. LaCapra, Dominick. "Representing the Holocaust: Reflections on the Historians' Debate," in *Probing the Limits of Representation. Nazism and the "Final Solution,"* ed. Saul Friedländer. (Cambridge, MA and London: Harvard University Press, 1992), p. 110.

17. *Au sujet de Shoah,* p. 243, my translation.

18. Cathy Caruth. "Unclaimed Experience: Trauma and the Possibility of History." *Yale French Studies,* 79 (1991): 181–192, p. 192.

19. In 1978, Beate and Serge Klarsfeld published *Le mémorial de la déportation des juifs de France,* a large volume which lists the convoys, including the names of the deportees, that left France for Auschwitz, Maidanek, Sobibor, and Buchenwald.

20. See Annette Wierviorka, *Déportation et génocide. Entre la mémoire et l'oubli,* (Paris: Plon, 1992), pp. 20–21.

21. A malaise evident in the delays marking the official commemoration at the site of the *Vel 'd'Hiv,* the trial of Paul Touvier, the release of the documents known as *Le Fichier.*

22. *Au sujet de Shoah,* p. 21, my translation.

23. For Cathy Caruth, Freud's insight on the question of trauma was his pointing out that the unconsciousness of a trauma is borne by an act of departure whose traces could be found, for example, in a switch from one language into another. See "Unclaimed Experience: Trauma and the Possibility of History," pp. 191–192.

24. *Au sujet de Shoah,* p. 316, my translation.

19

Duras's Aurélia Steiner,
or Beyond Essence

Herman Rapaport

I.

Aurélia Steiner, dite Aurélia Melbourne.[1] It is not the only film Marguerite Duras will make of Aurélia Steiner, not the only time Duras will tell Aurélia's story by way of a narration that is utterly unreliable, even if every word speaks a truth seldom heard in literary or visual works of art, murmured rather than spoken, reflected rather than seen. "When I speak, I have a negative concern, I'm taking care not to move away from the neutral ground where all words are equal."[2] So if one accedes to the truth in Duras's film, it is in terms of a muted view of the Seine in which oily waters lap up around the footings of bridges or merely slap against the sides of things . . . a barge, a retaining wall, a small boat. Here the eddying waters have already flattened before a procession of endless bridges, as if in anticipation of the dark openings and black toxins which have collected near the pontoons. While the arching darkness approaches, an ominous humming of motors can be heard, as if to suggest that something unpleasant and industrial is at hand. Then the sound subsides with an apprehension whose cause one cannot rationalize. A bright sky reappears and famous buildings reassure us that the world is whole. The sound, it turns out, was just sound. The people who stand on the bridges appear as feeble shadows, anonymous outlines. "We shot *Aurélia Melbourne* against the light. The faces are erased, you see only their outline, the camera swallows them, the river takes them."[3]

The voice-over is deliberate and soft. Duras: "When I am speaking, I am Aurélia Steiner, if you will. What I'm careful about is less, not more. It is not to convey the text but to be careful not to get away from her, Aurélia, who is speaking. It takes extreme care, every second, not to lose Aurélia."

To lose her between the vastness, the openness of the scenes, and the closeness of Marguerite Duras' mouth to the microphone would be to risk the destruction of the films, the failure to hold on to the voice of the one in whose name the name of Duras should never come to pass—"to stay with her, not to speak in my name."[4]

So that, when we hear the following lines, we know they do not belong to Duras but to Aurélia, with whom Duras is struggling so hard to keep within earshot, this inviolable and untranslatable voice.

> Do you remember?
>
> That word. That country. That obscure land.
>
> You could say: There is nothing left but the road. That river.
>
> How to reunite our love. How?[5]

The space between these and other sentences is flooded. As if the sentences were broken dams. Reprise of *L'amour*. Reprise of *Eden cinéma*. Reprise of the sea in *Savannah Bay*. Reprise of *Un barrage contre le Pacifique*. Speaking of the toxic waters, "The peasants had been a little astonished. To begin with, the sea had invaded the plain for thousands of years. They were used to it and had never imagined it could be held back. Then their misery had accustomed them to passivity, their one and only defense against the spectacle of their children dying of starvation, their crops being destroyed by salt."[6] As in the script for *Aurélia Steiner Melbourne,* the sentences in *Un barrage* are futile defenses against a periodic sterilization or poisoning which no one can hold back. In the villages of Cambodia, dying children are commonplace. There is no defense, no wall that can protect them from death by flooding. Hence everyone gives up, as it were, in advance.

> Listen.
>
> Beneath the arches of the river, this unfurling.
>
> Listen . . .
>
> This apparent fragmentation of which I have spoken, has vanished.
>
> We would be able to come together in the end
>
> Of that of our love
>
> Have no fear.[7]

But what overcomes this apparent fragmentation? What closes it up? Aurélia calls such closure "the sound of the sea," and "the dark vault." In other words, she has entered into an openness or opening, what Maurice Blanchot in an essay on Hölderlin has called a space that allows the poet to approach

the unapproachable in order to be near that truth which exceeds speech, a truth akin to the sacred. "For Hölderlin, for the poet, death is the poem. It is in the poem that he must achieve the extreme moment of opposition, the moment where he is caught up in disappearing and, by disappearing, to carry meaning to the highest pitch of what can be achieved only through this disappearance."[8] Inexistence, Blanchot says, is at the intersection of speech and the sacred. And in Duras this inexistence is nothing other than *Das Offene:* "la bruit de la mer," "la caverne noire," and, too, "le rectangle blanc." "Inscribed on the white rectangle are the letters A.S. and a birthdate. You are now seven years old."[9] Martin Heidegger has said of such openings, of such radiant suspensions, that in them the sacred and chaos have become one.[10] "I think that at one particular moment Aurélia is on a bridge. To the left of the picture, there is a silhouette of a girl with long blond hair. The face is blotted out like the others. She has a very lovely shape, tall, thin." But all we see of her against the light is a smile. In fact, "she is broken into bits, scattered throughout the film," which is to say, that she is an afterimage, a residue of something. "She is still on the rue des Rosiers, first there, then somewhere else at the same time, always there, then, later, always somewhere else, here as well as elsewhere, in all Jews: she is the first generation, like the last."[11] Like the walls that cannot keep the water back, Aurélia Steiner is a particle or fraction of something that cannot hold out the forces which invade and destroy. And as such, she is part of something that has been wrecked in advance, like a broken-down sea wall that has been inundated many times, but she is also, and at the same time, to be identified with that chaos which we identify with the flood, a streaming, radiant dissemination against the light: the harsh whiteness of the small rectangle . . . a face blotted out by the sun . . . a stroke of light on a figure's blond hair. But there is, too, the white noise of the sea, and alternately, the dark openings of the bridges, the black patches where oil has spilled onto the waters, the darkness between the plank beds at Auschwitz.

It is into these openings, into this Open, that Aurélia has fled from her persecutors, this place which, in and of itself, is the place of persecution, or, as Blanchot says, of Death. No wonder that "it takes extreme care, every second, not to lose Aurélia, to stay with her." And yet, who is this "her"? Who or what speaks? There are, after all, a considerable number of manifestations to be taken into consideration. She is perhaps the granddaughter of forebears who were gassed during the *Shoah,* perhaps the daughter of parents who died in the camps but who herself survived, perhaps a child who was saved from the *Shoah* in Paris, but whose parents did not escape murder. She may be a mad young woman, born into a well-to-do family in Melbourne, Vancouver, or Paris, whose masochistic fantasy is to vicariously undergo what Hitler's victims experienced in the camps. No doubt, the name Aurélia

Steiner is discontinuous with itself even as it resembles a linguistic shifter that traverses a number of similar accounts, each of which could be viewed as a variant of the other. Dina Sherzer, in *Representation in Contemporary French Fiction,* notes how serial composition by the new novelists has emphasized the construction of parallel or recurrent accounts that allow for "continuous discontinuous structures that combine extreme heterogeneity and cohesion." As one traverses the series, one encounters "correspondences, echoes, interferences, associations, and oppositions."[12] In Duras's Aurélia Steiner scripts, films, and commentary one could even make a thematic recovery of such seriality by arguing that the series is characteristic of what Blanchot calls the "open" and of what Duras herself calls in English the "Outside," a term which we could translate as "beyond Essence."

II.

My argument is that, especially in Duras's Aurélia Steiner films, scripts, and commentaries, one has the opportunity to consider the question of the beyond of essence in terms that complement and develop the thinking of Emmanuel Lévinas and his most important interpreter, Jacques Derrida. In particular, I am interested in how this complementarity touches on questions of Jewish identity in relation to the *Shoah,* though in terms that explode or break open our usual understanding of identity in terms of the difference between interiority and exteriority, subjectivity and objectivity. Duras, it seems to me, is quite underappreciated as a writer, critic, and filmmaker who has gone as far as anyone in philosophically reconceptualizing subjectivity, even to the point of moving "beyond Essence." In order to discuss this, however, it is necessary to consider Jacques Derrida's remarks on *sériature* in a paper on Emmanuel Lévinas, entitled "En ce moment même dans cet ouvrage me voici," since Derrida's essay will not only allow me to point out some features about Duras' films, scripts, and commentaries that are otherwise difficult to sight, but will also enable me to address some of the ways in which Duras is considering the *Shoah* in terms of a subjectivity that radically reorients one's understanding of essence.

In general, Derrida's essay makes yet another attempt to think beyond the Heideggerian impasse of the ontological difference, this time by means of considering Lévinas, who is somewhat less directly centered in the Western philosophical tradition. Whereas in the essay, "La différance," Derrida was very much concerned with difference in terms of undecidability, in "En ce moment même" he is largely concerned with the undecidability of identity and of the kind of temporality which is given in any moment where identity is presumed. This follows rather directly from Lévinas' considerations in *Autrement qu'être, ou au-delà de l'essence,* in which we are told that "temporal-

ity, in the divergence of the identical from itself, is *essence* and original light, that which Plato distinguished from the visibility of the visible and the clairvoyance of the eye." In close proximity to this statement, Lévinas also says that "the visibility of the same to the same [is] sometimes called openness."[13] This visibility of the same to the same, moreover, comes to pass *seriatum* and, of course, in and as that temporality which Lévinas sees as essential but, too, as beyond essence. In a typically difficult passage, Lévinas asks:

> Does temporality go beyond essence? The question remains: are this night or this sleep which being would "quit" by means of time so as to manifest itself still *essence,* simple negations of light and wakefulness? Or "are" they an "otherwise" or a "hither side"? Are they accorded to a temporality beyond reminiscence, in diachrony, beyond essence—on this side of, or beyond, *otherwise than being,* liable of being shown in the Said, in order to be immediately reduced to it? Is the subject completely comprehensible in terms of ontology? That is one of the principle problems of the present research.[14]

The passage concerns the central question of how there can be otherness within identity. Night and sleep are dialectically and thematically opposed to light and wakefulness as, presumably, is death to life. The temporality of my existence is essentially determined by this difference. Its identity depends upon it. However, night and sleep are something other as well. They are the manifestation of otherness within identity or that which is beyond essence and otherwise than being. But why? As Lévinas will demonstrate, they are so because they overflow their significance as *themes,* and hence the dialectic itself between night and light, sleep and wakefulness, life and death, blindness and insight. The instructive point in Lévinas's exposition is not that something other exists outside of identity *per se,* but that this something other takes place as the Same. Developing a philosophical language in which to discuss this phenomenon is the project of Lévinas's book.

One means of discussing how otherness takes place as the Same is by considering temporal terms that retain or, as Lévinas says, protrain time: terms like "already," "still," or "at this very moment." It is in such terms that the past can be seen as having been modified, even as it is retained and does not change its identity. Retention is the manifold of the Same, therefore, within which difference or otherness can come to appear as the Same. Such retention is, for Lévinas, a return to the Same in which the Same is both the Same and not the Same but, as such, returned or brought back to the Same, nevertheless. And it is this eternal return which Lévinas

equates with the word Truth. But such a truth can only arrive in what Lévinas considers a moment which, in various texts, he delimits by the phrase which Derrida will apprehend or take up, *"en ce moment même."* Like Lévinas, Derrida will be interested in how the Lévinasian retention of time bears on Saying and questions of obligation, responsibility, and morality. We know, of course, that Jean-François Lyotard has already explored this issue from some other philosophical vantage points in *Le différend,* where nonidentity within the identity may become an occasion for silence, nonrecognition of the Other, and of what theologians have traditionally called evil.[15] Derrida, however, is mainly interested in what happens to fall "outside" of Lévinas's control, both in terms of what Lévinas passively allows to be situated on the outside or hitherside of the moment in which he comes to pass in his work, as well as that which Lévinas might be chagrined to discover on the outside despite all attempts to determine its very indeterminacy.

In discussing Lévinas, Derrida necessarily undertakes an analysis of textual recursivity in order to demonstrate some curious serial effects of nonidentity within identity, effects which threaten the Western notion of essence, in that they negate the structural principles upon which any notion of essence depends: the unification of temporal moments, a notion of presence identical to itself as present, the idea of persistence as that which is the same, repetition of the same as the same rather than as difference, motility of the same as the same, and so on. For Lévinas and Derrida, the beyond of Essence is a structural effect that breaks with the Aristotelian contradiction between identity and difference, an effect Derrida locates in what he calls the *sériature,* the repetition of the signature, which is at odds with an Aristotelian conception of time in which an identity is thought to consist of a temporality dominated by the presence of a historical now according to which past and future moments are to be synchronized. In Lévinas, on the contrary, phrases like *"en ce moment même"* break with this essentializing historical logic within which the signature as subject is written.

> But there must be a *series,* a beginning of a series of that "same" (at least two occurrences) in order for the writing that dislocates the Same toward the Relation to have a hold and a chance. E.L. would have been unable to make understandable the *probable* essence of language without that singular repetition, without that citation or recitation which makes the Same come (*venir*) to rather than returning (*revenir*) to the Other. I said a "chance" because one is never constrained, even when obligated, to read what is thus rendered legible. Certainly, it appears clear, and clearly said, that, in the second occurrence, the "at this moment" which determines the language of thematization finds itself, one cannot say determined any longer, but disturbed from its normal signification of presence, by that Relation which makes it possible by opening (having opened) it up to the

Other, outside of the theme, outside presence, beyond the circle of the
Same, beyond Being. Such an opening doesn't open something (that would
have an identity) to something else.[16]

The *"en ce moment même"* which returns is, in being disturbed from its
normal signification of presence, othered, opened up to something outside
presence, "beyond the circle of the Same, beyond Being." But, following
Lévinas, Derrida cautions that this Other isn't simply something else. "Per-
haps it isn't even an opening, but what bids (*ordonne*) to the Other, from
out of the order of the other, a 'this very moment', which can no longer
return to itself."[17] In such passages, Derrida assumes that we already know
that the distinction between difference and identity is a fundamental struc-
tural principle for constructing notions of essence. And even the term *dif-
férance*, in which undecidability is introduced to dismantle the distinction
between difference and identity, is not sufficient to discuss Lévinas's project,
since for Lévinas the beyond of Essence is not strictly speaking beyond
identity—beyond the identity/difference or self/other question—but situ-
ated within identity as something that breaks with the logic of the same as
Same. In the phrase *"en ce moment même,"* Derrida will examine this sur-
passing of the same in terms of how two moments or occurrences are given,
the one thematic, the other unthematic. Derrida writes:

> You will have noticed that the two occurrences of "at this moment" are
> inscribed and interpreted, drawn along according to two different gestures.
> In the first case, the present moment is determined from the movement
> of a present thematization, a presentation that pretends to encompass
> within itself the Relation which yet exceeds it, pretends to exceed it, precede
> it, and overflow it. That first "moment" makes the other return to the
> same. But the other, the second "moment," if it is rendered possible by
> the excessive relation, is no longer nor shall it ever have been, a present
> "same." Its "same" is (will have been) dislocated by the very same thing
> which will have (probably, perhaps) been its "essence," namely, the Rela-
> tion. It is in itself anachronic, in itself disparate, it no longer closes in
> upon itself.[18]

Here Derrida draws out the synchronization of two identical moments in
which the one swears by the other as its truth even as the Relation between
such moments exceeds their coincidence. "[The moment] is not what it is,
in that strange and only probable essence, except by allowing itself before-
hand to be opened up and deported by the Relation which makes it possible.
The Relation *will have* made it possible—and, by the same stroke, impossible
as presence, sameness, and assured essence."[19]

III.

Aurélia Steiner is the name or signature whose identity is never bound to any one person or to any one moment, even if she comes to appearance *"en ce moment même."* The name, therefore, broaches what Lévinas and Derrida call anachrony, repetition, difference, and identity. The voice which has returned to the world outside the camps and inhabits a temporality not of the *Shoah* is a voice that has either projected itself into the future beyond the times of the camps or has spoken retroactively from some point long after the camps are barely imaginable. The script, therefore, is temporally divided and perhaps even folded over on itself, at once the same and not the same with itself. The name, Aurélia Steiner, is subjected to serial effacement, since the name cannot be determined as having a singular identity or moment within which its call can be restricted. Aurélia Steiner names the woman dying under the plank beds in Auschwitz, but also the young woman who, long after the war, is calling herself the daughter of highly educated parents, the daughter born in the death camp, or the daughter of this daughter. In the following phrases, the fissuring and doubling of temporality is quite noticeable, since the lines describe the feelings of the Aurélia of the camp who has just lost her husband, though the text could just as easily comprise the remarks of an other Aurélia, that of Melbourne or Vancouver, who is calling out to her own lover.

> Where are you?
>
> What are you doing?
>
> Where have you gone to?
>
> Where have you gone to while I cried that I was afraid?[20]

Such words speak the *Shoah* thematically, even as they speak out of their difference in a way that both makes the first moment, that of the camp, withdraw into an uncomplicated self-presence or self-presentation, even as the second moment, spoken retroactively by the Aurélia of Melbourne, is peculiarly nonthematizable, since it is so utterly nondescript and adaptable to so many situations. The division between the name Aurélia—the Aurélia of Auschwitz and the Aurélias of Melbourne, Vancouver, Paris—brings the thematic and the nonthematic into proximity, as if to elude any determinate moment in which the name can be concretized or essentialized. For the first thematic moment is overshot or superseded by the second nonthematic moment that encompasses the Relation and yet exceeds or overflows it. That is, the text addresses a moment in Auschwitz whose thematic is that of the father's slow death by hanging and the mother's grief, though this

moment is shared, parcelled out, or divided with a second concomitant moment from long after the war that resists localization and determinability. Although the first moment is necessarily recovered, if not rendered entirely from the position of the second moment, that second moment does not, in fact, merely encompass the Relation—the genealogy of Aurélia Steiner Melbourne—but exceeds and overflows it. As Derrida says, "It is in itself anachronic, in itself disparate, it no longer closes in upon itself." And yet, for all that, it is the Same.

This logic also explains some of the cinematic features of the Aurélia Steiner films. For example, the filmed shots of the Seine address the thematics of the *Shoah,* something that is evident in Duras's comment in which she speaks of the way in which she imagines the Jews being carried away down river like so much sewage. However, these shots are, at the same time, so utterly unthematic, nondescript, or neutral that they could just as well be the images taken by a tourist on holiday, or the images in a bad travelogue. Maurice Blanchot has spoken of neutrality in Duras as something which bestows "an infinite emptiness where the word destroy becomes a non-privative, non-positive, neutral word which bears neutral desire."[21] The water, bridges, and buildings in *Aurélia Steiner Melbourne* are, for all their cultural significance and presence, oddly remote and neutral, or nonthematic. Blanchot is correct to have identified in this neutrality a consciousness of destruction—his comments pertain to the novel and film *Détruire dit-elle*—though it is an understanding of destruction that is not literally or metaphorically represented on screen. Like the text, then, the visual *mise en scène* is also to a certain degree "outside of the theme, outside presence, beyond the circle of the Same." Openings, therefore, like the dark, cavernous passageways of the bridges, do not open from something to something else, but are themselves part of a *sériature* that bids us "from out of the order of the other," as if the bridges, the Seine, Notre Dame Cathedral, and the shadowy faces on the bridges, were themselves taking place outside the orders of difference and identity necessary to constitute that ethical relation in which the Jew and the non-Jew come into proximity.

This coincides with Lévinas's fundamental point that, from a Jewish orientation, the ethical relation is always outside or beyond essence, since the relation to an Other precedes the construction of ontological and epistemological categories based on the coincidence of Being and beings. In the Duras film, we have the rather complex matter of there being two structural relations to bear in mind, the first a thematizable and dialectical relation which is of the *Shoah* and, consequently, of the difference between persecutor and persecuted, anti-Semite and Jew; and, then, of a nonthematizable relation which we could call the neutral or open, after Blanchot, in which one is beyond the previous dialectic even as this moment has the capacity

to lapse back into that thematic as its Same. If the nonthematic moment easily slips back into the thematized dialectic, it is because the nonthematic moment cannot absolutely maintain its neutrality, but becomes temporally and historically polarized. Hence the very same bridges that we see today as neutral were, during the Occupation, present as part of that openness in which the destruction of the Jews took place. In looking at the Seine in its manifestation as the neutral or the merely banal, the ethical relation between anti-Semite and Jew is clearly suspended or forgotten. The dialectical or violent relation is overtaken by the neutral one. And yet this structural moment of the thematic and the nonthematic is overtaken by yet a third moment, namely, Blanchot's reminder that in Duras the neutral and the open is precisely where destruction comes to pass. So that, in effect, the difference between the two occasions, the one thematic, the other not, results in the iteration of an imperative — "destroy." While all three of these moments concern comportment toward the Other, taken together they are, strictly speaking, exceeding essence in that collectively they defy the philosophical protocols of identification established within a metaphysical tradition.

In the film *Aurélia Steiner, dite Aurélia Vancouver* the rocks, the felled trees, the serial numbers, the water, all function as neutral things plainly identical to themselves in which an ethical relation is simply dropped. Yet, in this particular film, some of these images also function to metaphorically mark the ethical relation of responsibility that their neutrality is excluding, even while we are listening to the following remarks:

> My name is Aurélia Steiner. I am your child.
>
> You weren't told of my existence.
>
> You cannot give me any sign. Death prohibited you from seeing me; I know that. And I, I see your death like a fleeting illusion of your life, for example, that of another love. It's the same to me. I found out about you on my own. This morning, for example, by the momentary dissolution of the sea's movement, that sudden shock without any evident object. I have found out about our deep affinity before the ordeal of desire.[22]

While the camera is tracking a lumberyard in which we see the logs with serial numbers and the letter D stamped for identification, the writing transposes what would have been a neutral or unthematic image into a thematic register. Therefore the logs become metaphors for the Jewish dead. Yet even this thematic is not as stable as one might think, since Duras is also touching on Heidegger's way of seeing the *Shoah* as just another aberration akin to those one sees in the production of raw materials and foodstuffs. In other words, a callous and unsympathetic attitude has simultaneously surfaced.

Instead of thematically supporting the text, the tracking shots purposefully exclude or neutralize the ethical relation between Jew and non-Jew by affirming things as merely present to themselves in the filmic now. In this example, we begin to glimpse the motility of various constructions that are to be sorted out in the moment we see and hear a sequence of shots in Duras's film.

Duras herself has pointed to the unsympathetic side of her treatment of her central Jewish figure(s):

> It's already almost forty years ago. She could not have been writing in '45. To do it, time has to pass over the horror. She is the leprous cat too, Aurélia Steiner is. That Jew, that Jewish cat. Moreover, in those days, you would cross a Jewish continent. During that journey on the river in the north, Aurélia is calling her lover who has disappeared in the charnel houses, the wars, the crematories, the equatorial lands of hunger. We are exactly in the center of an unknown city where the river cuts through. The river would drain off all the Jewish dead and carry them away. They would be talking about Aurélia everywhere. You would hear her name whispered under the bridges, she would be in everyone's memory those days. Yes, the river would carry them away in the funeral bark toward the singular end of the river, to be diluted in the sea, throughout the universe.[23]

We have, in this instance, a decided return to thematic materials with strong historical resonances. The river in *Aurélia Steiner Melbourne* reminds Duras of a sewer for the dead, a draining off or hemorrhaging which cannot be arrested or walled off, even if the shots of Notre Dame and the Louvre are shown in order to remind us of how some buildings have dreamed the grandiose dream of self-enclosure. In contrast to them, the bridges remind us of liquidation, of invasion, of an alien and destructive force which the city has aesthetically incorporated so that we might forget its threatening presence. We recall that the dilapidated chateau in the film, *Son nom de Venise dans Calcutta désert,* has a similar function, and Duras expects us to recall that French culture has always been permeable, a host to something lethal. Especially the bridges in *Aurélia Steiner Melbourne* raise the question of what it might mean to cross over the lethal, to pass over or by those who are transported by toxins. One thinks, for example, of an ecstatic transportation watched from above, an emotional transportation in which the Jew is being watched as he or she is drained away or hauled off, as if punished by a sacred decree as old as the river itself, as inevitable as the seas which flood the plains of Indochina.

This, of course, is a powerful thematic, and a troubled one, because it takes sides, as it were, with the anti-Semites for whom the Jews are to be bled off. Just as the mother hemorrhages to death after the birth of her

child, the river leaks out of Paris with its bloody debris "at the very moment" a very young woman smiles to us on the bridge, who is herself transported, carried away, as it were—an Aurélia who is repeating or reinventing the life of someone called Aurélia Steiner who has died in Auschwitz but has given birth to a daughter whom the young woman may or may not be. The husband is hung for having stolen food, and through a small rectangle of harsh white light his corpse is hanging. Duras adds that "This is the scene of a double death she would experience in her orgasm with strangers, that is, in a form of anonymous prostitution—the anonymity of the crematoria, of the camps."[24] Aurélia, then, is memorializing her love for the dead within a single ecstatic embrace, an "*en ce moment même,*" in which an Other— the lover? whom?—witnesses her coming into Being from beyond the plank beds, even as the very moment in which she has the orgasm, that moment is kept safe and secret within the very same moment she comes into being as a Jew. For Duras, however, this sexual circumscription of the moment is objectionable, insofar as it is really a female type of circumcision that has cut something away from her *jouissance* by means of remembering the past. Given such a self-mutilation of love, the genealogy of Jewishness circumnavigates the limits of passion:

> For me, it's not an insult when the black-haired sailor switches from the name Aurélia Steiner to the name Juden; he's letting himself be taken in, swept away by the strength of the curse that prevails over the race and the body of Aurélia Steiner; he isn't aware that he's no longer naming her but that he's calling her by the word that invokes her race and doing so, he enters into the vertigo of wild desire. This word becomes a word that takes him way beyond the limits of himself, an insane word, like those cried out in insane desire. This word fits Aurélia Steiner perfectly, her sexual pleasure comes with this word through which she completely rejoins the lovers of the white rectangle of death.[25]

What occurs, then, is that the name itself is cut away, circumcised, when Aurélia Steiner is caught "in a kind of coming and going between the inscribing and the wearing away of the name and that's it, the racial, Jewish orgasm of Aurélia Steiner."[26] No doubt one might wonder about his locution, the so-called "racial, Jewish orgasm," and ponder the objectionability of such a phrase, if not to say Duras's construction of the Jewess as a figure for race, in whose sexual pleasure persecution or liquidation necessarily comes about as an essential and defining element: circumcision of pleasure at the behest of an Other. No doubt, one could speak of a writing of the Jewish female body as the circumcision of pleasure, or, as Duras puts it, a racial, Jewish orgasm. Whatever this orgasm is, it obliquely addresses the well-known

question, put to us by Hélène Cixous, of "Who am I?" in relation to "How do I feel pleasure?" For the racial, Jewish orgasm is precisely one that defines "whom am I?" in terms of what it has cut away or cut out of itself, in the service of providing a historical continuity which the world at large has broken by means of disclosing itself as the eternally banal and inoffensive, as if the *Shoah* never could have taken place there at all. In other words, in this example one continuity or identity, the world as banally present to itself, breaks with or excludes an other continuity or identity, the historical community of the *Shoah* with postwar society. The racial, Jewish orgasm, however, by cutting something away from itself, makes the connection possible whereby the orgasm's *imaginaire* is the world of the extermination camp:

> She is in the concentration camps, that is where Aurélia Steiner lives. The German concentration camps, Auschwitz, Birkenau, were continental locations, stifling, very cold in winter, scorching in summer, very deep into the interior of Europe, very far from the sea. It's there that she goes to write her story, that is, the story of the Jews of all time.[27]

While the circumcision of her pleasure — her racial, Jewish orgasm — remains a constant which traverses all manifestations of Aurélia Steiner — the signature that is the name comprises a *sériature* by means of which the Same is historically fissured, cut by that orgasm, even within "the very same moment." Notice, for example, Duras's following account given on the same page as that just previously cited:

> The first generation — the grandparents — were gassed at Auschwitz. They were Aurélia Steiner's grandparents. When that generation was exterminated they already had children. From the beginning of the war and even in the years preceding it, many of those children were sent away and entrusted to relatives who lived far from Europe, the aunts and the uncles of Aurélia Steiner's parents. The last Aurélia was therefore born abroad, in Melbourne and in Vancouver. I don't think she ever went back to Europe.[28]

Both of these reconstructions take place or are given at the very same moment, and each negates, effaces, or cuts out the other as if to cut something from Aurélia herself. In this sense, the circumcision of pleasure relates closely to the seriality of Aurélia's anonymous lovers, but, more widely as well, to the *sériature* of these numerous retellings of her genealogy and of her life, that "stringed sequence of enlaced *erasures*," to quote Derrida, or what he has also called the *sériasure*:

A *series* (a stringed sequence of enlaced *erasures*), an interrupted series, a *series* of interlaced interruptions, series of *hiatuses* (gaping mouth, mouth opened out to the cut-off-word, or to the gift of the other and to the break in his mouth) that I shall henceforth call, in order to formalize in economical fashion and so as not to dissociate what is not dissociable within this fabric, the *sériasure (sériature)*.[29]

IV.

In *Green Eyes* someone asks Duras,

Is she the same one in Paris, Melbourne, and Vancouver?

Yes. She's the same one. At the same time. At every age. I can show you her photograph, as a child. I found her, Aurélia, at Neauphle. She was seven. She is not in the film but even so she was filmed. We didn't know how to film her with Pierre Lhomme, we didn't know how to capture her wildness. There is no difference between Aurélia's eyes and the sea, between her penetrating look and the depth of time.[30]

In the rectangle of the photograph she remains static. The Same. At every age. So that, somewhere, there is someone who literally corresponds to an image and a name. Someone who is Aurélia *"en ce moment même"* and who, in the framework of a photograph, doesn't necessarily open something to something else, or devolve into a series. That is, like the stones, the battlements, the pavements, Aurélia too is impenetrable. Suspended in the photograph as in brackets, she is a singularity. Yet, she nevertheless hails the Other from outside of the order of the Other, from that outside we know as the impenetrable. In this sense she exists beyond the serial order of Duras's Aurélias, who can say to themselves, behind whatever else they're saying, at this very moment, in this camp, here I am. For like the stone battlements, she exists in a neutral clearing where something is only pending. Like the stones of *Aurélia Vancouver,* she is merely "thereness," a "there-ness" for this moment and within this photograph which, in fact, constitutes a horizon established outside time: that horizon of *Da-Sein* (or *Das Ein*) in which the Jew appears like everyone or everything else. In the photograph, then, one only has the affirmation of stasis and continuity, a stasis that Duras does not insert into the films or the scripts, but must keep "outside" or "exterior" to the work.

In this representation, therefore, an identity can be said to break with the Same, even as it is posited as the Same itself. In other words, the photograph of the green-eyed girl is a radiant photographic suspension in which the violence between anti-Semite and Jew is sewn up in an image wherein

the destruction is held in abeyance. To some extent, she is like a survivor, in that "she can be only in a place of this kind, where nothing happens except memory," the memory of the Same.[31] In this construction we find an interiority in which each moment is remembered even while it is not being absorbed in a universal time. Hence the photograph is but a supernumerary instant that resists incorporation into the whole that could be called Aurélia Steiner. And yet, for all that, the photograph overshoots the resistance in terms of its presence-to-itself, its presence as *presence*. In returning to herself as herself in the photograph, Aurélia Steiner accedes to a forgetting or obviation of the Other and an awakening to the Same.

In terms of the photograph, therefore, we see a *passage des frontières* in which an incessant *sériature* has recollected or gathered itself into a unity of perception, the *"me voici."* The photograph, therefore, could be said to be an instantiation of the *"en ce moment même dans cet ouvrage me voici,"* an instantiation in which the disaster of the *"me voici"* is safeguarded in terms of the Same—a nonrelation with the Other. In the films this nonrelation repeats itself as the *"il y a"* of the bridges, the stones, the logs, the water, the lights, the sky, things overshot with a nonrelation we might call the inhuman—the infinity of an ipseity closed upon itself. And yet, within this ipseity—this presence of the girl who remains exterior and inviolate to the very *sériature* of which she is a part—or this return of the same to the Same, one notices something else, too, namely the trace of an other moment or nonrelation, as it were, which exceeds it and ruptures any potential for absolute closure. If we consider the photograph as the inviolate or the impenetrable, as that which represents an absolute nonrelation which corresponds to the film's images of the outside, that outside also carries with it a reference to something which is repeated numerous times in Jean-Paul Sartre's *Anti-Semite and Jew*.

Speaking of the anti-Semite, Sartre asks, "How can one choose to reason falsely? It is because of a longing for impenetrability. . . . There are people who are attracted by the durability of a stone. They wish to be massive and impenetrable; they wish not to change." The image of stone is mentioned on several occasions. "Choos[ing] for his personality the permanence of rock, he chooses for his morality a scale of petrified values." Or, "The anti-Semite is a man who wishes to be pitiless stone, a furious torrent, a devastating thunderbolt—anything except a man."[32] Clearly Sartre is addressing the question of the outside as that neutral Sameness in which a nonrelation comes to pass, except that here the Same is that of the Fascist (the anti-Semite) who looks upon others with a blank and pitiless attitude that in and of itself withdraws from any motivated or personal relation. The stone, therefore, represents a neutrality of the unmotivated in which disaster is always pending, into whose anonymity the destroyer retreats. In both *Aurélia*

Steiner Melbourne and *Aurélia Steiner Vancouver,* stone suggests precisely this kind of impenetrability, as if the films were a gloss on Sartre's text. As in *Anti-Semite and Jew,* Duras considers the remoteness and distance of objects in a world that permitted the *Shoah* in contrast to the victim's individual experience, in Duras, to the intimacy of the voice(s) of the victims. As in Sartre, the outside in Duras corresponds to the anti-Semite, to one who isn't anyone in particular but who exists as a potential for violence once he or she seizes the opportunity to politically activate an identity closely associated with the natural (that is, *Heimat*) and the pitiless (that is, things in themselves). As merely beings, the anti-Semites are very much like Notre Dame Cathedral, in that they are simply there as timeless, impenetrable neutrality, a neutrality that, according to Blanchot, says "destroy." It is this obliteration which is given alongside the nonrelation which comes to appear in the face of the girl with the green eyes, a "destruction" which accedes to the Same as otherwise than the Same. This Same, therefore, will, as Derrida says, always have been dislocated by the very same thing—in this case the very same concrete image disclosed outside—which will have (probably, perhaps) been its anachronic relation, which is to say, the disparate Relation of a Nonrelation that is serially given as the Same.[33] It is in this sense that the *"me voici"* of Aurélia is necessarily given in a moment that is "not what it is, in that strange and only probable essence, except by allowing itself beforehand to be opened up and deported by the Relation that makes it possible." This is the very relation which enables the coming into presence as the Same—or what gives or recollects itself as essence—to exceed its own horizon not simply by stepping beyond the Same, but by returning to the Same as a separability or Nonrelation in whose iteration one can think existence with "no exists." This, according to Lévinas himself, would enable us to think of Interiority as an order "different from historical time in which totality is constituted, an order where everything is *pending.*"[34] And this imminence—this sense of the pending as an approach of something disastrous—is what Duras characterizes as the experience of the Same, in whose advent the beyond of essence comes into a certain clearing or cinematic luminescence in which what Duras calls the Outside is radiantly suspended.

The Outside. It is precisely what one has encountered all along in Duras: the sea in *Barrage,* the yachting in *Le marin du Gibraltar,* the murder in the street in *Moderato Cantabile,* the cellar window in *Hiroshima mon amour,* life outdoors of *La femme du Ganges,* the vagrancies of Lola Valerie Stein, the tennis court of *Détruire, dit-elle,* the open French windows of *Agatha,* the estuary of *Savannah Bay,* the imagery of light in *Emily L.,* the deserted scenes in *Son nom de Venise dans Calcutta désert.* The outside is whatever interiority one has on the hitherside of essence, a hiterside in which alterity is no longer thinkable as such, and alienation has been superseded, since terms

such as these imply merely a negated relation that could be undone, the possibility of a way back. In Duras's Aurélia Steiner films, the *"me voici"* is the disclosure of an exteriority or outside that is beyond solitude and despair, beyond any ordeal of desire, since it is the revelation of that which is otherwise than human, the face of what lies beyond essence. It is for this reason that Duras can say of Aurélia, "Eighteen-year-old Aurélia Steiner, forgotten by God, sets herself up as equal to God face to face with herself."[35] To fully comprehend this, however, we would have to encounter the face of another child, one photographed during the Final Solution, which would require us to think the beyond of essence and the otherwise-than-human as the disclosure of what Lévinas calls the face and how it reveals the Law. In lieu of such an analysis, which I take up elsewhere,[36] I will only point out that if the *"me voici"* of Aurélia's face is not seen in the Aurélia Steiner films, it is because of her being set up as an "equal to God." That consequently the divine is not disclosed indicates the disregard and obliteration of the very Law which such an act implies. Indeed, the impenetrable neutrality of the photographic image from *Green Eyes* suggests obliteration has occurred in advance as an obviation or forgetting of the Other in the name of singularity. Yet it is against this forgetting that Aurélia will struggle to identify with the dead, as if the ability to remember their fate matched a capacity only imaginable of the very God to whom she would equal herself. In either instance, her face is occulted or effaced, as if it were the trace of the very destruction it was trying to overcome.

Notes

1. *Aurélia Steiner, dite Aurélia Melbourne* and *Aurélia Steiner, dite Aurélia Vancouver* are films produced in 1979 by Marguerite Duras, whose scripts are to be found in a volume entitled *La navire Night—Césarée—Les mains négatives—Aurélia Steiner—Aurélia Steiner—Aurélia Steiner* (Paris: Mercure de France, 1979). The three scripts entitled *Aurélia Steiner* are referred to in conversation by Duras as *Aurélia Steiner Melbourne*, *Aurélia Steiner Vancouver*, and *Aurélia Steiner Paris*. As is not uncommon, Duras has produced works which cross various generic boundaries, in this case, prose poem, theater, film, and *récit*. My focus in this paper will be on the cinematic aspect of the Aurélia Steiner scripts, as well as on Duras's rethinking of these scripts in a volume entitled "Les Yeux Verts," *Cahiers du cinéma* (1980), translated by Carol Barko as *Green Eyes* (New York: Columbia University Press, 1990).

2. *Green Eyes*, p. 135.

3. *Green Eyes*, p. 119.

4. *Green Eyes*, p. 145.

5. *Aurélia Steiner*, p. 121.

6. *The Sea Wall* (New York: Vintage, 1990), p. 42.

7. *Aurélia Steiner,* pp. 125–126.

8. Maurice Blanchot, *La part du feu* (Paris: Gallimard, 1949), p. 132.

9. *Aurélia Steiner,* p. 179.

10. *La part du feu,* p. 123.

11. *Green Eyes,* p. 119.

12. Dina Sherzer, *Representation in Contemporary French Fiction* (Lincoln: University of Nebraska Press, 1986), pp. 39; 30.

13. Emmanuel Lévinas, *Otherwise Than Being Or Beyond Essence,* trans. Alphonso Lingis, (Hague: Martinus Nijhoff, 1981), p. 30.

14. *Otherwise Than Being,* translation slightly modified, pp. 30–31.

15. Jean-François Lyotard, *Le différend* (Paris: Minuit, 1983).

16. Jacques Derrida, "At This Very Moment Here I Am," trans. Ruben Berezdivin in *Re-Reading Lévinas,* eds. Robert Bernasconi and Simon Critchley (Bloomington: Indiana University Press, 1991), p. 24. "En ce moment même dans cet ouvrage me voici" appeared originally in *Texts pour Emmanuel Lévinas* (Paris: J.-M. Place, 1980) and is collected in a revised version in Jacques Derrida, *Psyché* (Paris: Galilée, 1987).

17. Derrida, p. 24.

18. Derrida, p. 24.

19. Derrida, p. 24.

20. *Aurélia Steiner,* p. 119.

21. Maurice Blanchot, "Destroy," in *Marguerite Duras* (San Francisco: City Lights, 1987), p. 130. "Détruire" appears in Maurice Blanchot, *L'amitié* (Paris: Gallimard, 1971).

22. *Aurélia Steiner,* p. 142.

23. *Green Eyes,* p. 120.

24. *Green Eyes,* p. 84.

25. *Green Eyes,* p. 85.

26. *Green Eyes,* p. 84.

27. *Green Eyes,* p. 123.

28. *Green Eyes,* p. 123.

29. Derrida, p. 36. *Sériasure* in this case is the *sériature sous rature.*

30. *Green Eyes,* p. 143.

31. *Green Eyes,* p. 120.

32. Jean-Paul Sartre, *Anti-Semite and Jew* (New York: Knopf, 1963), pp. 18, 27, 54. Originally published as *Réflexions sur la question juive* (Paris: Morihien, 1946).

33. In "Le dernier mot du racisme," *Psyché* (Paris: Galilée, 1987), Jacques Derrida refers to this by invoking the word "apartheid." I elaborate this elsewhere in an as-yet-unpublished paper, "The Radiant Suspensions of Julien Gracq and Maurice Blanchot."

34. Emmanuel Lévinas, *Totality and Infinity* (Pittsburgh: Duquesne, 1969), p. 55.

35. *Green Eyes,* p. 121.

36. See my "Of the Eye and the Law," in *Unruly Examples,* ed. Alexander Gelley (Stanford: Stanford University Press, 1994).

Contributors

ORA AVNI is a Professor of French at Yale University. She has published extensively on nineteenth- and twentieth-century French theory and literature. Her last book, *The Resistance of Reference* examines treatments of reference and truth in linguistics, philosophy, and literature. She is currently writing a book on historical discourse and post-*Shoah* historical consciousness.

ROGER BUTLER-BORRUAT is a doctoral candidate in the department of Romance Languages at the University of Michigan. He is writing a dissertation on "Transformations of Racist Discourse: The Construction of Identity and Alterity from Drumont to Céline."

ALAIN FINKIELKRAUT, one of the most prominent of the new generation of French intellectuals, is the author of *The Undoing of Thought; The Imaginary Jew; Remembering in Vain: The Klaus Barbie Trial and Crimes Against Humanity;* and *The Future of A Negation.* He edits the journal *Le messager européen.*

JUDITH FRIEDLANDER is Dean of the Graduate Faculty of Political and Social Sciences and Walter Eberstadt Professor of Anthropology at the New School for Social Research. She is author of *Being Indian in Hueyapan: A Study of Forced Identity in Contemporary Mexico,* and *Vilna on the Seine: Jewish Intellectuals in France since 1968.*

NELLY FURMAN is Professor of French at Cornell University. Her areas of scholarship are nineteenth- and twentieth-century French literature, criticism, and feminist theory. She is the author of *La revue des deux mondes et le romantisme (1831–1848),* and the editor of the literary section of *Woman and Language in Literature and Society.*

NAOMI GREENE is Professor of French and Film Studies at the University of California-Santa Barbara. Her most recent book is *Pier Paolo Pasolini: Cinema as Heresy.* She is currently preparing a study on the relationship between cinema and history that will focus on post-1968 French film.

GEOFFREY HARTMAN is Sterling Professor of English and Comparative Literature at Yale. Among his many books are the recently published *Easy Pieces,* and *Minor Prophecies in the Culture Wars.* He is also editor of several important volumes on Jewish issues, most notably *Bitburg in Moral and Political Perspective,* and *Shapes of Memory.*

LAWRENCE D. KRITZMAN is the Edward Tuck Professor of French and Chair of the Program in Comparative Literature at Dartmouth. He has written extensively on Renaissance literature, French culture and intellectual thought, and literary and cultural theory. His most recent book is *The Rhetoric of Sexuality and the Literature of the French Renaissance*. He is currently completing a study on the politics of French intellectuals since World War Two.

EMMANUEL LÉVINAS has been Professor of Philosophy at the Sorbonne and the director of the *Ecole Normale Israélite Orientale*. Having played a major role in such areas as phenomenology, aesthetics, religion, ethics, and politics, Lévinas has had an important influence on twentieth-century Continental philosophy, especially the work of Blanchot, Derrida, Irigaray, and Lyotard. Amongst his major works are *Totality and Infinity; Otherwise Than Being; Time and the Other;* and *Difficult Freedom*.

JEAN-FRANÇOIS LYOTARD, one of France's leading philosophers, is a founding member of the Collège International de Philosophie and Professor Emeritus at the University of Paris. He is the author of numerous works, of which many have appeared in English, notably *The Postmodern Condition; The Differend; Heidegger and the 'jews';* and *Political Writings*.

ELAINE MARKS is Germaine Brée Professor of French and Women's Studies and Chair of the Department of French and Italian at the University of Wisconsin-Madison. She is the author of books on Colette and Simone de Beauvoir, and coeditor of volumes on *Homosexualities and French Literature*, and *New French Feminisms*. She has recently completed a manuscript on "The Jewish Presence in French Writing."

JEFFREY MEHLMAN is Professor of French Literature at Boston University and author, most recently, of *Legacies: Of Anti-Semitism in France*, and *Walter Benjamin for Children: An Essay on his Radio Years*. A collection of his essays written over the last twenty years is forthcoming from Cambridge University Press.

WARREN MOTTE is Professor of French and Comparative Literature at the University of Colorado. He is a specialist in Twentieth-Century French Literature, particularly avant-garde writing. His most recent book is entitled *Questioning Edmond Jabès. Playtexts: Ludics in Contemporary Literature* will be published shortly.

JEANINE PARISIER PLOTTEL, chair of Romance Languages at Hunter College, is Professor of French at Hunter and the Graduate Center, City University of New York. She is the publisher of *New York Literary Forum*, and the author and editor of books and articles on modern French literature, art, and theory.

HERMAN RAPAPORT, Professor of English and Comparative Literature, is Chair of the Program in Comparative Literature at the University of Iowa. His most recent book is a collection of essays entitled *Between the Sign and the Gaze*. Included in that volume is a companion essay on Marguerite Duras.

RONNIE SCHARFMAN, a specialist in Francophone literature, is Professor of French at SUNY-Purchase. She is the author of *Engagement and the Language of the Subject in the Poetry of Aimé Césaire*. Most recently, she has coedited, with Françoise Lionnet, a special issue of *Yale French Studies* on *Post/Colonial Conditions: Exiles, Migrations and Nomadisms*.

RICHARD STAMELMAN is Director of the Center for Foreign Languages, Literatures, and Culture at Williams College. He is the author of *Lost Beyond Telling: Representations of Death and Absence in Modern French Poetry*, and editor and principal translator of *The Lure and the Truth of Painting. Selected Essays on Art by Yves Bonnefoy*.

ALLEN STOEKL, an Associate Professor of French and Comparative Literature at Pennsylvania State University, is the author of *Politics, Writing, Mutilation: The Cases of Bataille, Blanchot, Roussel, Leiris and Ponge*, and *Agonies of the Intellectual. Commitment, Subjectivity, and the Performative in the 20th Century French Tradition*.

SUSAN RUBIN SULEIMAN is Professor of Romance and Comparative Literatures at Harvard University. Her books include *Authoritarian Fictions: The Ideological Novel as a Literary Genre; Subversive Intent: Gender, Politics and the Avant-Garde;* and *Risking Who One Is: Encounters with Contemporary Art and Literature.*

PIERRE VIDAL-NAQUET is Director of the Centre Louis Gernet de Recherches Comparées sur les Sociétés Anciennes at the Ecole des Hautes Etudes en Sciences Sociales in Paris. He is a renowned historian of the ancient world and the author of numerous books on Greek drama, mythology, economy, and society. He has also written on issues dealing with political ethics, particularly concerning torture in Algeria and questions relating to the Holocaust. His most recent book to appear in English, *The Assassins of Memory*, offers a detailed refutation of revisionist ideology.